2018
第五届丝绸之路国际艺术节
The Fifth Silk Road International Arts Festival

今日丝绸之路国际美术展
Today Silk Road Special Exhibition of International Art Works

作品集
Work Collection of Arts

任宗哲　蔺宝钢　主编
Zongzhe Ren　Baogang Lin　chief Editor

主办 Host
中华人民共和国文化和旅游部
Ministry of Culture and Tourism of the People's Republic of China
陕西省人民政府
The People's Government of Shaanxi Province

承办 Organizer
陕西省文化厅
Shaanxi Provincial Department of Culture

协办 Co-Organizer
西安建筑科技大学
Xi'an University of Architecture and Technology

中国建筑工业出版社
China Architecture & Building Press

Fifth

丝绸之路国际艺术节
The Silk Road International Arts Festival

Fifth

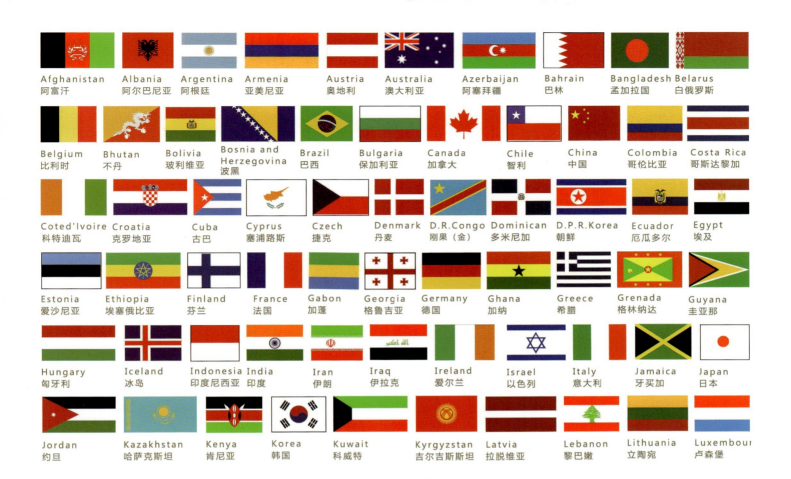

115 Countries

305 Artworks

115 个国家参展 共计 305 幅作品

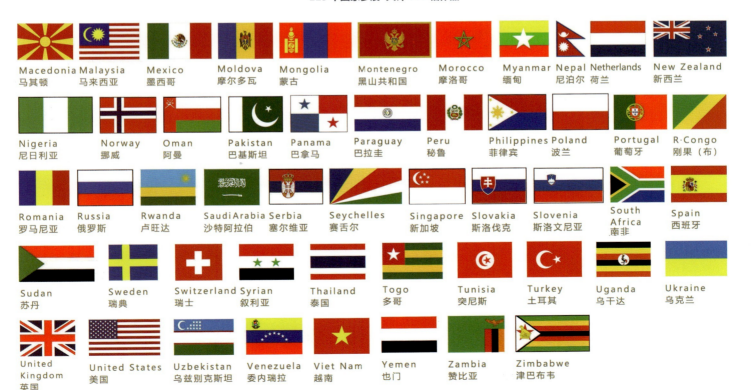

2018 第五届丝绸之路国际艺术节 今日丝绸之路国际美术展 **参展艺术家**
2018 the Fifth Silk Road International Arts Festival Today Silk Road
Special Exhibition of International Art Works Participating Artists

丝绸之路国际艺术节
The Silk Road International Arts Festival

陕西美术博物馆
Shaanxi Provincial Museum Art Museum
中国·西安
XI'AN·CHINA
2018 年 9 月 7-21 日
September 7, 2018 - September 21, 2018

前 言

在第五届丝绸之路国际艺术节开幕之际，2018今日丝绸之路国际美术邀请展于金秋九月拉开了帷幕。在习近平新时代中国特色社会主义思想指引下，由中华人民共和国文化和旅游部、陕西省人民政府共同主办的丝绸之路国际艺术节立足陕西，放眼世界，是推动中外人文交流、促进中外文明互鉴的重要平台和窗口。艺术节旗下的"今日丝绸之路国际美术邀请展"经过多年发展，其参与规模和海内外影响力使之成为美术界年度重要盛会。

今年举办的2018今日丝绸之路国际美术邀请展，115个国家的参与又一次刷新了纪录，展览成为在中国举办的参与国家和地区数量最多的国际美术展览之一，其关注度和影响力也达到了新的高度。海内外各门类的美术作品交相辉映，共同弘扬丝路精神，诠释丝路文化，展示艺术魅力，促进共赢发展。此次展览也是陕西美术与海外同行交流和学习的重要机遇，将有力促进陕西美术事业蓬勃发展。

在国家"一带一路"倡议下，陕西文化发展迎来了新的历史机遇。作为古丝绸之路的起点省份，陕西在"一带一路"人文交流、促进民心相通的大格局之下应当抢抓机遇、主动作为、积极谋划，充分发挥历史人文优势，弘扬中华文化，讲好中国故事，让世界了解中国，让陕西走向世界。

祝2018今日丝绸之路国际美术邀请展圆满成功。

陕西省文化厅厅长 任宗哲

2018年9月7日

Preface

On September 7, 2018, The Fifth Silk Road International Arts Festival, organized by the Ministry of Culture of the People's Republic of China and the Shaanxi Provincial People's Government, will commence in Xi'an China.

This year, the Fifth Silk Road International Arts Festival continues to uphold the spirit of Silk Road with international vision, and gathers Chinese and foreign cultural and artistic masterpieces. As the core content of the Arts Festival Arts Exhibition, the Today Silk Road International Arts Exhibition expands the range of participations of artists and artworks around the world with 115 countries participating this year. Excellent artists, from different countries and regions with variable cultural and artistic characteristics, appreciate the culture of others as do to one's own. Artists could comprehend the profoundness of Chinese culture, enjoy the charm of Silk Road spirit, feel the beauty of Chinese characteristics, Chinese style and the art of Chinese style, and promote the development of art in the world simultaneously. This exhibition will also increase the international influence Shaanxi's Today Silk Road Arts Exhibition Project into a new level, and fully highlight the new look and unique charm of the Shaanxi culture and arts in the social development and progress. Leading with cultures, Shaanxi culture characteristics, as the representative Chinese culture, will be promoted to the world.

Five years passed in an instant. With five years of rapid development of the Art Festival, the scale effects are expanding, the brand value is increasing, and the affinity, appeal, and international influence of the Silk Road cultural symbol is growing. With the care and support of the community, the Silk Road International Arts Festival has continuous development, growth, and progress. With the continuous improvement of the festival, the attractiveness and international influence is expanding. In this common endeavour, we share the contribution and encouragement with artists around the world.

The Silk Road International Festival is a positive implement of President Xi's great strategic conception of "One Belt, One Road" in the field of humanities, and it is an important project for strengthening the communications and cooperation between Chinses and other cultures. It is an important new starting point for the construction of the Silk Road economy in the new period, and a critical move to promote the spirit of the Silk Road, establish cultural self-confidence, adhere to the culture first, and create cultural Shaanxi. Moreover, it is an important communication platform for Chinese and foreign cultural and artistic mutual education, exchange and integration.

Wish the Fifth Silk Road International Arts Festival Today Silk Road International Arts Exhibition a complete success.

Shaanxi Provincial Department of Culture Director
Zongzhe Ren
September 7, 2018

第五届丝绸之路国际艺术节
今日丝绸之路国际美术展
组委会名单

主　任
任宗哲 / 陕西省文化厅厅长

副主任
蔺宝钢 / 西安建筑科技大学艺术学院院长
李象群 / 鲁迅美术学院院长
赵晓强 / 陕西省文化厅对外文化处副处长

The Fifth Silk Road International Arts Festival

Today Silk Road International Art Exhibition

Organizing committee list

Director

Zongzhe Ren, Shaanxi Provincial Department of Culture, China

Vice Chairman

Baogang Lin, Dean of the College of Arts of China Xi'an University of Architecture and Technology

Xiangqun Li, Vice Dean, Luxun Academy of Fine Arts

Xiaoqiang Zhao, Vice Division Head of International Office of Shaanxi Province Department of Culture

第五届丝绸之路国际艺术节
今日丝绸之路国际美术展
组委会名单

艺术总顾问
吴为山
全国政协常委 / 中国美术馆馆长 / 中国美术家协会副主席

The Fifth Silk Road International Arts Festival

Today Silk Road International Art Exhibition

Organizing committee list

Chief Art Advisor
Weishan Wu
CPPCC National Committee Member & Director of China Art Museum & Vice President of China Artists Association

第五届丝绸之路国际艺术节
今日丝绸之路国际美术展

学术委员会名单

主 任
蔺宝钢（中国）/ 西安建筑科技大学艺术学院院长

学术委员
李范宪（韩国）
马蒂尔德·莫里奥（科特迪瓦）
比利·李（美国）
李象群（中国）
莱纳·亨策（德国）

The Fifth Silk Road International Arts Festival

Today Silk Road International Art Exhibition

Academic Committee List

Director

Baogang Lin, Dean of the College of Arts of (China)Xi'an University of Architecture and Technology

Academic Committee

Lee Bum Hun (Korea)

Mathilde Moreau(Cote d'Ivoire)

Billy Lee (USA)

Xiangqun Li (China)

Rainer Henze (Germany)

第五届丝绸之路国际艺术节
今日丝绸之路国际美术展
策展委员会名单

总策展人
文集（中国）/ 世界美术同盟发起人

策展委员
宋晓明（德国）
洛伊特·卓卡达（爱沙尼亚）
杨觉昇（马来西亚）
赵莉（中国）
沙基（苏丹）
李始珪（韩国）
何建国（中国）

The Fifth Silk Road International Arts Festival

Today Silk Road International Art Exhibition

List of Strategic Development Committee

Curator/ Collector
Ji Wen, *Founder of the World Art League*

Commissioner of Planning and Development
Xiaoming Song (Germany)
Loit Jõekalda (Estonia)
Juesheng Yang (Malaysia)
Li zhao (China)
Zaki AL-Maboren (Sudan)
Lee Si Kyu (Korea)
Jianguo He (China)

第五届丝绸之路国际艺术节
今日丝绸之路国际美术展

秘书长
姜　涛
副秘书长
刘福龙
杜　喆
媒　体
王永亮
岳士俊
国际联络
王海苏
李紫姣
崔宁娜
编　务
支少层
刘熙媛
翻　译
王海苏

The Fifth Silk Road International Arts Festival
Today Silk Road International Art Exhibition

Secretary General
Tao Jiang
Deputy Secretary General
Fulong Liu
Zhe Du
Media
Yongliang Wang
Shijun Yue
International Contact
Haisu Wang
Zijiao Li
Ningna Cui
Editing Workers
Shaoceng Zhi
Xiyuan Liu
Translators
Haisu Wang

Work Collection of Arts | The Fifth Silk Road International Arts Festival
美术作品集 | 第五届丝绸之路国际艺术节

前言 / Preface

阿富汗 / Afghanistan
001 融合 / Fusion
若雅·艾什 / Roya Ash

阿尔巴尼亚 / Albania
002 被遗弃的人 / Untouchable
卡特里娜·霍蒂 / Kaltrina Hoti

阿根廷 / Argentina
003 花期 / Florescence
卡里纳·法巴罗 / Carina Fabaro

004 蓝色裸体 / Nude in Blue
索菲亚·若凯罗莉·罗芭德 / Sofia Roncayoli Lombardi

亚美尼亚 / Armenia
005 生命的流 / Flow of Life
哈格普·苏拉希安 / Hagop Sulahian

奥地利 / Austria
006 渴望 / Lust
卡塔琳娜·莫斯 / Katharina Moerth

澳大利亚 / Australia
007 原子 II / Atom 2
吉娜·李 / Jina Lee

008 潘达纳斯 I / Pandanas 1
威尼撒·沃格 / Wynetha Vogel

阿塞拜疆 / Azerbaijan
009 阿布歇隆 / Absheron
艾敏·阿拉克巴洛夫 / Emin Alakbarov

B

巴林 / Bahrain
010 阿拉伯字体 / Arabic Fonts
阿巴斯·阿尔穆萨维 / Abbas Almosawi

孟加拉国 / Bangladesh
011 向上 / Rise Up
安里斯 / Md Anisnl Haque

012 丝绸情 / Silk Relation
默罕默德·雷塞尔·雷曼 / Mohammed Rezaur Ranman
高艳慧 / Yanhui Gao

白俄罗斯 / Belarus

013 沉默的旋律 / Melody of Silence
达雅·苏玛芮沃·科佩奇 / Darya Sumarav Kopach

014 历史的窗口 / Window History
奥列格·乌西诺维奇 / Oleg Uscinovich

015 牡丹与丁香 / Peony Sang Lilac
吉红诺娃·奥尔加 / Tikhonova Olga

016 对话 / Dialog
维克塔·科佩奇 / Viktar Kopach

比利时 / Belgium
017 那幅 / Picture That
乔格·范·戴勒 / Jorg Van Daele

018 锈影 / Rust Shadow
玛蒂娜·范帕里什 / Martine Vanparijs

不丹 / Bhutan
019 无题 / Unnamed
滕津·多吉 / Tenzin Dorji

玻利维亚 / Bolivia
020 安第斯小径靠近天空 / Andean Trails near the Sky
伊万·奥雷利亚纳·弗洛 / Ivan Orellana Flores

波黑 / Bosnia and Herzegovina
021 圆顶试验石 II / Test Stone with Dome Study 2
恩迪·波斯科维奇 / Endi Poskovic

022 无题 / Unnamed
维拉·凯基 / Vera Kekic

巴西 / Brazil
023 无题 / Unnamed
伊里努·加西亚 / Irineu Garcia

024 秋天 / Autumn
玛西娅·德·贝尔纳多 / Marcia De Bernardo

保加利亚 / Bulgaria
025 更大的碎片 / Fragment of Something Bigger
格奥尔基·铭澈威 / Georgi Minchev

026 无穷 / Infinity
利利亚·波博尼克娃 / Liliya Pobornikova

027 人之躯 10815 / 20815 / 30815 / Bodies of None 10815 / 20815 / 30815
米纶·克拉斯蒂夫 / Milen Krastev

028 疯狂 / Madness
兹德拉夫科 / Zdravko Zdravkov

加拿大 / Canada

029 珍珠 / Pearls
唐娜·艾奇逊·朱利特 / Donna Acheson Juillet

030 无题 / Unnamed
玛芮·乔西·勒克斯 / Marie Josée Leroux

031 生命之路——动态空间 13 系列 / Life Path—Dynamic Space 13（Series）
戴维·罗撒 / David Roche

032 岁月留痕 / Memories
游荣光 / Yau Stephen Wing Kong

智利 / Chile
033 灯塔 / Lighit House
卢比·加查都 / Rubio Guajardo

034 旅行 / Travel
安德烈·莫拉 / Andrés Mora

中国 / China
035 马克思 / Marx
吴为山 / Weishan Wu

036 行者 / Spiritnal Practitioner
李象群 / Xiangqun Li

037 残荷 / Remaining Lotus
宁钢 / Gang Ning

038 华年之一 / One of the Time
庞茂琨 / Maokun Pang

039 无题 / Unnamed
郭线庐 / Xianlu Guo

040 母亲 / Mother
王西京 / Xijng Wang

041 各叙己见 / Each Airs His Own Views
何晓佑 / Xiaoyou He

042 千古一帝 / The Emperor of Qin Dynasty
蔺宝钢 / Baogang Lin

043 苍茫大地 / Exploration of the Earth
文集 / Ji Wen

044 僧——行与量天尺 / Monk—Walk and Measure the Meridian
景育民 / Yumin Jing

045 无为 / Doing Nothing
朱尽晖 / Jinhui Zhu

046 雄壮的和声 / The Mighty Harmonies
丁方 / Fang Ding

047 无题 / Unnamed
郭北平 / Beiping Guo

048 尧家族 / Yao Family
朱尚熹 / Shangxi Zhu

049 王实甫像 / Sculpture of Wang Shifu
鲍海宁 / Haining Bao

050 绝色江山之二十六、二十八 / Indescribable Beautiful Scenery 26&28
谢海 / Hai Xie

International Art Exhibition
国际美术展

051 丽娘寻梦——致敬《牡丹亭》/ The Dream of Li Niang—A Tribute to the Peony Pavilion
罗小平 / Xiaoping Luo

052 听泉 / Listen to the Spring
王志刚 / Zhigang Wang

053 无题 / Unnamed
巨石 / Shi Ju

054 无象 No.63-68 / Can't Be Last Image No 63-68
赵莉 / Li Zhao

055 无题 / Unnamed
董书兵 / Shubing Dong

056 亮相 / Appearance
张琨 / Kun Zhang

057 无题 / Unnamed
王志平 / Zhiping Wang

058 春秋 / In the Spring and Autumn
高筠 / Yun Gao

059 鸟鸣涧 / Birdsong in the Valley
李哲虎 / Zhehu Li

060 七品人格 / Seven Character Personality
姜涛 / Tao Jiang

061 无题 / Unnamed
马强 / Qiang Ma

062 重生 / Rebirth
刘福龙 / Fulong Liu

063 北风 3 号 / The North Wind No. 3
朱羿郎 / Yilang Zhu

064 荡然虚静 / Nothing but Quiet Being
张洪源 / Hongyuan Zhang

065 行香子 / Xingxiangzi
王海燕 / Haiyan Wang

066 最后的女酋长——玛丽亚索 / The Last Female Chief—Maria Solow
张士勤 / Shiqin Zhang

067 丝路——辉煌 / Silk Road—Brilliant
司小刚 / Xiaogang Si

068 行走的片段 / Walking Fragment
楚泓晋 / Hongjin Chu

069 静物 / Still Life
冯丹 / Dan Feng

070 凹 / Concave
李峰 / Feng Li

071 孔雀舞——韵味 / Peacock Dance—Lasting Appeal
章华 / Hua Zhang

072 对弈 / Chess Playing
郭继峰 / Jifeng Guo

073 静谧系列 I / Quiet Series 1
胡日查 / Richa Hu

074 印象大自然 / Impression of Nature
金永植 / Yongzhi Jin

075 瑞士乡村卢本立 / Village Lauterbrunnen
李伟明 / Wai Ming Mingo Li

076 无题 / Unnamed
黎思思 / Ze Ze Lai

077 理想主义 / Idealism
卡纳·贾格罗斯 / Canal Cheong Jagerroos

078 多彩澳门 / Colorful Macao
杨维凡 / Waifan Ieong

079 息 / Stopover
黄文祥 / Wenxiang Huang

080 呵护 / Cherish
许云翔 / Yunxiang Xu

081 璇外之音 / The Voice of Grace Outside
王标 / Biao Wang

082 无题 / Unnamed
林立仁 / Liren Lin

083 贵妃出浴 / The Imperial Concubine Beauties
李宝龙 / Baolong Li

哥伦比亚 / Colombia

084 候选人 / The Candidate
费尔南多·平多 / Fernando Pinto

085 离开巢穴，永远飞翔 / Leaving the Nest to Jump in Eternal Flight
安娜·伊莎贝尔·梅萨 / Ana Isabel Mesa

哥斯达黎加 / Costa Rica

086 夜的守护者 / Guardian of the Night
阿基莱斯·吉姆尼斯 / Aquiles Jiménez

科特迪瓦 / Côte d'Ivoire

087 超越时代 / Beyond the Time
夸思 / Kouame Kouassi Marc Eric

088 为和平工作的妇女们 / The Work of Women as a Condition for Peace
马蒂尔德·莫里奥 / Mathilde Moreau

克罗地亚 / Croatia

089 可折叠的宇宙 / Foldable Universe
利奥·卡塔纳里克 / Leo Katunaric

古巴 / Cuba

090 避难所 / The Shelter
奥斯卡·劳瑞劳诺·艾格瑞·卡门达都 / Oscar Laurelino Aguirre Comendador

塞浦路斯 / Cyprus

091 黎巴嫩反射 / Lebanon Reflections
希尔达·凯莱基安 / Hilda Kelekian

捷克 / Czech

092 女性的原型 / Archetype of a Woman
吉特卡·库索娃 / Jitka Kusova

丹麦 / Denmark

093 飞翔 / Flying Ove
斯蒂芬·佩德森 / Steffie Pedersen

刚果（金）/ D.R. Congo

094 繁衍 / Multiplication
姆布利·皮杜索·博图卢 / Mbuli Pitshou Botulu

095 花园里 / In the Garden
本琦·克恁噶 / Mushila Benj Kinenga

多米尼加 / Dominican

096 理智的篝火 / Bonfire of the Sanity
尤妮斯·马蒂奥 / Eunice Mateo

厄瓜多尔 / Ecuador

097 无题 / Unnamed
莫顿·艾斯特里亚 / Milton Estrella

埃及 / Egypt

098 民族道路 / Nations Road
埃米尔·艾利希 / Amir Ellithy

099 路上精神 / On the Road Spirit
纳吉·弗瑞德 / Nagi Farid

爱沙尼亚 / Estonia

100 东西方 / East West
洛伊特·卓卡达 / Loit Jõekalda

101 靠近围栏 IV / Close to the Fence 4
维格·卓卡达 / Virge Jõekalda

埃塞俄比亚 / Ethiopia

102 爱国者 / Patriot
哈伊路·科菲·茵多弗 / Hailu Kifle Endalew

芬兰 / Finland

103 修建记忆 / Constructed Memory
詹妮·莱恩 / Janne Laine

Work Collection of Arts
美术作品集

The Fifth Silk Road International Arts Festival
第五届丝绸之路国际艺术节

法国 / France
104 向下 / Down Under
莫利艾·波瑟尔·凯崔恩 / Muriel Buthier Chartrain

105 维亚河·吉斯蒂尼亚尼 / Via Giustiniani
翁贝托·罗西尼 / Umberto Rossini

加蓬 / Gabon
106 妇女与生活 / Femme Et Vie
比罗格·泽利亚·弗罗 / Bilogue Zelia Flore

格鲁吉亚 / Georgia
107 冲动 / Impulses
露露·达迪妮 / Lulu Dadiani

德国 / Germany
108 杂波Ⅰ / Durch Einander 1
克里斯廷·瑞肯斯 / Christine Reinckens

109 神秘通道 / The Passage
迪特尔·韦斯特普 / Dieter Wystemp

110 三只猴子 / 3 Monkeys
弗里安·沃尔夫 / Folrian Wolf

111 无题 / Unnamed
乔·凯莱 / Jo Kley

112 欲望的记忆 / Memory of a Desire
约尔格·普利卡 / Jorg Plickat

113 《发光》系列 4 幅 / Luminescence Series 4
克尔斯滕·西格 / Kirsten Seeger

114 无题 / Unnamed
雷纳·汉斯 / Rainer Henze

115 对立 / Opposites
斯特凡·米茨拉夫 / Stefan Mitzlaff

116 在路上 / On the Way
宋晓明 / Xiaoming Song

加纳 / Ghana
117 来自加纳的问候 / Greetings from Ghana
乔纳森·肯瓦吉亚·安格里 / Jonathan Kwegyir Aggrey

希腊 / Greece
118 打破国界 / Breaking the Borders
安东尼斯·麦洛迪亚斯 / Antonis Myrodias

119 无题 / Unnamed
埃弗斯塔西亚·米拉瑞基 / Efstathia Milaraki

120 怀疑的好处 / The Benefit of a Doubt
乔治·波利提斯 / George Politis

格林纳达 / Grenada
121 辣妹 / The Spice Girls
泰瑞希亚·毕索 / Tricia Bethel

圭亚那 / Guyana
122 无题 / Unnamed
阿尔弗雷德·尼古拉斯 / Alfred Nichols

匈牙利 / Hungary
123 禅音 / Zen
海德林德·玛什·特罗特 / Heidelinde Mation Trott

冰岛 / Iceland
124 旅行者 / The Traveler
恩格斯多缇·斯万蒂斯 / Egilsdóttir Svandís

印度尼西亚 / Indonesia
125 萨米 & 哈比尔 2017 / Ai Sami & Ai Khabir 2017
奥格斯·布迪安托 / Agus Budiyanto

126 三个苹果 / Three Apples
伽马·纳古勒 / Darma Ngurah

127 拷问的梦想 / Torture Dreams
西克西奥·斯特万 / Sixcio Stevan

128 丝路印象 / Silk Road Impression
饶韵芝 / Yince Djuwidja

印度 / India
129 午休 / Noon Break
拉玛什·库玛·贾沃 / Ramesh Kumar Jhawar

130 自由 / Freedom
丽金 / Gurjinder Kaur

131 在田野 / Out in the Fields
马杜·库马尔 / Madhu Kumar

伊朗 / Iran
132 悖论（圣迹集）/ Paradox(Immortals Collection)
哈格海格·马吉德 / Haghighi Majid

133 橙色果皮和书法 / Orange Peel and Calligraphy
哈米德·纳姆达尔 / Hamid Namdar

134 想象的乐器Ⅱ / Imaginary Musical Instrument 2
赫达亚特·撒哈拉 / Hedayat Sahraei

135 新飞马 / Neo Pegasus
雷扎伊·埃斯梅尔 / Rezaei Esmaeil

136 为我飞翔 / Fly instead of Me
赛义德·艾哈麦迪 / Saeid Ahmadi

伊拉克 / Iraq
137 无题 / Unnamed
阿里·穆萨维 / Ali Moussawi

138 玩偶和男孩 / Dolls and Boys
拉娜·马托鲁布 / Rana Matloub

爱尔兰 / Ireland
139 绞纱——羊群 / Skein—Flock
凯尔文·曼那 / Kelvin Mann

140 公民 / Citizens
雷蒙德·和邵 / Raymond Henshaw

以色列 / Israel
141 原始生物 2016 / Primordial Creature 2016
蒂娜·梅尔哈夫 / Dina Merhav

意大利 / Italy
142 筒仓 13/ Silos 13
格瑞米亚·赛睿 / Geremia Cerri

143 阳光明媚 / Bright Sunshine
古尔·菲林 / Gueorgui Filin

144 无题 / Unnamed
玛丽亚·格拉齐亚·科里尼 / Maria Grazia Collini

145 无题 / Unnamed
马西米兰·伊德里斯 / Massimiliano Iocco

146 条码 / Bar Code
保罗·维维安 / Paolo Vivian

147 进步的发电机 / Progressione Dinamica
伦佐·杜兰特 / Renzo Durante

148 弗拉门戈笔记 / Flamenco Notes
罗伯托·安德鲁利 / Roberto Andreoli

牙买加 / Jamaica
149 四轮之上的丝绸之路 / Silk Road on Four Wheels
布莱恩·马克·法兰 / Bryan Mc Farlane

日本 / Japan
150 无题 / Unnamed
林胜煌 / Shenghuang Lin

International Art Exhibition
国际美术展

151 安静的风 / Quiet Wind
田中等 / Hitoshi Tanaka

152 黑月亮 / Black Moon
博行朝野 / Hiroyuki Asano

约旦 / Jordan

153 球形的秘密 / The Secret of Spherical Shape
雅库布 / Yacoub Alatoom

K

哈萨克斯坦 / Kazakhstan

154 在草原上跳舞 / Dancing on the Grass
鹿和棕榈 / The Deer and Palm
羚羊在草原上跳舞 / The Antelope Danced on the Grassland
黑乌鸦 / Black Crow
莱拉·马哈特 / Leyla Mahat

肯尼亚 / Kenya

155 非洲女孩 / The Girl from Africa
安妮·姆威蒂 / Anne Mwiti

156 竞争 / Competition
杰拉德·欧若·莫通地 / Gerard Oroo Motondi

科威特 / Kuwait

157 差不多 / Almost There
阿布杜拉·阿甽瑟 / Abdulla Alnaser

吉尔吉斯斯坦 / Kyrgyzstan

158 碗 / Bowl
纳斯让·特干拔 / Nasira Turganbaj

159 俄罗斯停留 / Stopover Russia
弗拉基米尔·布兰特 / Wladimir Barantschikov

L

拉脱维亚 / Latvia

160 野兽 / Beast
乌斯马·沙米 / Ausma Šmite

黎巴嫩 / Lebanon

161 多元化的地球 / The Diversified Planet Earth
列纳·凯勒基安 / Lena Kelekian

立陶宛 / Lithuania

162 苏州 / Suzhou
里斯·瑟积 / Lysyy Sergiy

163 无数 / Myriads
兹奈特·尼尔 / Zirnite Nele

卢森堡 / Luxembourg

164 无题 / Unnamed
莫妮卡·贝克 / Monique Becker

M

马其顿 / Macedonia

165 弯曲的路 / The Curvy Road
亚历山大·爱福特摩斯基 / Aleksandar Eftimovski

166 时间 / The Time
安德烈·米捷夫斯基 / Andrej Mitevski

马来西亚 / Malaysia

167 兰卡威岛 / Langkawi
谢龙超 / Cheah Anthony

168 漫漫长路 / A Long Way
周靖化 / Chiew Cheng Hwa

169 邻里 / Neighbourhood
曹振全 / Chow Chin Chuan

170 映像Ⅲ / Reflection 3
李荣钦 / Lee Weng Khim

171 马来亚大波罗 / Terap
穆罕默德·拉赫曼 / Mohamed Rahman

172 信心 / Confidence
郑春香 / Nancy Chang

173 没落的行业 / Declining Industry
温秉升 / Oon Bing Shen

174 明天的记忆 2018 / Memory of Tomorrow 2018
陈毓康 / Tang Yeok Khang

175 隐现之间 58 号 / Betweeen Looming#58
杨觉昇 / Yeoh Choon Seng

墨西哥 / Mexico

176 削减四分之一 / Quarter Waning
蒙格·桑切斯·卡洛斯 / Monge Sánchez Carlos

177 拥抱亚当和夏娃 / The Hug Adan and Eve
佩德罗·马尔蒂斯 / Pedro Martínez

摩尔多瓦 / Moldova

178 无限 / Unendlichkeit
朱莉·柏拉图 / Juri Plato

蒙古 / Mongolia

179 等待 / Waiting
恩格图夫辛·巴托尔 / Enkhtuvshin Batbaatar

黑山共和国 / Montenegro

180 温柔和爱 / Tenderness and Love
安娜·米列科瓦克 / Ana Miljkovac

摩洛哥 / Morocco

181 超越表象 / Au Dela Des Apparences
布塔勒·蒙尼亚 / Boutaleb Mounia

缅甸 / Myanmar

182 丝路精神 / Silk Road Spirit
琴芒皂 / Khin Maung Zaw

183 房子（缅甸）/ House in Inlay (Myanmar)
木因特·那英 / Myint Naing

N

尼泊尔 / Nepal

184 老妇人肖像 / A Portrait of an Old Woman
NB 高隆 / NB Gurung

185 继承遗产 / Inheriting Heritage
瑞蒂 / Maharjan Riti

荷兰 / Netherlands

186 哈勒姆的夏末（荷兰）/ End of Summer in Haarlem,The Netherlands
安妮·罗斯·奥斯特巴恩 / Anne Rose Oosterbann

187 中国锣 / Chinese Gong
海格曼·汤姆 / Hageman Tom

188 静物 2017 / Still Even Met Kweepernn 2017
亨克·赫尔曼特尔 / Henk Helmantel

189 镂空 / Ajour
希尔达·斯莱杰尔 / Hilda Snoeijer

190 无题 / Unnamed
吉塔·巴尔多尔 / Gitta Pardoel

191 水的音乐 / Water Music
莱因·波尔 / Rein Pol

新西兰 / New Zealand

192 停火 (A/P) / Hold Fire (A/P)
格拉汉姆·霍尔 / Graham Hall

193 无题 / Unnamed
陈坚 / Jian Chen

尼日利亚 / Nigeria

194 人，城市，街道，动物 / People,Cites, Streets, Animals
奥拉扬朱·达达 / Olayanju Dada

挪威 / Norway

195 触 / Touch
安琪·金 / Anki King

Work Collection of Arts | The Fifth Silk Road International Arts Festival
美术作品集 | 第五届丝绸之路国际艺术节

196 螺旋式上升的烟Ⅱ / Spiraling Smoke 2
　　索尔·乔珂 / Sol Kjok

阿曼 / Oman

197 自画像 / Self Portrait
　　阿里·奈塞尔·萨夫·艾希耐 / Ali Nasser Saif Alhinai

巴基斯坦 / Pakistan

198 无题 / Unnamed
　　S.M. 海亚姆 / S.M.Khayyam

巴拿马 / Panama

199 非理性风险 / Irrational Risk
　　安东尼·乔司·盖兹曼 / Antonio José Guzman

巴拉圭 / Paraguay

200 外壳Ⅱ / Enclosure 2
　　米莉安·鲁道夫·米里亚姆 / Miriam Rudolph Hildebrand

秘鲁 / Peru

201 梦幻旅人 / Dream Traveler
　　阿尔多·希罗玛 / Aldo Shiroma

202 安第斯城堡 / Andean Citadel
　　巴勃罗·叶塔约 / Pablo Yactayo

菲律宾 / Philippines

203 马来粽 / Patupat
　　艾沙·乔伊·马帕瑙·艾利 / Aizza Joy Mapanao Allid

204 来之不易 / Hard Earned
　　迪诺·但丁·巴约 / Dino Dante Pajao

205 日出的海湾 / Sunrise by the Bay
　　约翰·卡罗·巴尔加斯 / John Carlo Vargas

206 巴招 / Badjao
　　威尔弗雷多·卡尔德龙 / Wilfredo Calderon

波兰 / Poland

207 简单生活 / Simple Live
　　麦克·加斯威克斯 / Michal Jasiewicz

葡萄牙 / Portugal

208 有机结构 / (In) Organic Structure
　　路易斯·菲利普·罗德里戈 / Luis Filipe Rodrigues

刚果（布）/ R. Congo

209 少爷 / Tambourinier
　　马森戈·艾玛 / Massengo Emma

罗马尼亚 / Romania

210 沙漠火车 / Desert Train
　　马里安·芦浦 / Marian Lupu

俄罗斯 / Russia

211 飞越达姆施塔特到法兰克福 / Flying Over Darm Stadt to Frankfurt
　　格里博斯·特卡琴科 / Glebos Tkachenko

212 无题 / Unnamed
　　尼古拉·卡莱科诺夫 / Nikolay Karlykhanov

213 普什科夫 / Pskov
　　奥尔加·卡成克 / Olga Kharchenko

214 日出 / Sunrise
　　瓦伦蒂娜·杜萨维茨卡亚 / Valentina Dusavitskaya

215 盐 / Salt
　　沃茨姆什·亚历克桑德尔 / Votsmush Aleksandr

216 山之晨 / Mountains in the Morning
　　谢尔盖·库尔巴托夫 / Sergei Kurbatov

217 海天一体 / The Motion of Sea, the Motion in the Skies
　　谢尔盖·特米雷夫 / Sergei Temerev

卢旺达 / Rwanda

218 无题 / Unnamed
　　尤马希尔·艾萨卡里 / Umuhire Isakari

沙特阿拉伯 / Saudi Arabia

219 无题 / Unnamed
　　云芸 / Aisha Yun

塞尔维亚 / Serbia

220 创造之美 / Beauty of Creation
　　德左克·科帕杰克 / Djordje Cpajak

221 勇敢 / Gallant
　　因迪尔·庞万诺科 / Endre Penovac

塞舌尔 / Seychelles

222 无题 / Unnamed
　　朱莉叶·齐利姆 / Juliette Zelime

新加坡 / Singapore

223 谁最美？/ Who's the Fairest of Them All?
　　谭关元 / Tam Kwan Yuen

斯洛伐克 / Slovakia

224 橡胶紫茉莉花 / Brasilien
　　朱迪特·罗萨斯 / Judit Rozsas

225 探头 / Sonde
　　马丁·赛维科伟奇 / Martin Ševčovič

斯洛文尼亚 / Slovenia

226 灵魂的影响 / Soul Impacts
　　阿里日尔·施特鲁凯莱 / Arijrl Štrukelj

南非 / South Africa

227 役于土地的忧虑 / Slave Land Spectres
　　多米尼克·托本 / Dominic Thorburn

西班牙 / Spain

228 地中海景色 / Mediterranean View
　　塞斯克·法雷 / Cesc Farre

229 中心 / Center
　　丹尼尔·保罗 / Daniel Pablo

230 桥之颜色Ⅰ / Bridge of Colors 1
　　费尔南多·巴里昂诺沃 / Fernando Barrionuevo

231 海贝 / Sea Shell
　　南多·阿尔瓦雷斯 / Nando Alvarez

232 维多利亚女王大桥 / Queen Victoria Bridge
　　巴勃罗·鲁本·洛佩斯·桑兹 / Pablo Ruben Lopez Sanz

苏丹 / Sudan

233 一起 / Together
　　扎克·艾尔·玛波伦 / Zaki Al Maboren

瑞典 / Sweden

234 缠裹 / Wrapped Motions
　　乔纳斯·佩特森 / Jonas Pettersson

International Art Exhibition
国际美术展

瑞士 / Switzerland

235 巴塞罗那 IV / Barcelona 4
卡尔·艾伯特·扬森 / Karl Albert Jansen

叙利亚 / Syrian

236 诺拉 / Nora
阿利亚·阿布·哈多尔 / Aliaa Abou Khaddour

237 新生 / Neues Leben
哈立德·阿尔多 / Khaled Al Deab

238 无题 / Unnamed
纳赛尔·侯塞因 / Nasser Hussein

T

泰国 / Thailand

239 一起 / Together
苏曼尼·克里斯蒂娜 / Supmanee Chaisansuk

240 中国圣殿 / Chinese Shrine
苏比霍沃特·锡兰塔那威沃特 / Suphawat Hiranthanawiwat

多哥 / Togo

241 交响乐 / Symphonie
鲍佛·阿贝尔 / Aboflan Abel

突尼斯 / Tunisia

242 我的突尼斯 / My Tunisia
瑞姆·阿雅 / Rim Ayari

土耳其 / Turkey

243 秋色 / Autum Reflections
路基·贾丽普 / Rukiye Garip

244 里尔克和我 / Rilke and I
穆罕默德·居尔 / Mehmet Güler

245 鸽 / Pigeons
奥尔罕·贾丽普 / Orhan Garip

246 艺术工作 / Cultured Work
瓦罗·拖帕奇 / Varol Topaç

U

乌干达 / Uganda

247 无题 / Unnamed
安培·吉利安·斯迪希 / Abe Gillian Stacey

乌克兰 / Ukraine

248 我的个人电脑 / My Personal Computer
安娜·伊万诺娃 / Anna Ivanova

249 守护天使 / Guardian Angel
斯比尼耶夫·瑟希 / Sbitniev Serhii

250 薰衣草咖啡馆 / Café Lavender
格里戈耶娃·维多利亚 / Grigorieva Victoria

251 贝拉特尔巴尼亚 / Berat Albania
尤尔琴科·伊霍尔 / Yurchenko Ihor

英国 / United Kingdom

252 铁丝网 / Chicken Wire
安古斯·麦克尤恩 / Angus Mcewan

253 沉重的负荷 / Heavy Load
戴维·伯克森 / David Poxon

254 时间和运动Ⅰ / Time and Motion Studies 1
尼古拉斯·迪维森 / Nicholas Devison

美国 / United States

255 请听 4 号的沉默 / Listen to the Silence No.4
比利·李 / Billy Lee

256 老邻居，那不勒斯 / Old Neighborhood ,Napoli
约翰·萨尔米宁 / John Salminen

257 无题 / Unnamed
乔恩·巴洛·哈德森 / Jon Barlow Hudson

258 总督宫Ⅰ / Study For Doge's Palace 1
奥泰罗·帕伊洛斯·乔治 / Otero Pailos Jorge

259 闪光 / Illumination
克里斯·克鲁平斯基 / Chris Krupinski

260 蓝色玻璃 / Glass in Blue
劳里·金斯坦·华伦 / Laurie Goldstein Warren

261 精神食粮 / Food for Thought Ties
盖尔·列文 / Gail Levin

262 乡村绘画——意大利 / Painting in the Countryside—Italy
托马斯·W.夏尔 / Thomas W Schaller

乌兹别克斯坦 / Uzbekistan

263 多面的东方 / The Many—Sided Eas
古尔佐尔·苏塔诺娃 / Gulzor Sultanova

264 无题 / Unnamed
扎卡耶夫 / Zakarya Zakaryaev

V

委内瑞拉 / Venezuela

265 东部的拥抱 / Eastern Embrace
罗纳德·帕雷德斯·瓦佳斯 / Ronald Paredes Vargas

越南 / Viet Nam

266 利奇菲尔德乡村 / Lichfield Countryside
阮麦 / Mai Nguyen

267 花儿 / Flowers
阮图红 / Thu Huong Nguyen

Y

也门 / Yemen

268 无题 / Unnamed
亚希尔·穆罕穆德·阿普度·阿斯安 / Yasser Mohammed Abdo Alansi

Z

赞比亚 / Zambia

269 遣返 / Repatriation
查尔·昌巴塔 / Charles Chambata

津巴布韦 / Zimbabwe

270 合为一体 / Together as One
玛利亚·南亚行谷 / Marian S. Nyanhongo

朝鲜／韩国联合特展作品
A Special Exhibition of D.P.R.Korea and Korea Joint Works

（朝鲜 ／ D.P.R Korea ）

272 饲养员 / Breeder
成哲 / Zhe Cheng

273 江边 / Riverside
金哲顺 / Zheshun Jin

274 冬季 / Winter
崔大成 / Dacheng Cui

275 孙女 / Granddaughter
姜勋英 / Xunying Jiang

276 山村 / Mountain Village
金永哲 / Yongzhe Jin

277 故乡山村 / Home Village
金元植 / Yuanzhi Jin

Work Collection of Arts | The Fifth Silk Road International Arts Festival
美术作品集 | 第五届丝绸之路国际艺术节

278 满船喜悦 / Loaded with Joy
　　景玉 / Yu Jing

279 女儿 / Daughter
　　崔明国 / Mingguo Cui

280 希望 / Hope
　　李尚文 / Shangwen Li

281 猎手 / Hunter
　　李玄哲 / Xuanzhe Li

282 二月的大同江 / Datong River in February
　　李哲 / Zhe Li

283 金刚山东石洞溪谷 / Jin'gang Mountain and Dongshi Stone Cave Valley
　　朴贤哲 / Xianzhe Piao

284 金刚山 / Jin'gang Mountain
　　宋永日 / Yongri Song

285 乙密台 / Dense Units
　　俞赫哲 / Hezhe Yu

（韩国 / Korea ）

286 花舞 / Flower Dance
　　李範憲 / Lee Bum Hun

287 禅 / Zen
　　李始珪 / Lee Si Kyu

288 恨——农家 / Hate—Peasant Family
　　梁性模 / Yang Seong Mo

289 都市木 / Urban Wood
　　金钟寿 / Kim Jong Shu

290 白陶瓷 / White Ceramics
　　具滋胜 / Koo Cha Soong

291 山光山舞——张家界 / Mountain Light Mountain—Zhangjiajie
　　韩相润 / Han Sang Yoon

292 青色裸妇 / Cyan Naked Woman
　　崔礼泰 / Choi Ye Tae

293 我心目中的一座城市 / A City of My Mind
　　金永珉 / Kim Yeong Min

294 游牧民 / Nomads
　　黄济性 / Hwang Jea Sung

295 独岛 / Island Alone
　　洪石苍 / Hong Suk Chang

296 女人 / Woman
　　徐明德 / Seo Myong Duk

297 独岛气韵 / Rhyme of a Single Island
　　南君锡 / Nam Gun Seok

298 祝祭 / Festival
　　林美子 / Lim Mi Ja

299 牡丹 / Peony
　　李是昀 / Lee Ha Yoon

300 金麦白陶瓷 / Wheat White Ceramics
　　金银珍 / Kim Eun Jin

301 组成 / Look at Line
　　秦美晶 / Jin Mi Jeong

302 生活故事——欧洲陶瓷的永恒爱情 / Life Story—the Eternal Love of European Ceramics
　　金容模 / Kim Yong Mo

303 具象绘画 / Figurative Painting
　　黄顺圭 / Hwang Soon Gou

304 圣托里尼 / Santorini
　　赵成户 / Jo Sung Ho

305 花盆 / Flowerpot
　　尹命镐 / Yoon Myoung Ho

306 时间旅行 / Time Trvael
　　金美兰 / Kim Mi Ran

结语 / Conclusion

Fifth

Afghanistan
阿富汗

International Art Exhibition
国际美术展

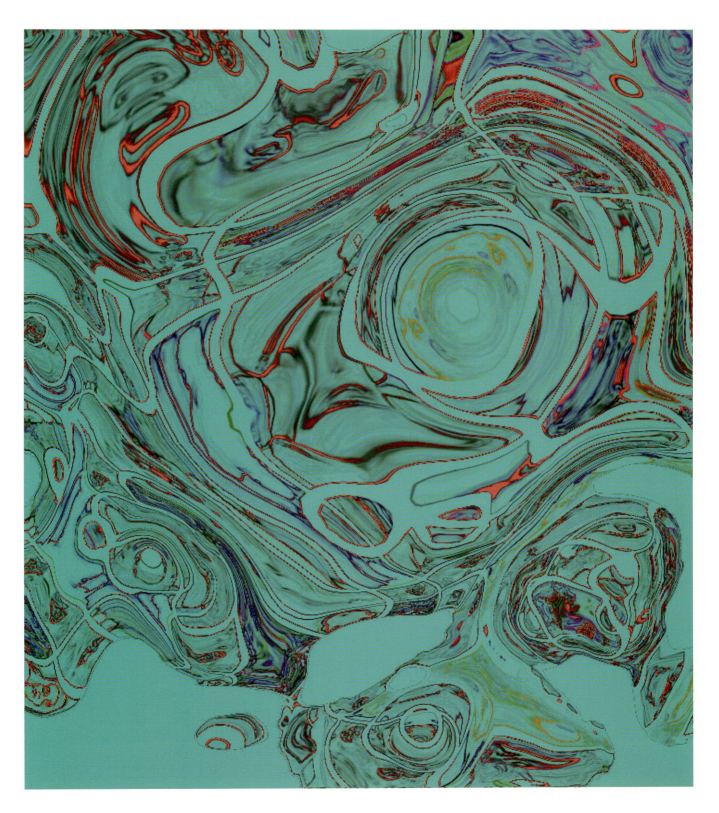

融合 / Fusion

若雅·艾什 | Roya Ash
阿富汗 | Afghanistan
绘画 | Painting

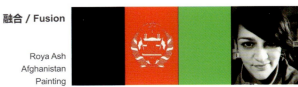

Work Collection of Arts	The Fifth Silk Road International Arts Festival	Albania
美术作品集	第五届丝绸之路国际艺术节	阿尔巴尼亚

被遗弃的人 / Untouchable
457.2 mm x 609.6mm

卡特里娜·霍蒂	Kaltrina Hoti
阿尔巴尼亚	Albania
绘画	Painting

Argentina

阿根廷

International Art Exhibition

国际美术展

花期 / Florescence
500mm x 400mm x 200mm

卡里纳·法巴罗 | Carina Fabaro
阿根廷 | Argentina
雕塑 | Sculpture

| Work Collection of Arts | The Fifth Silk Road International Arts Festival | Argentina |
| 美术作品集 | 第五届丝绸之路国际艺术节 | 阿根廷 |

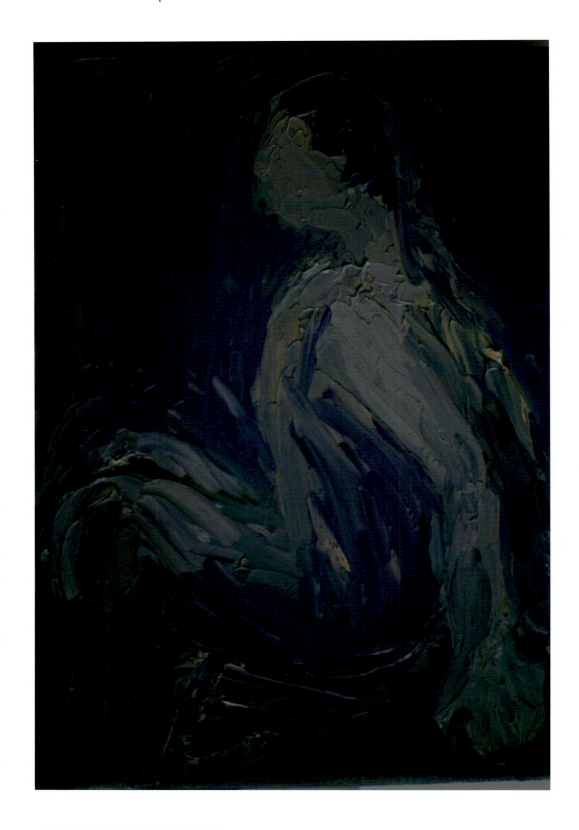

蓝色裸体 / Nude in Blue
300mm x 240mm

索菲亚·若凯罗莉·罗芭德 | Sofia Roncayoli Lombardi
阿根廷 | Argentina
绘画 | Painting

Armenia
亚美尼亚

International Art Exhibition
国际美术展

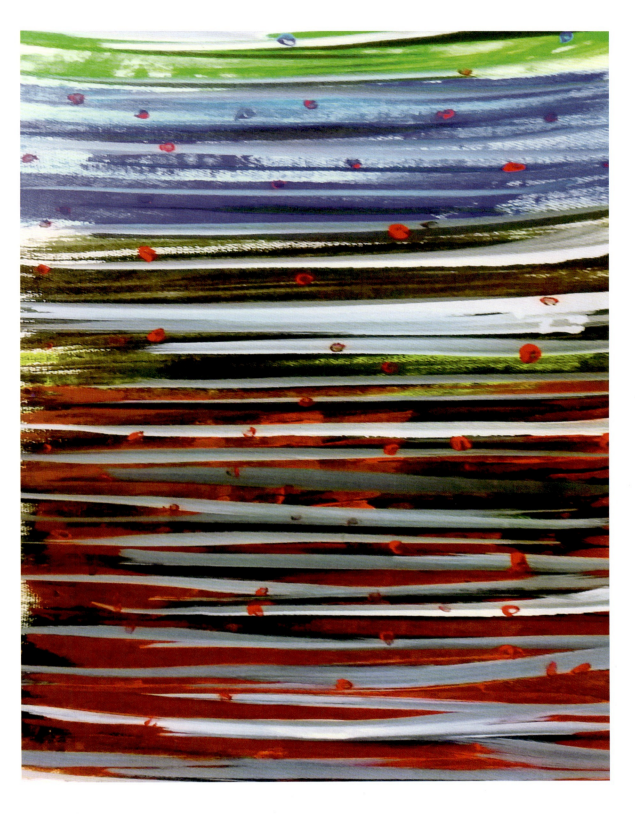

生命的流 / Flow of Life
1000mm x 800mm

哈格普·苏拉希安 | Hagop Sulahian
亚美尼亚 | Armenia
绘画 | Painting

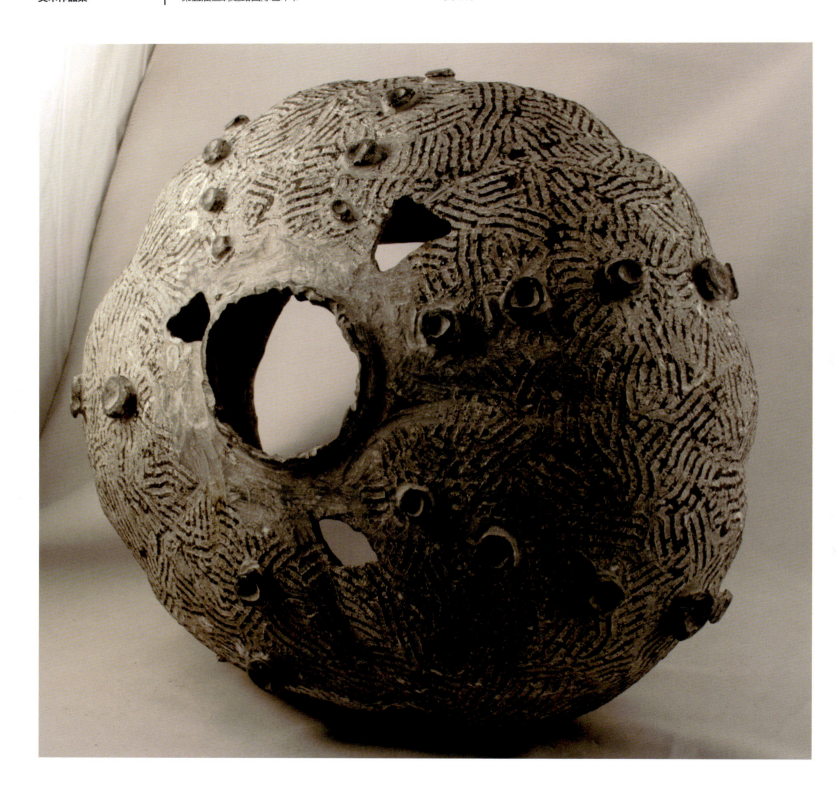

渴望 / Lust
400mm x 200mm x 200mm

卡塔琳娜·莫斯 | Katharina Moerth
奥地利 | Austria
雕塑 | Sculpture

Australia
澳大利亚

International Art Exhibition
国际美术展

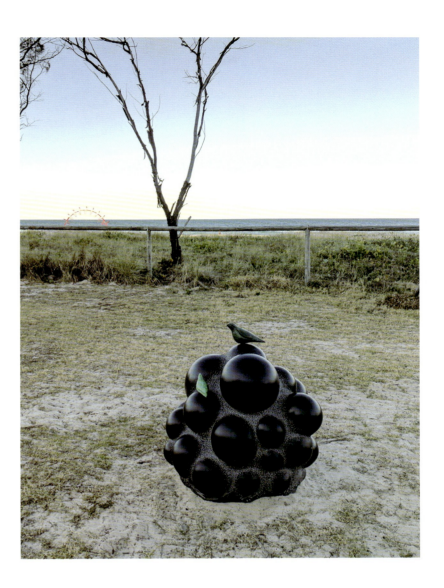

原子 II / Atom 2
1400mm x 1000mm x 1000mm

吉娜·李
澳大利亚
雕塑

Jina Lee
Australia
Sculpture

Work Collection of Arts	The Fifth Silk Road International Arts Festival	Australia
美术作品集	第五届丝绸之路国际艺术节	澳大利亚

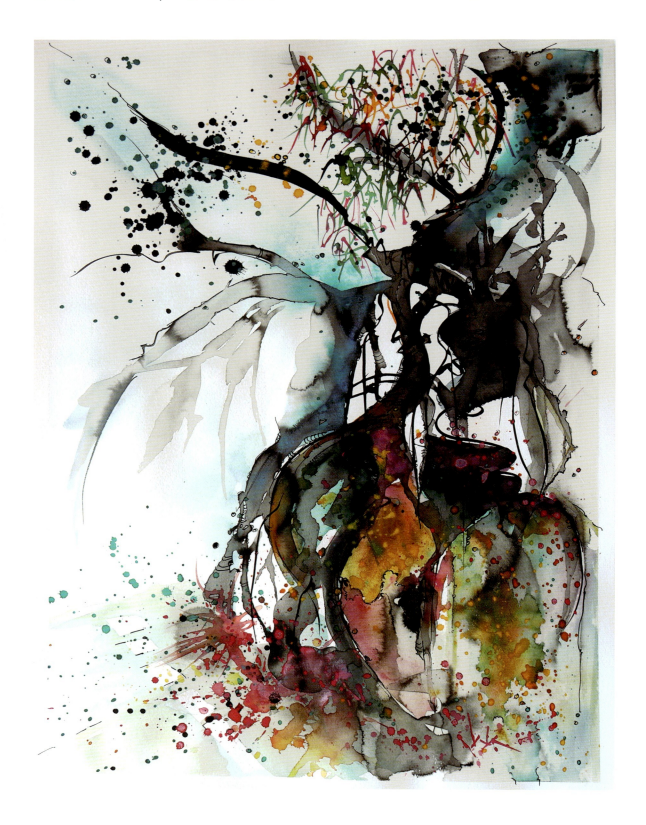

潘达纳斯 I / Pandanas 1

威尼撒·沃格 | Wynetha Vogel
澳大利亚 | Australia
绘画 | Painting

Azerbaijan / 阿塞拜疆 — International Art Exhibition / 国际美术展

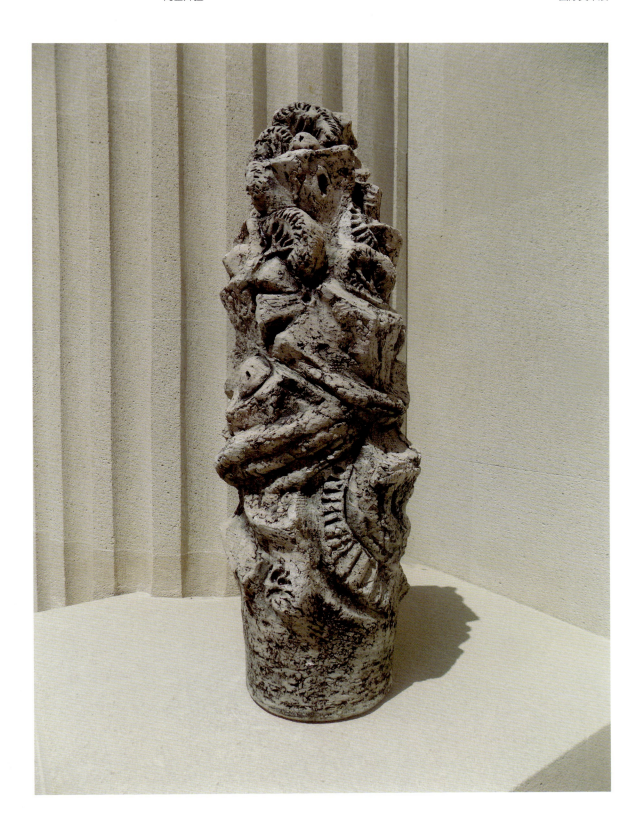

阿布歇隆 / Absheron
540mm x 170mm x 170mm

艾敏·阿拉克巴洛夫	Emin Alakbarov
阿塞拜疆	Azerbaijan
雕塑	Sculpture

| Work Collection of Arts / 美术作品集 | The Fifth Silk Road International Arts Festival / 第五届丝绸之路国际艺术节 | Bahrain / 巴林 |

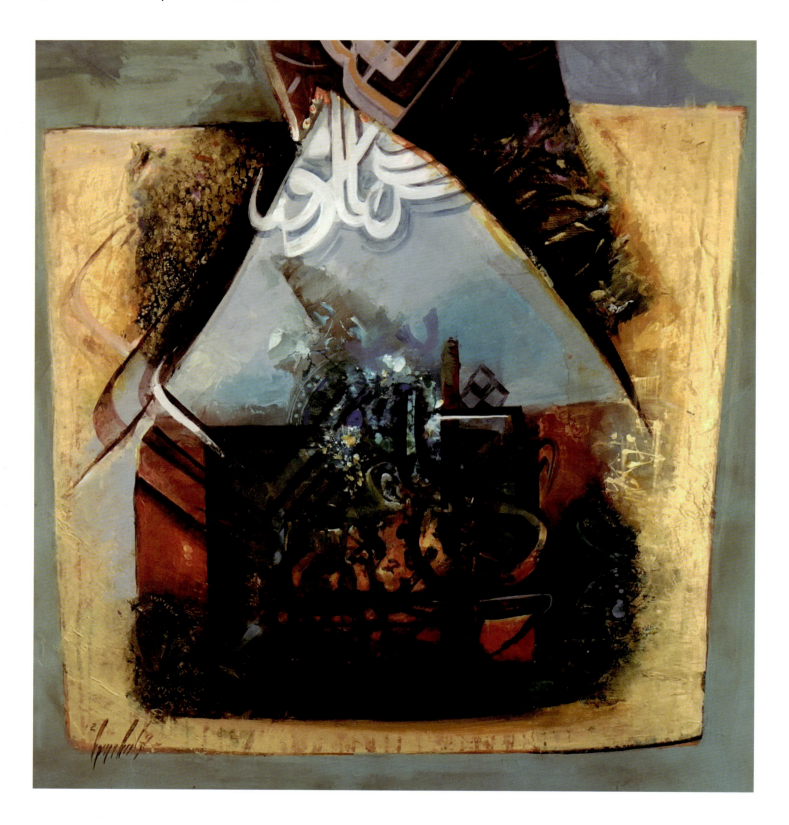

阿拉伯字体 / Arabic Fonts
1000mm x 1000mm

阿巴斯·阿尔穆萨维	Abbas Almosawi
巴林	Bahrain
绘画	Painting

Bangladesh 孟加拉国 | International Art Exhibition 国际美术展

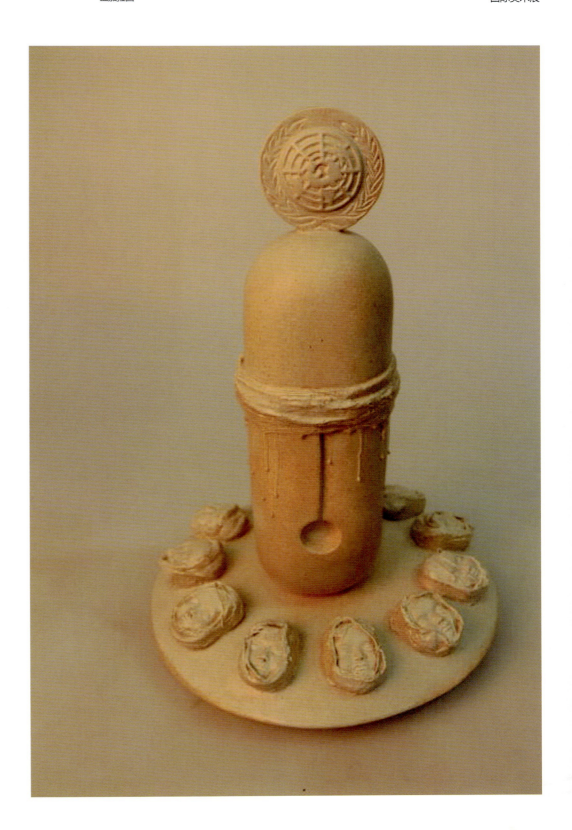

向上 / Rise Up
300mm x 300mm x 500mm

安里斯
孟加拉国
雕塑

Md Anisul Haque
Bangladesh
Sculpture

Work Collection of Arts	The Fifth Silk Road International Arts Festival	Bangladesh
美术作品集	第五届丝绸之路国际艺术节	孟加拉国

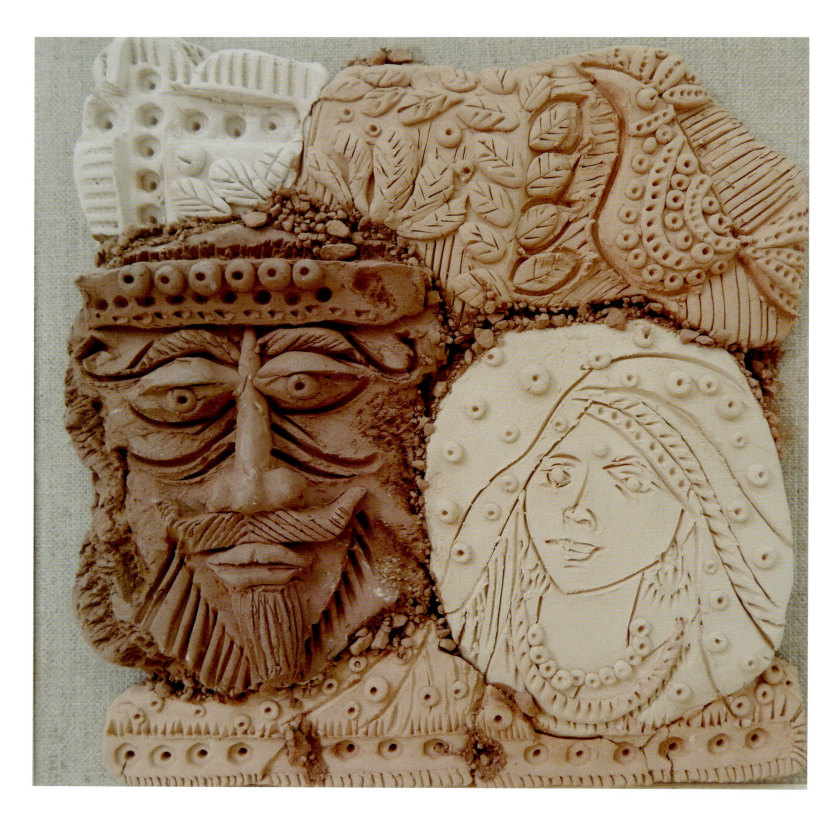

丝绸情 / Silk Relation
250mm x 250mm

默罕默德·雷塞尔·雷曼 / 高艳慧　　Mohammed Rezaur Ranman / Yanhui Gao
孟加拉国 / 中国　　　　　　　　　　　Bangladesh / China
雕塑　　　　　　　　　　　　　　　　Sculpture

Belarus
白俄罗斯

International Art Exhibition
国际美术展

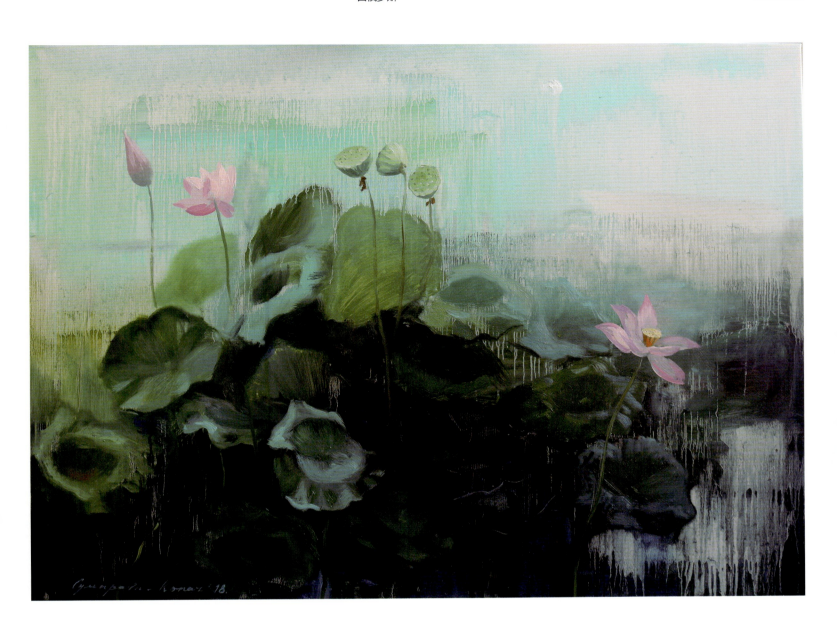

沉默的旋律 / Melody of Silence
600mm x 800mm

达雅·苏玛芮沃·科佩奇
白俄罗斯
绘画

Darya Sumarav Kopach
Belarus
Painting

Work Collection of Arts	The Fifth Silk Road International Arts Festival	Belarus
美术作品集	第五届丝绸之路国际艺术节	白俄罗斯

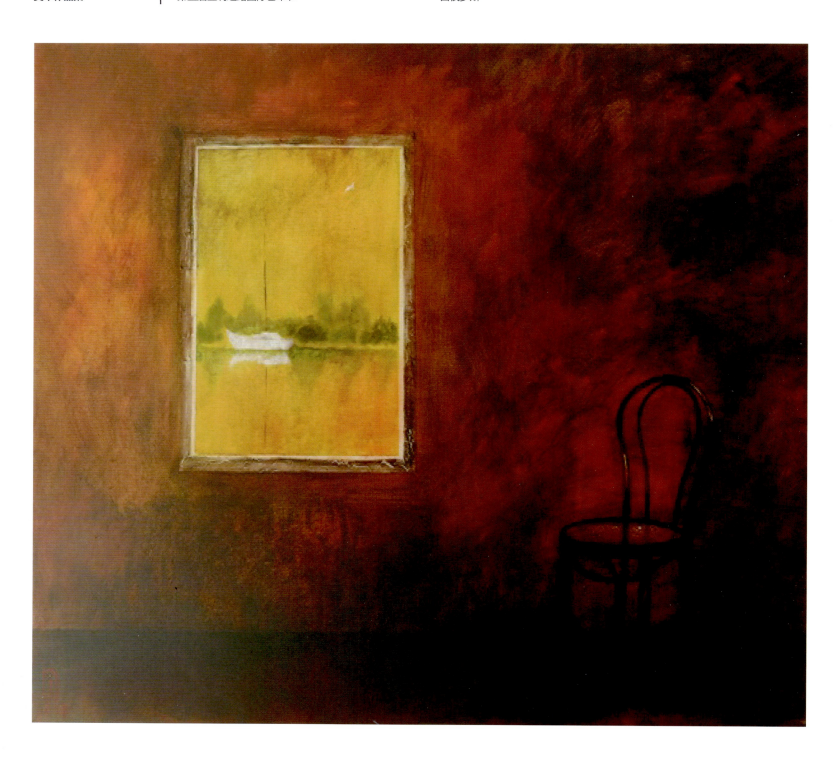

历史的窗口 / Window History
600mm x 770mm

奥列格·乌西诺维奇	Oleg Uscinovich
白俄罗斯	Belarus
绘画	Painting

Belarus
白俄罗斯

International Art Exhibition
国际美术展

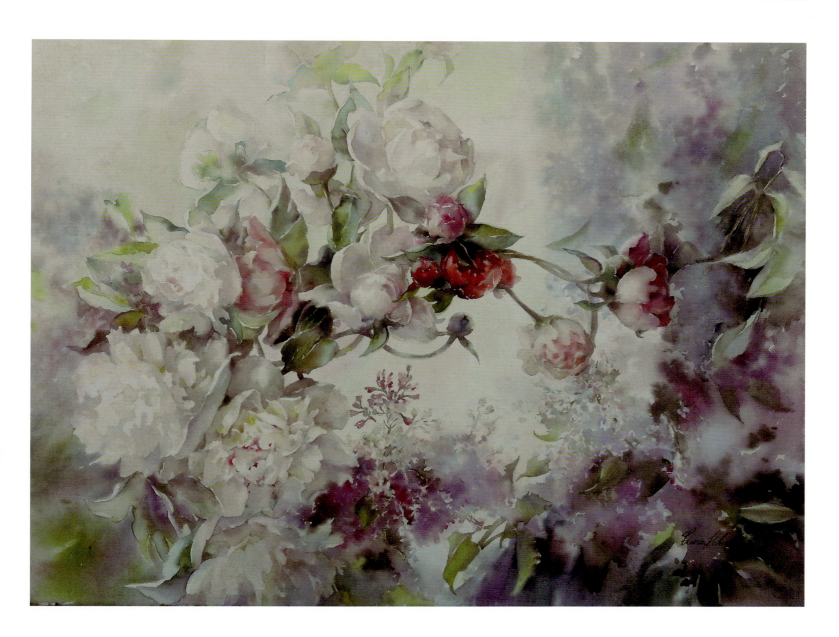

牡丹与丁香 / **Peony Sang Lilac**
560mm x 760mm

吉红诺娃·奥尔加 | Tikhonova Olga
白俄罗斯 | Belarus
绘画 | Painting

| Work Collection of Arts | The Fifth Silk Road International Arts Festival | Belarus |
| 美术作品集 | 第五届丝绸之路国际艺术节 | 白俄罗斯 |

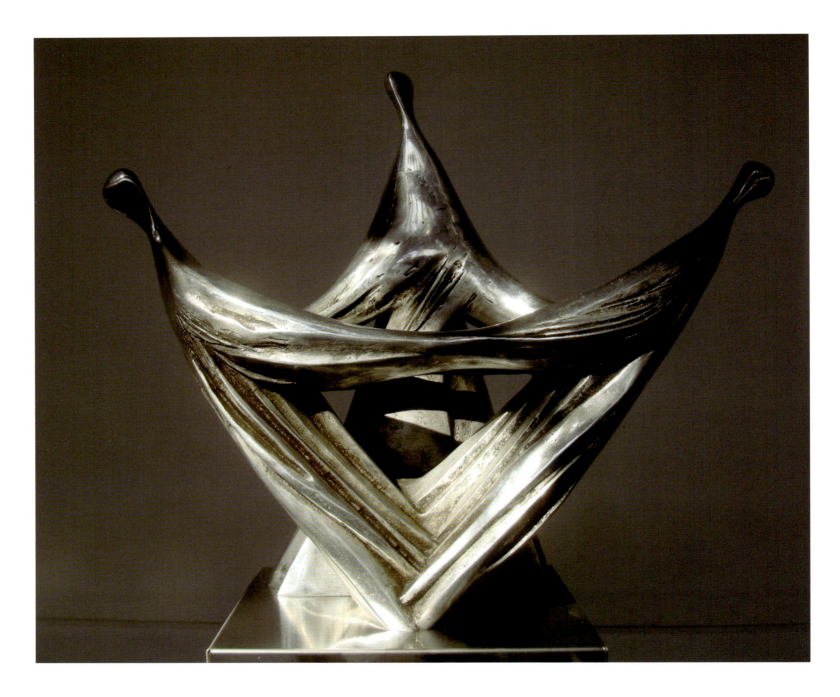

对话 / Dialog
650mm x 550mm x 250mm

维克塔·科佩奇 — Viktar Kopach
白俄罗斯 — Belarus
雕塑 — Sculpture

Belgium / 比利时　　　　International Art Exhibition / 国际美术展

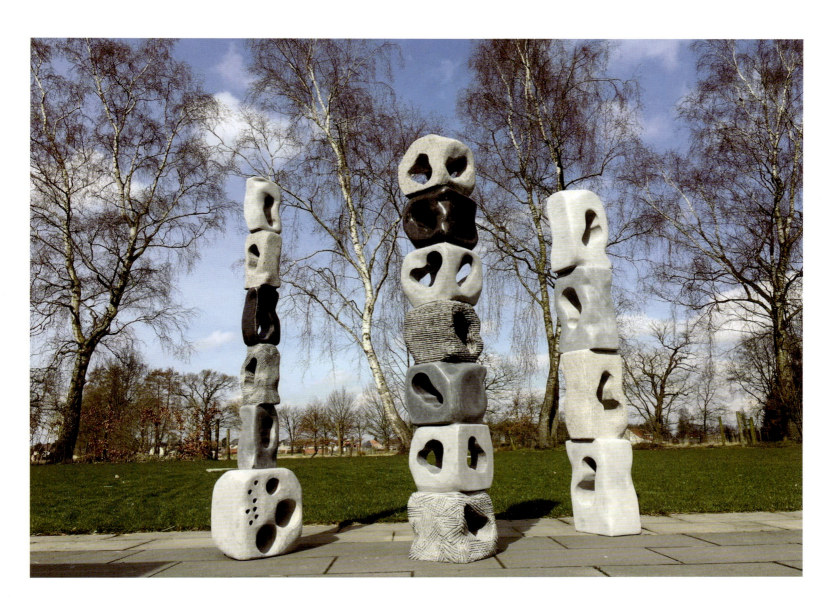

那幅 / Picture That
1800mm x 250mm x 250mm

乔格·范·戴勒 | Jorg Van Daele
比利时 | Belgium
雕塑 | Sculpture

| Work Collection of Arts | The Fifth Silk Road International Arts Festival | Belgium |
| 美术作品集 | 第五届丝绸之路国际艺术节 | 比利时 |

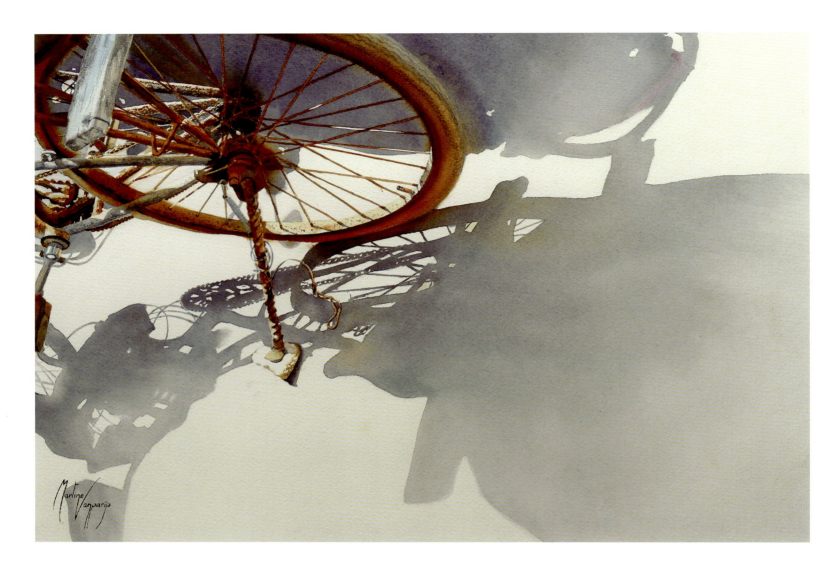

锈影 / Rust Shadow
380mm x 560mm

玛蒂娜·范帕里什	Martine Vanparijs
比利时	Belgium
绘画	Painting

Bhutan
不丹

International Art Exhibition
国际美术展

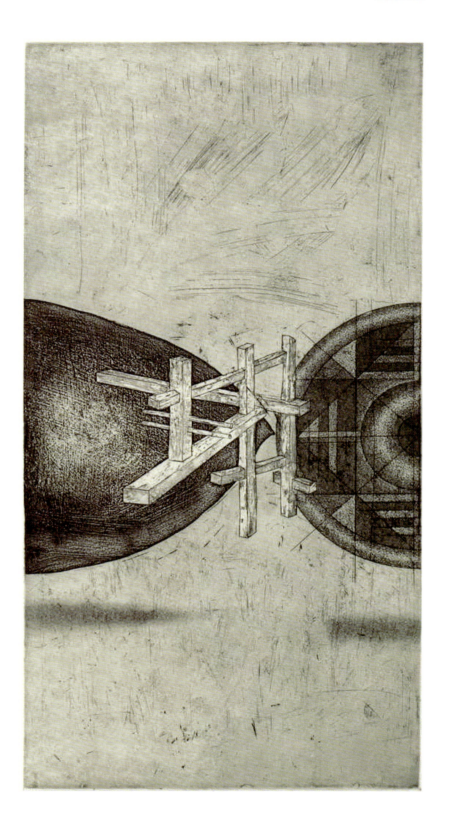

无题 / Unnamed

滕津·多吉 | Tenzin Dorji
不丹 | Bhutan
绘画 | Painting

| **Work Collection of Arts** | The Fifth Silk Road International Arts Festival | Bolivia |
| 美术作品集 | 第五届丝绸之路国际艺术节 | 玻利维亚 |

安第斯小径靠近天空 / Andean Trails near the Sky
630mm x 840mm

伊万·奥雷利亚纳·弗洛	Ivan Orellana Flores
玻利维亚	Bolivia
绘画	Painting

Bosnia and Herzegovina
波黑

International Art Exhibition
国际美术展

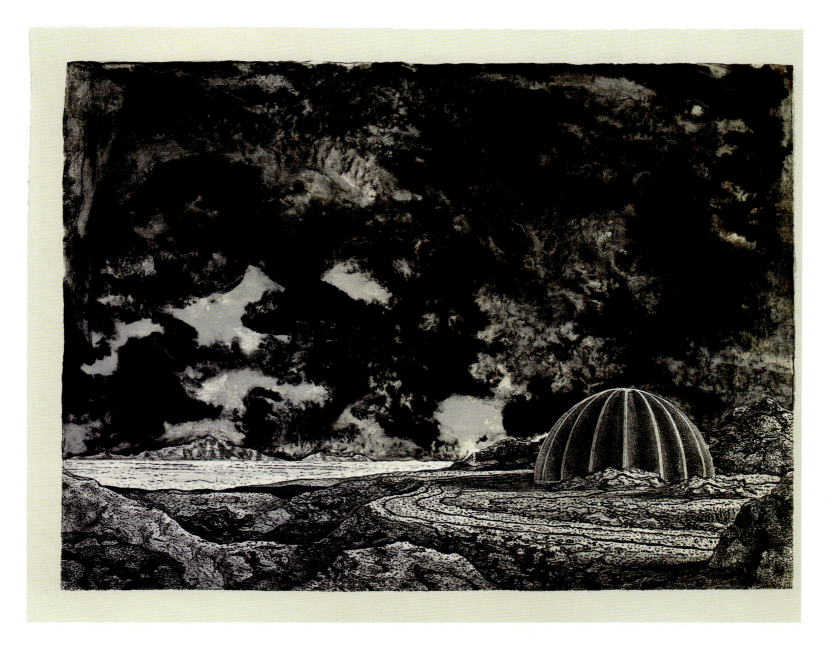

圆顶试验石 II / Test Stone with Dome Study 2
800mm x 1000mm

恩迪·波斯科维奇 | Endi Poskovic
波黑 | Bosnia and Herzegovina
绘画 | Painting

| Work Collection of Arts | The Fifth Silk Road International Arts Festival | Bosnia and Herzegovina |
| 美术作品集 | 第五届丝绸之路国际艺术节 | 波黑 |

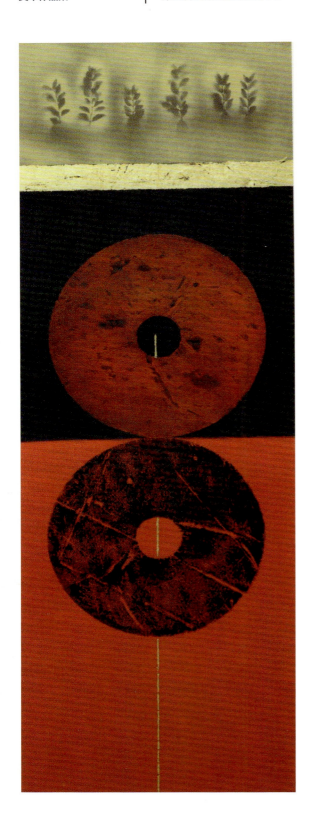

无题 / Unnamed
500mm x 1500mm

维拉·凯基
波黑
绘画

Vera Kekic
Bosnia and Herzegovina
Painting

Brazil / 巴西 — International Art Exhibition / 国际美术展

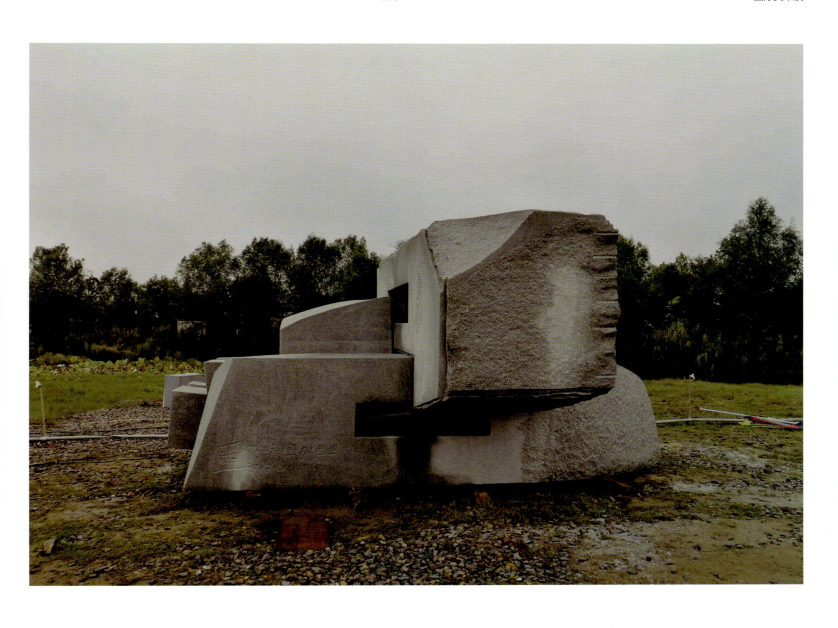

无题 / Unnamed

伊里努·加西亚 | Irineu Garcia
巴西 | Brazil
雕塑 | Sculpture

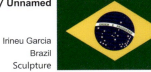

| Work Collection of Arts | The Fifth Silk Road International Arts Festival | Brazil |
| 美术作品集 | 第五届丝绸之路国际艺术节 | 巴西 |

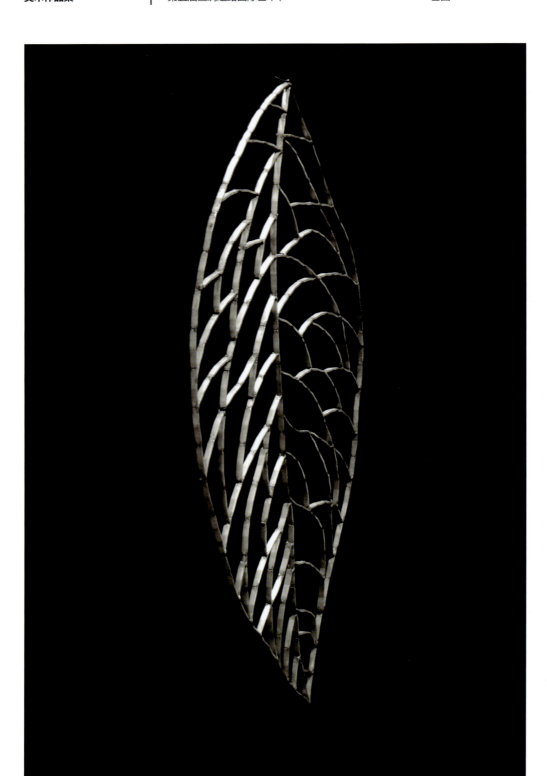

秋天 / Autumn
600mm x 1000mm x 10mm

玛西娅·德·贝尔纳多	Marcia De Bernardo
巴西	Brazil
雕塑	Sculpture

Bulgaria 保加利亚

International Art Exhibition 国际美术展

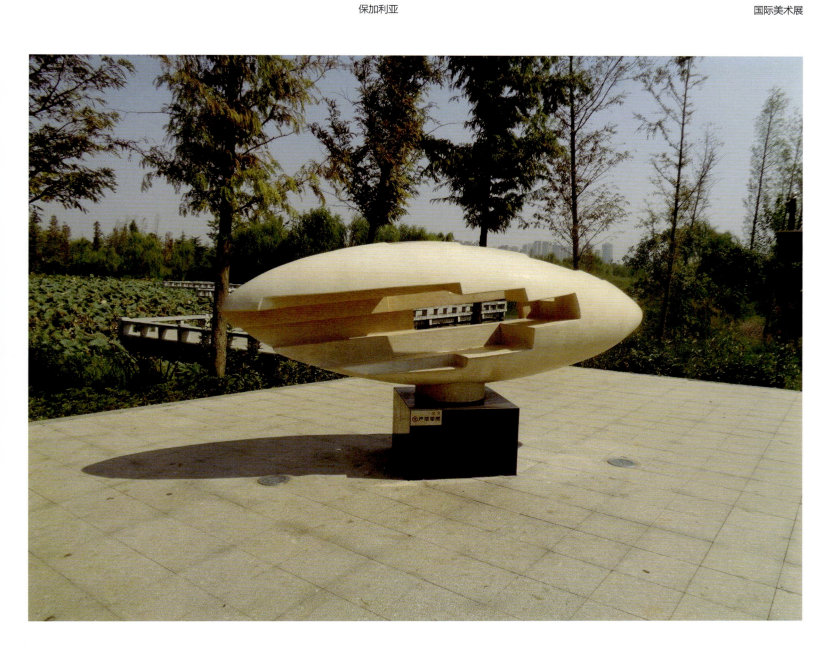

更大的碎片 / Fragment of Something Bigger

3000mm x 1700mm x 1000mm

格奥尔基·铭澈威 | Georgi Minchev
保加利亚 | Bulgaria
雕塑 | Sculpture

Work Collection of Arts	The Fifth Silk Road International Arts Festival	Bulgaria
美术作品集	第五届丝绸之路国际艺术节	保加利亚

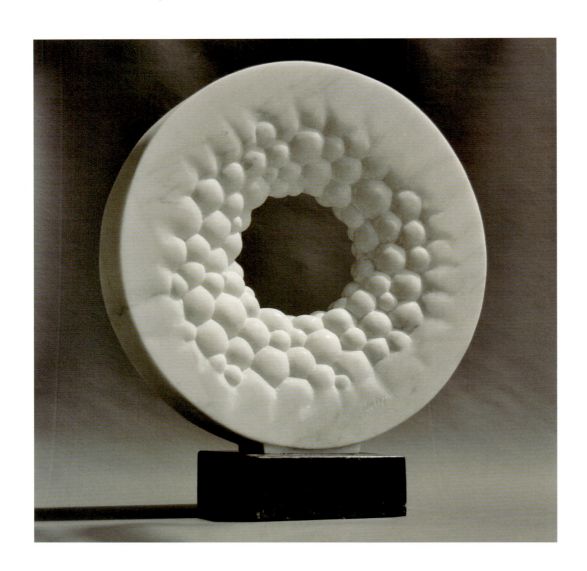

无穷 / Infinity
420mm x 420mm x 90mm

利利亚·波博尼克娃 | Liliya Pobornikova
保加利亚 | Bulgaria
雕塑 | Sculpture

Bulgaria　　　　　　　　　　　　　　　　　International Art Exhibition
保加利亚　　　　　　　　　　　　　　　　　国际美术展

人之躯 10815/20815/30815 / Bodies of None 10815/20815/30815
200mm x 300mm

米纶·克拉斯蒂夫　　　Milen Krastev
保加利亚　　　　　　　Bulgaria
摄影　　　　　　　　　Photography

Work Collection of Arts	The Fifth Silk Road International Arts Festival	Bulgaria
美术作品集	第五届丝绸之路国际艺术节	保加利亚

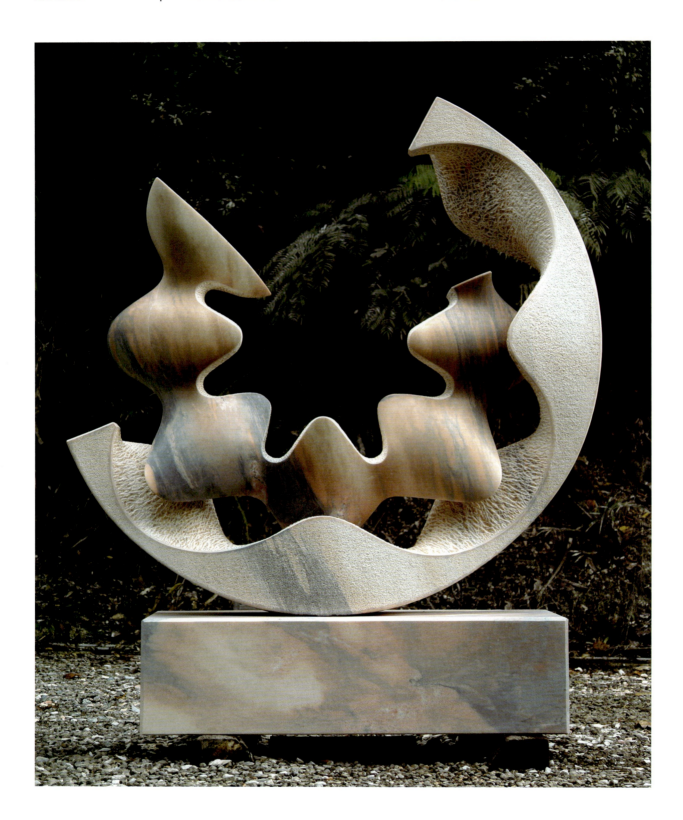

疯狂 / Madness
2400mm x 2000mm x 580mm

兹德拉夫科	Zdravko Zdravkov
保加利亚	Bulgaria
雕塑	Sculpture

Canada
加拿大

International Art Exhibition
国际美术展

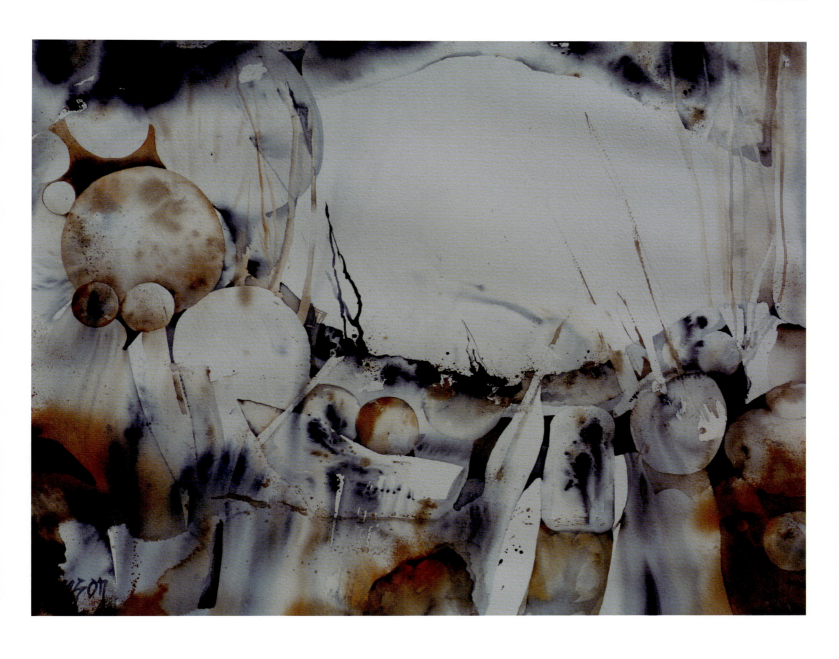

珍珠 / Pearls
550mm x 750mm

唐娜·艾奇逊·朱利特 | Donna Acheson Juillet
加拿大 | Canada
绘画 | Painting

| Work Collection of Arts | The Fifth Silk Road International Arts Festival | Canada |
| 美术作品集 | 第五届丝绸之路国际艺术节 | 加拿大 |

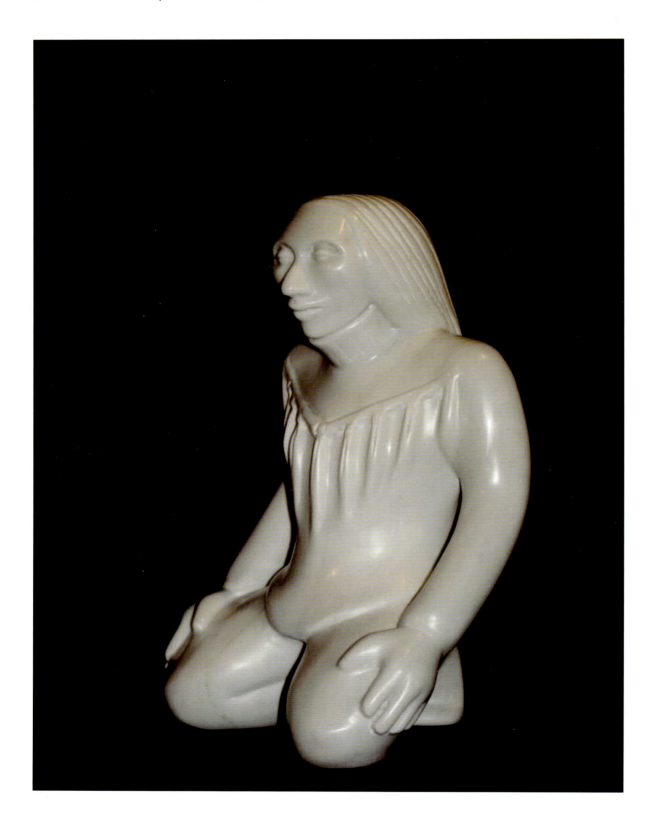

无题 / Unnamed

玛芮·乔西·勒克斯	Marie Josée Leroux
加拿大	Canada
雕塑	Sculpture

Canada
加拿大

International Art Exhibition
国际美术展

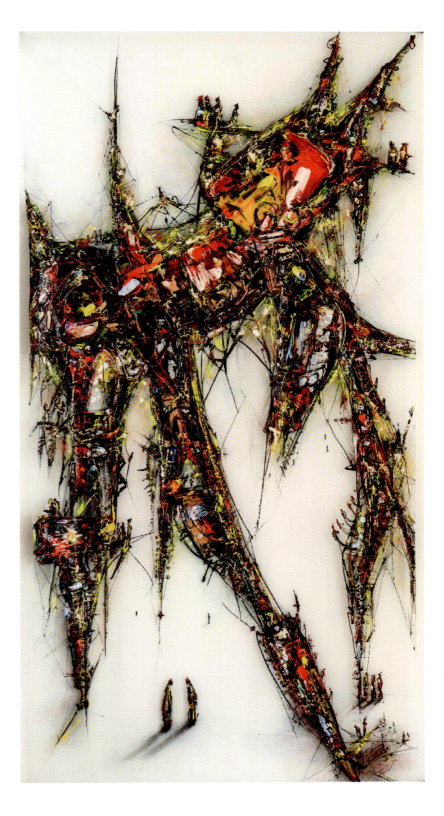

生命之路——动态空间 13（系列）/ Life Path—Dynamic Space 13(Series)

480mm x 920mm

戴维·罗撤	David Roche
加拿大	Canada
绘画	Painting

| **Work Collection of Arts** | The Fifth Silk Road International Arts Festival | Canada |
| 美术作品集 | 第五届丝绸之路国际艺术节 | 加拿大 |

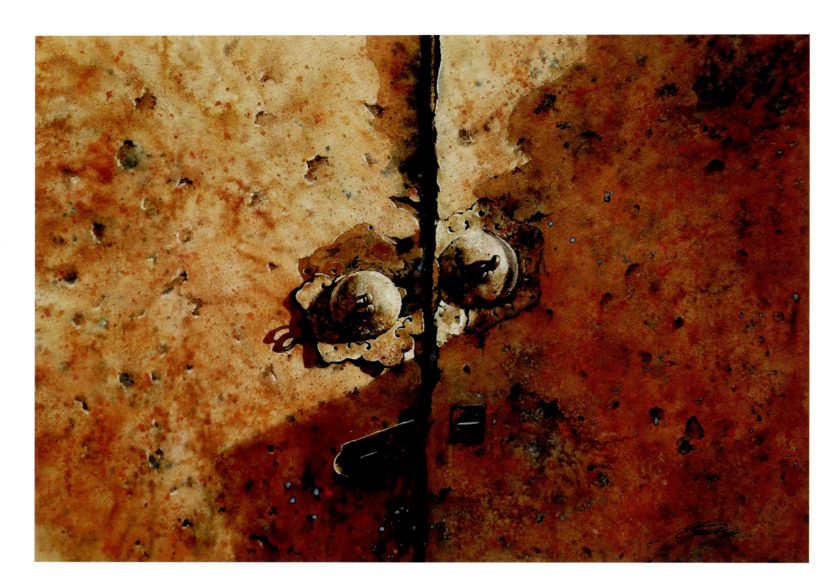

岁月留痕 / Memories
380mm x 480mm

游荣光	Yau Stephen Wing Kong
加拿大	Canada
绘画	Painting

Chile 智利 | International Art Exhibition 国际美术展

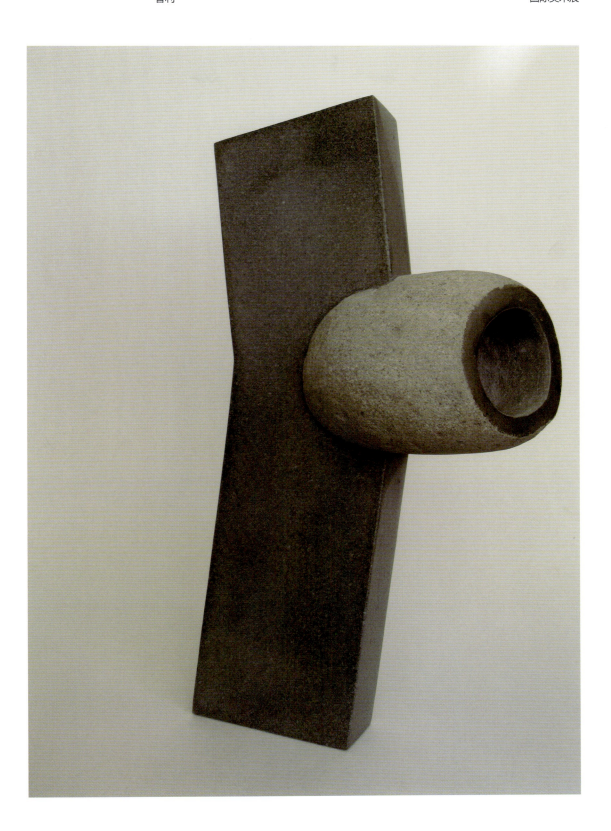

灯塔 / **Light House**
130mm x 280mm x 500mm

卢比·加查都 | Rubio Guajardo
智利 | Chile
雕塑 | Sculpture

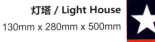

Work Collection of Arts	The Fifth Silk Road International Arts Festival	Chile
美术作品集	第五届丝绸之路国际艺术节	智利

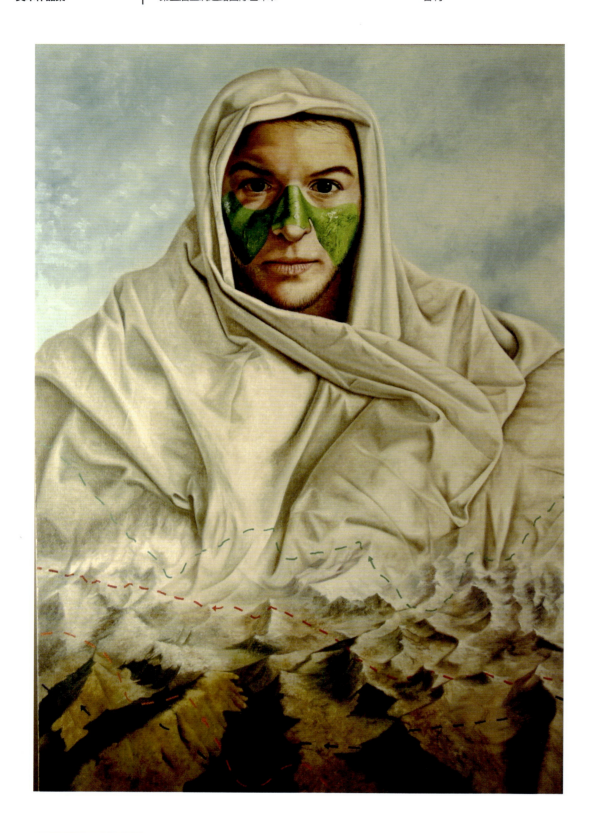

旅行 / Travel
1000mm x 700mm

安德烈·莫拉　　　　　　　Andrés Mora
智利　　　　　　　　　　　Chile
绘画　　　　　　　　　　　Painting

China International Art Exhibition
中国 国际美术展

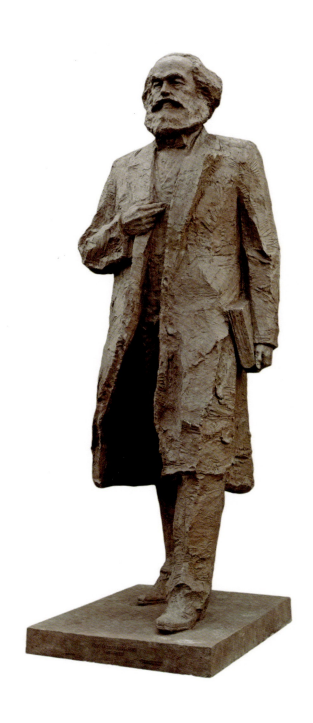

马克思 / Marx

吴为山 | Weishan Wu
中国 China
雕塑 Sculpture

| Work Collection of Arts | The Fifth Silk Road International Arts Festival | China |
| 美术作品集 | 第五届丝绸之路国际艺术节 | 中国 |

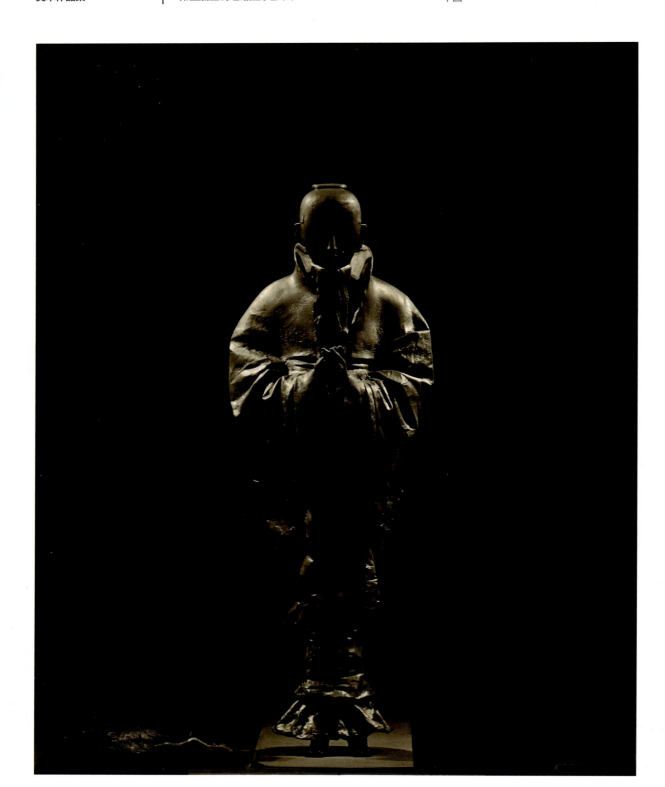

行者 / Spiritnat Practitioner
1000mm x 400mm x 250mm

李象群	Xiangqun Li
中国	China
雕塑	Sculpture

China　　　　　　　　　　　　　　　　　　　　　　　　　　　　International Art Exhibition
中国　　　　　　　　　　　　　　　　　　　　　　　　　　　　国际美术展

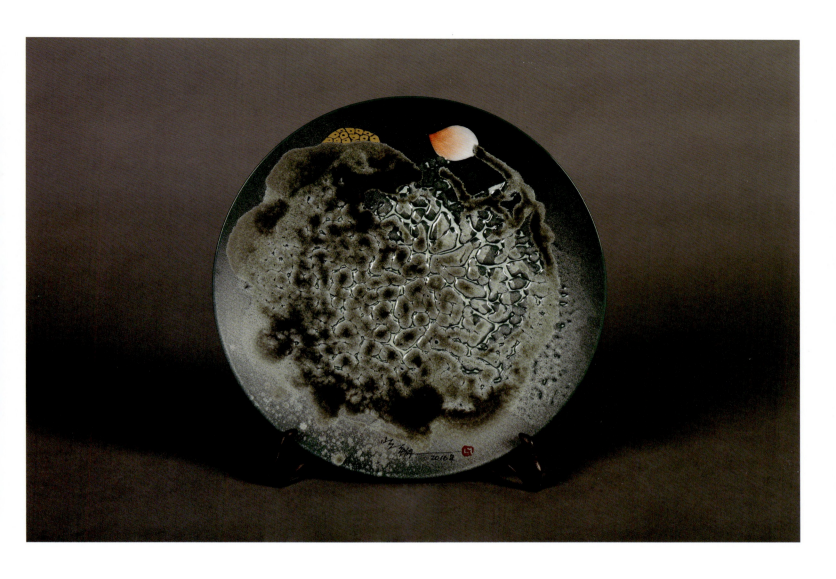

残荷 / Remaining Lotus

宁钢　　　　　　Gang Ning
中国　　　　　　China
陶瓷　　　　　　Ceramics

| Work Collection of Arts | The Fifth Silk Road International Arts Festival | China |
| 美术作品集 | 第五届丝绸之路国际艺术节 | 中国 |

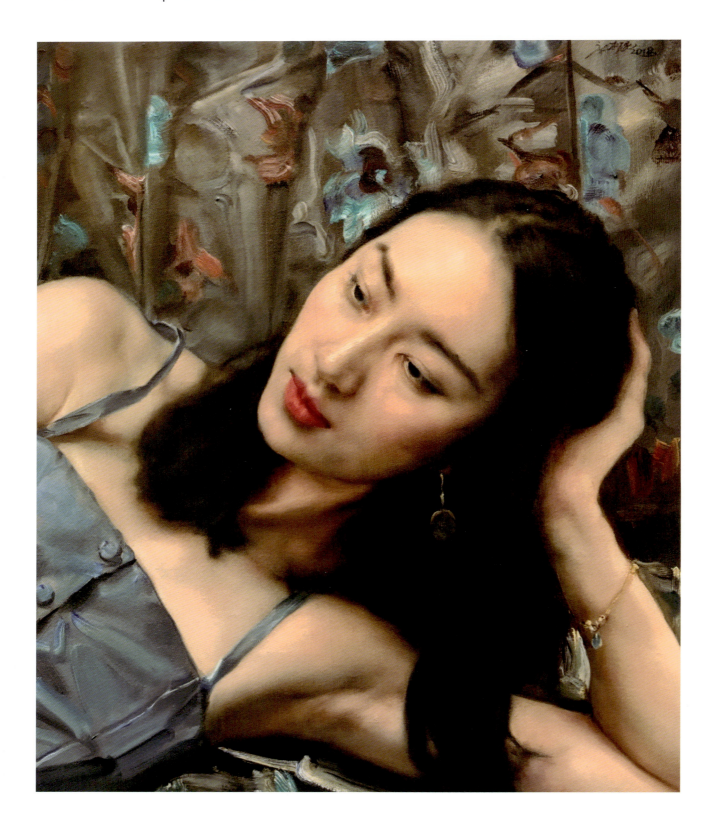

华年之一 / One of the Time
600mm x 500mm

庞茂琨	Maokun Pang
中国	China
绘画	Painting

China | International Art Exhibition
中国 | 国际美术展

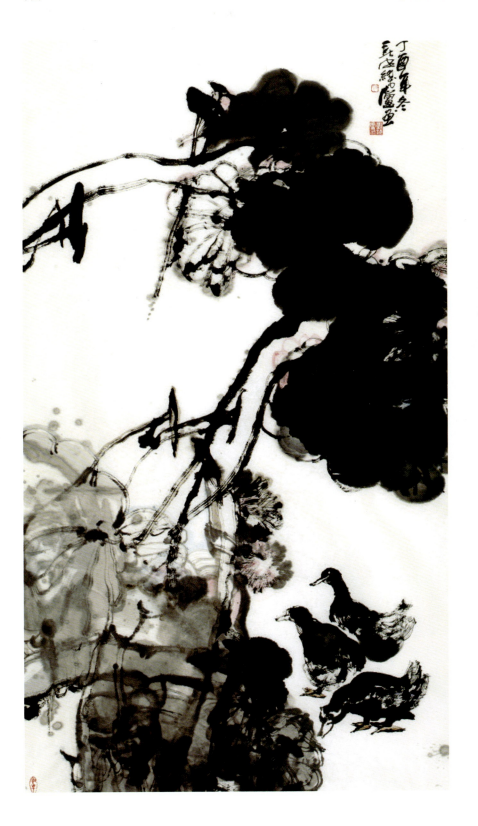

无题 / Unnamed

郭线庐 | Xianlu Guo
中国 | China
绘画 | Painting

Work Collection of Arts	The Fifth Silk Road International Arts Festival	China
美术作品集	第五届丝绸之路国际艺术节	中国

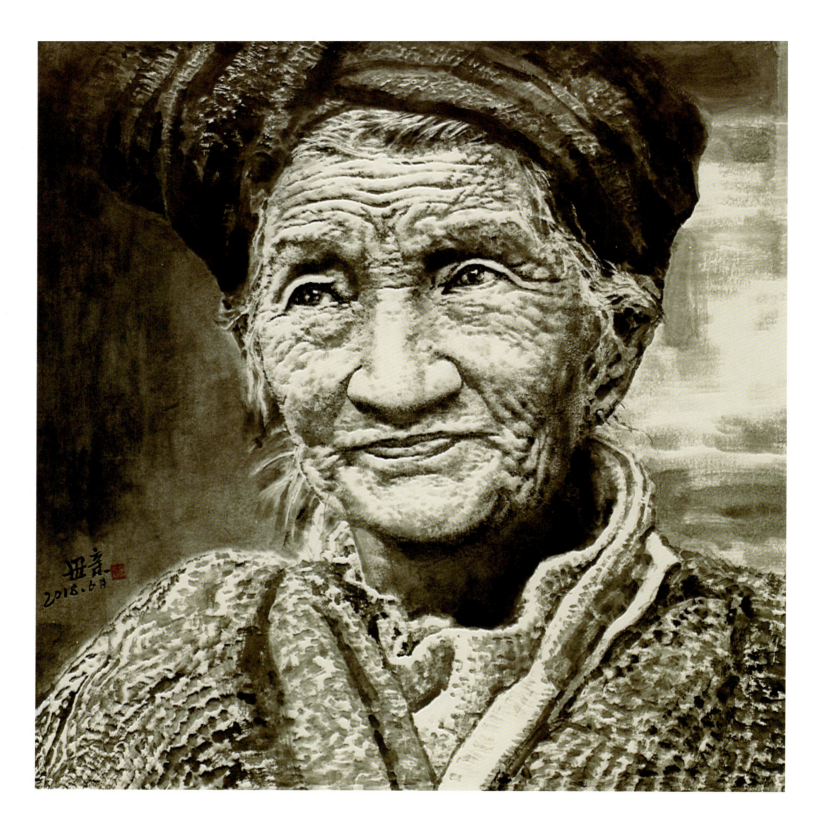

母亲 / Mother
1380mm x 1380mm

王西京	Xijing Wang
中国	China
绘画	Painting

| China | International Art Exhibition |
| 中国 | 国际美术展 |

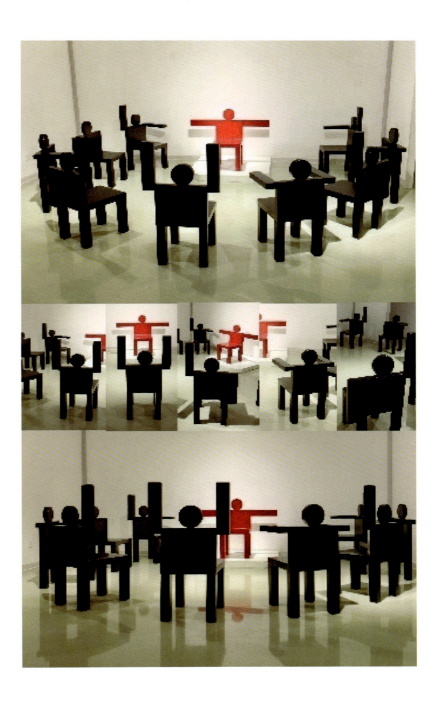

各叙己见 / Each Airs His Own Views
1000mm x 1200mm

何晓佑 | Xiaoyou He
中国 | China
装置艺术 | Installation Art

| Work Collection of Arts | The Fifth Silk Road International Arts Festival | China |
| 美术作品集 | 第五届丝绸之路国际艺术节 | 中国 |

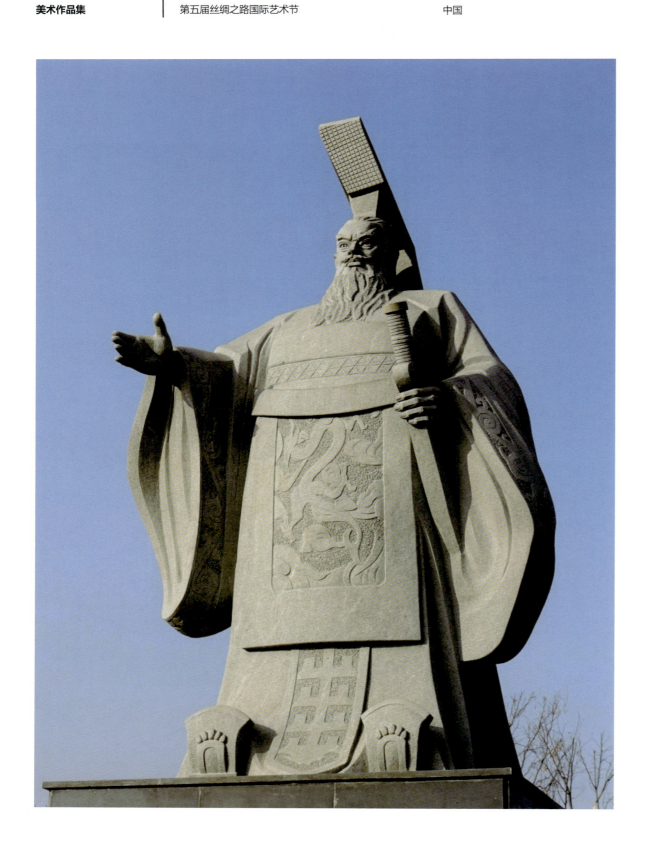

千古一帝 / The Emperor of Qin Dynasty

蔺宝钢 　　　　　Baogang Lin
中国 　　　　　　China
雕塑 　　　　　　Sculpture

China | International Art Exhibition
中国 | 国际美术展

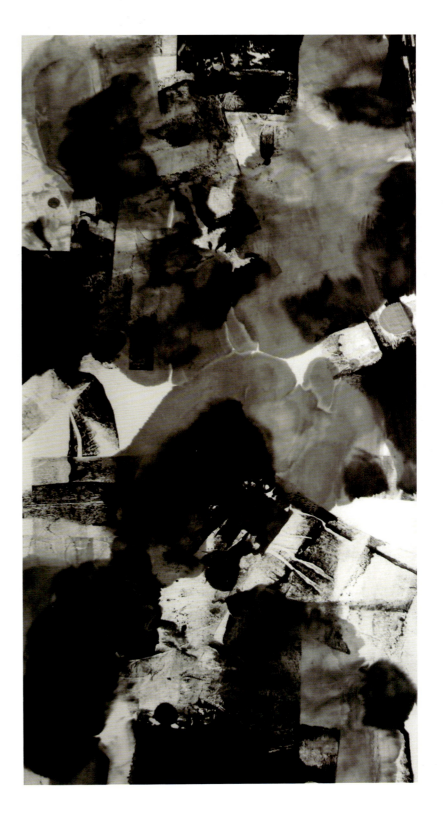

苍茫大地 / Exploration of the Earth
1680mm x 900mm

文集 | Ji Wen
中国 | China
绘画 | Painting

| Work Collection of Arts | The Fifth Silk Road International Arts Festival | China |
| 美术作品集 | 第五届丝绸之路国际艺术节 | 中国 |

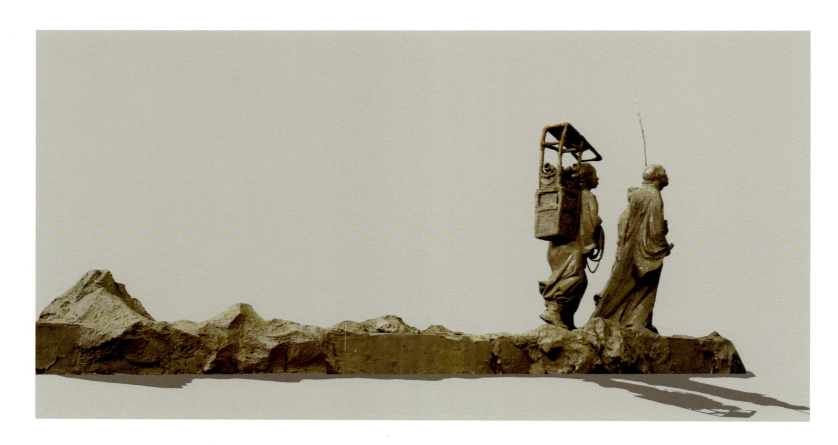

僧——行与量天尺 / Monk—Walk and Measure the Meridian
2400mm x 850mm x 800mm

景育民	Yumin Jing
中国	China
雕塑	Sculpture

China / 中国 — International Art Exhibition / 国际美术展

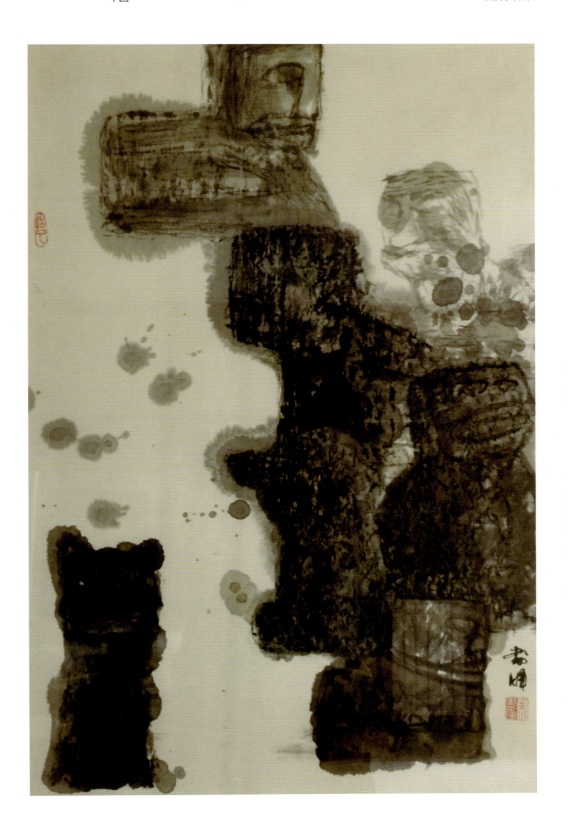

无为 / Doing Nothing

朱尽晖 / Jinhui Zhu
中国 / China
绘画 / Painting

Work Collection of Arts	The Fifth Silk Road International Arts Festival	China
美术作品集	第五届丝绸之路国际艺术节	中国

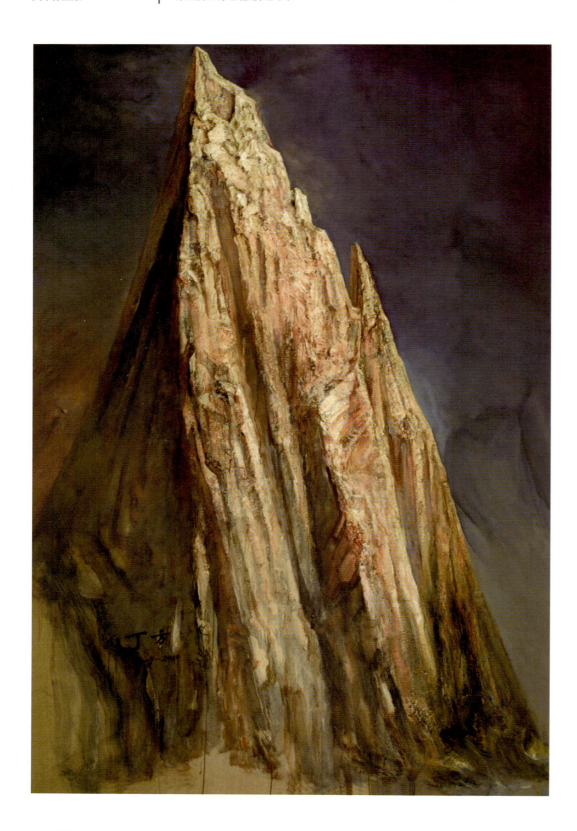

雄壮的和声 / The Mighty Harmonies
3000mm x 2000mm

丁方	Fang Ding
中国	China
绘画	Painting

China
中国

International Art Exhibition
国际美术展

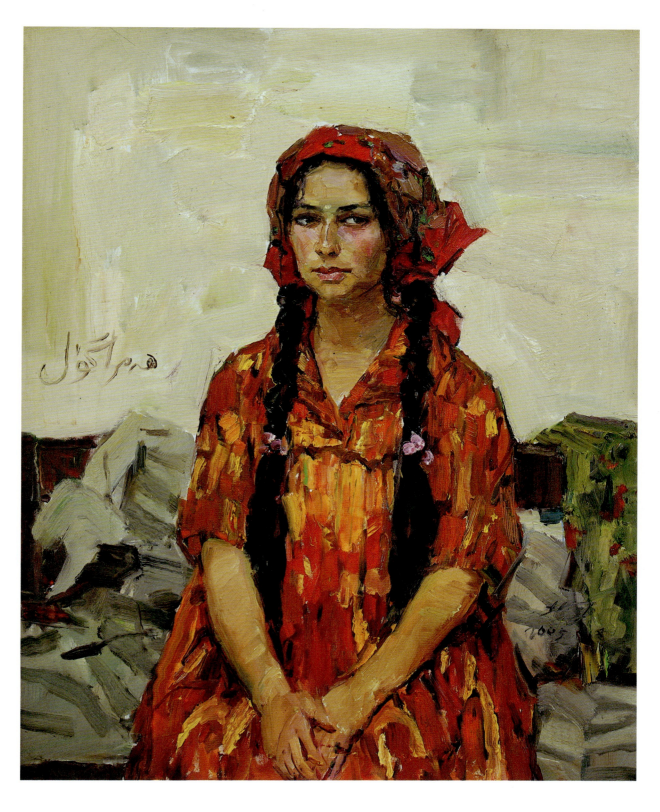

无题 / Unnamed
800mm x 600mm

郭北平　　Beiping Guo
中国　　　China
绘画　　　Painting

| Work Collection of Arts | The Fifth Silk Road International Arts Festival | China |
| 美术作品集 | 第五届丝绸之路国际艺术节 | 中国 |

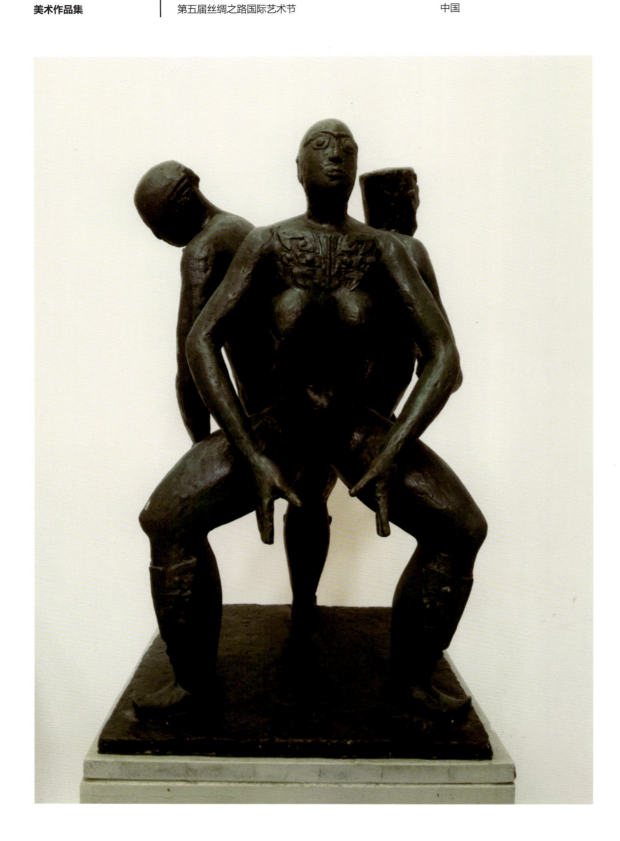

尧家族 / Yao Family
370mm x 300mm x 520mm

朱尚熹	Shangxi Zhu
中国	China
雕塑	Sculpture

China
中国

International Art Exhibition
国际美术展

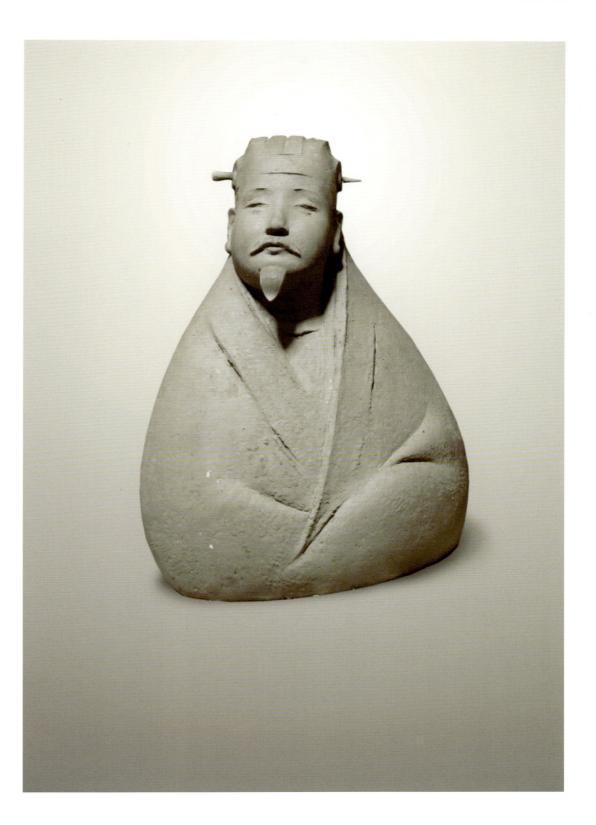

王实甫像 / Sculpture of Wang Shifu
4500mm x 3500mm x 3000mm

鲍海宁	Haining Bao
中国	China
雕塑	Sculpture

Work Collection of Arts	The Fifth Silk Road International Arts Festival	China
美术作品集	第五届丝绸之路国际艺术节	中国

绝色江山之二十六、二十八 / Indescribable Beautiful Scenery 26&28
690mm x 350mm

谢海	Hai Xie
中国	China
绘画	Painting

China | International Art Exhibition
中国 | 国际美术展

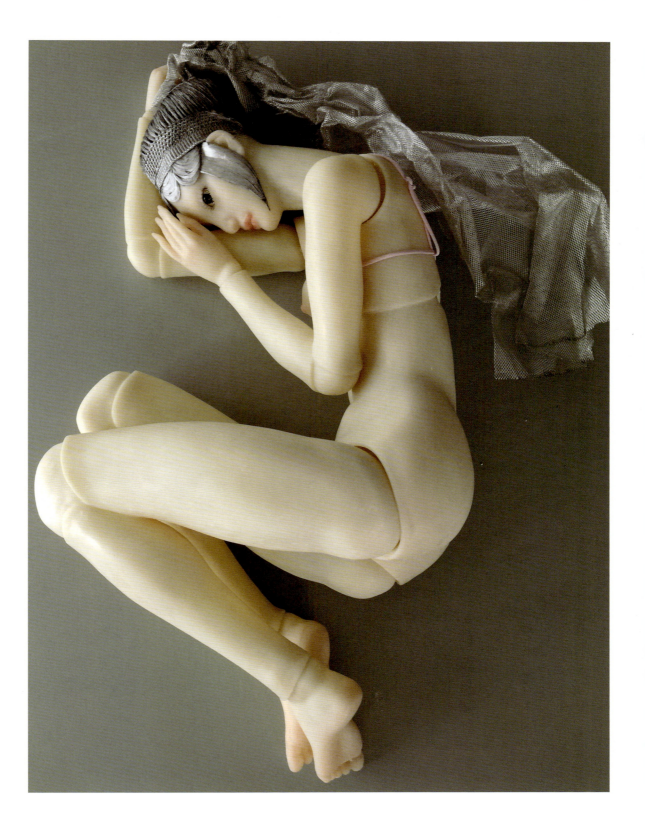

丽娘寻梦——致敬《牡丹亭》 / The Dream of Li Niang—A Tribute to the Peony Pavilion
890mm x 780mm x 270mm

罗小平 | Xiaoping Luo
中国 | China
雕塑 | Sculpture

| Work Collection of Arts | The Fifth Silk Road International Arts Festival | China |
| 美术作品集 | 第五届丝绸之路国际艺术节 | 中国 |

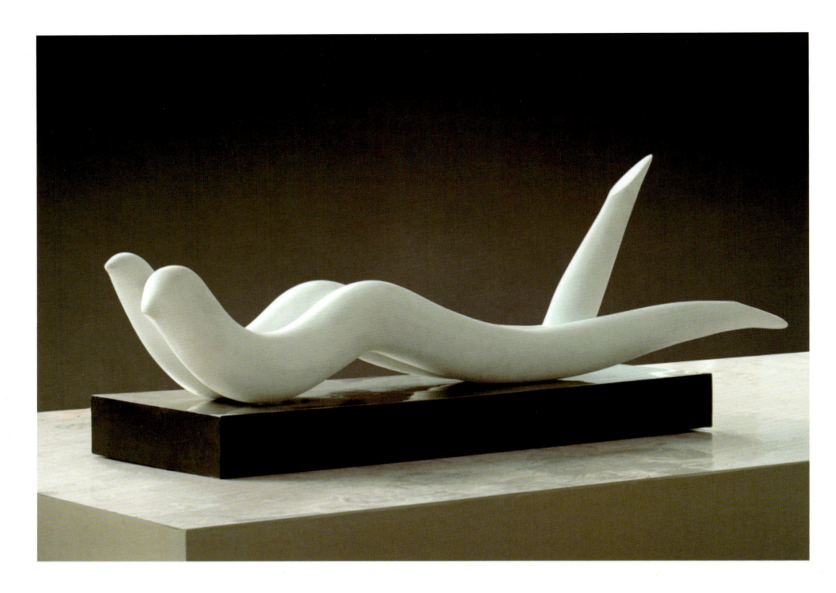

听泉 / Listen to the Spring
1200mm x 350mm x 400mm

王志刚	Zhigang Wang
中国	China
雕塑	Sculpture

China　　　　　　　　　　　　　　　　　　　　　　　　　　　　　International Art Exhibition
中国　　　　　　　　　　　　　　　　　　　　　　　　　　　　　　国际美术展

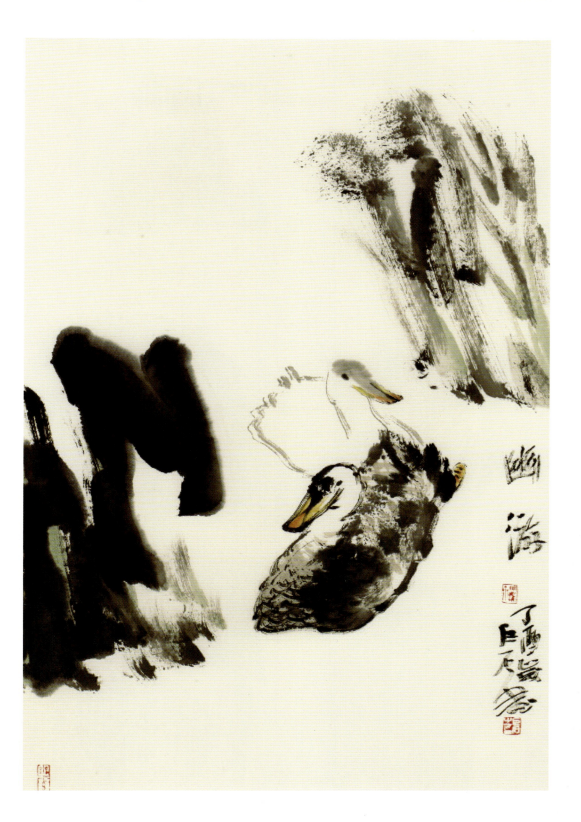

无题 / Unnamed

巨石　　　　　　　Shi Ju
中国　　　　　　　China
绘画　　　　　　　Painting

Work Collection of Arts	The Fifth Silk Road International Arts Festival	China
美术作品集	第五届丝绸之路国际艺术节	中国

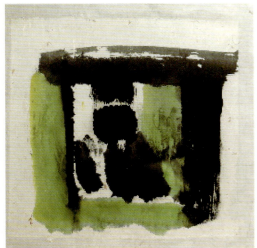
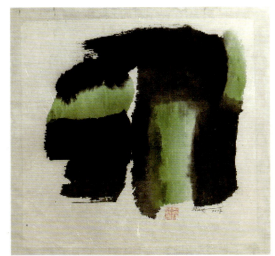
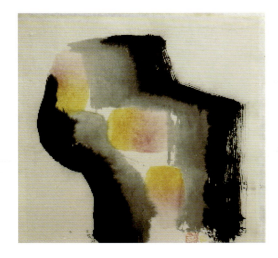
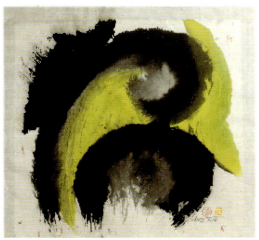

无象 No.63-68 / Can't be Last Image No.63-68
1080mm x 720mm

赵莉	Li Zhao
中国	China
绘画	Painting

China　　　　　　　　　　　　　　　　　　　　　　　　　　　　International Art Exhibition
中国　　　　　　　　　　　　　　　　　　　　　　　　　　　　国际美术展

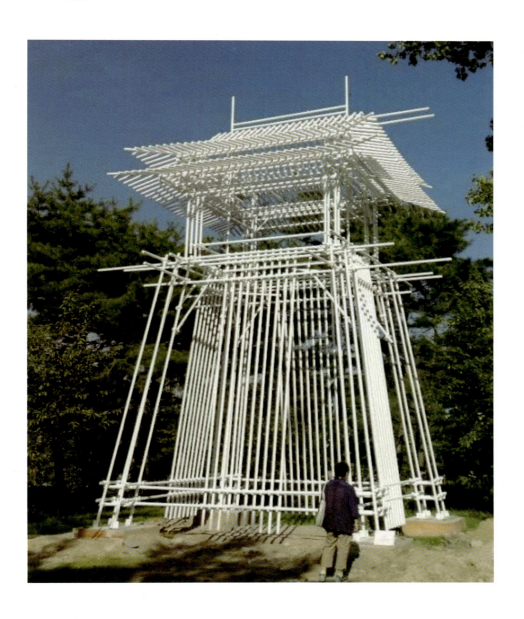

无题 / Unnamed
7000mm x 7000mm

董书兵　｜　Shubing Dong
中国　　｜　China
雕塑　　｜　Sculpture

055

| Work Collection of Arts | The Fifth Silk Road International Arts Festival | China |
| 美术作品集 | 第五届丝绸之路国际艺术节 | 中国 |

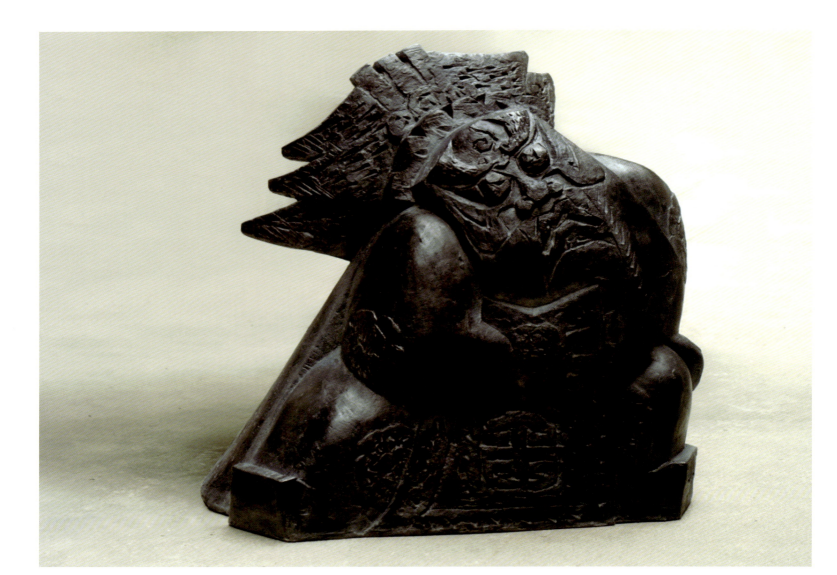

亮相 / Appearance
800mm x 600mm

张琨	Kun Zhang
中国	China
雕塑	Sculpture

China 中国　　　International Art Exhibition 国际美术展

无题 / Unnamed

王志平　　Zhiping Wang
中国　　　China
绘画　　　Painting

| Work Collection of Arts | The Fifth Silk Road International Arts Festival | China |
| 美术作品集 | 第五届丝绸之路国际艺术节 | 中国 |

春秋 / In the Spring and Autumn
600mm x 600mm

高筠	Yun Gao
中国	China
绘画	Painting

China　中国　International Art Exhibition　国际美术展

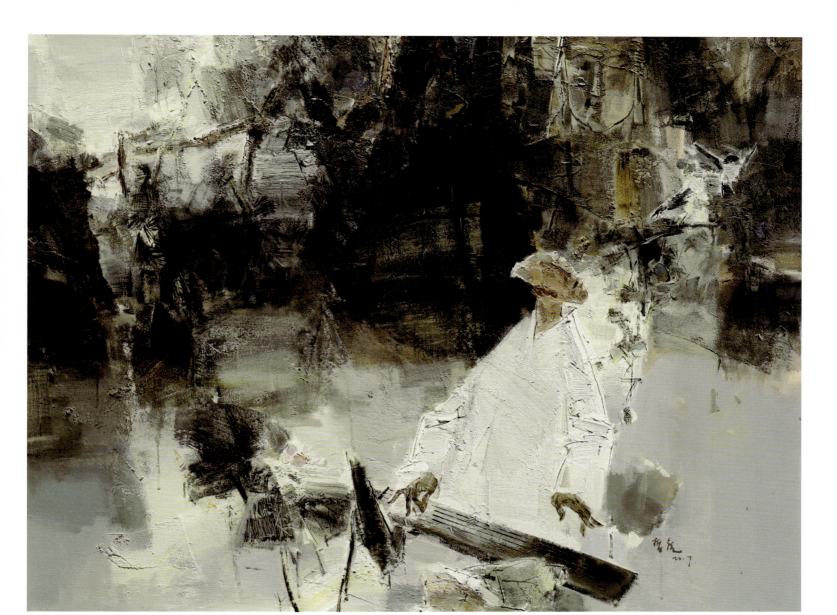

鸟鸣涧 / Birdsong in the Valley
1100mm x 840mm

李哲虎　｜　Zhehu Li
中国　｜　China
绘画　｜　Painting

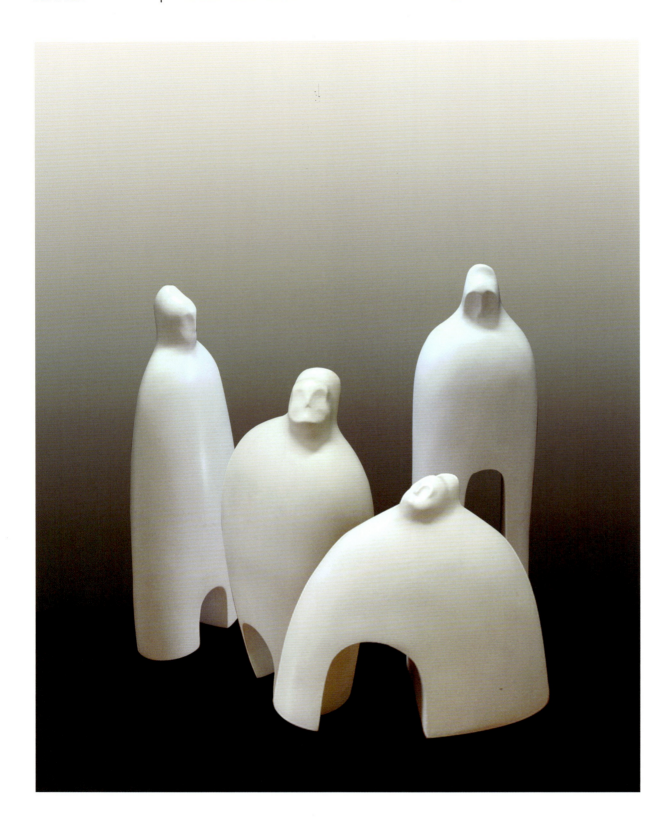

七品人格 / Seven Character Personality

姜涛
中国
雕塑

Tao Jiang
China
Sulputure

China
中国

International Art Exhibition
国际美术展

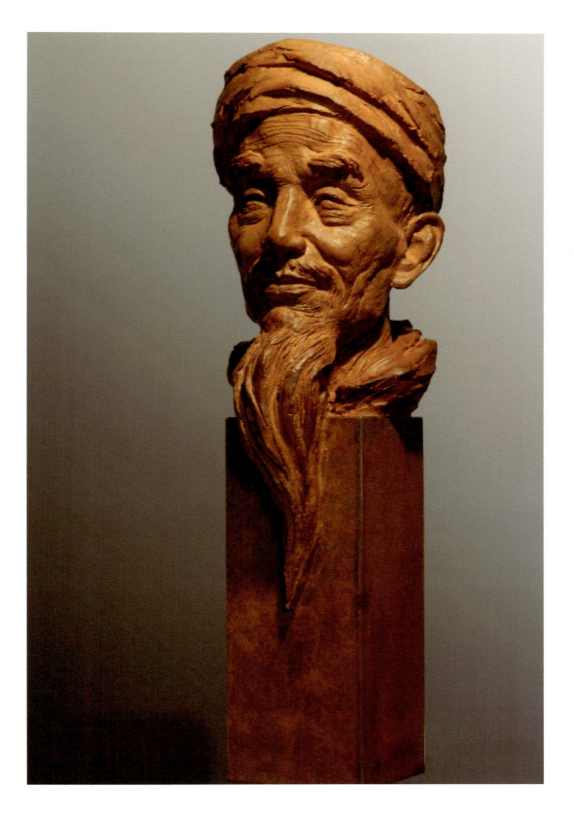

无题 / Unnamed
850mm x 400mm x 360mm

马强 | Qiang Ma
中国 | China
雕塑 | Sulputure

| Work Collection of Arts | The Fifth Silk Road International Arts Festival | China |
| 美术作品集 | 第五届丝绸之路国际艺术节 | 中国 |

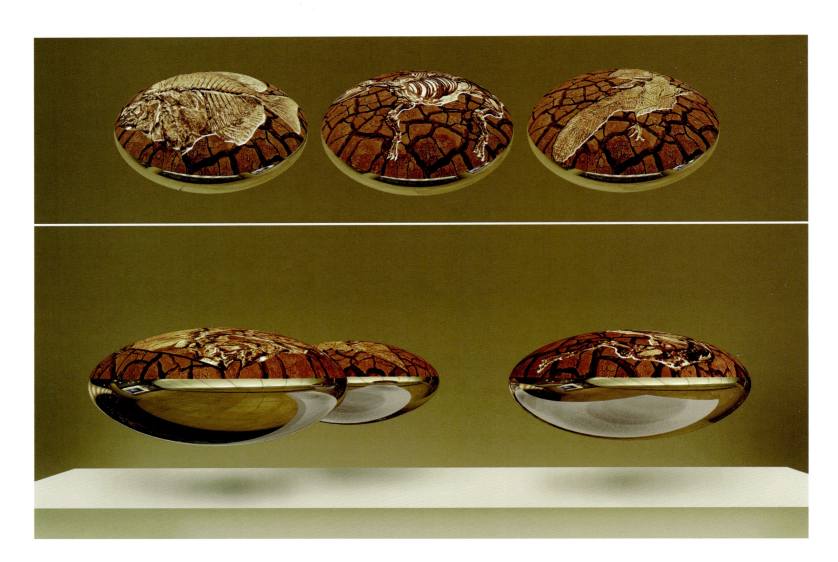

重生 / Rebirth

刘福龙	Fulong Liu
中国	China
雕塑	Sulputure

China / 中国 — International Art Exhibition / 国际美术展

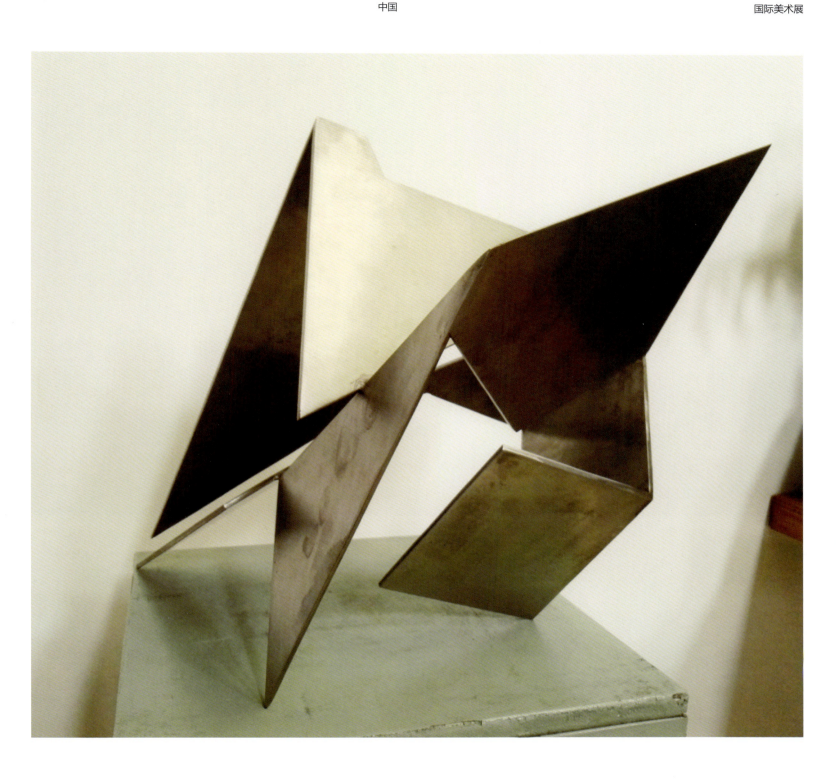

北风 3 号 / The North Wind No. 3
400mm x 300mm x 370mm

朱羿郎	Yilang Zhu
中国	China
雕塑	Sculpture

| Work Collection of Arts / 美术作品集 | The Fifth Silk Road International Arts Festival / 第五届丝绸之路国际艺术节 | China / 中国 |

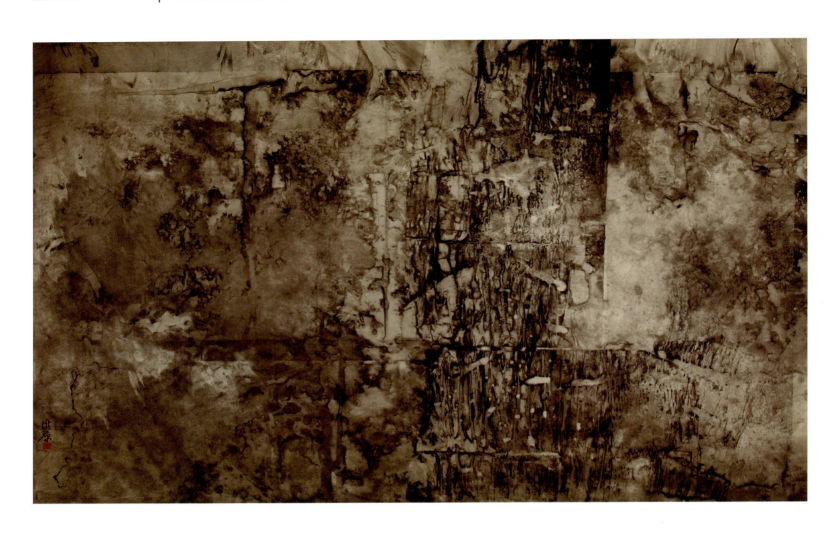

荡然虚静 / Nothing but Quie Being
1200mm x 2000mm

张洪源 | Hongyuan Zhang
中国 | China
绘画 | Painting

China / 中国 — International Art Exhibition / 国际美术展

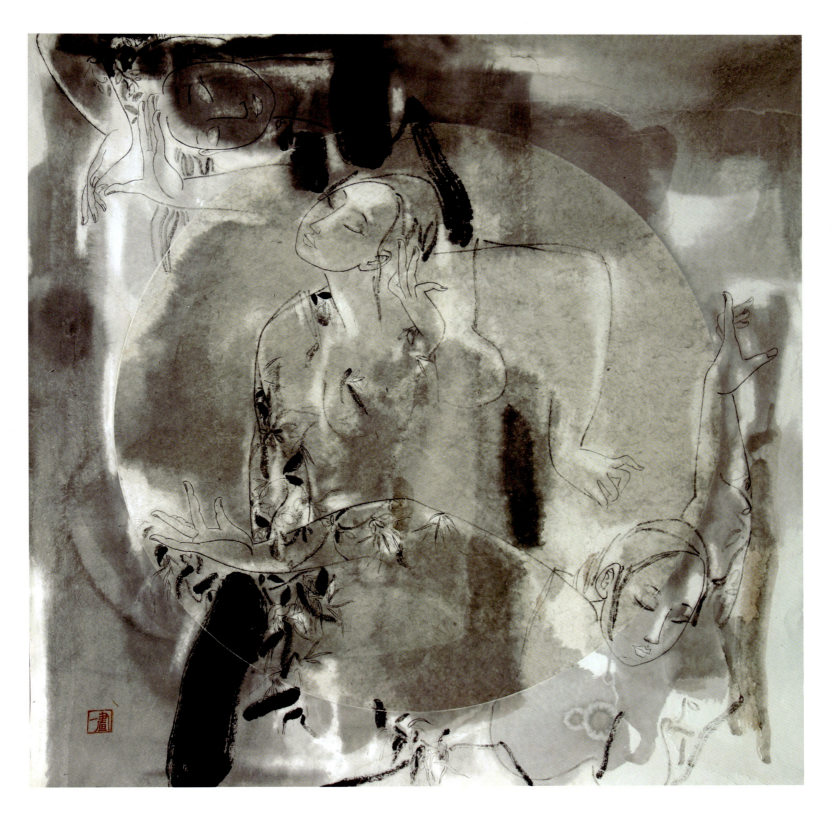

行香子 / Xingxiangzi
680mm x 680mm

王海燕 | Haiyan Wang
中国 | China
绘画 | Painting

| Work Collection of Arts | The Fifth Silk Road International Arts Festival | China |
| 美术作品集 | 第五届丝绸之路国际艺术节 | 中国 |

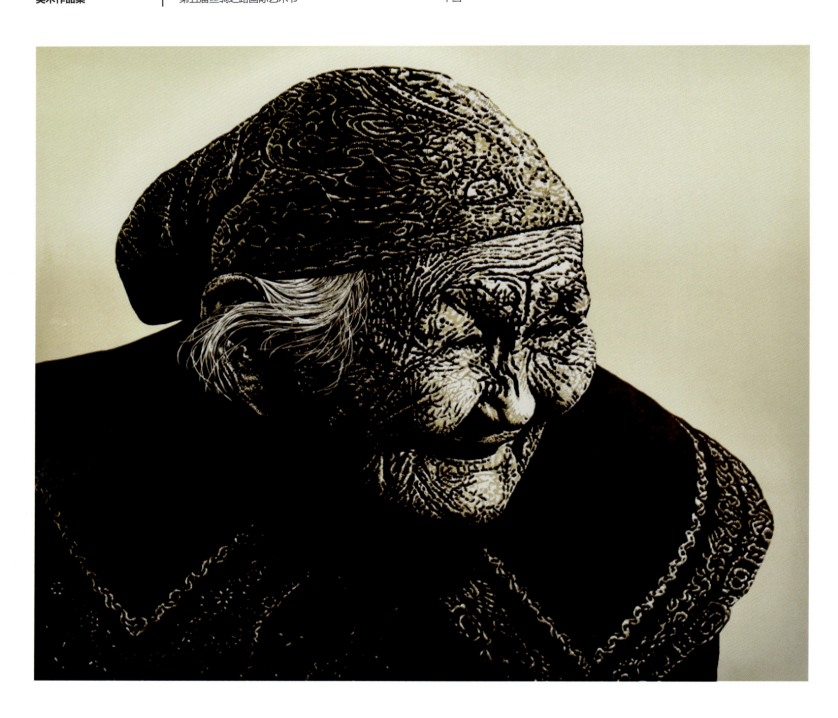

最后的女酋长——玛丽亚索 / The Last Female Chief—Maria Solow
750mm x 680mm

张士勤	Shiqin Zhang
中国	China
绘画	Painting

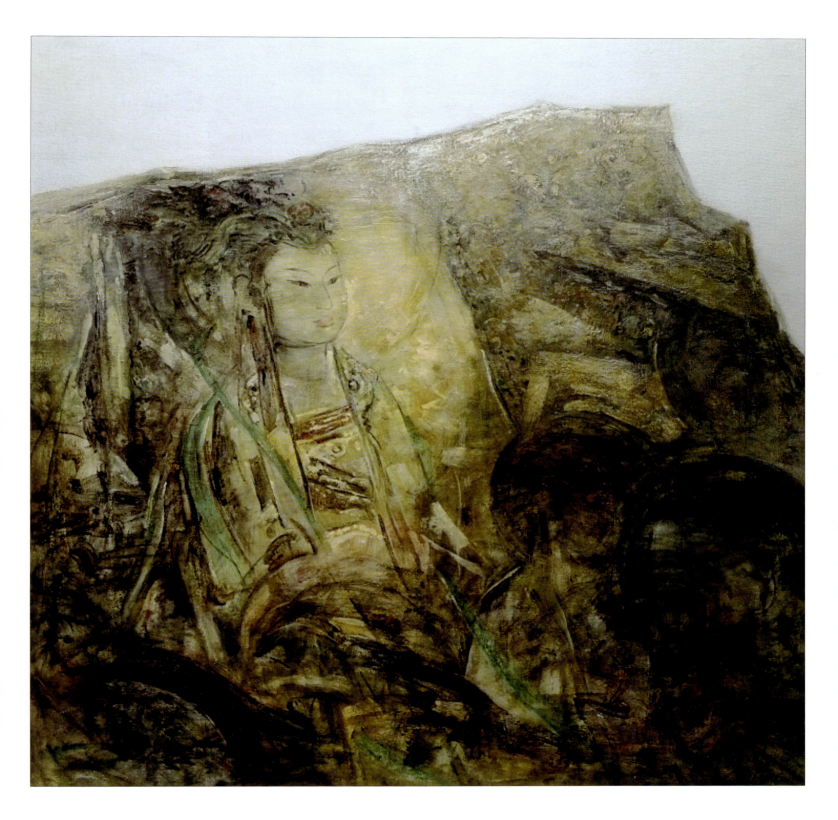

丝路——辉煌 / Silk Road—Brilliant
1200mm x 1200mm

司小刚 | Xiaogang Si
中国 | China
绘画 | Painting

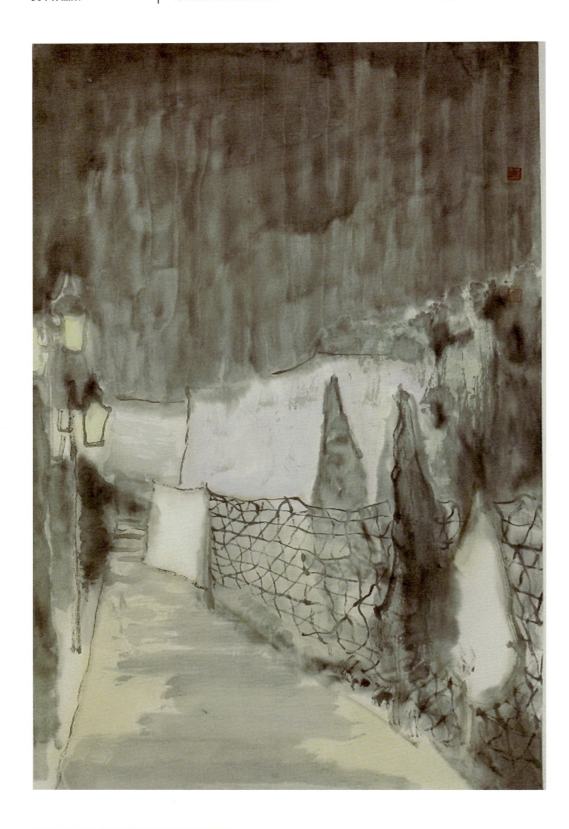

行走的片段 / Walking Fragment
680mm x 460mm

楚泓晋 | Hongjin Chu
中国 | China
绘画 | Painting

China / 中国 — International Art Exhibition / 国际美术展

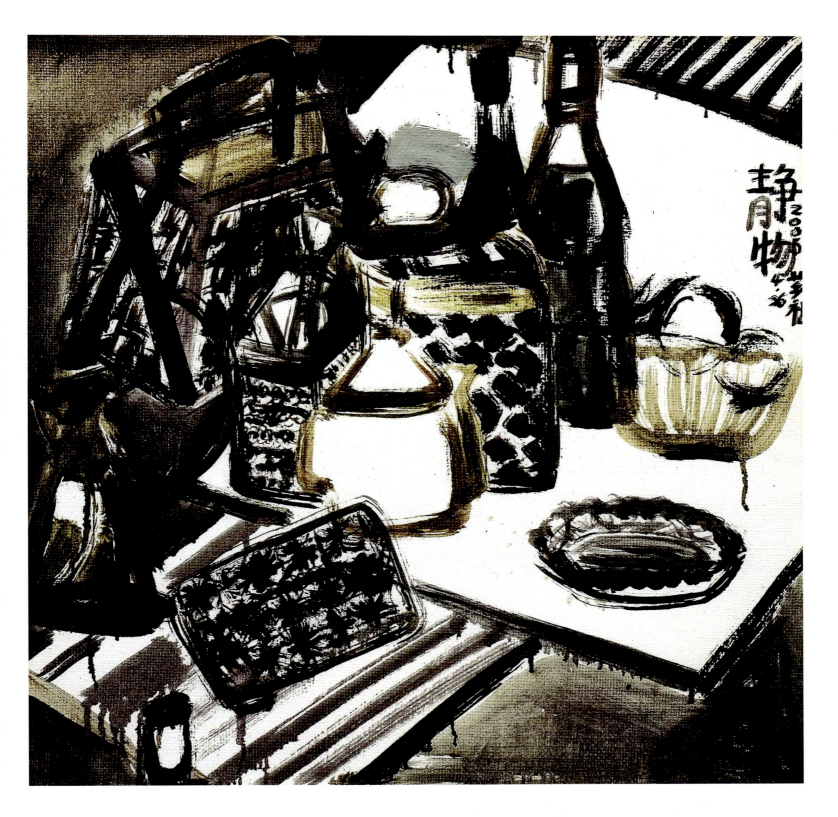

静物 / Still Life
600mm x 600mm

冯丹 / Dan Feng
中国 / China
绘画 / Painting

Work Collection of Arts	The Fifth Silk Road International Arts Festival	China
美术作品集	第五届丝绸之路国际艺术节	中国

凹 / Concave
575mm x 755mm

李峰	Feng Li
中国	China
绘画	Painting

China 中国 | International Art Exhibition 国际美术展

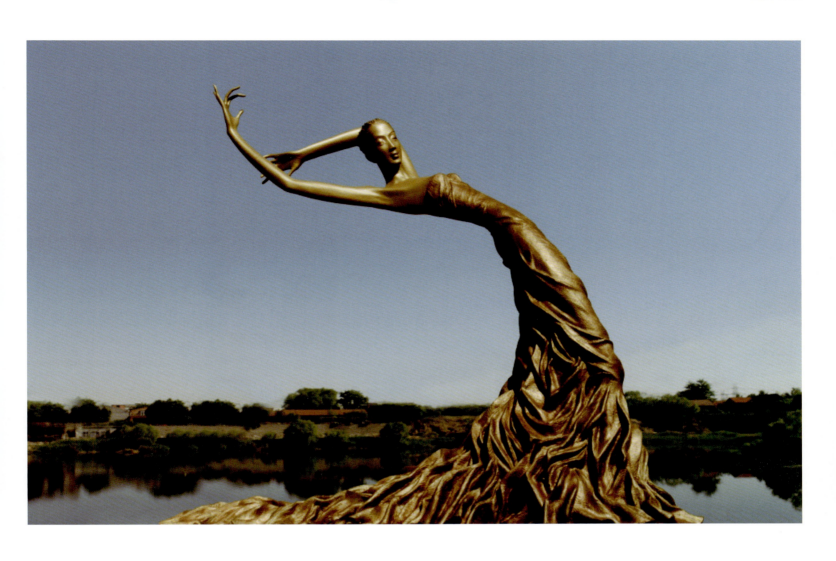

孔雀舞——韵味 / Peacock Dance—Lasting Appeal
710mm x 310mm x 830mm

章华 | Hua Zhang
中国 | China
雕塑 | Sculpture

| Work Collection of Arts | The Fifth Silk Road International Arts Festival | China |
| 美术作品集 | 第五届丝绸之路国际艺术节 | 中国 |

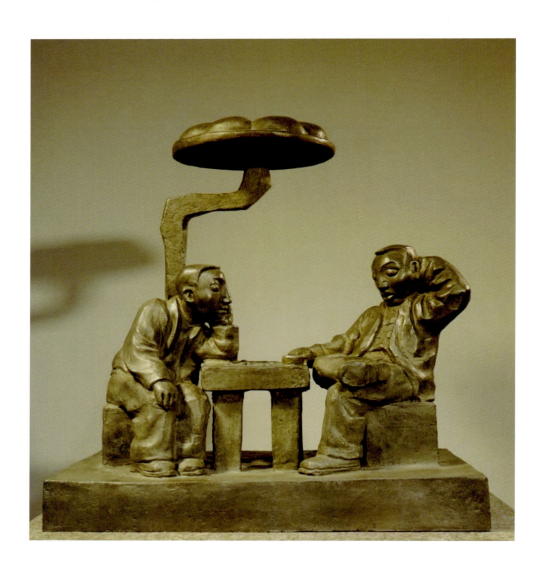

对弈 / Chess Playing
900mm x 800mm

郭继峰	Jifeng Guo
中国	China
雕塑	Sculpture

China　　　　　　　　　　　　　　　　　　　　　　　　　　　　International Art Exhibition
中国　　　　　　　　　　　　　　　　　　　　　　　　　　　　　　国际美术展

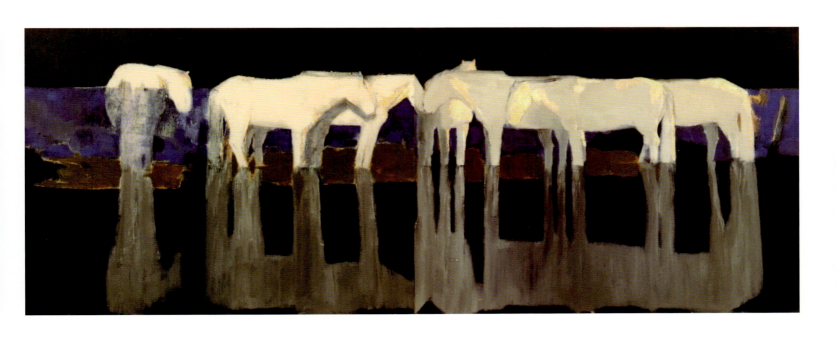

静谧系列 I / Quiet Series 1
600mm x 1600mm

胡日查　　　　Richa Hu
中国　　　　　China
绘画　　　　　Painting

Work Collection of Arts	The Fifth Silk Road International Arts Festival	China
美术作品集	第五届丝绸之路国际艺术节	中国

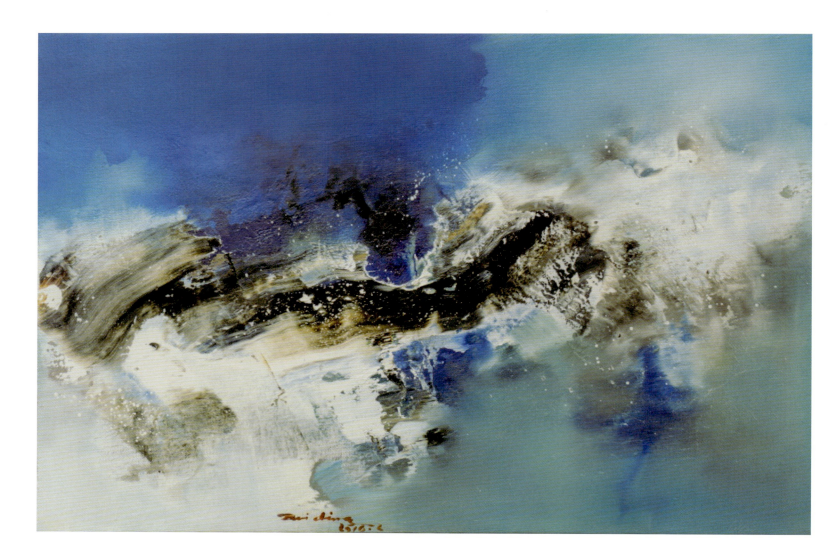

印象大自然 / Impression of Nature
900mm x 600mm

金永植	Yongzhi Jin
中国	China
绘画	Painting

Hong Kong, China — International Art Exhibition
中国香港 — 国际美术展

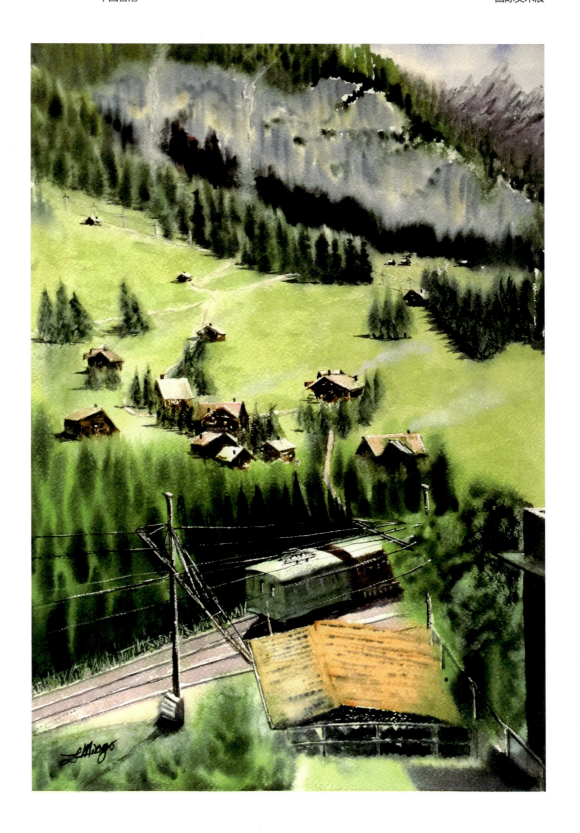

瑞士乡村卢本立 / Village Lauterbrunnen
380mm x 540mm

李伟明 | Wai Ming Mingo Li
中国香港 | Hong Kong, China
绘画 | Painting

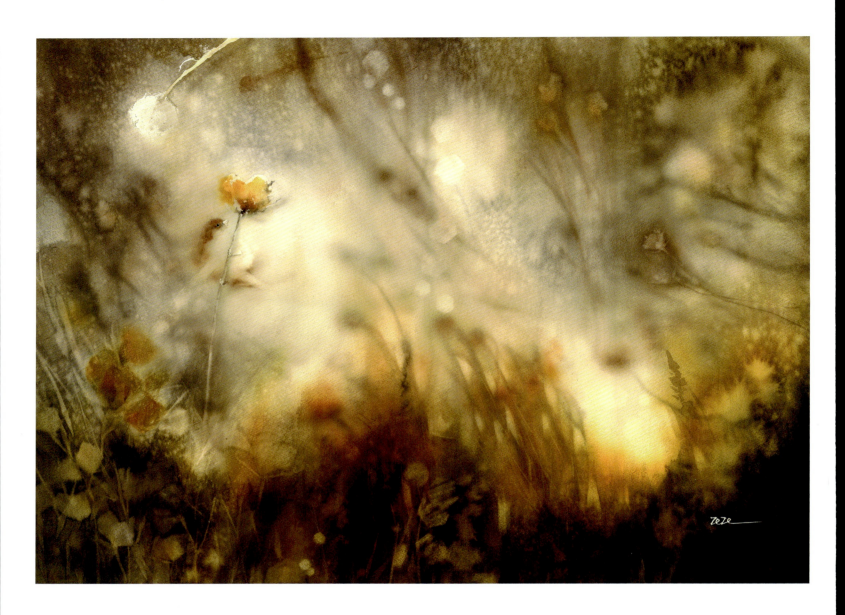

无题 / Unnamed
560mm x 760mm

黎思思
中国香港
绘画

Ze Ze Lai
Hong Kong, China
Painting

Macao,China 中国澳门 — International Art Exhibition 国际美术展

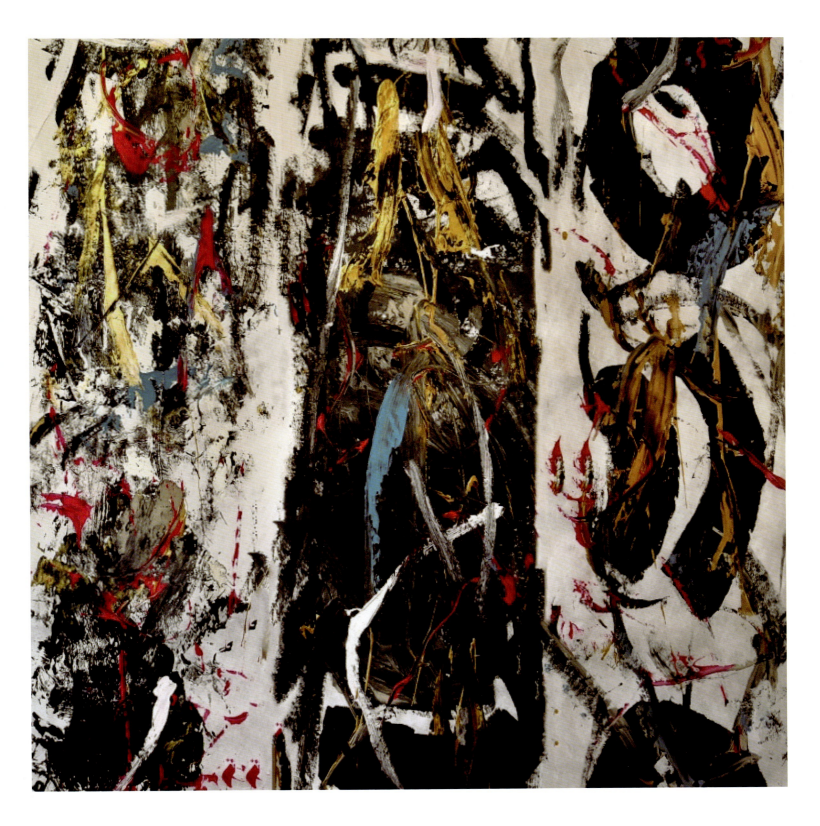

理想主义 / Idealism
250mm x 900mm

卡纳·贾格罗斯
中国澳门
绘画

Canal Cheong Jagerroos
Macao, China
Painting

| Work Collection of Arts 美术作品集 | The Fifth Silk Road International Arts Festival 第五届丝绸之路国际艺术节 | Macao, China 中国澳门 |

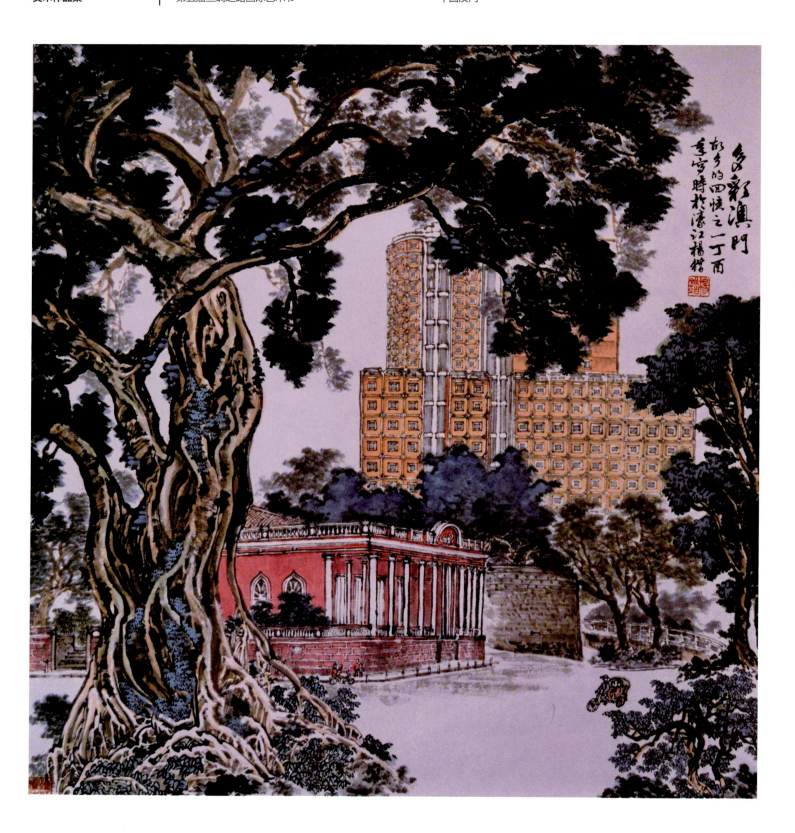

多彩澳门 / Colorful Macao
980mm x 950mm

杨维凡	Weifan Ieong
中国澳门	Macao, China
绘画	Painting

Taiwan, China
中国台湾

International Art Exhibition
国际美术展

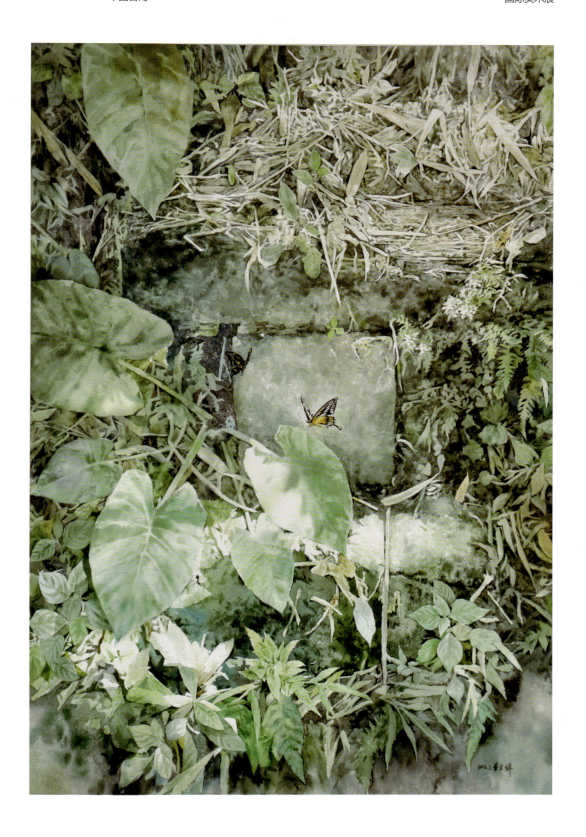

息 / Stopover
995mm x 705mm

黄文祥
中国台湾
绘画

Wenxiang Huang
Taiwan, China
Painting

Work Collection of Arts	The Fifth Silk Road International Arts Festival	Taiwan, China
美术作品集	第五届丝绸之路国际艺术节	中国台湾

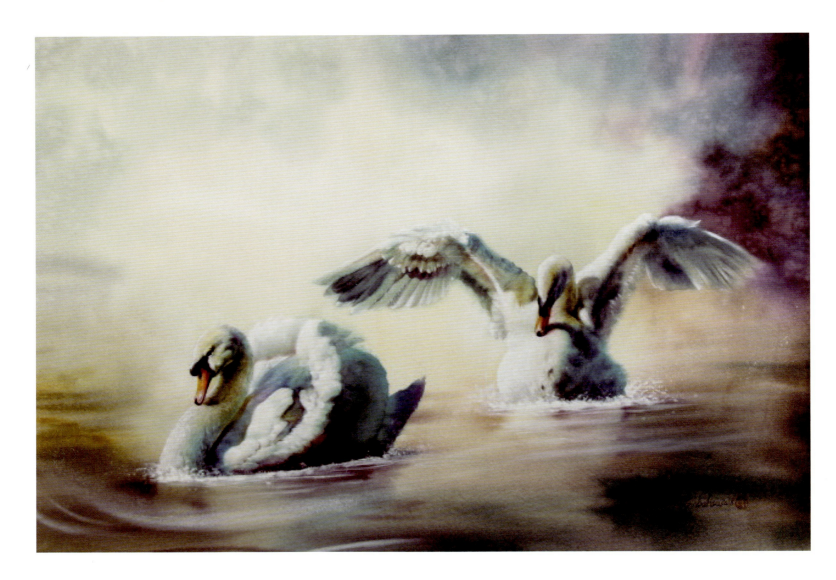

呵护 / Cherish

750mm x 510mm

许云翔	Yunxiang Xu
中国台湾	Taiwan, China
绘画	Painting

Taiwan, China
中国台湾

International Art Exhibition
国际美术展

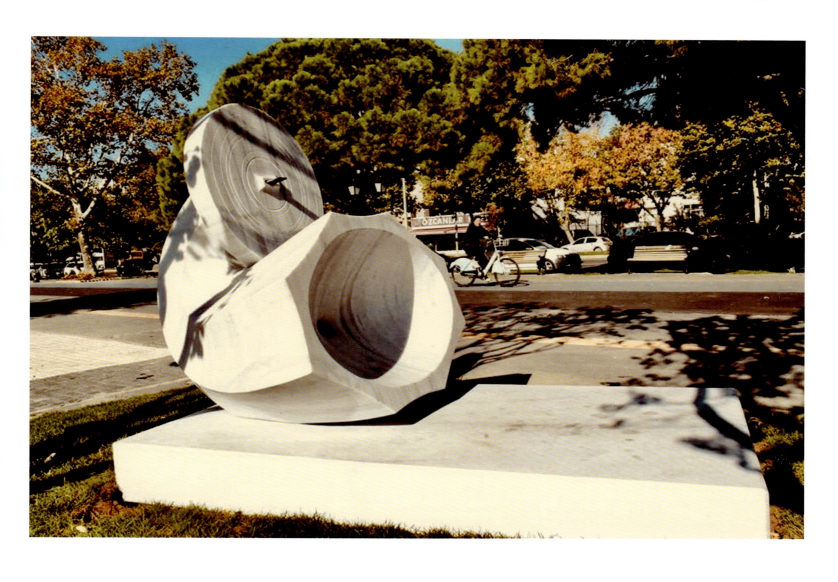

璇外之音 / The Voice of Grace Outside
1300mm x 1200mm x 1550mm

王标	Biao Wang
中国台湾	Taiwan, China
雕塑	Sculpture

Work Collection of Arts	The Fifth Silk Road International Arts Festival	Taiwan, China
美术作品集	第五届丝绸之路国际艺术节	中国台湾

无题 / Unnamed
5650mm x 250mm x 270mm

林立仁	Liren Lin
中国台湾	Taiwan, China
雕塑	Sculpture

Taiwan, China
中国台湾

International Art Exhibition
国际美术展

贵妃出浴 / The Imperial Concubine Beauties
620mm x 170mm x 170mm

李宝龙	Baolong Li
中国台湾	Taiwan, China
雕塑	Sculpture

| Work Collection of Arts | The Fifth Silk Road International Arts Festival | Colombia |
| 美术作品集 | 第五届丝绸之路国际艺术节 | 哥伦比亚 |

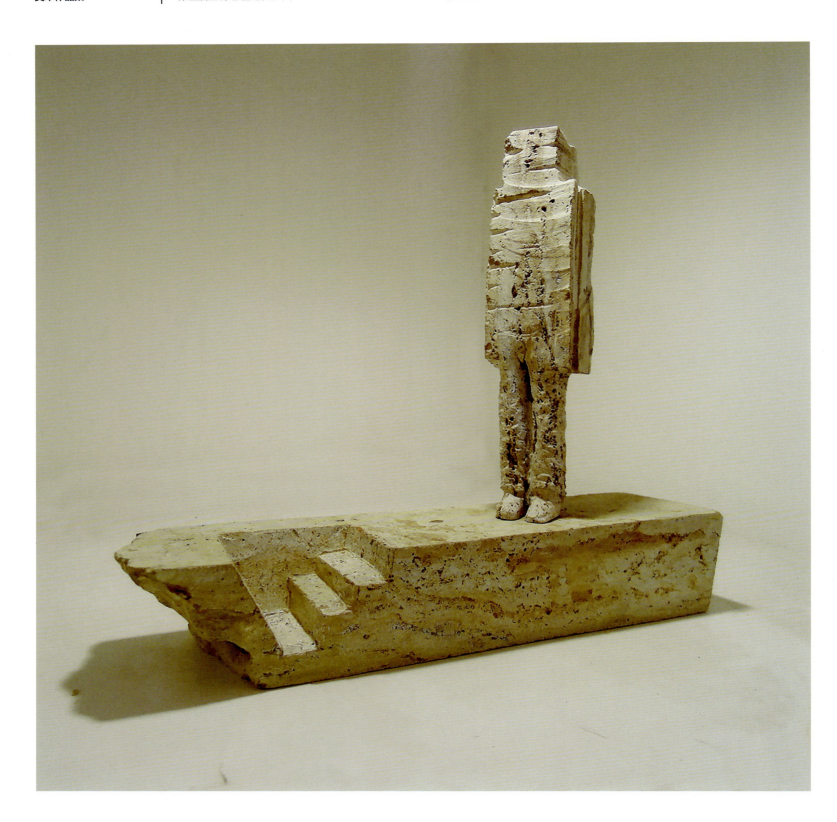

候选人 / The Candidate
250mm x 270mm x 70mm

费尔南多·平多　　　Fernando Pinto
哥伦比亚　　　　　Colombia
雕塑　　　　　　　Sculpture

Colombia
哥伦比亚

International Art Exhibition
国际美术展

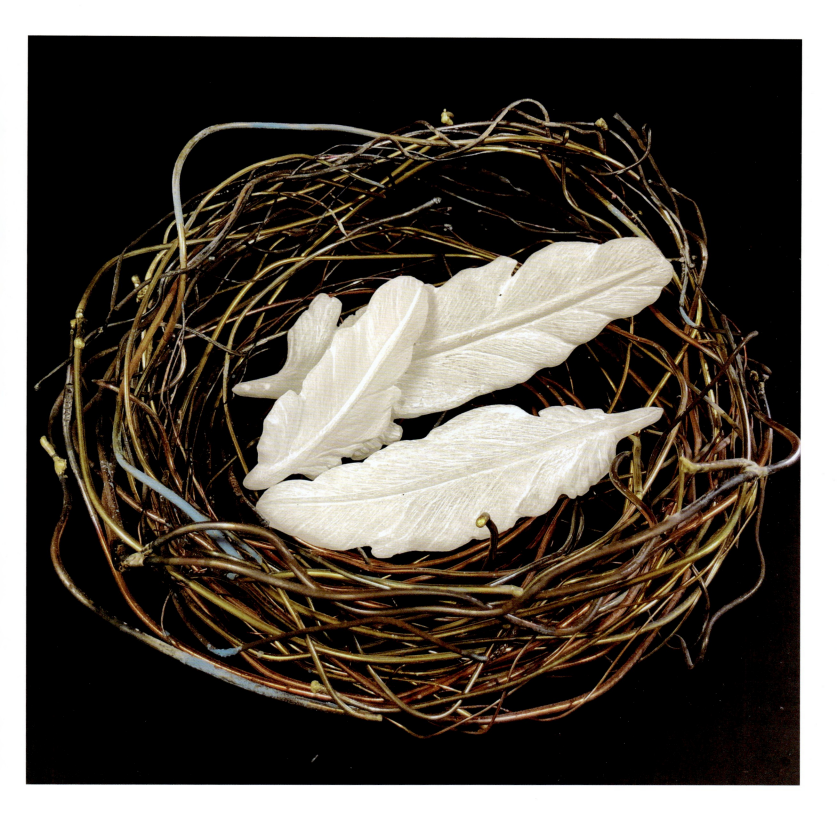

离开巢穴，永远飞翔 / Leaving the Nest to Jump in Eternal Flight
240mm x 120mm

安娜·伊莎贝尔·梅萨 | Ana Isabel Mesa
哥伦比亚 | Colombia
雕塑 | Sculpture

Work Collection of Arts	The Fifth Silk Road International Arts Festival	Costa Rica
美术作品集	第五届丝绸之路国际艺术节	哥斯达黎加

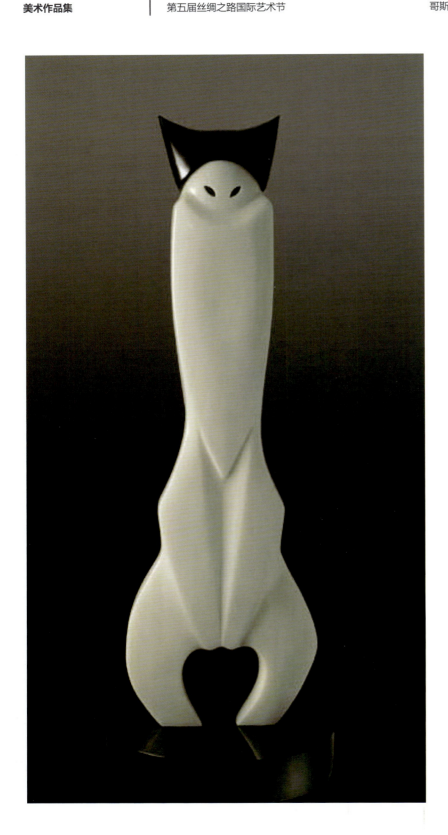

夜的守护者 / Guardian of the Night
530mm x 190mm x 60mm

阿基莱斯·吉姆尼斯　　Aquiles Jiménez
哥斯达黎加　　　　　　Costa Rica
雕塑　　　　　　　　　Sculpture

Côte d'Ivoire
科特迪瓦

International Art Exhibition
国际美术展

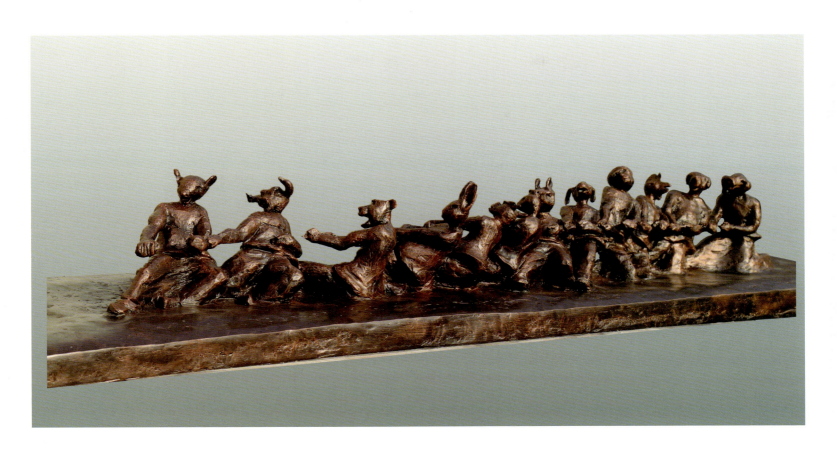

超越时代 / Beyond the Time
1940mm x 270mm x 240mm

夸思
科特迪瓦
雕塑

Kouame Kouassi Marc Eric
Côte d'Ivoire
Sculpture

| Work Collection of Arts | The Fifth Silk Road International Arts Festival | Côte d'Ivoire |
| 美术作品集 | 第五届丝绸之路国际艺术节 | 科特迪瓦 |

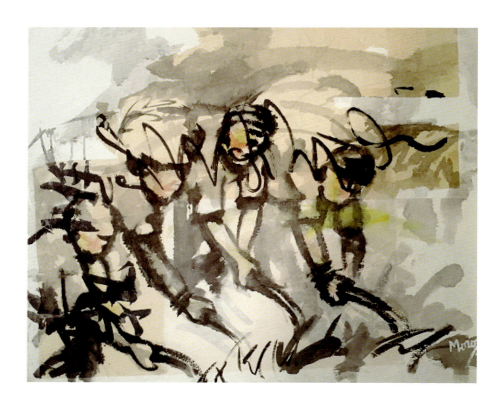

为和平工作的妇女们 / The Work of Women as a Condition for Peace
1000mm x 800mm

马蒂尔德·莫里奥	Mathilde Moreau
科特迪瓦	Côte d'Ivoire
绘画	Painting

Croatia / International Art Exhibition
克罗地亚 / 国际美术展

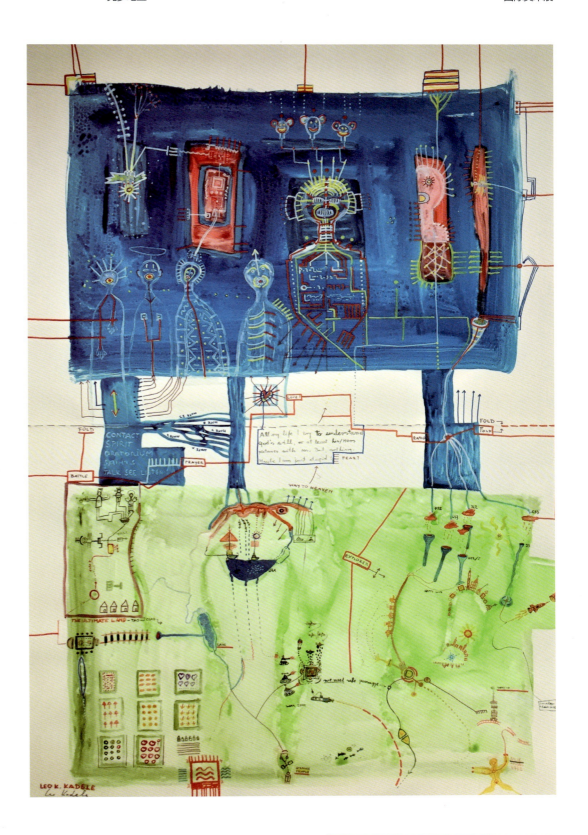

可折叠的宇宙 / Foldable Universe
1000mm x 700mm

利奥·卡塔纳里克 | Leo Katunaric
克罗地亚 | Croatia
绘画 | Painting

| Work Collection of Arts | The Fifth Silk Road International Arts Festival | Cuba |
| 美术作品集 | 第五届丝绸之路国际艺术节 | 古巴 |

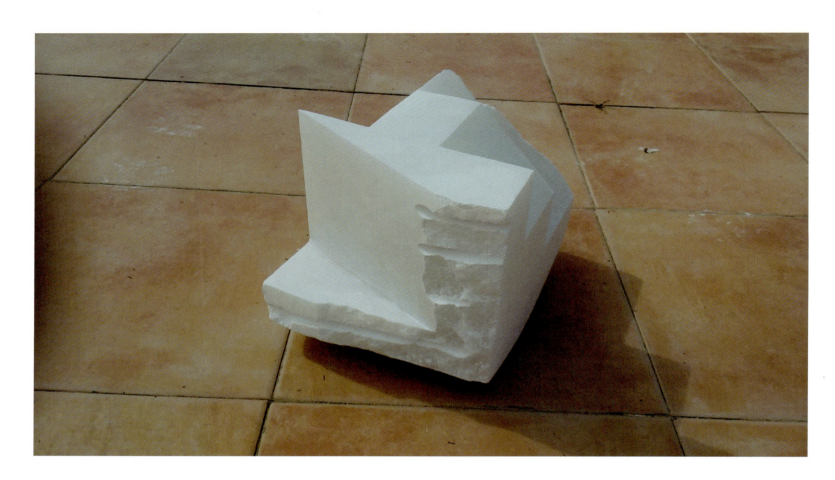

避难所 / The Shelter

270mm x 200mm x 200mm

奥斯卡·劳瑞劳诺·艾格瑞·卡门达都　　Oscar Laurelino Aguirre Comendador
古巴　　　　　　　　　　　　　　　　Cuba
雕塑　　　　　　　　　　　　　　　　Sculpture

Cyprus 塞浦路斯 — International Art Exhibition 国际美术展

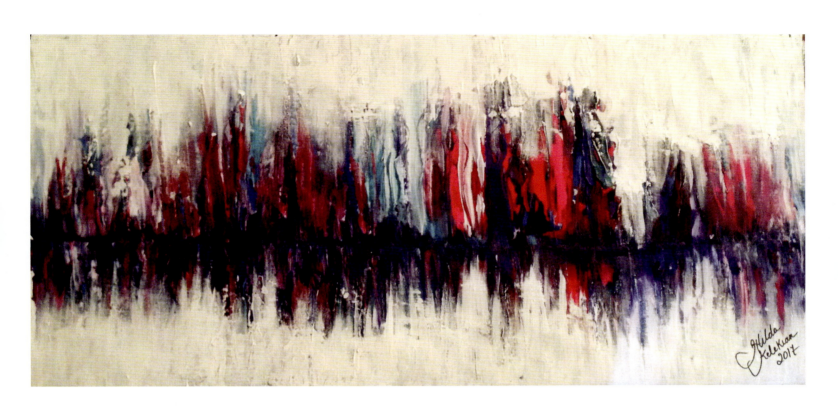

黎巴嫩反射 / Lebanon Reflections
420mm x 950mm

希尔达·凯莱基安 | Hilda Kelekian
塞浦路斯 | Cyprus
绘画 | Painting

Work Collection of Arts	The Fifth Silk Road International Arts Festival	Czech
美术作品集	第五届丝绸之路国际艺术节	捷克

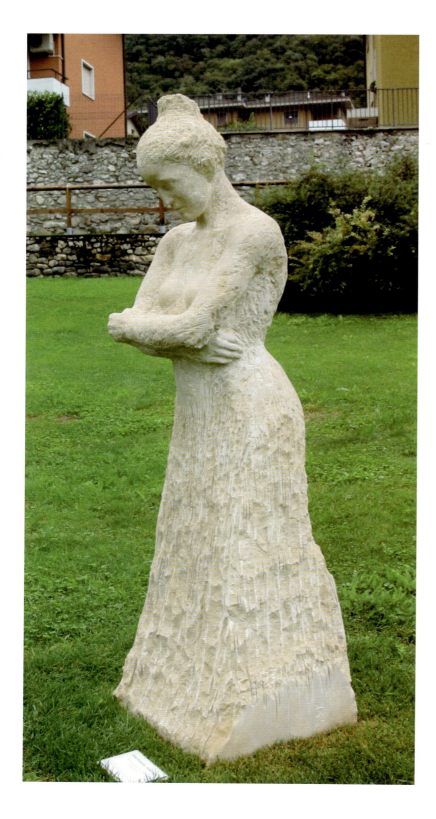

女性的原型 / Archetype of a Woman
3500mm x 1900mm x 1200mm

吉特卡·库索娃	Jitka Kusova
捷克	Czech
雕塑	Sculpture

Denmark
丹麦

International Art Exhibition
国际美术展

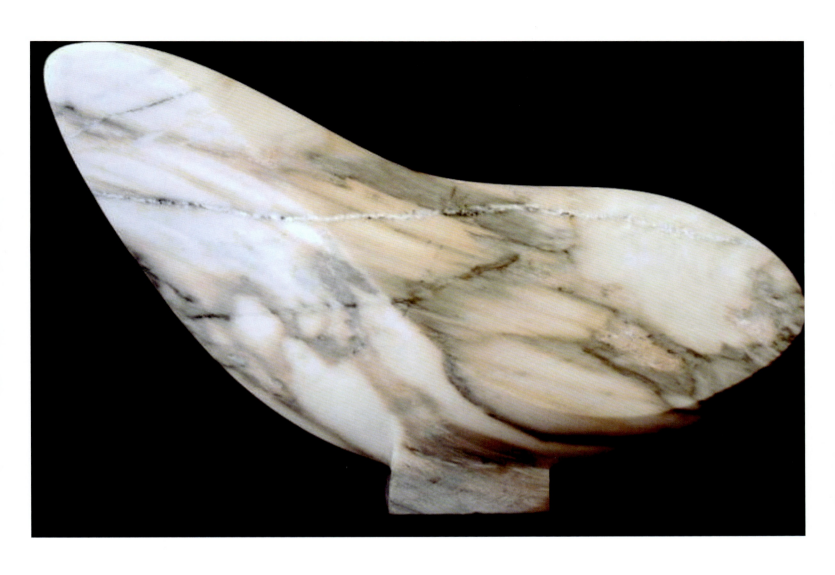

飞翔 / Flying Ove
500mm x 400mm x 600mm

斯蒂芬·佩德森
丹麦
雕塑

Steffie Pedersen
Denmark
Sculpture

| Work Collection of Arts | The Fifth Silk Road International Arts Festival | D.R.Congo |
| 美术作品集 | 第五届丝绸之路国际艺术节 | 刚果（金） |

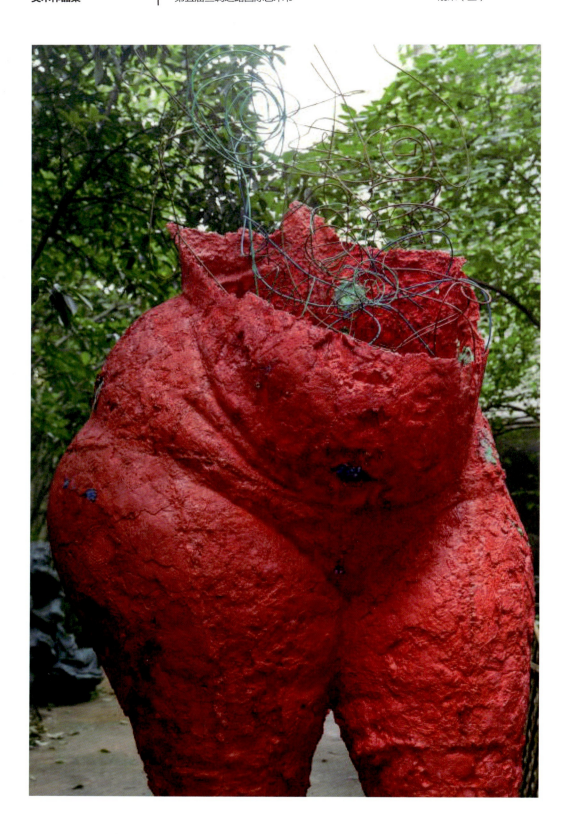

繁衍 / **Multiplication**
3500mm x 1900mm x 1200mm

姆布利·皮杜索·博图卢	Mbuli Pitshou Botul
刚果（金）	D.R.Congo
雕塑	Sculpture

D.R.Congo 刚果（金） — International Art Exhibition 国际美术展

花园里 / In the Garden
1000mm x 600mm

本琦·克恁噶 | Mushila Benj Kinenga
刚果（金） | D.R.Congo
绘画 | Painting

| Work Collection of Arts 美术作品集 | The Fifth Silk Road International Arts Festival 第五届丝绸之路国际艺术节 | Dominican 多米尼加 |

理智的篝火 / Bonfire of the Sanity
800mm x 600mm

尤妮斯·马蒂奥　　　Eunice Mateo
多米尼加　　　　　 Dominican
绘画　　　　　　　 Painting

厄瓜多尔
Ecuador

International Art Exhibition
国际美术展

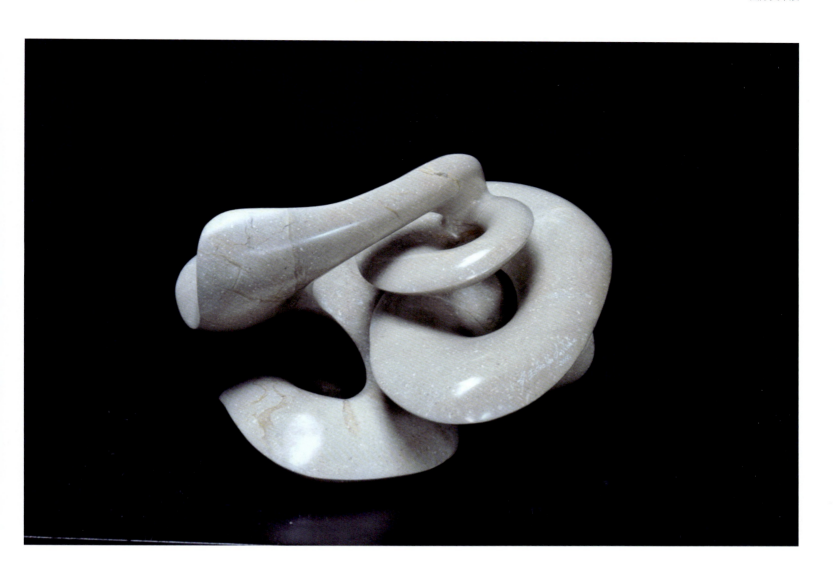

无题 / Unnamed

莫顿·艾斯特里亚 | Milton Estrella
厄瓜多尔 | Ecuador
雕塑 | Sculpture

| Work Collection of Arts / 美术作品集 | The Fifth Silk Road International Arts Festival / 第五届丝绸之路国际艺术节 | Egypt / 埃及 |

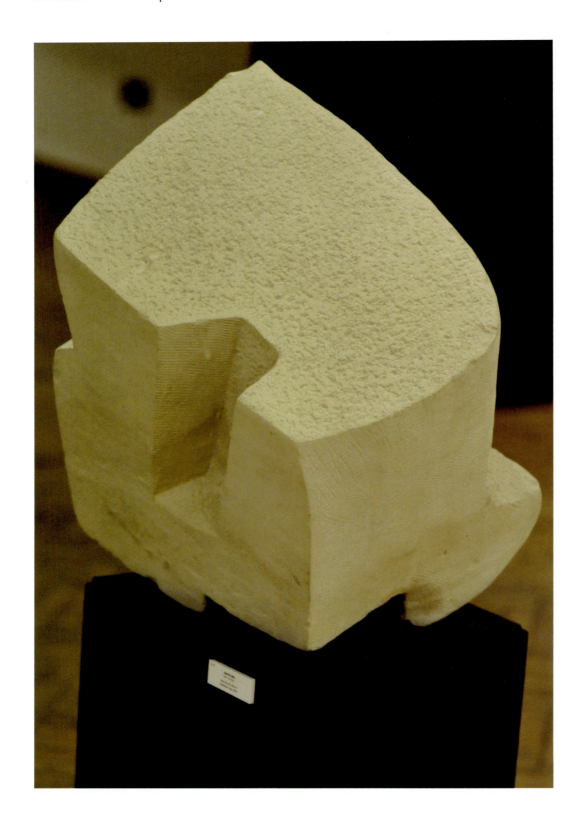

民族道路 / Nations Road
400mm x 350mm x 280mm

埃米尔·艾利希	Amir Ellithy
埃及	Egypt
雕塑	Sculpture

Egypt
埃及

International Art Exhibition
国际美术展

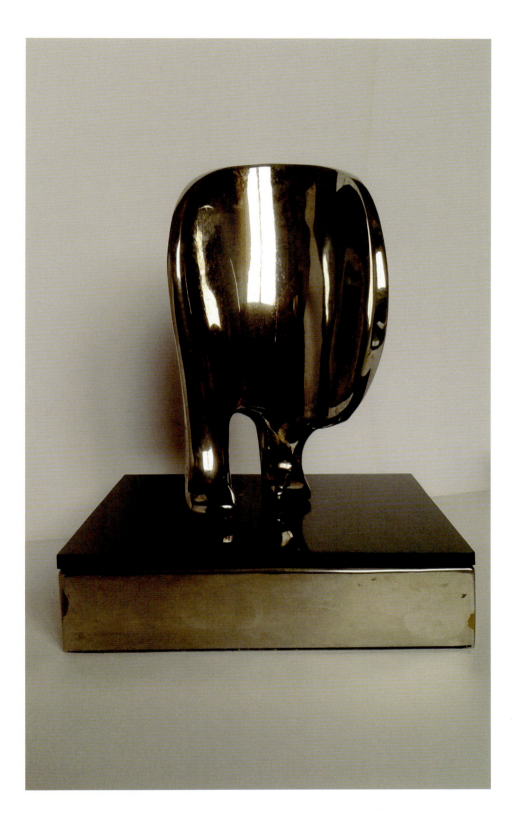

路上精神 / On the Road Spirit
230mm x 100mm x 80mm

纳吉·弗瑞德 | Nagi Farid
埃及 | Egypt
雕塑 | Sculpture

Work Collection of Arts | The Fifth Silk Road International Arts Festival | Estonia
美术作品集 | 第五届丝绸之路国际艺术节 | 爱沙尼亚

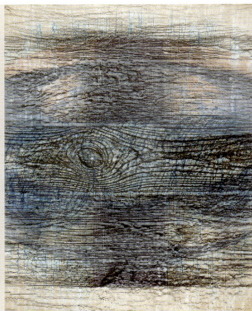
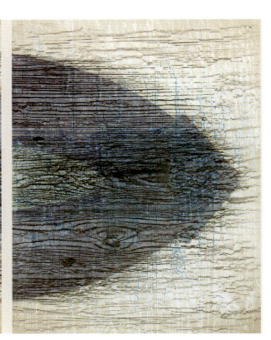

东西方 / East West
400mm x 1000mm

洛伊特·卓卡达 | Loit Jõekalda
爱沙尼亚 | Estonia
绘画 | Painting

Estonia / 爱沙尼亚 — International Art Exhibition / 国际美术展

靠近围栏 IV / Close to the Fence 4
1000mm x 700mm

维格·卓卡达 | Virge Jõekalda
爱沙尼亚 | Estonia
绘画 | Painting

| Work Collection of Arts | The Fifth Silk Road International Arts Festival | Ethiopia |
| 美术作品集 | 第五届丝绸之路国际艺术节 | 埃塞俄比亚 |

爱国者 / Patriot

哈伊路·科菲·茵多弗 | Hailu Kifle Endalew
埃塞俄比亚 | Ethiopia
绘画 | Painting

Finland 芬兰　　　　International Art Exhibition 国际美术展

修建记忆 / **Constructed Memory**
200mm

詹妮·莱恩 | Janne Laine
芬兰 | Finland
绘画 | Painting

103

Work Collection of Arts	The Fifth Silk Road International Arts Festival	France
美术作品集	第五届丝绸之路国际艺术节	法国

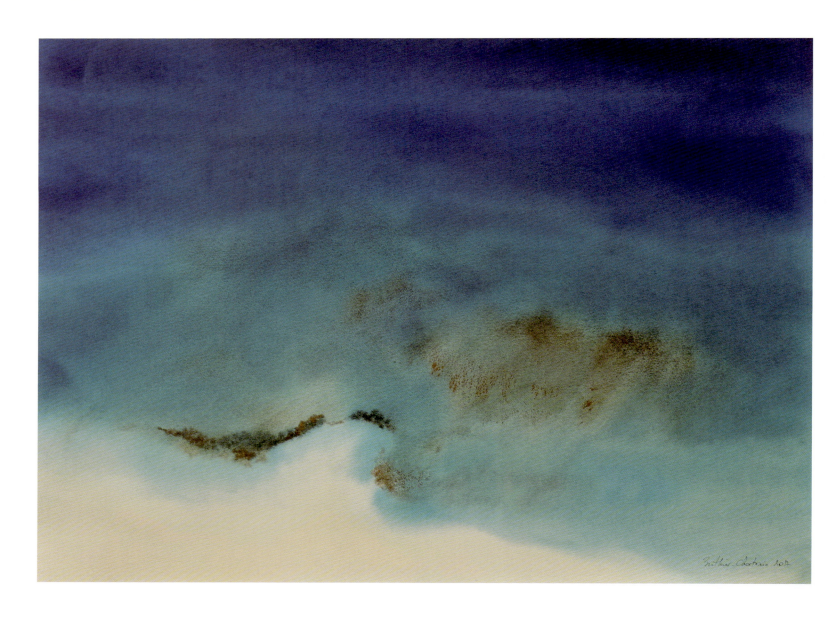

向下 / Down Under
560mm x 760mm

莫利艾·波瑟尔·凯崔恩	Muriel Buthier Chartrain
法国	France
绘画	Painting

维亚河·吉斯蒂尼亚尼 / Via Giustiniani
760mm x 560mm

翁贝托·罗西尼 | Umberto Rossini
法国 | France
绘画 | Painting

妇女与生活 / Femme Et Vie
800mm

比罗格·泽利亚·弗罗
加蓬
雕塑

Bilogue Zelia Flore
Gabon
Sculpture

Georgia
格鲁吉亚

International Art Exhibition
国际美术展

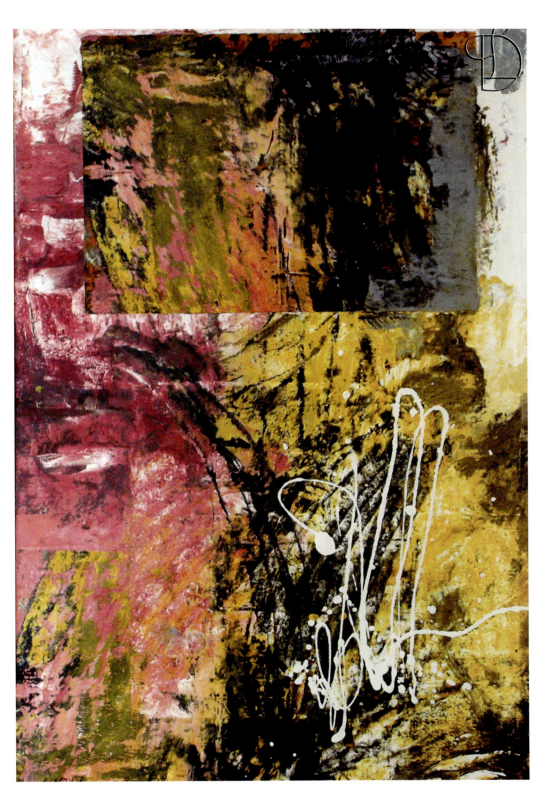

冲动 / Impulses
1000mm x 640mm

露露·达迪妮
格鲁吉亚
绘画

Lulu Dadiani
Georgia
Painting

Work Collection of Arts	The Fifth Silk Road International Arts Festival	Germany
美术作品集	第五届丝绸之路国际艺术节	德国

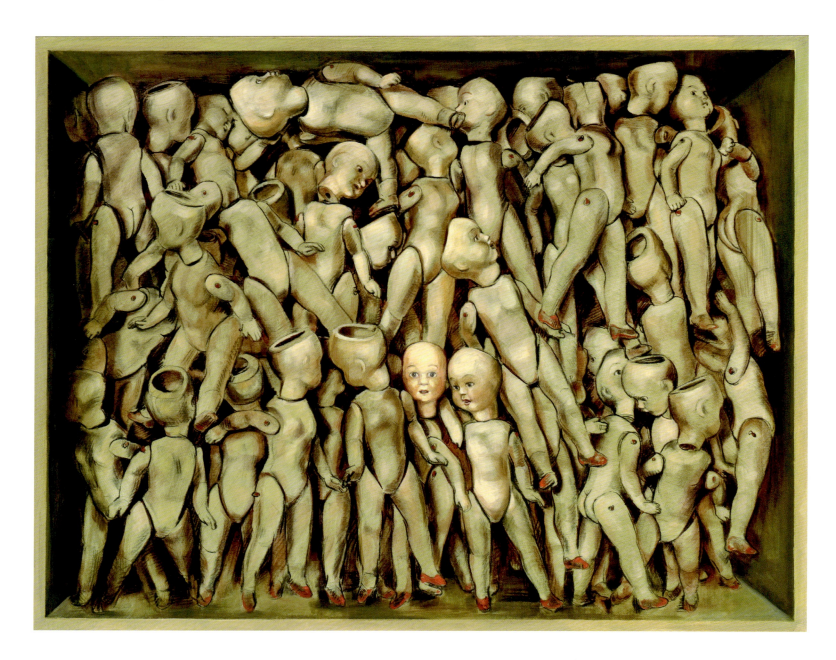

杂波 I / Durch Einander 1
740mm x 940mm

克里斯廷·瑞肯斯	Christine Reinckens
德国	Germany
雕塑	Sculpture

Germany / 德国 — International Art Exhibition / 国际美术展

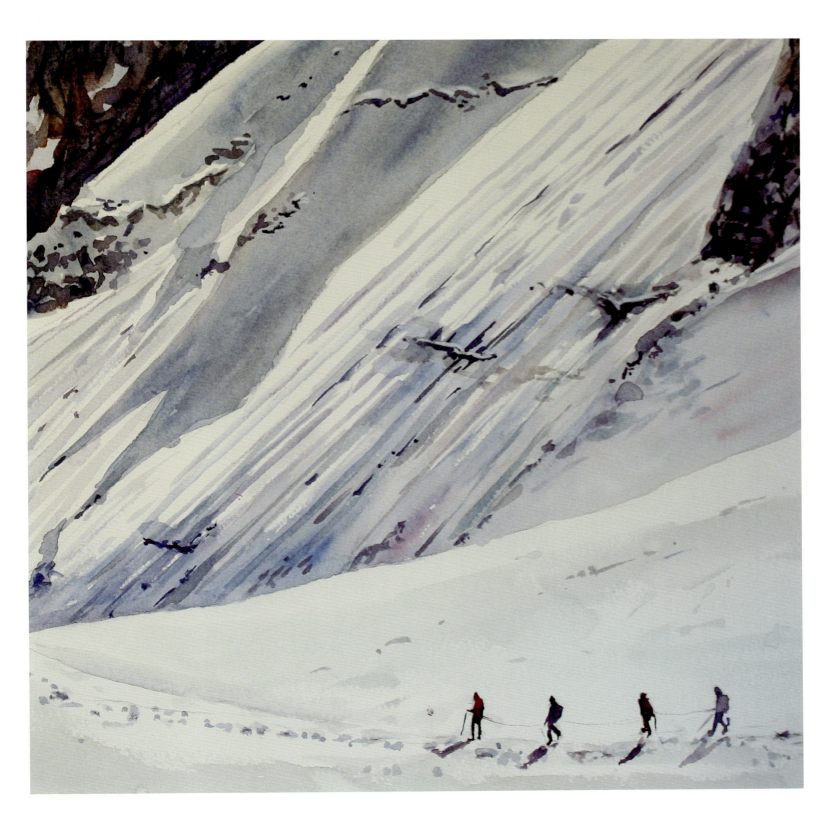

神秘通道 / **The Passage**
560mm x 380mm

迪特尔·韦斯特普 | Dieter Wystemp
德国 | Germany
绘画 | Painting

Work Collection of Arts	The Fifth Silk Road International Arts Festival	Germany
美术作品集	第五届丝绸之路国际艺术节	德国

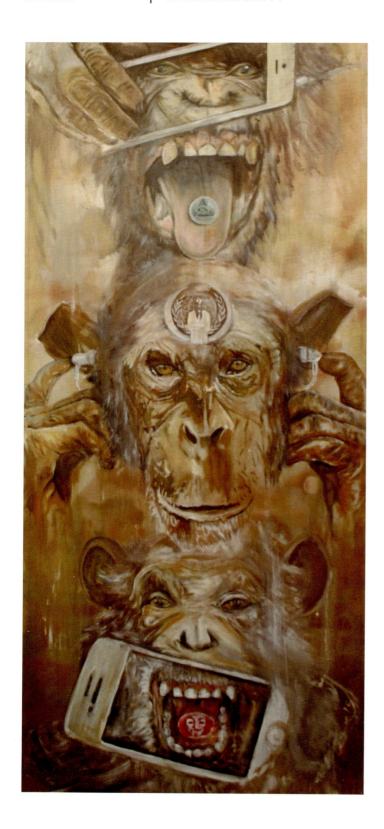

三只猴子 / 3 Monkeys
500mm x 2000mm

弗里安·沃尔夫 | Folrian Wolf
德国 | Germany
绘画 | Painting

Germany 德国 | International Art Exhibition 国际美术展

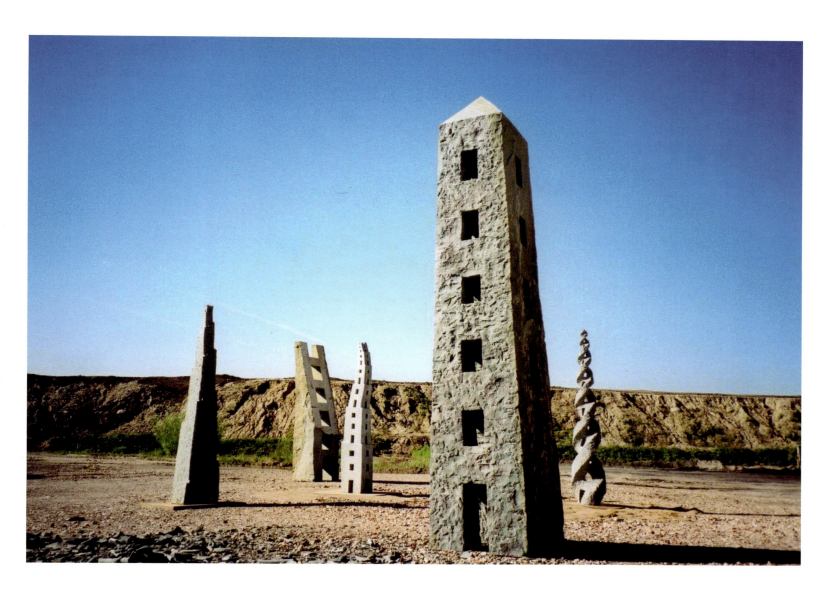

无题 / Unnamed

乔·凯来 | Jo Kley
德国 | Germany
雕塑 | Sculpture

| Work Collection of Arts / 美术作品集 | The Fifth Silk Road International Arts Festival / 第五届丝绸之路国际艺术节 | Germany / 德国 |

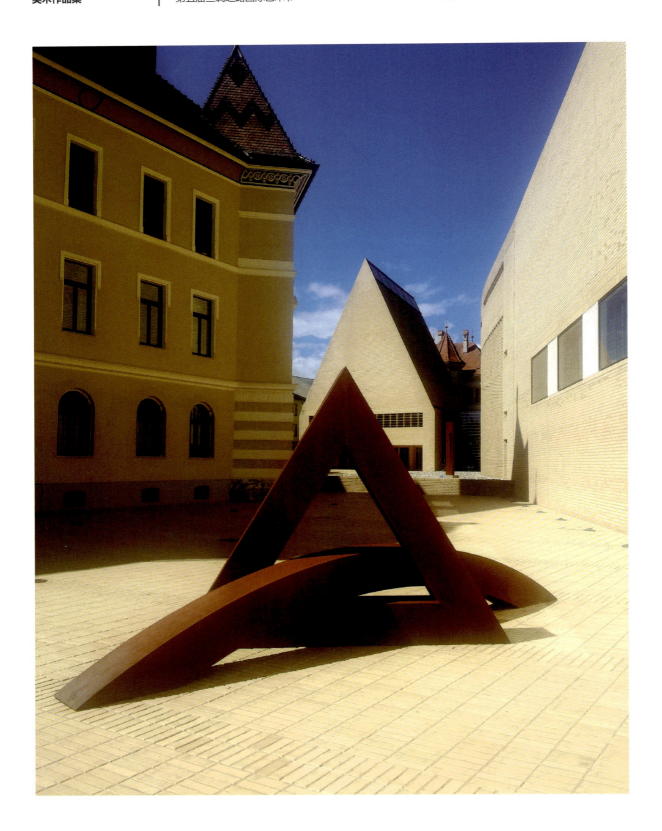

欲望的记忆 / Memory of a Desire
6000mm x 2700mm x 2700mm

约尔格·普利卡 | Jorg Plickat
德国 | Germany
雕塑 | Sculpture

Germany / 德国 — International Art Exhibition / 国际美术展

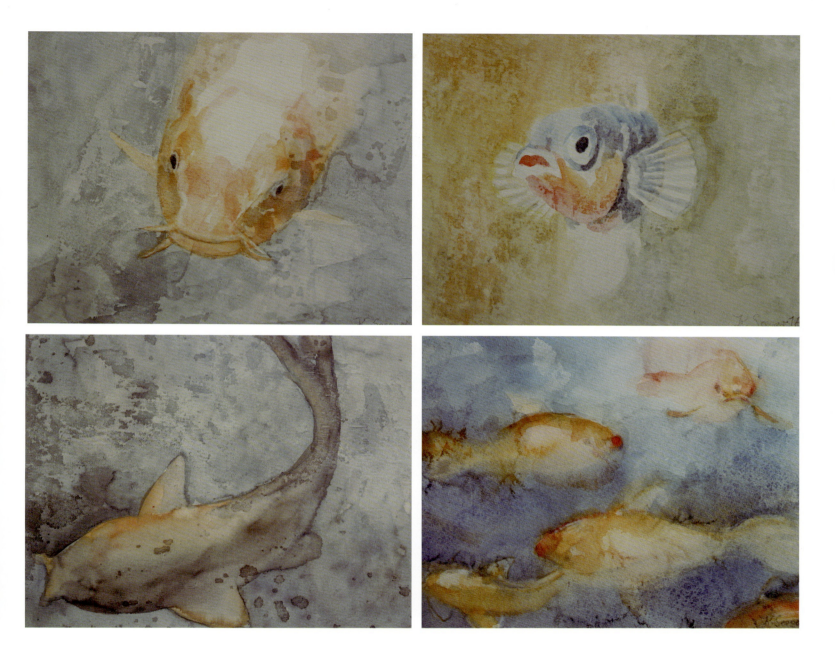

《发光》系列 4 幅 / Luminescence Series 4
320mm x 260mm

克尔斯滕·西格 / Kirsten Seeger
德国 / Germany
绘画 / Painting

| Work Collection of Arts | The Fifth Silk Road International Arts Festival | Germany |
| 美术作品集 | 第五届丝绸之路国际艺术节 | 德国 |

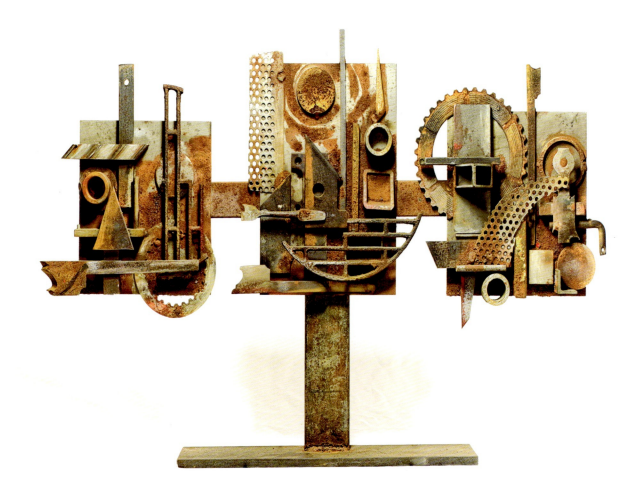

无题 / Unnamed
450mm

雷纳·汉斯 | Rainer Henze
德国 | Germany
雕塑 | Sculpture

Germany | International Art Exhibition
德国 | 国际美术展

对立 / Opposites
600mm x 300mm

斯特凡·米茨拉夫 | Stefan Mitzlaff
德国 | Germany
印刷 | Print

Work Collection of Arts | The Fifth Silk Road International Arts Festival | Germany
美术作品集 | 第五届丝绸之路国际艺术节 | 德国

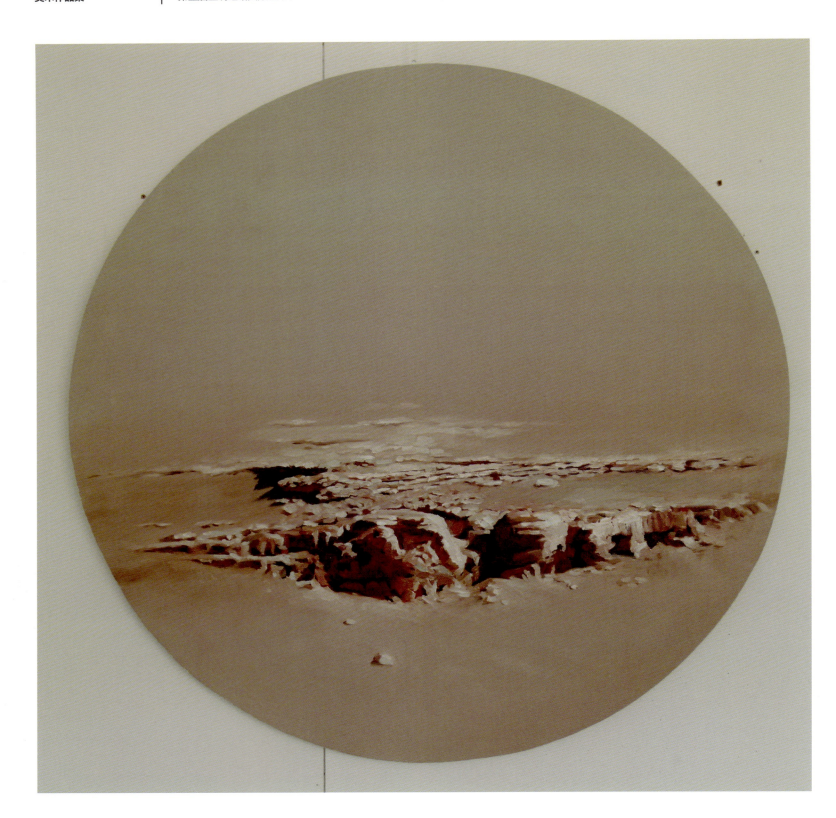

在路上 / On the Way
1000mm x 1000mm

宋晓明 | Xiaoming Song
德国 | Germany
绘画 | Painting

116

Ghana
加纳

International Art Exhibition
国际美术展

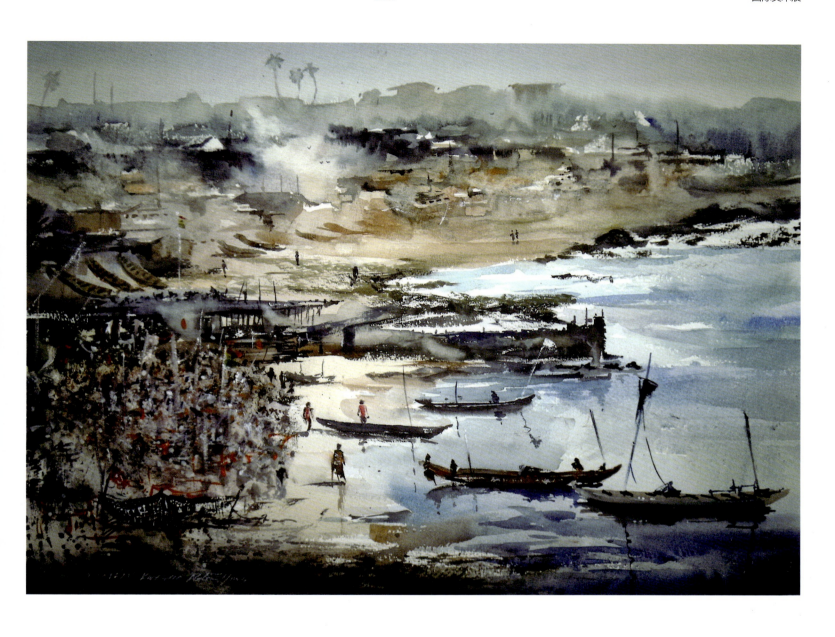

来自加纳的问候 / Greetings from Ghana
400mm x 610mm

乔纳森·肯瓦吉亚·安格里 | Jonathan Kwegyir Aggrey
加纳 | Ghana
绘画 | Painting

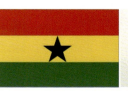

Work Collection of Arts	The Fifth Silk Road International Arts Festival	Greece
美术作品集	第五届丝绸之路国际艺术节	希腊

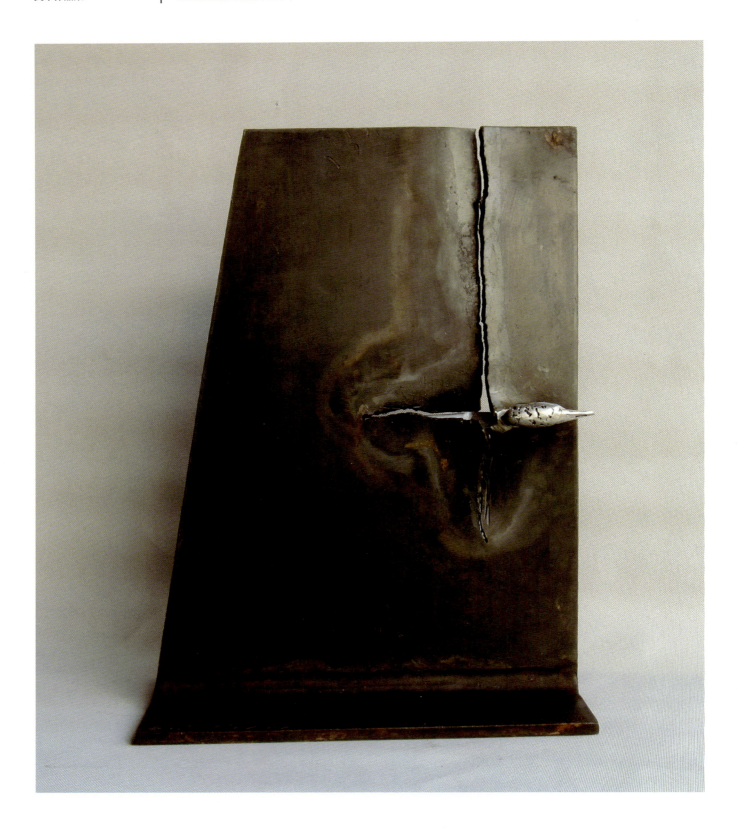

打破国界 / Breaking the Borders
480mm x 380mm x 180mm

安东尼斯·麦洛迪亚斯	Antonis Myrodias
希腊	Greece
雕塑	Sculpture

118

Greece | International Art Exhibition
希腊 | 国际美术展

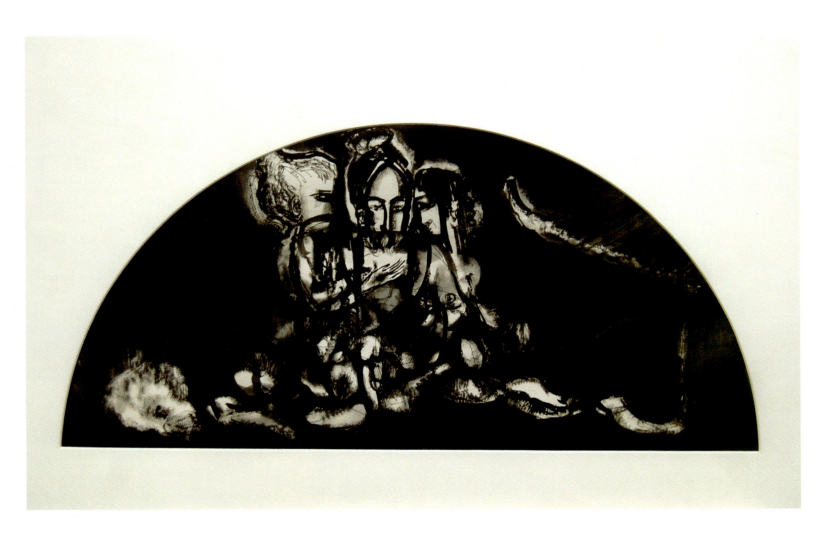

埃弗斯塔西亚·米拉瑞基
希腊
绘画

无题 / Unnamed
840mm x 460mm

Efstathia Milaraki
Greece
Painting

Work Collection of Arts	The Fifth Silk Road International Arts Festival	Greece
美术作品集	第五届丝绸之路国际艺术节	希腊

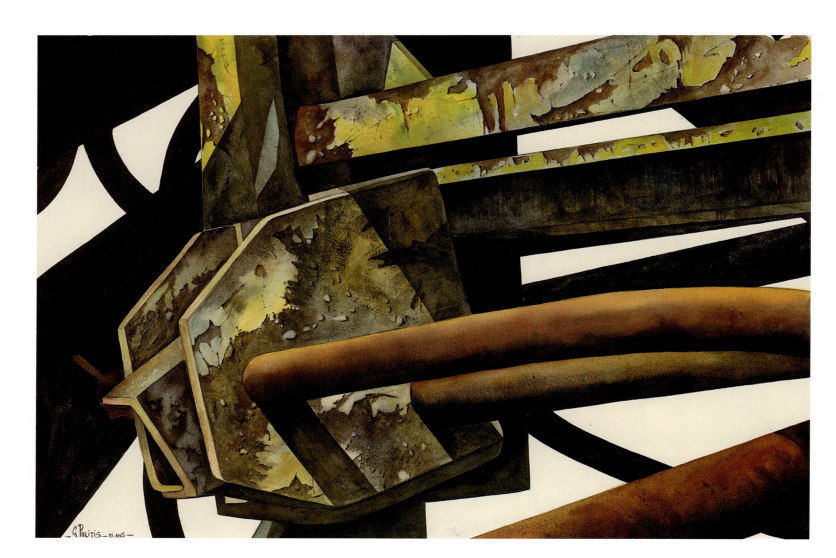

怀疑的好处 / The Benefit of a Doubt
380mm x 560mm

乔治·波利提斯	George Politis
希腊	Greece
绘画	Painting

Grenada / 格林纳达 — International Art Exhibition / 国际美术展

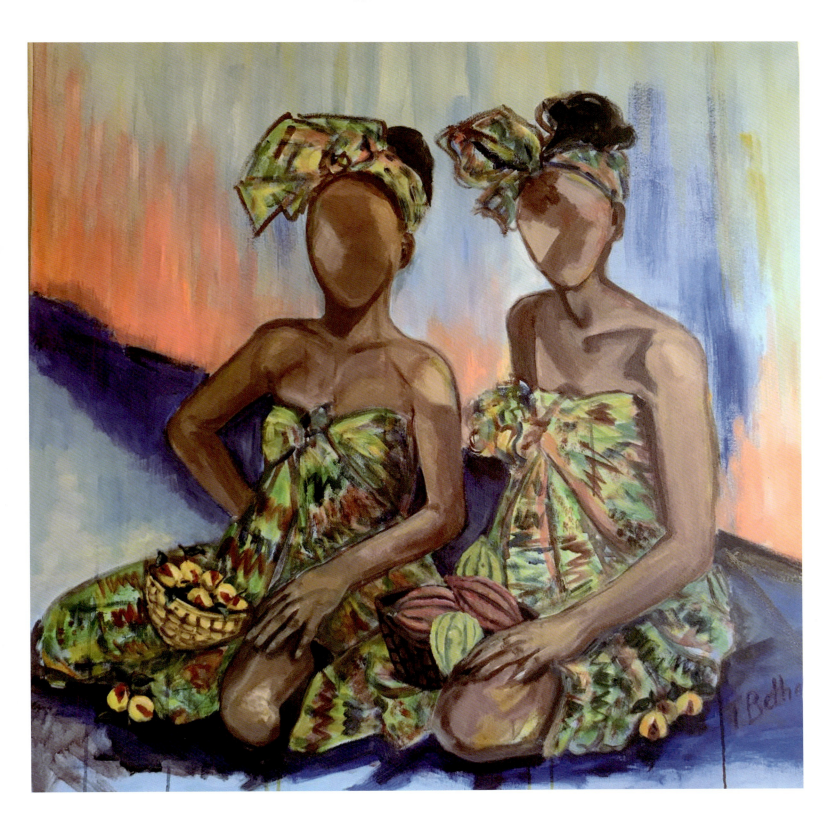

辣妹 / The Spice Girls
1000mm x 1000mm

泰瑞希亚·毕索 / Tricia Bethel
格林纳达 / Grenada
绘画 / Painting

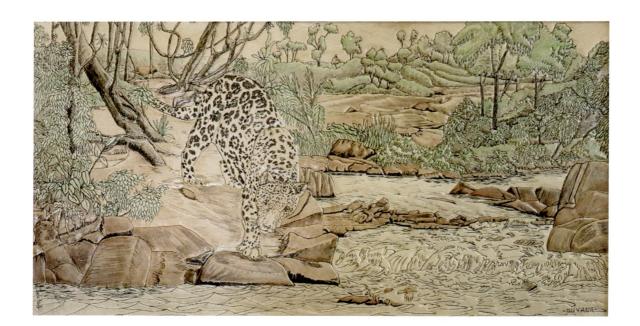

无题 / Unnamed

阿尔佛雷德·尼古拉斯 | Alfred Nichols
圭亚那 | Guyana
绘画 | Painting

Hungary / 匈牙利 — International Art Exhibition / 国际美术展

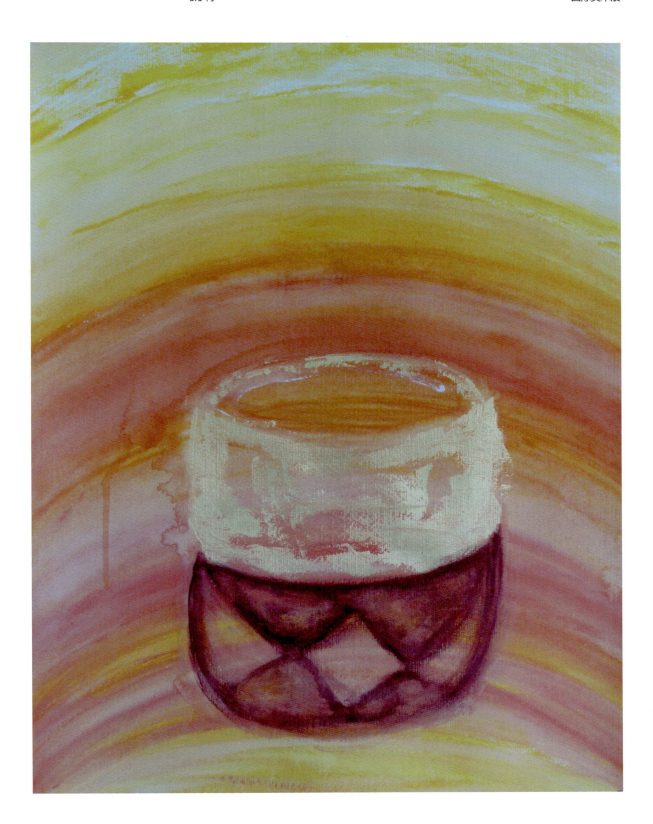

海德林德·玛什·特罗特 | Heidelinde Mation Trott
匈牙利 | Hungary
绘画 | Painting

禅音 / Zen
500mm x 800mm

Work Collection of Arts	The Fifth Silk Road International Arts Festival	Iceland
美术作品集	第五届丝绸之路国际艺术节	冰岛

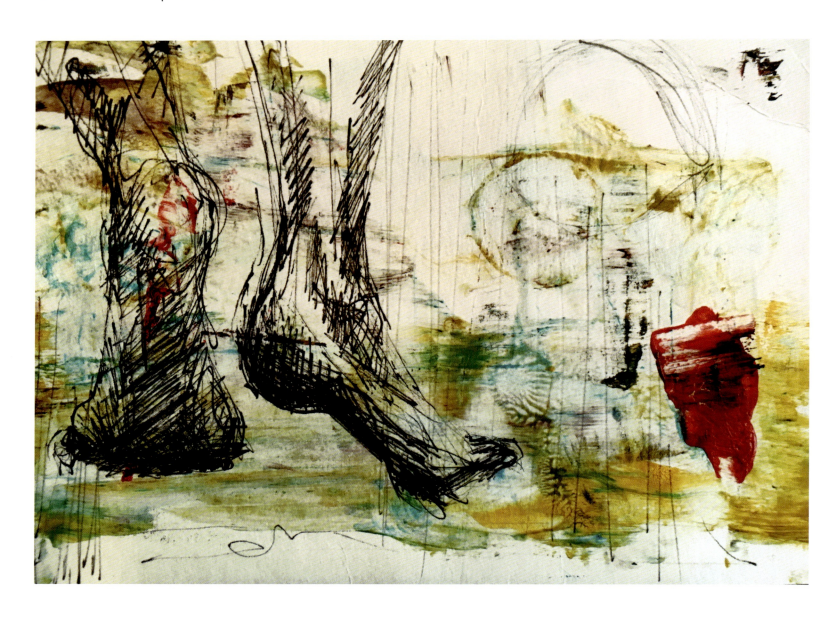

旅行者 / The Traveler
500mm x 750mm

恩格斯多缇·斯万蒂斯 | Egilsdóttir Svandís
冰岛 | Iceland
绘画 | Painting

Indonesia // 印度尼西亚

International Art Exhibition // 国际美术展

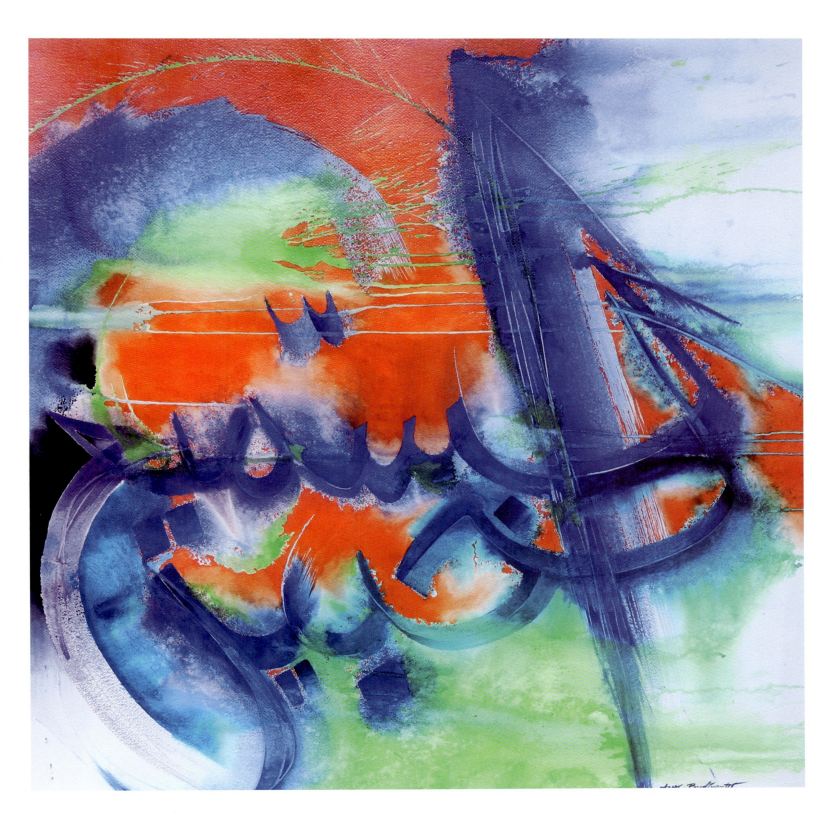

萨米 & 哈比尔 2017 / Ai Sami & Ai Khabir 2017
1000mm x 1000mm

奥格斯·布迪安托 | Agus Budiyanto
印度尼西亚 | Indonesia
绘画 | Painting

Work Collection of Arts	The Fifth Silk Road International Arts Festival	Indonesia
美术作品集	第五届丝绸之路国际艺术节	印度尼西亚

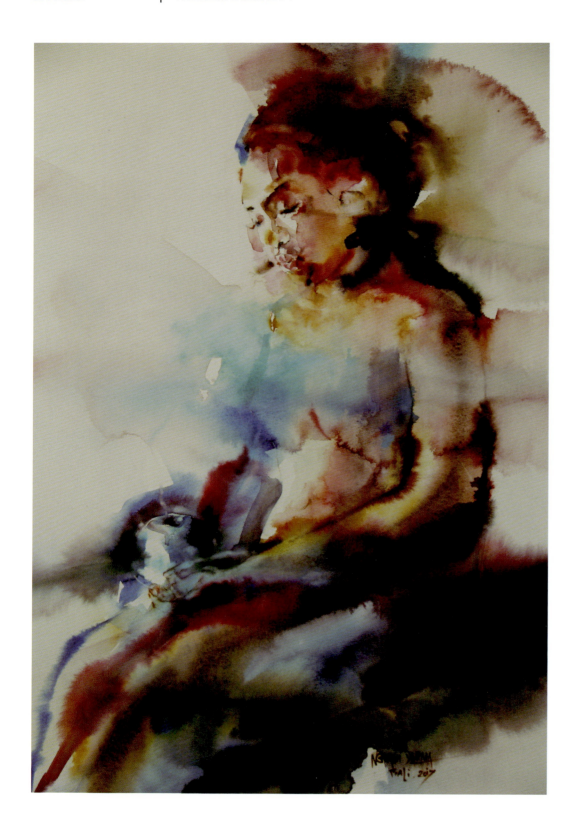

三个苹果 / Three Apples
550mm x 750mm

伽马·纳古勒 　　　　Darma Ngurah
印度尼西亚　　　　　Indonesia
绘画　　　　　　　　Painting

Indonesia / 印度尼西亚 — International Art Exhibition / 国际美术展

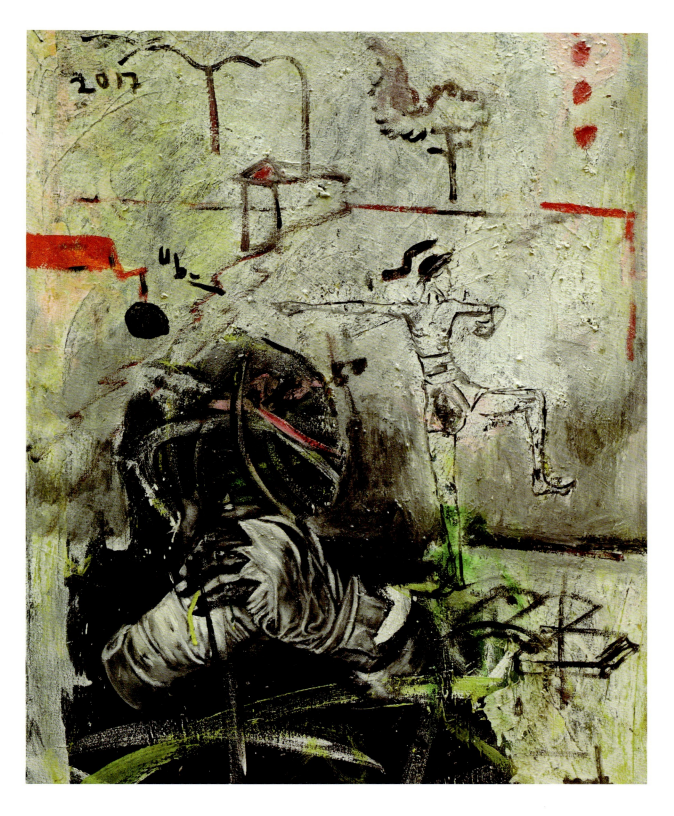

拷问的梦想 / Torture Dreams
900mm x 700mm

西克西奥·斯特万 | Sixcio Stevan
印度尼西亚 | Indonesia
绘画 | Painting

| Work Collection of Arts / 美术作品集 | The Fifth Silk Road International Arts Festival / 第五届丝绸之路国际艺术节 | Indonesia / 印度尼西亚 |

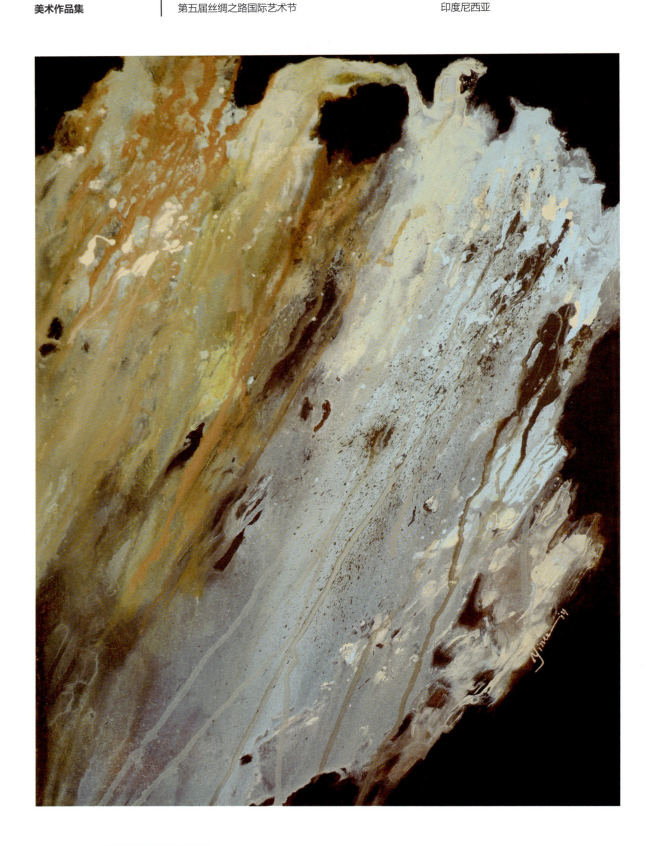

丝路印象 / Silk Road Impression
600mm x 800mm

饶韵芝　　　　　Yince Djuwidja
印度尼西亚　　　Indonesia
绘画　　　　　　Painting

India
印度

International Art Exhibition
国际美术展

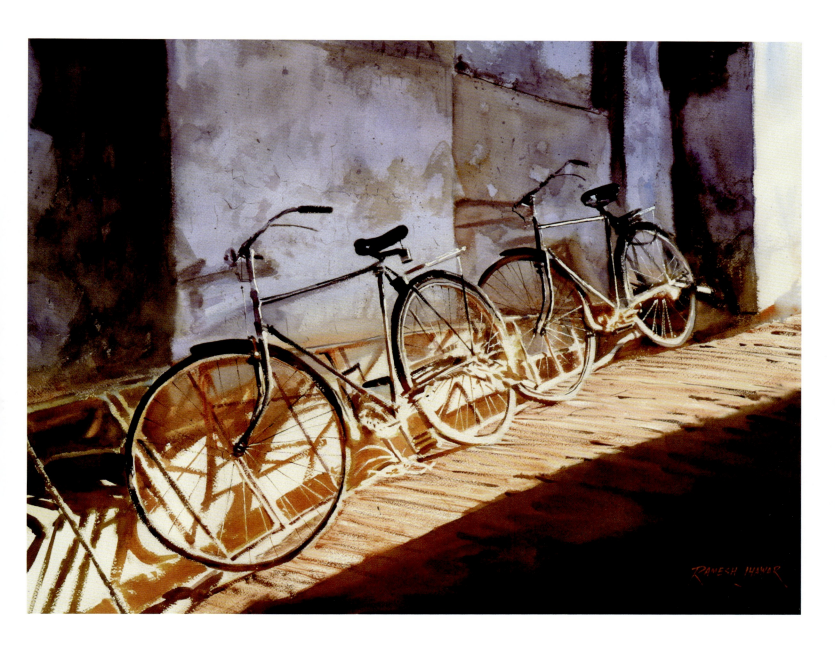

午休 / Noon Break
530mm x 740mm

拉玛什·库玛·贾沃
印度
绘画

Ramesh Kumar Jhawar
India
Painting

Work Collection of Arts | The Fifth Silk Road International Arts Festival | India
美术作品集 | 第五届丝绸之路国际艺术节 | 印度

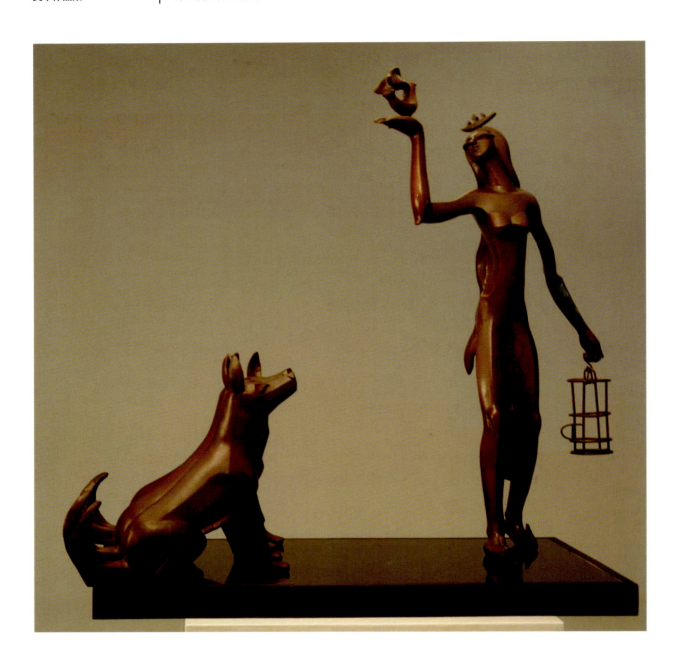

自由 / Freedom
750mm x 350mm x 600mm

丽金 | Gurjinder Kaur
印度 | India
雕塑 | Sculpture

India
印度

International Art Exhibition
国际美术展

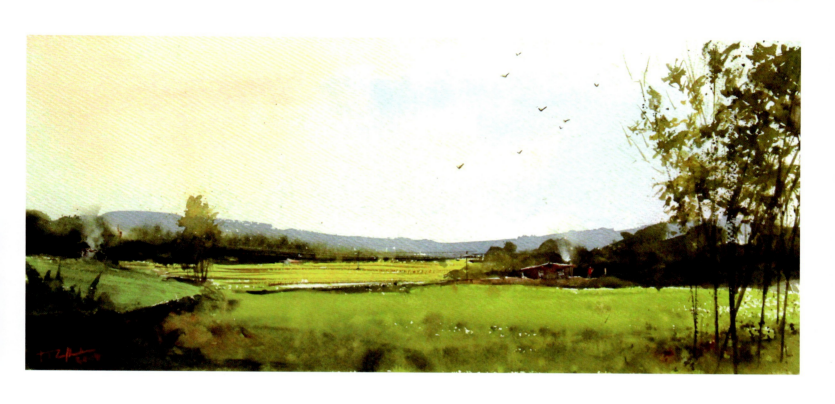

在田野 / Out in the Fields
533mm x 228mm

马杜·库马尔 | Madhu Kumar
印度 | India
绘画 | Painting

| Work Collection of Arts | The Fifth Silk Road International Arts Festival | Iran |
| 美术作品集 | 第五届丝绸之路国际艺术节 | 伊朗 |

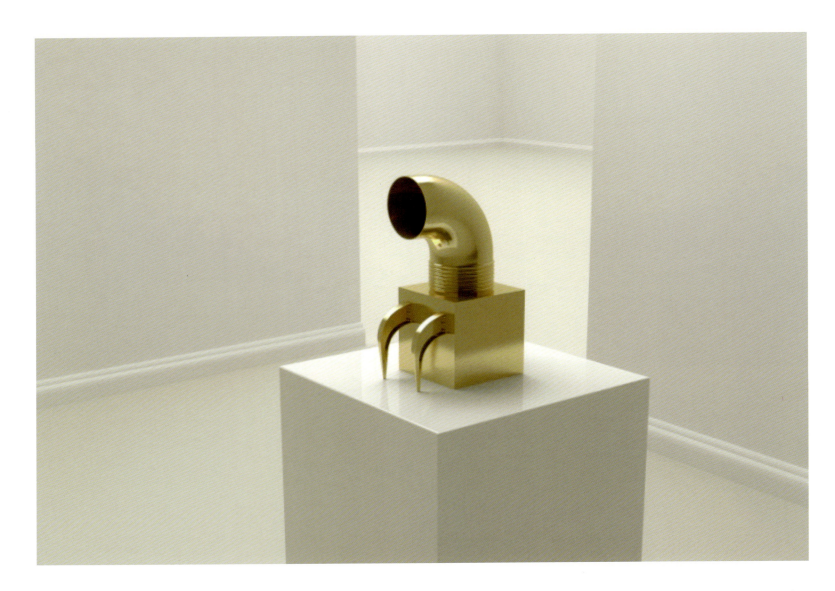

悖论（圣迹集）/ Paradox(Immortals Collection)
200mm x 300mm x 500mm

哈格海格·马吉德	Haghighi Majid
伊朗	Iran
雕塑	Sculpture

Iran
伊朗

International Art Exhibition
国际美术展

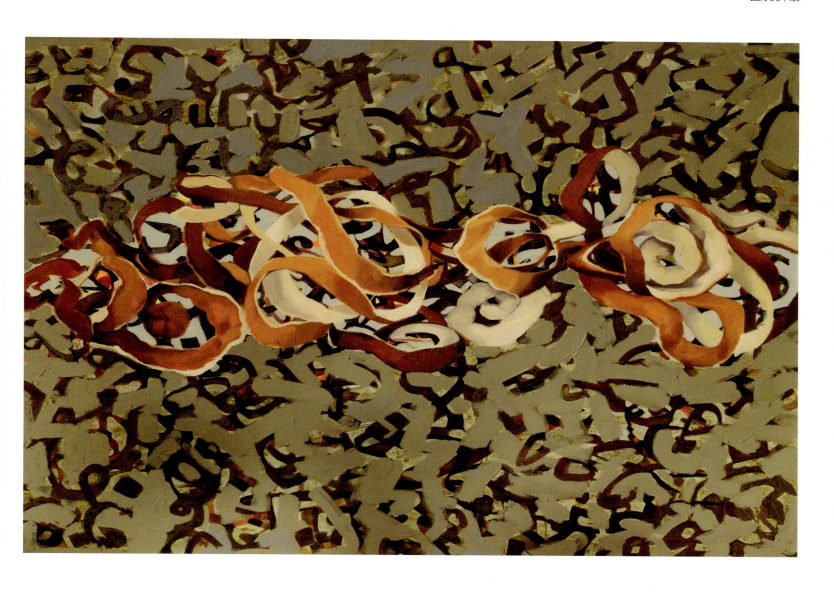

橙色果皮和书法 / Orange Peel and Calligraphy
1200mm x 1200mm x 2400mm

哈米德·纳姆达尔	Hamid Namdar
伊朗	Iran
绘画	Painting

| Work Collection of Arts | The Fifth Silk Road International Arts Festival | Iran |
| 美术作品集 | 第五届丝绸之路国际艺术节 | 伊朗 |

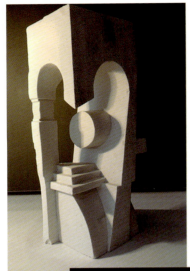
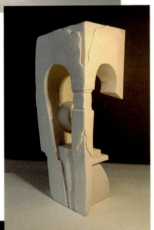
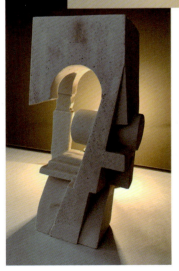
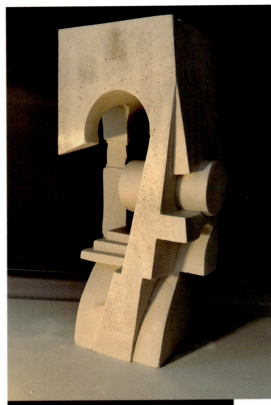
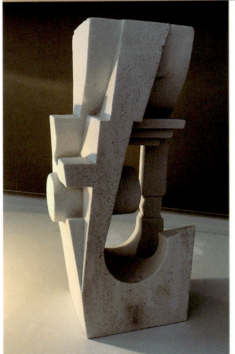

想象的乐器Ⅱ / Imaginary Musical Instrument 2
3000mm x 3000mm x 1600mm

赫达亚特·撒哈拉	Hedayat Sahraei
伊朗	Iran
雕塑	Sculpture

Iran
伊朗

International Art Exhibition
国际美术展

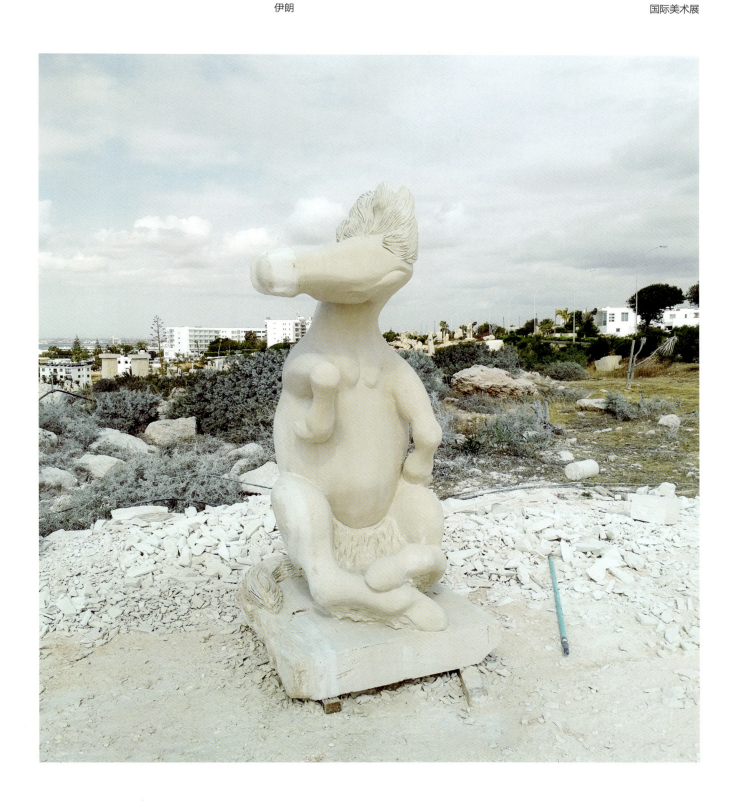

新飞马 / Neo Pegasus
1200mm x 1200mm x 2400mm

雷扎伊·埃斯梅尔 | Rezaei Esmaeil
伊朗 | Iran
雕塑 | Sculpture

Work Collection of Arts	The Fifth Silk Road International Arts Festival	Iran
美术作品集	第五届丝绸之路国际艺术节	伊朗

为我飞翔 / Fly instead of Me
2000mm x 1070mm

赛义德·艾哈迈迪	Saeid Ahmadi
伊朗	Iran
雕塑	Sculpture

Iraq / 伊拉克 — International Art Exhibition / 国际美术展

无题 / Unnamed
900mm x 900mm

阿里·穆萨维
伊拉克
混合材料

Ali Moussawi
Iraq
Composite Material

| Work Collection of Arts | The Fifth Silk Road International Arts Festival | Iraq |
| 美术作品集 | 第五届丝绸之路国际艺术节 | 伊拉克 |

玩偶和男孩 / Dolls and Boys
220mm x 300mm

拉娜·马托鲁布 | Rana Matloub
伊拉克 | Iraq
混合材料 | Composite Material

Ireland
爱尔兰

International Art Exhibition
国际美术展

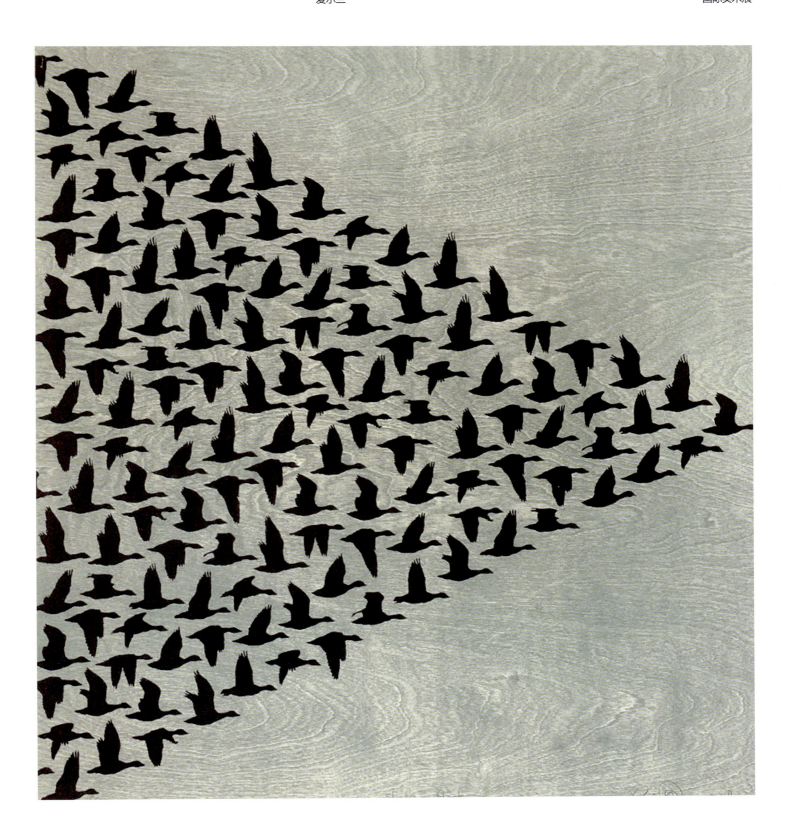

绞纱——羊群 / Skein—Flock
710mm x 750mm

凯尔文·曼那　　Kelvin Mann
爱尔兰　　　　　Ireland
雕塑　　　　　　Sculpture

Work Collection of Arts	The Fifth Silk Road International Arts Festival	Ireland
美术作品集	第五届丝绸之路国际艺术节	爱尔兰

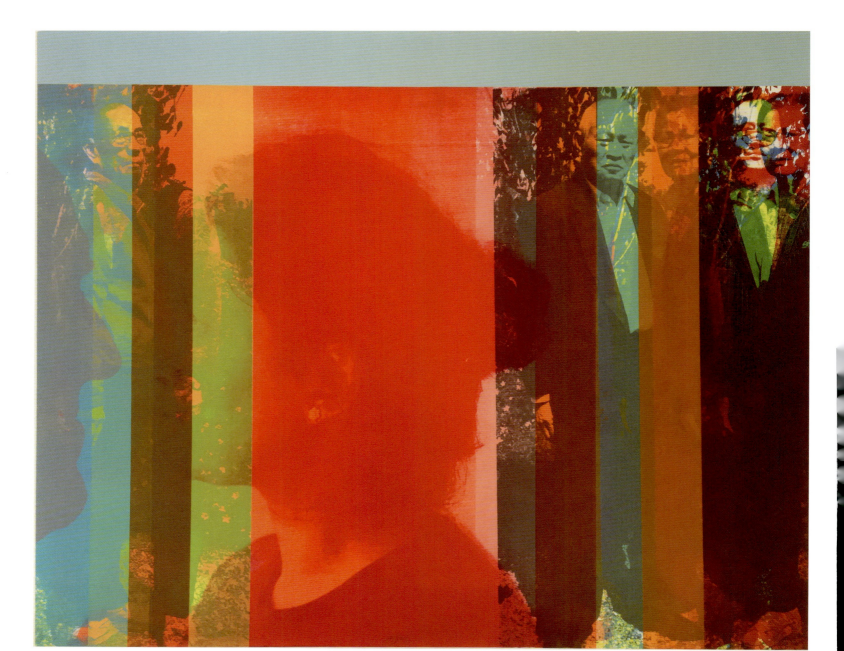

公民 / Citizens
840mm x 1000mm

雷蒙德·和邵	Raymond Henshaw
爱尔兰	Ireland
绘画	Painting

Israel
以色列

International Art Exhibition
国际美术展

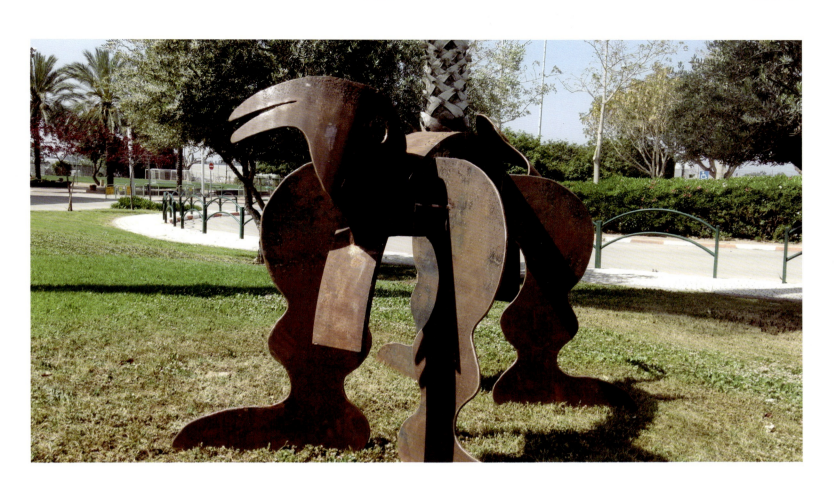

原始生物 2016 / Primordial Creature 2016
1750mm x 1200mm x 1200mm

蒂娜·梅尔哈夫 | Dina Merhav
以色列 | Israel
雕塑 | Sculpture

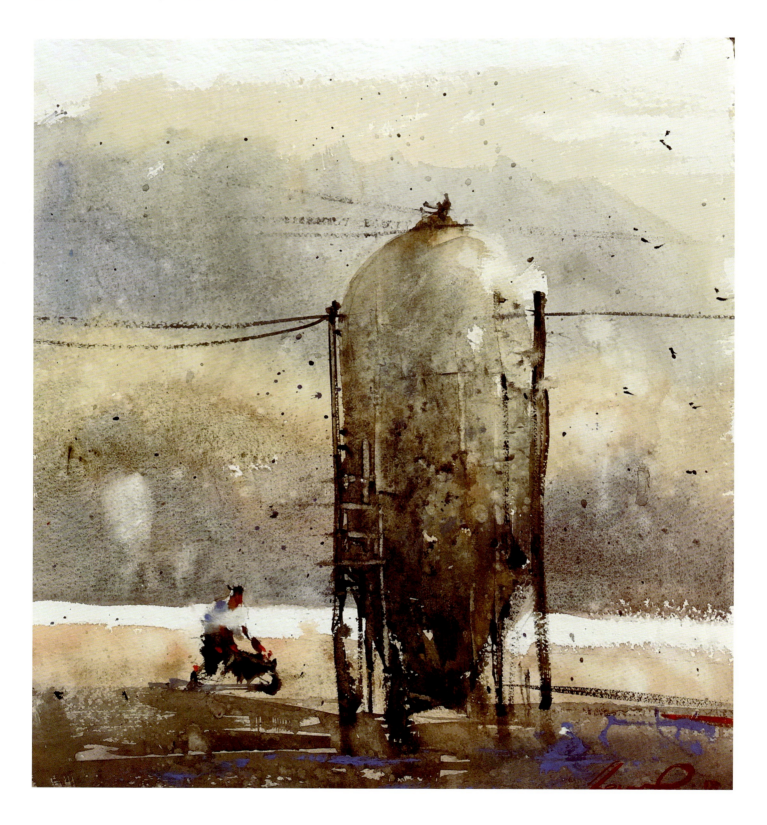

筒仓 13 / Silos13
360mm x 380mm

格瑞米亚·赛睿	Geremia Cerri
意大利	Italy
绘画	Painting

Italy
意大利

International Art Exhibition
国际美术展

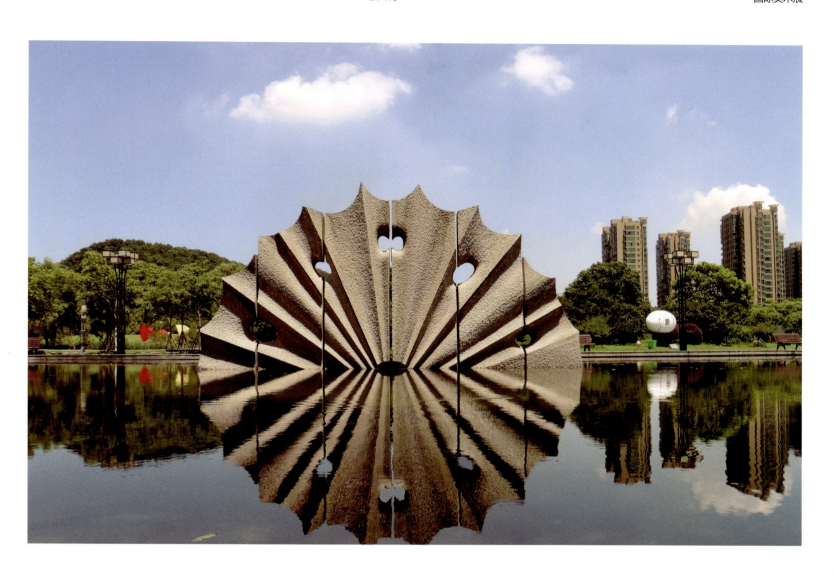

阳光明媚 / **Bright Sunshine**
8000mm x 4000mm x 900mm

古尔·菲林	Gueorgui Filin
意大利	Italy
雕塑	Sculpture

| Work Collection of Arts / 美术作品集 | The Fifth Silk Road International Arts Festival / 第五届丝绸之路国际艺术节 | Italy / 意大利 |

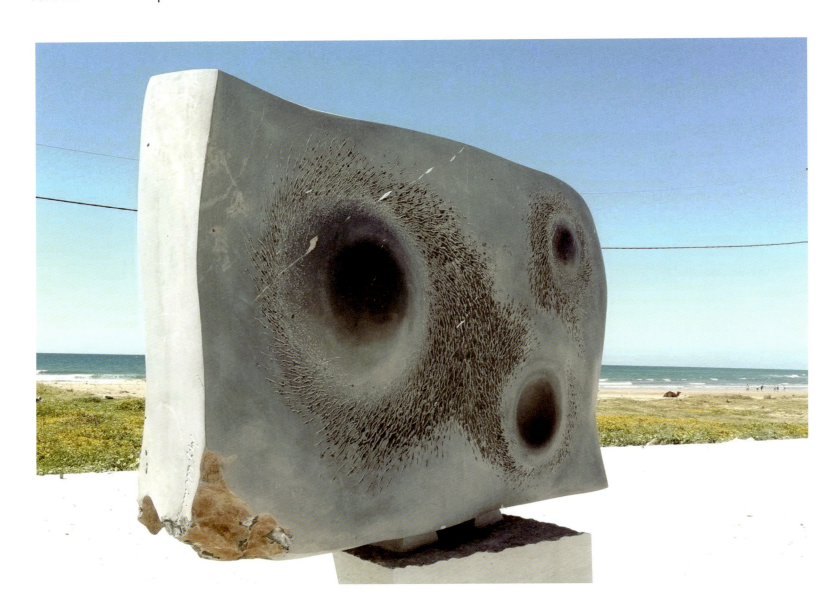

无题 / Unnamed

玛丽亚·格拉齐亚·科里尼	Maria Grazia Collini
意大利	Italy
雕塑	Sculpture

Italy
意大利

International Art Exhibition
国际美术展

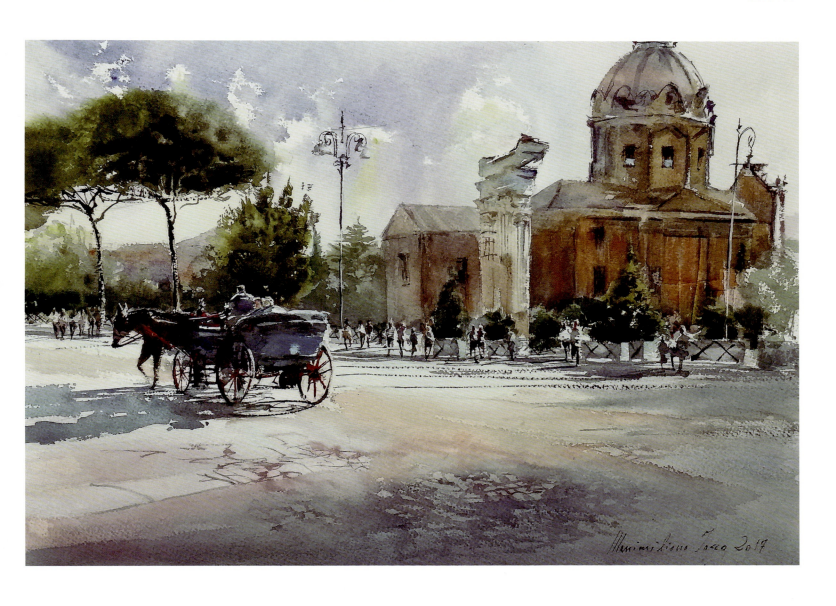

无题 / Unnamed
360mm x 510mm

马西米兰·伊德里斯
意大利
绘画

Massimiliano Iocco
Italy
Painting

Work Collection of Arts	The Fifth Silk Road International Arts Festival	Italy
美术作品集	第五届丝绸之路国际艺术节	意大利

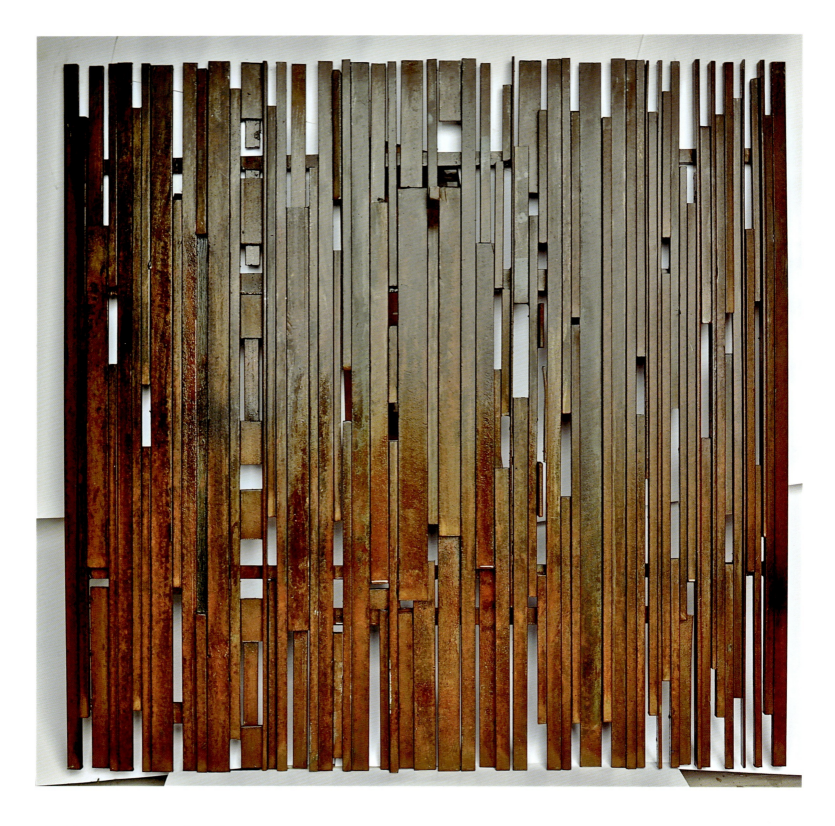

条码 / Bar Code
1000mm x 1000mm

保罗·维维安	Paolo Vivian
意大利	Italy
雕塑	Sculpture

Italy
意大利

International Art Exhibition
国际美术展

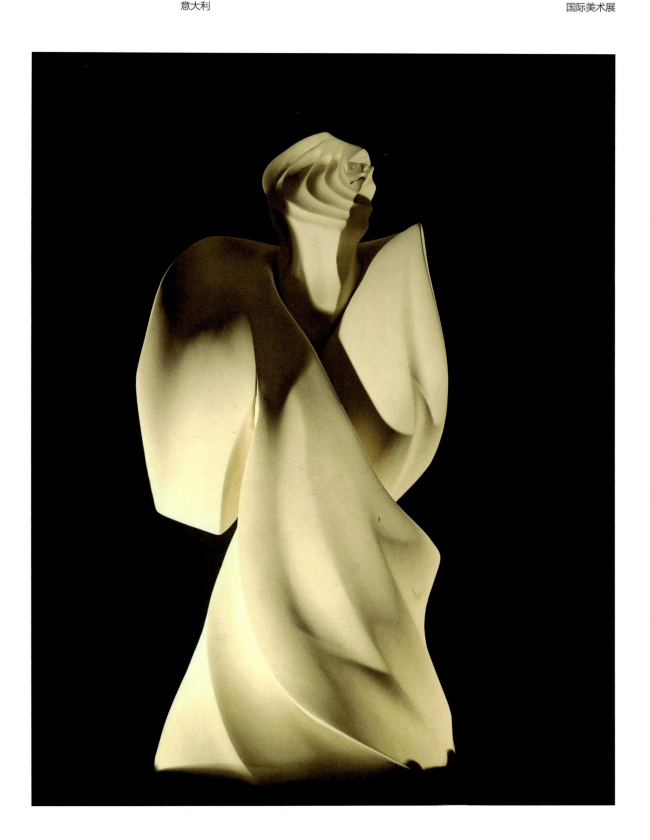

进步的发电机 / Progressione Dinamica
900mm x 320mm

伦佐·杜兰特
意大利
雕塑

Renzo Durante
Italy
Sculpture

147

| Work Collection of Arts | The Fifth Silk Road International Arts Festival | Italy |
| 美术作品集 | 第五届丝绸之路国际艺术节 | 意大利 |

弗拉门戈笔记 / Flamenco Notes
560mm x 380mm

罗伯托·安德鲁利	Roberto Andreoli
意大利	Italy
绘画	Painting

Jamaica 牙买加 — International Art Exhibition 国际美术展

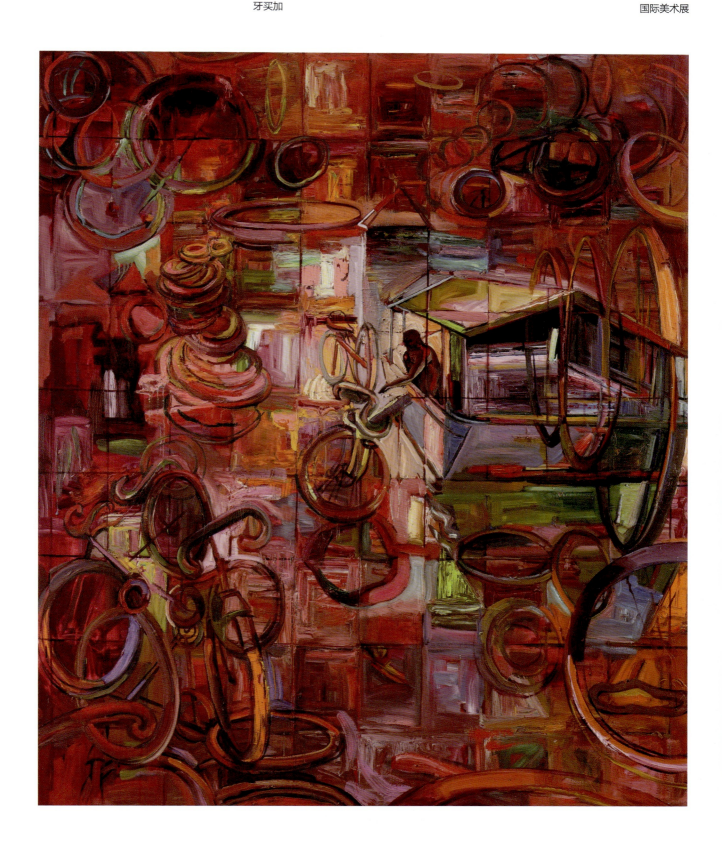

四轮之上的丝绸之路 / Silk Road on Four Wheels
920mm x 102mm

布莱恩·马克·法兰	Bryan Mc Farlane
牙买加	Jamaica
绘画	Painting

Work Collection of Arts	The Fifth Silk Road International Arts Festival	Japan
美术作品集	第五届丝绸之路国际艺术节	日本

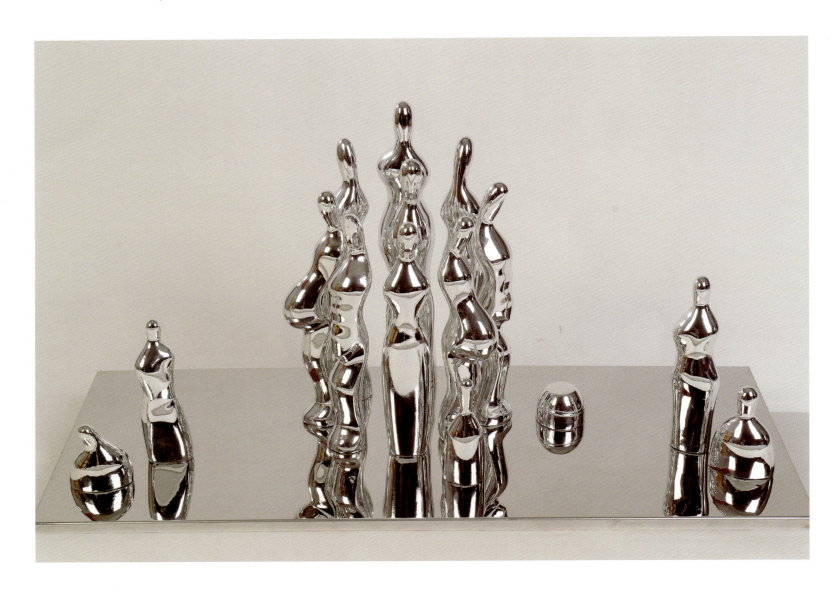

无题 / Unnamed
900mm x 400mm x 410mm

林胜煌	Shenghuang Lin
日本	Japan
雕塑	Sculpture

Japan / 日本 — International Art Exhibition / 国际美术展

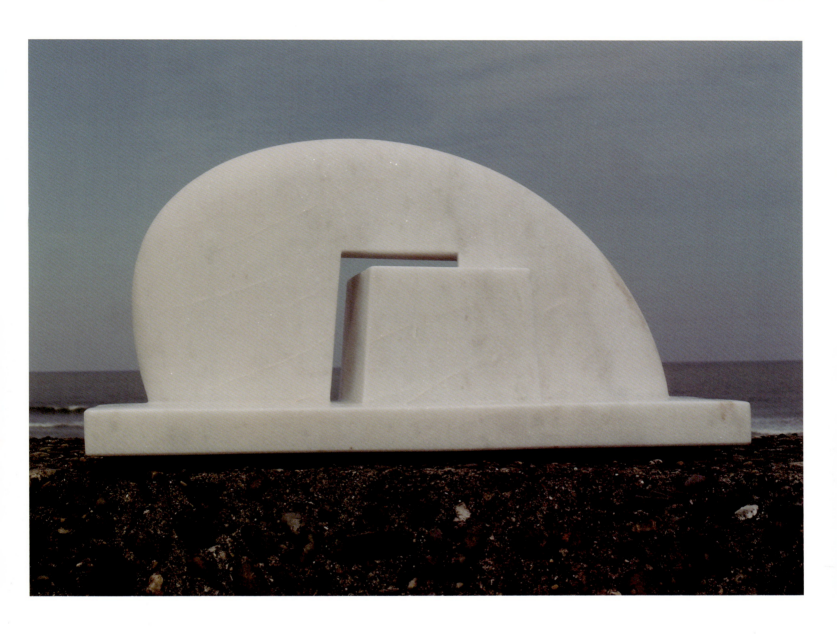

安静的风 / Quiet Wind

25500mm x 49500mm x 19500 mm

田中等	Hitoshi Tanaka
日本	Japan
雕塑	Sculpture

Work Collection of Arts	The Fifth Silk Road International Arts Festival	Japan
美术作品集	第五届丝绸之路国际艺术节	日本

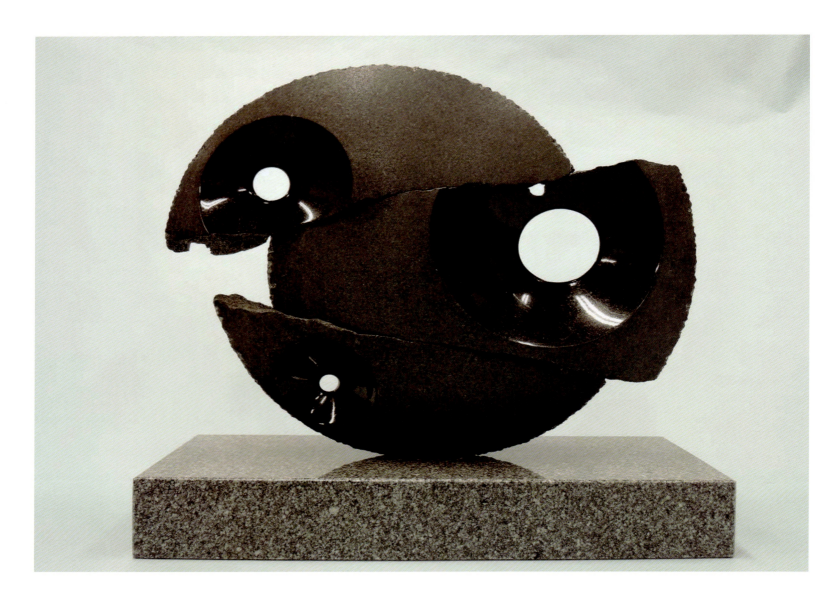

黑月亮 / Black Moon

400mm x 400mm x 220mm

博行朝野	Hiroyuki Asano
日本	Japan
雕塑	Sculpture

Jordan 约旦 International Art Exhibition 国际美术展

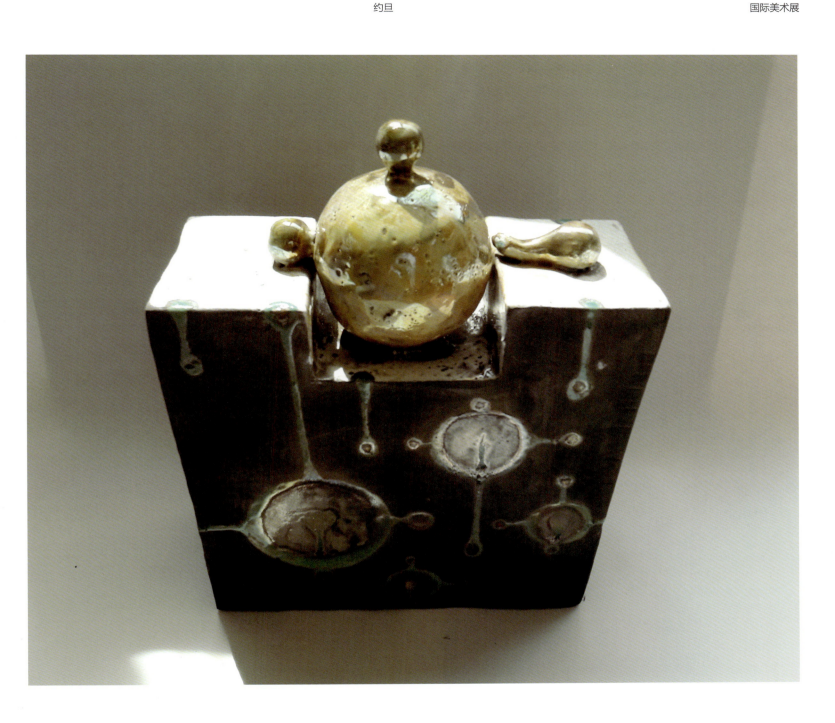

球形的秘密 / The Secret of Spherical Shape
400mm x 150mm

雅库布 | Yacoub Alatoom
约旦 | Jordan
雕塑 | Sculpture

Work Collection of Arts	The Fifth Silk Road International Arts Festival	Kazakhstan
美术作品集	第五届丝绸之路国际艺术节	哈萨克斯坦

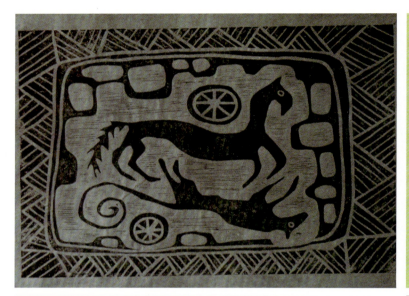
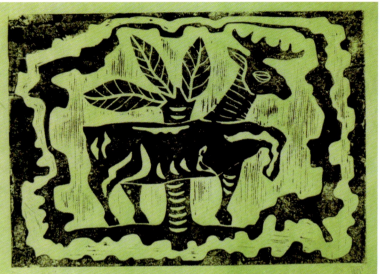
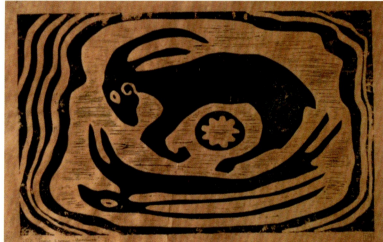
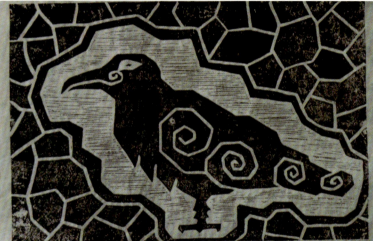

在草原上跳舞 / Dancing on the Grass; 鹿和棕榈 / The Deer and Palm; 羚羊在草原上跳舞 / The Antelope Danced on the Grassland; 黑乌鸦 / Black Crow
700mm x 500mm

莱拉·马哈特	Leyla Mahat
哈萨克斯坦	Kazakhstan
版画	Print

Kenya　　　　　　　　　　　　　　　　　　　　　　　International Art Exhibition
肯尼亚　　　　　　　　　　　　　　　　　　　　　　　国际美术展

非洲女孩 / The Girl from Africa
800mm x 600mm

安妮·姆威蒂　　　　Anne Mwiti
肯尼亚　　　　　　　Kenya
绘画　　　　　　　　Painting

| Work Collection of Arts | The Fifth Silk Road International Arts Festival | Kenya |
| 美术作品集 | 第五届丝绸之路国际艺术节 | 肯尼亚 |

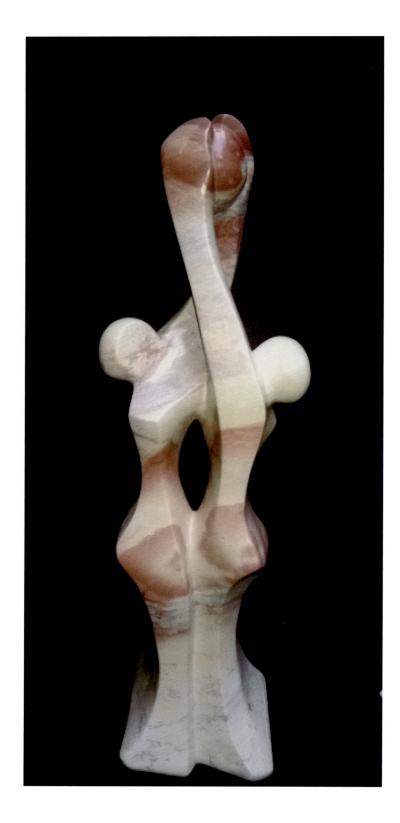

竞争 / Competition
600mm x 240mm x 200mm

杰拉德·欧若·莫通地 | Gerard Oroo Motondi
肯尼亚 | Kenya
雕塑 | Sculpture

Kuwait 科威特 — International Art Exhibition 国际美术展

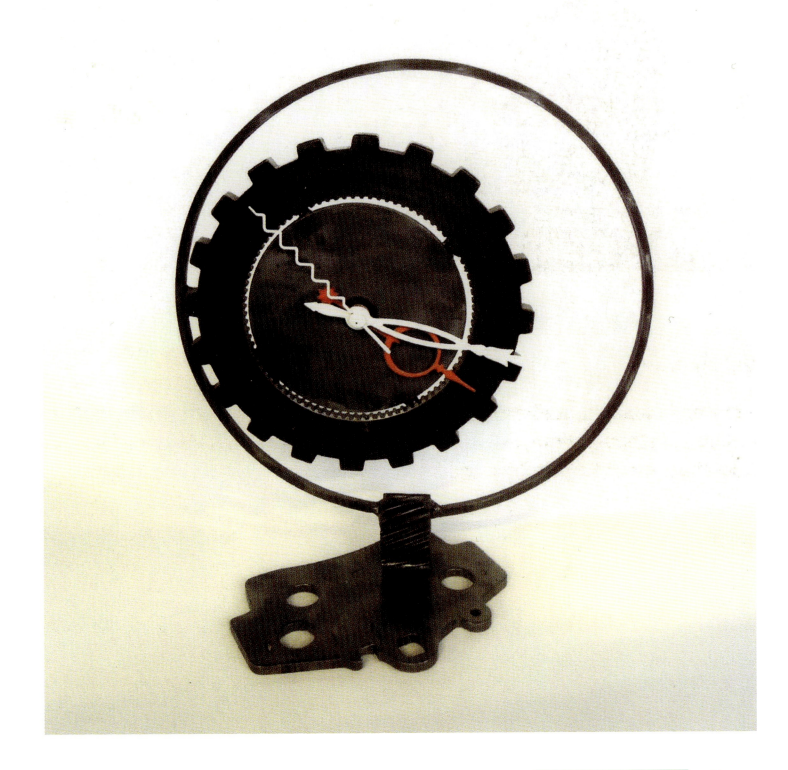

差不多 / Almost There
2500mm x 1100mm

阿布杜拉·阿那瑟 / Abdulla Alnaser
科威特 / Kuwait
雕塑 / Sculpture

Work Collection of Arts	The Fifth Silk Road International Arts Festival	Kyrgyzstan
美术作品集	第五届丝绸之路国际艺术节	吉尔吉斯斯坦

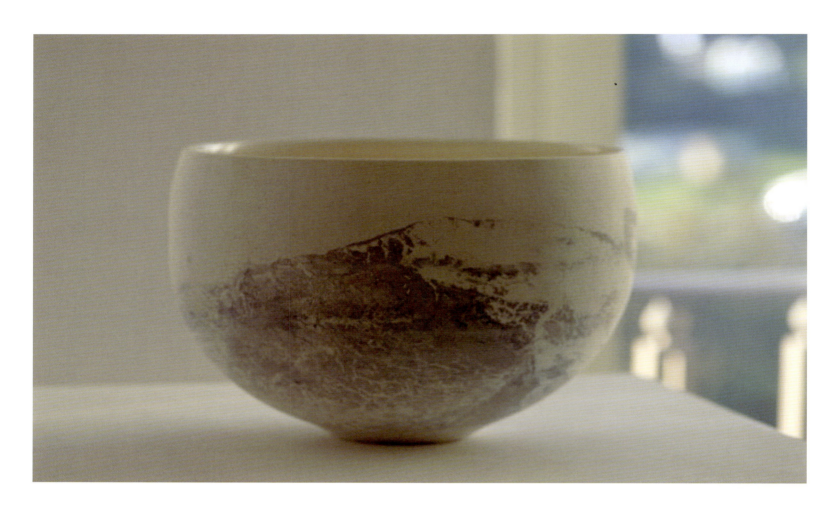

碗 / Bowl
250mm

纳斯让·特干拔	Nasira Turganbaj
吉尔吉斯斯坦	Kyrgyzstan
陶艺	Ceramics

Kyrgyzstan
吉尔吉斯斯坦

International Art Exhibition
国际美术展

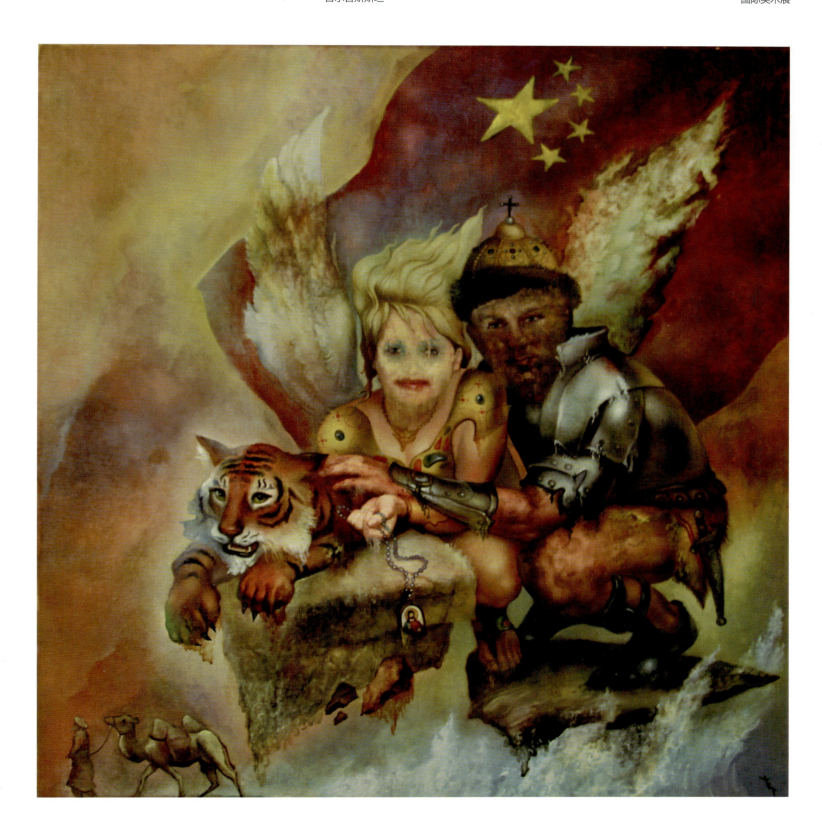

俄罗斯停留 / **Stopover Russia**
800mm x 800mm

弗拉基米尔·布兰特 | Wladimir Barantschikov
吉尔吉斯斯坦 | Kyrgyzstan
绘画 | Painting

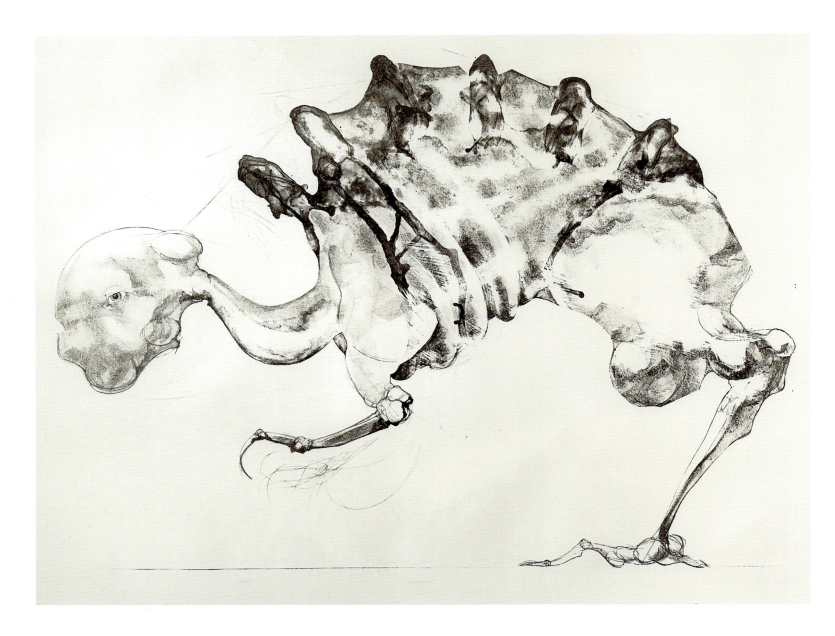

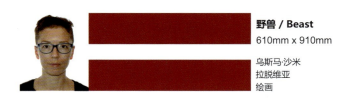

野兽 / Beast
610mm x 910mm

乌斯马·沙米 | Ausma Šmite
拉脱维亚 | Latvia
绘画 | Painting

Lebanon 黎巴嫩 — International Art Exhibition 国际美术展

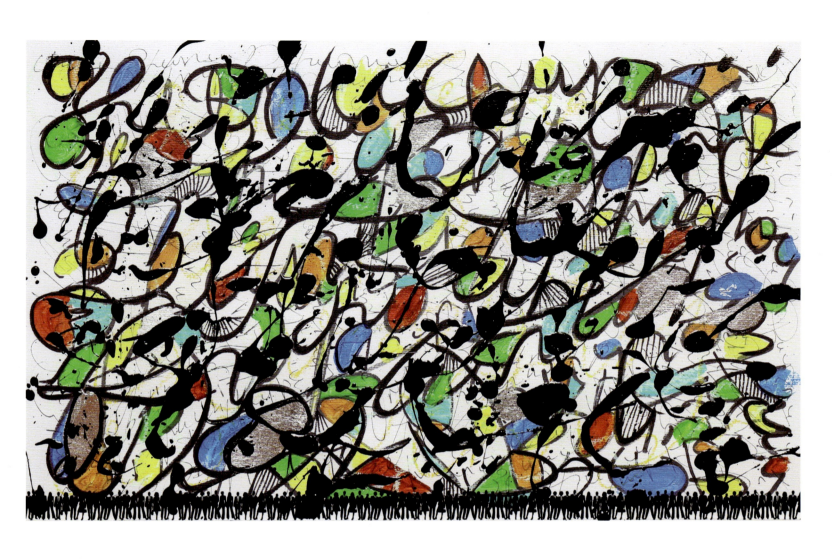

多元化的地球 / The Diversified Planet Earth
630mm x 1000mm

列纳·凯勒基安 | Lena Kelekian
黎巴嫩 | Lebanon
绘画 | Painting

| Work Collection of Arts | The Fifth Silk Road International Arts Festival | Lithuania |
| 美术作品集 | 第五届丝绸之路国际艺术节 | 立陶宛 |

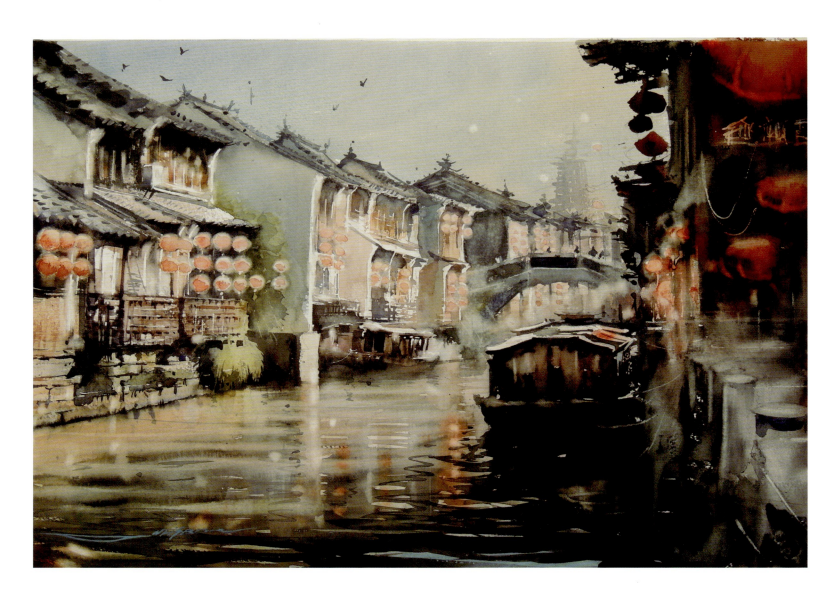

苏州 / Suzhou
490mm x 640mm

里斯·瑟积
立陶宛
绘画

Lysyy Sergiy
Lithuania
Painting

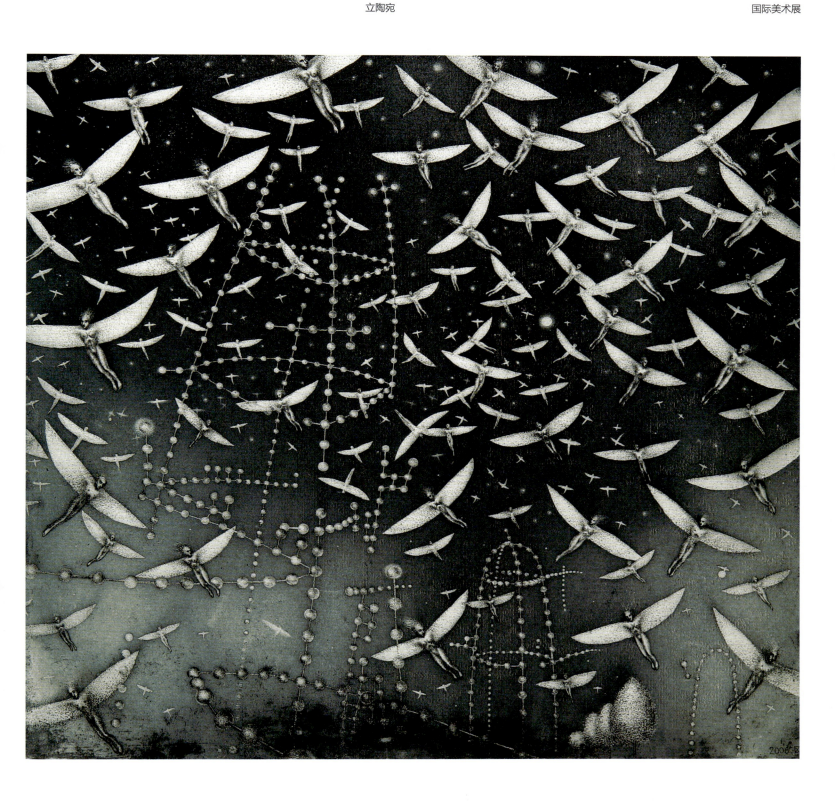

无数 / Myriads
680mm x 700mm

兹奈特·尼尔
立陶宛
绘画

Zirnite Nele
Lithuania
Painting

| Work Collection of Arts | The Fifth Silk Road International Arts Festival | Luxembourg |
| 美术作品集 | 第五届丝绸之路国际艺术节 | 卢森堡 |

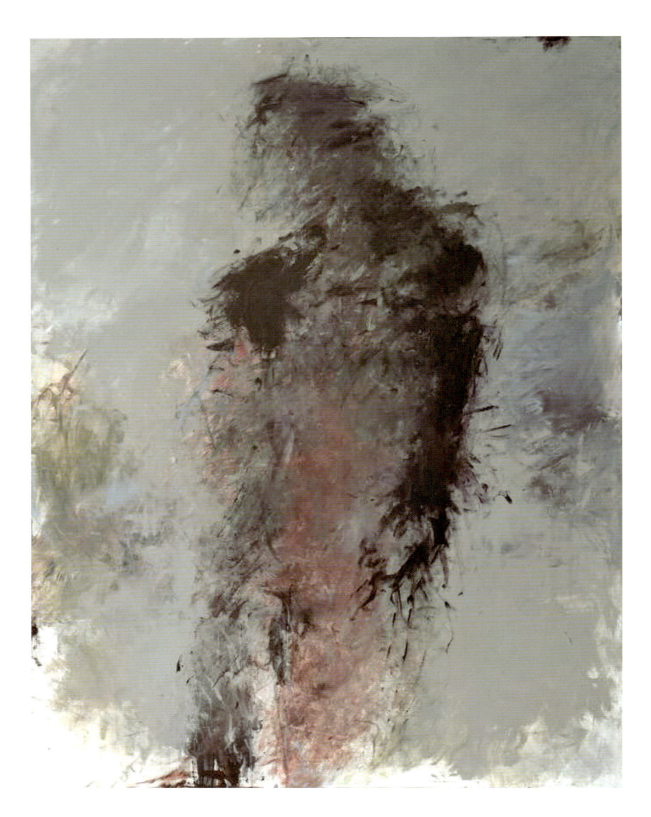

无题 / Unnamed

莫妮卡·贝克 Monique Becker
卢森堡 Luxembourg
绘画 Painting

Macedonia / 马其顿 — International Art Exhibition / 国际美术展

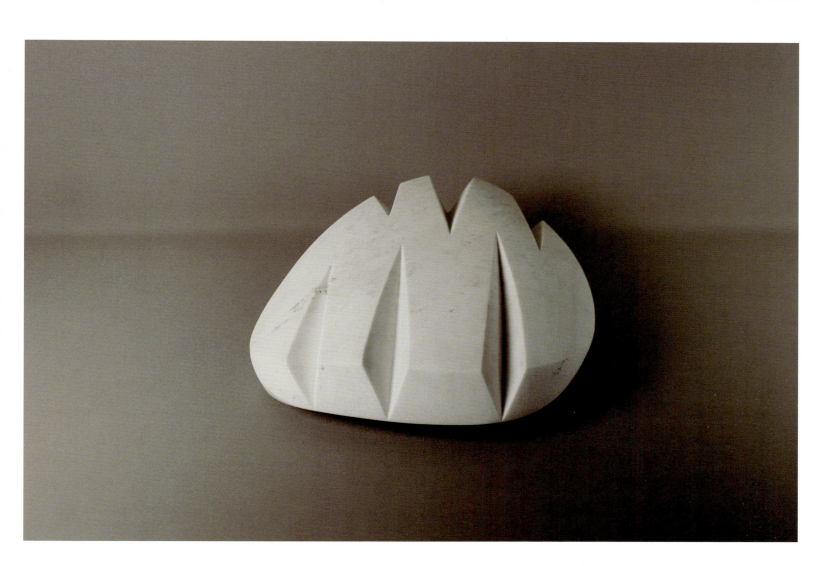

弯曲的路 / The Curvy Road
150mm x 350mm x 300mm

亚历山大·爱福特摩斯基 | Aleksandar Eftimovski
马其顿 | Macedonia
雕塑 | Sculpture

Work Collection of Arts	The Fifth Silk Road International Arts Festival	Macedonia
美术作品集	第五届丝绸之路国际艺术节	马其顿

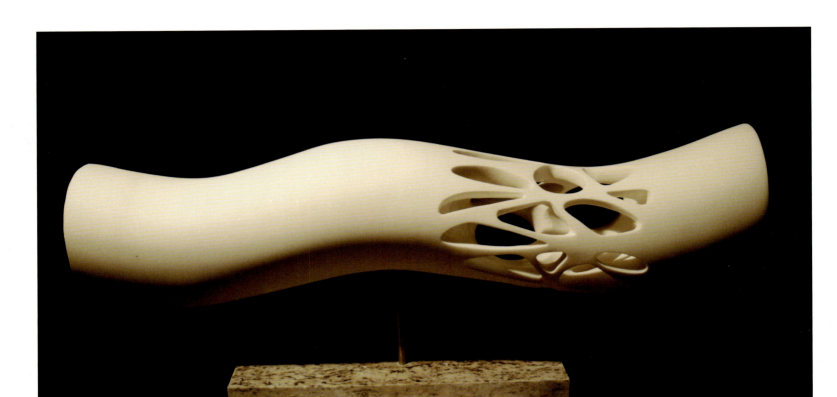

时间 / The Time
350mm x 1000mm x 200mm

安德烈·米捷夫斯基	Andrej Mitevski
马其顿	Macedonia
雕塑	Sculpture

Malaysia
马来西亚

International Art Exhibition
国际美术展

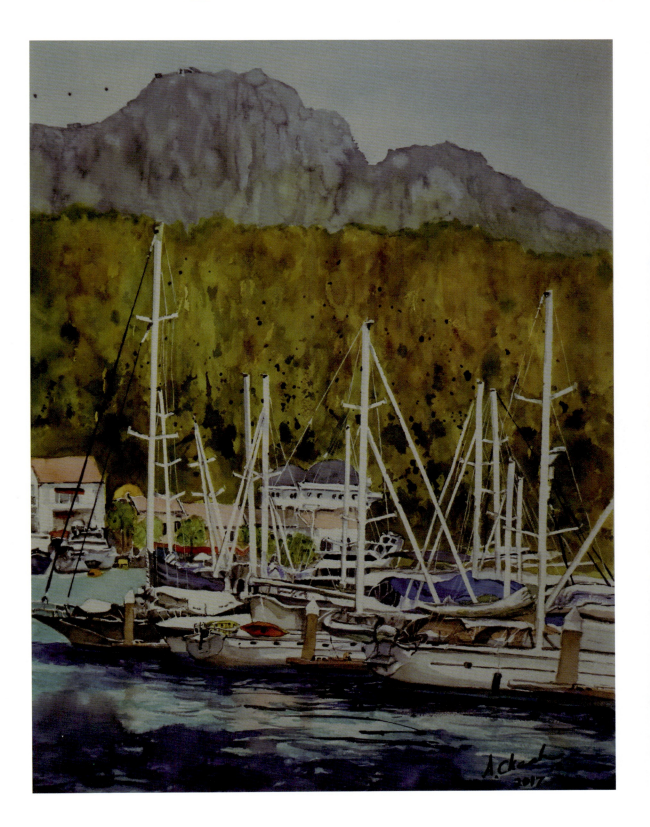

兰卡威岛 / Langkawi
560mm x 760mm

谢龙超
马来西亚
绘画

Cheahi Anthony
Malaysia
Painting

| Work Collection of Arts | The Fifth Silk Road International Arts Festival | Malaysia |
| 美术作品集 | 第五届丝绸之路国际艺术节 | 马来西亚 |

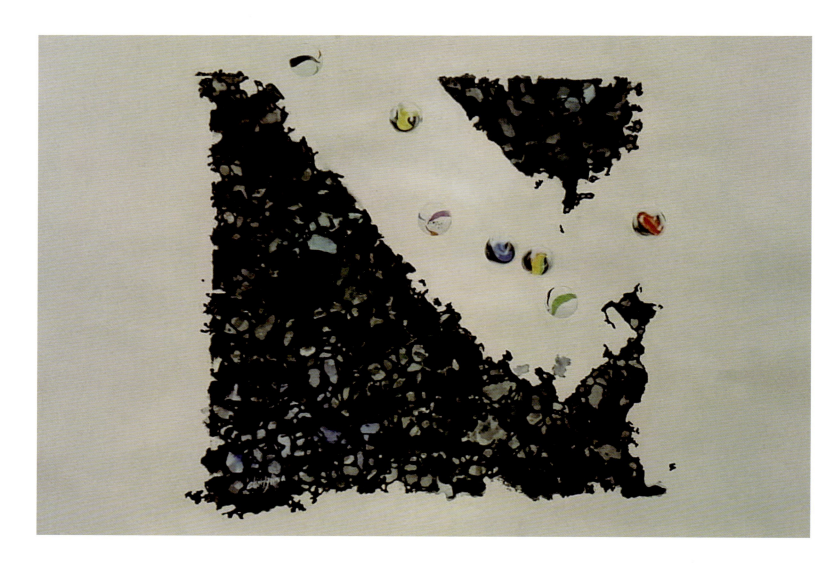

漫漫长路 / A Long Way
550mm X 380mm

周靖化	Chiew Cheng Hwa
马来西亚	Malaysia
绘画	Painting

Malaysia
马来西亚

International Art Exhibition
国际美术展

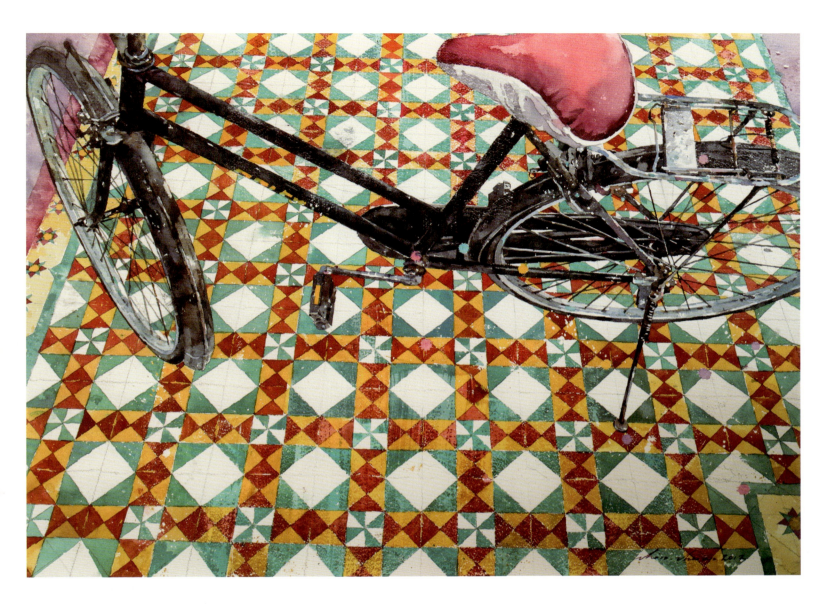

邻里 / Neighbourhood
760mm x 550mm

曹振全
马来西亚
绘画

Chow Chin Chuan
Malaysia
Painting

| Work Collection of Arts | The Fifth Silk Road International Arts Festival | Malaysia |
| 美术作品集 | 第五届丝绸之路国际艺术节 | 马来西亚 |

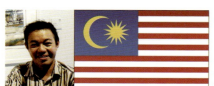

映像Ⅲ / Reflection 3
380mm x 560mm

李荣钦 — Lee Weng Khim
马来西亚 — Malaysia
绘画 — Painting

Malaysia / 马来西亚

International Art Exhibition / 国际美术展

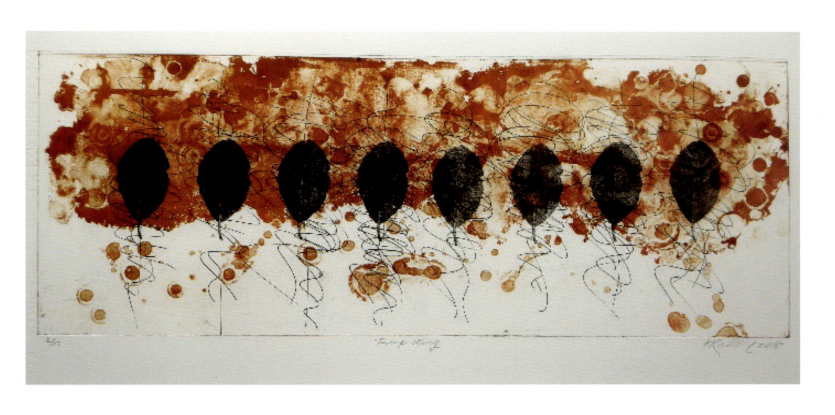

马来亚木波罗 / **Terap**
680mm x 270mm

穆罕默德·拉赫曼 | Mohamed Rahman
马来西亚 | Malaysia
绘画 | Painting

Work Collection of Arts	The Fifth Silk Road International Arts Festival	Malaysia
美术作品集	第五届丝绸之路国际艺术节	马来西亚

信心 / Confidence
380mm X 560mm

郑春香	Nancy Chang
马来西亚	Malaysia
绘画	Painting

Malaysia / 马来西亚 — International Art Exhibition / 国际美术展

没落的行业 / Declining Industry
390mm x 540mm

温秉升 | Oon Bing Shen
马来西亚 | Malaysia
绘画 | Painting

Work Collection of Arts	The Fifth Silk Road International Arts Festival	Malaysia
美术作品集	第五届丝绸之路国际艺术节	马来西亚

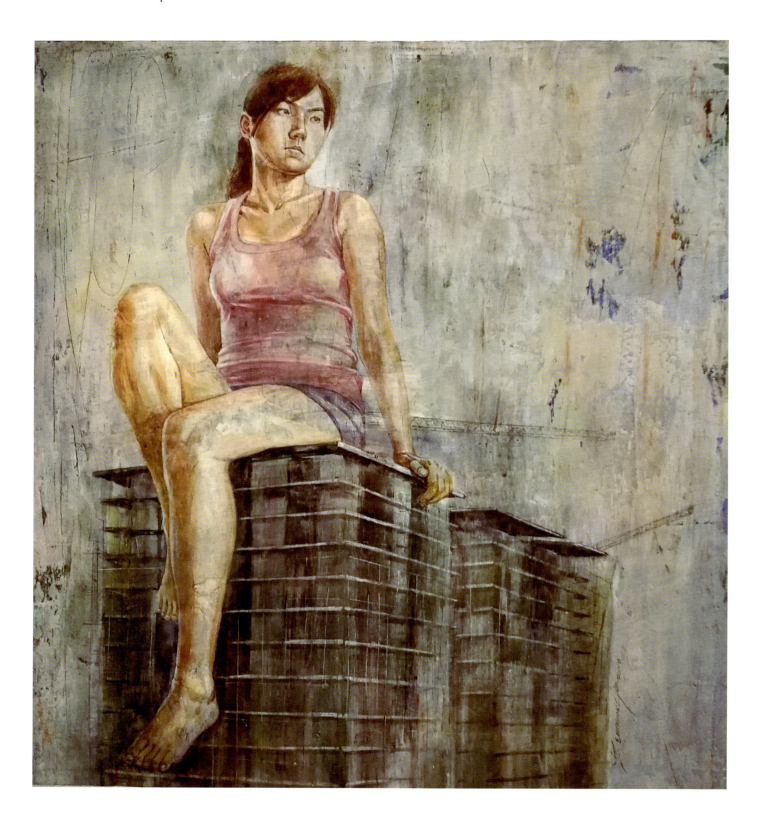

明天的记忆 2018 / Memory of Tomorrow 2018
1000m x 900mm

陈毓康 | Tang Yeok Khang
马来西亚 | Malaysia
绘画 | Painting

Malaysia / 马来西亚 — International Art Exhibition / 国际美术展

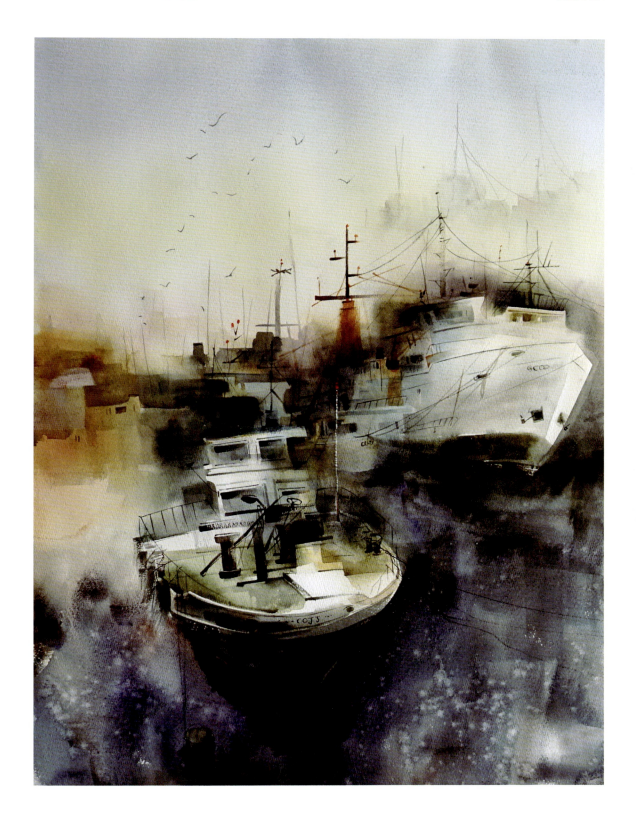

隐现之间 58 号 / Between Looming#58
560m x 760mm

杨觉昇 / Yeoh Choon Seng
马来西亚 / Malaysia
绘画 / Painting

| Work Collection of Arts | The Fifth Silk Road International Arts Festival | Mexico |
| 美术作品集 | 第五届丝绸之路国际艺术节 | 墨西哥 |

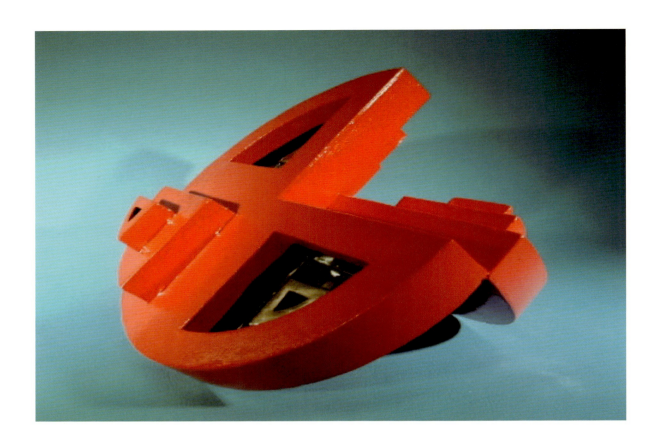

削减四分之一 / Quarter Waning
400mm x 400mm x 400mm

蒙格·桑切斯·卡洛斯	Monge Sánchez Carlos
墨西哥	Mexico
雕塑	Sculpture

Mexico / 墨西哥

International Art Exhibition / 国际美术展

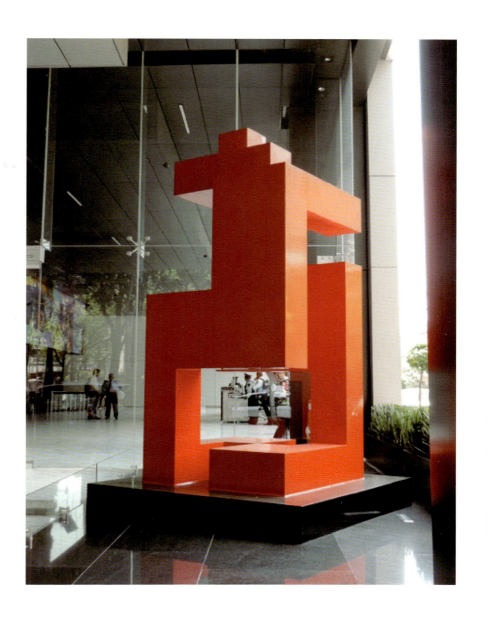

拥抱亚当和夏娃 / The Hug Adan and Eve
3600mm x 1800mm x 1800mm

佩德罗·马尔蒂斯	Pedro Martínez
墨西哥	Mexico
雕塑	Sculpture

| Work Collection of Arts | The Fifth Silk Road International Arts Festival | moldova |
| 美术作品集 | 第五届丝绸之路国际艺术节 | 摩尔多瓦 |

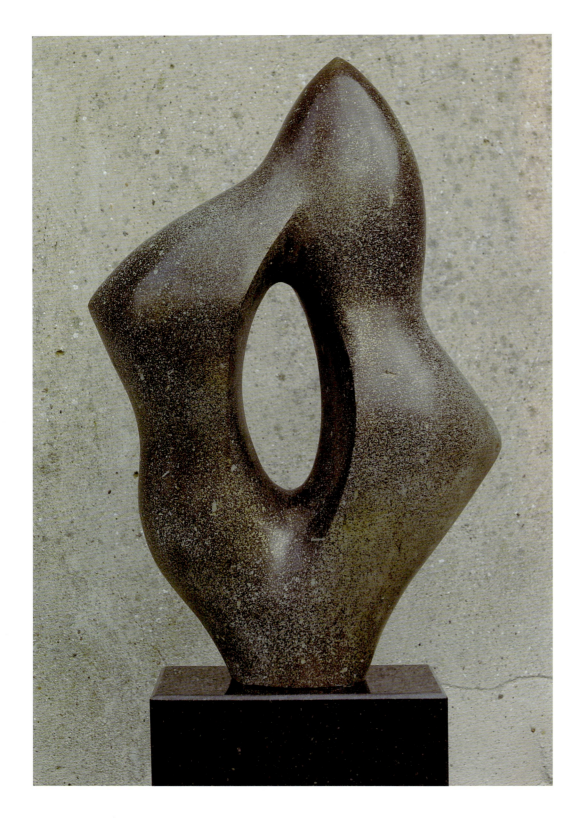

无限 / Unendlichkeit
3600mm x 1800mm x 1800mm

朱莉·柏拉图 | Juri Plato
摩尔多瓦 | Moldova
雕塑 | Sculpture

Mongolia
蒙古

International Art Exhibition
国际美术展

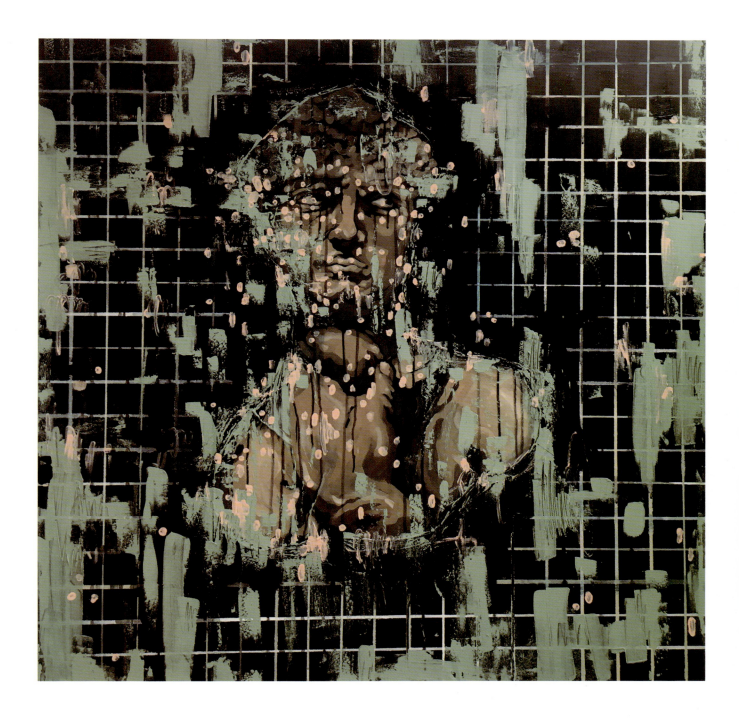

恩科图夫辛·巴托尔
蒙古
绘画

等待 / Waiting
1000mm x 1000mm

Enkhtuvshin Batbaatar
Mongolia
Painting

Work Collection of Arts	The Fifth Silk Road International Arts Festival	Montenegro
美术作品集	第五届丝绸之路国际艺术节	黑山共和国

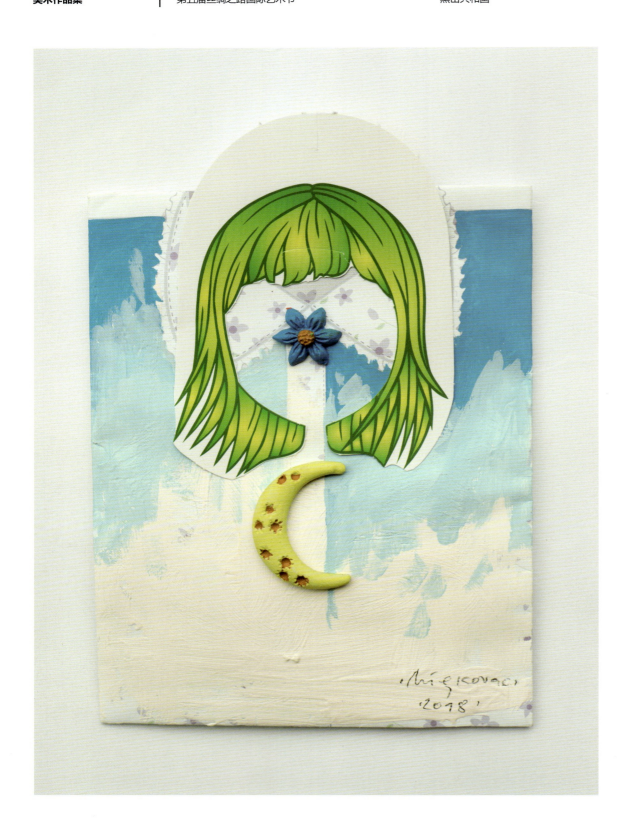

温柔和爱 / Tenderness and Love
120mm x 170mm

安娜·米列科瓦克 | Ana Miljkovac
黑山共和国 | Montenegro
绘画 | Painting

超越表象 / Au Dela Des Apparences
1000mm x 1000mm

布塔勒·蒙尼亚 | Boutaleb Mounia
摩洛哥 | Morocco
绘画 | Painting

Work Collection of Arts	The Fifth Silk Road International Arts Festival	Myanmar
美术作品集	第五届丝绸之路国际艺术节	缅甸

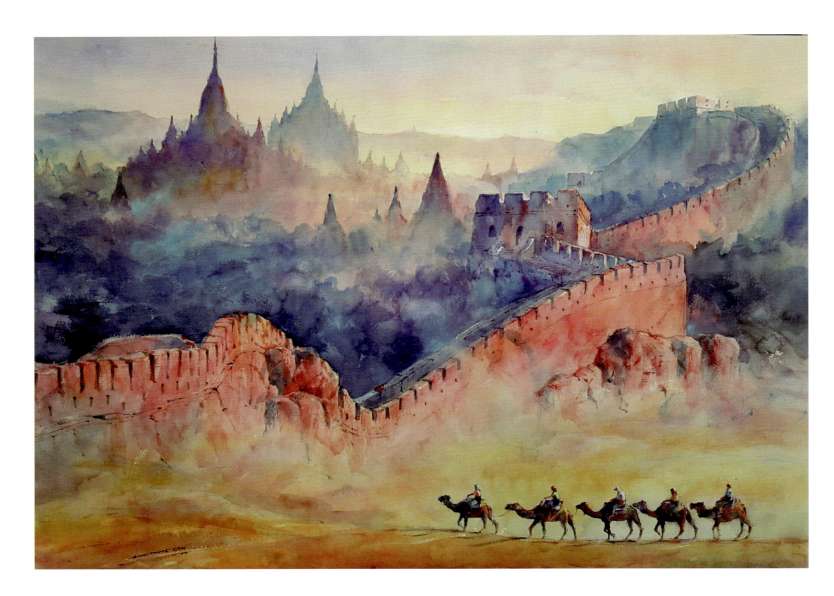

丝路精神 / Silk Road Spirit
750mm x 1000mm

琴芒皂	Khin Maung Zaw
缅甸	Myanmar
绘画	Painting

Myanmar
缅甸

International Art Exhibition
国际美术展

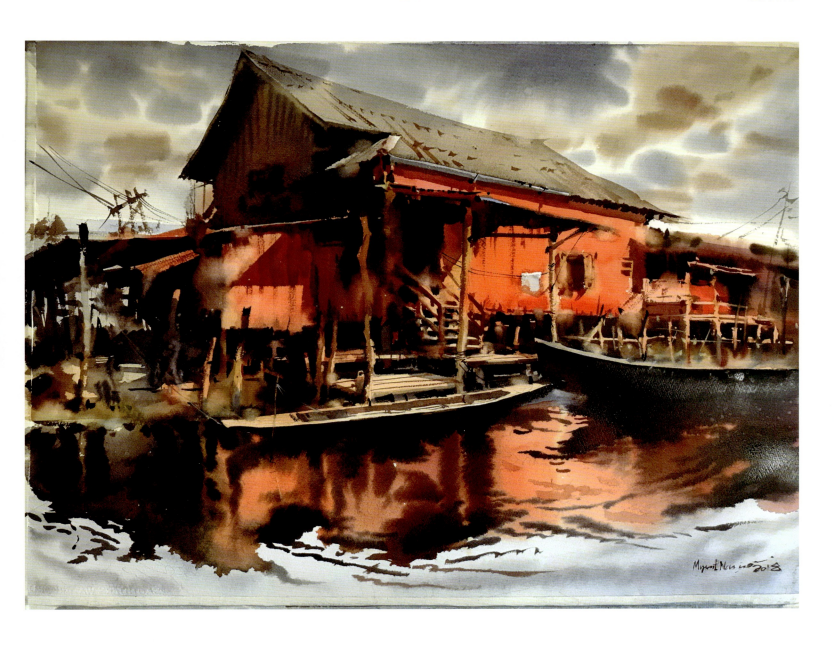

房子（缅甸）/ House in Inlay (Myanmar)
560mm x 760mm

木因特·那英 | Myint Naing
缅甸 | Myanmar
绘画 | Painting

| Work Collection of Arts | The Fifth Silk Road International Arts Festival | Nepal |
| 美术作品集 | 第五届丝绸之路国际艺术节 | 尼泊尔 |

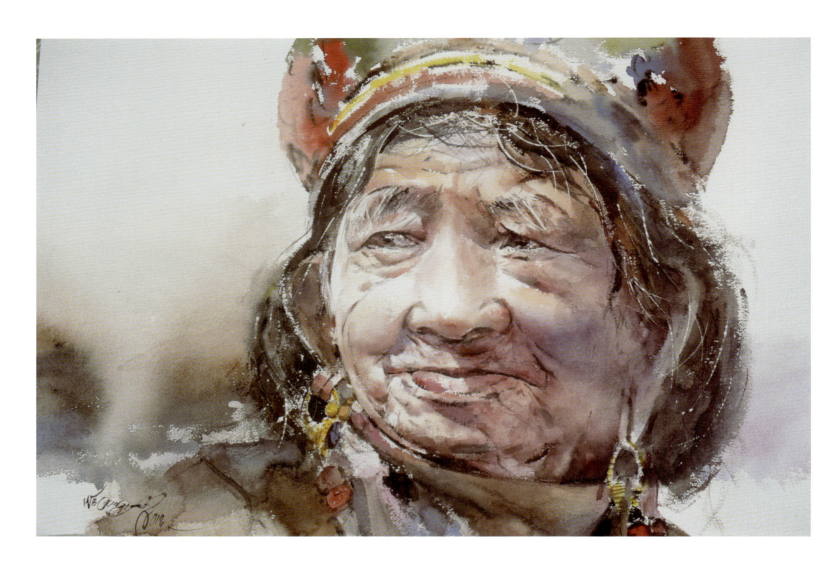

老妇人肖像 / A Portrait of an Old Woman
560mm x 760mm

NB 高隆	NB Gurung
尼泊尔	Nepal
绘画	Painting

Nepal / 尼泊尔 — International Art Exhibition / 国际美术展

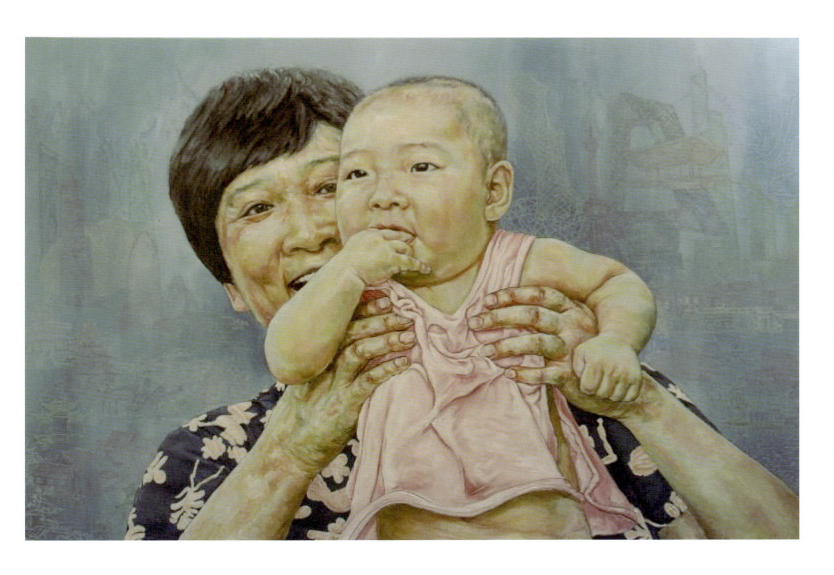

继承遗产 / Inheriting Heritage
2000mm x 1800mm

瑞蒂 | Maharjan Riti
尼泊尔 | Nepal
绘画 | Painting

| Work Collection of Arts | The Fifth Silk Road International Arts Festival | Netherlands |
| 美术作品集 | 第五届丝绸之路国际艺术节 | 荷兰 |

哈勒姆的夏末（荷兰）/ End Of Summer in Haarlem, The Netherlands
297mm x 420mm

安妮·罗斯·奥斯特巴恩	Anne Rose Oosterbaan
荷兰	Netherlands
绘画	Painting

Netherlands
荷兰

International Art Exhibition
国际美术展

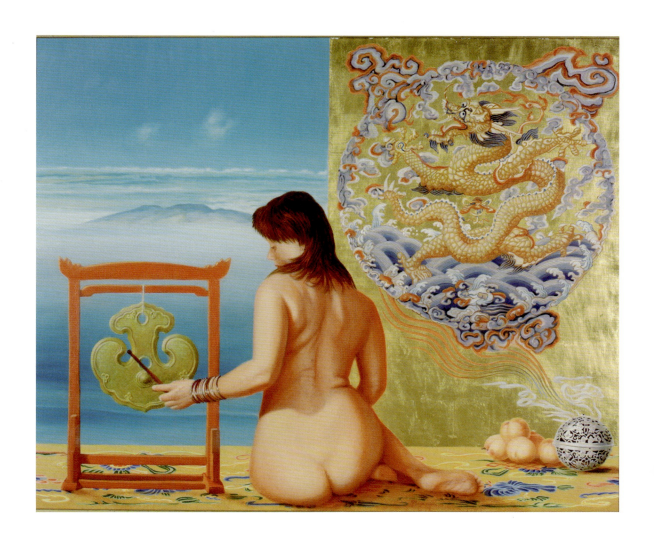

中国锣 / Chinese Gong
1000mm x 1200mm

海格曼·汤姆 | Hageman Tom
荷兰 | Netherlands
绘画 | Painting

| Work Collection of Arts | The Fifth Silk Road International Arts Festival | Netherlands |
| 美术作品集 | 第五届丝绸之路国际艺术节 | 荷兰 |

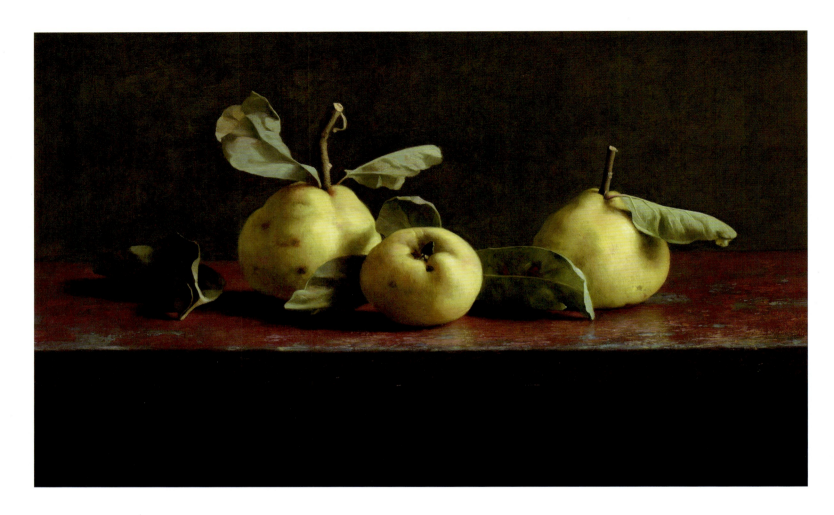

静物 2017 / Still Even Met Kweepernn 2017
450mm x 650mm

亨克·赫尔曼特尔 Henk Helmantel
荷兰 Netherlands
绘画 Painting

Netherlands
荷兰

International Art Exhibition
国际美术展

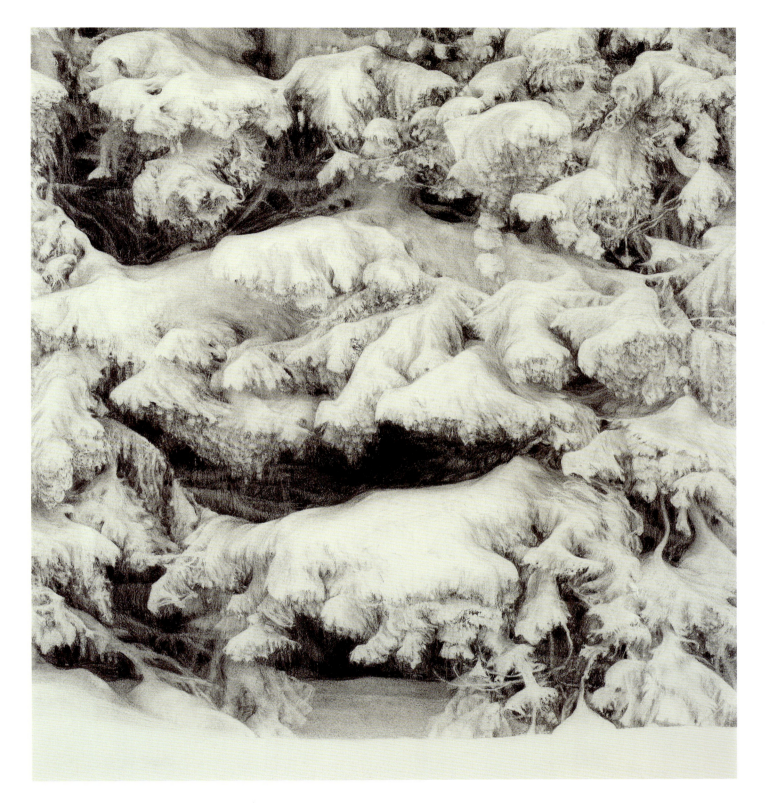

希尔达·斯莱杰尔
荷兰
绘画

镂空 / Ajour
612mm x 446mm

Hilda Snoeijer
Netherlands
Painting

Work Collection of Arts	The Fifth Silk Road International Arts Festival	Netherlands
美术作品集	第五届丝绸之路国际艺术节	荷兰

无题 / Unnamed
400mm x 400mm

吉塔·巴尔多尔	Gitta Pardoel
荷兰	Netherlands
绘画	Painting

Netherlands / 荷兰 — International Art Exhibition / 国际美术展

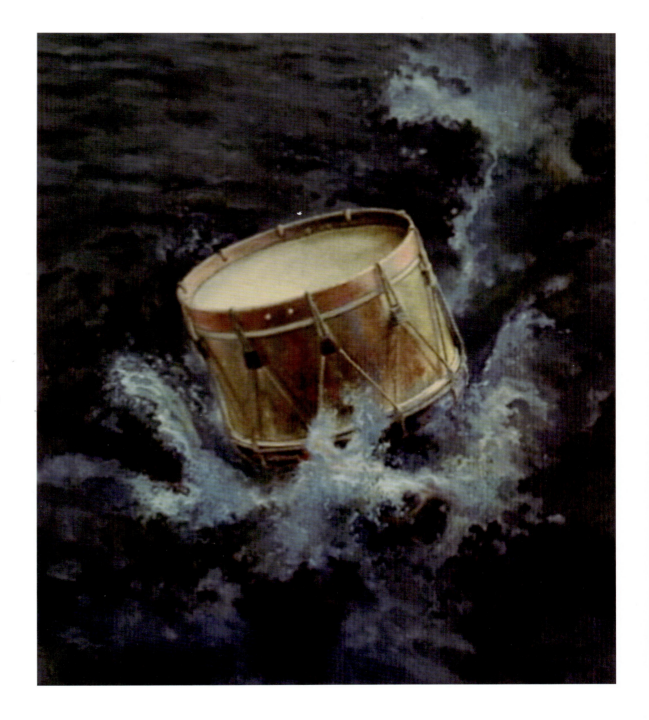

水的音乐 / Water Music
940mm x 730mm

莱因·波尔 / Rein Pol
荷兰 / Netherlands
绘画 / Painting

| Work Collection of Arts | The Fifth Silk Road International Arts Festival | New Zealand |
| 美术作品集 | 第五届丝绸之路国际艺术节 | 新西兰 |

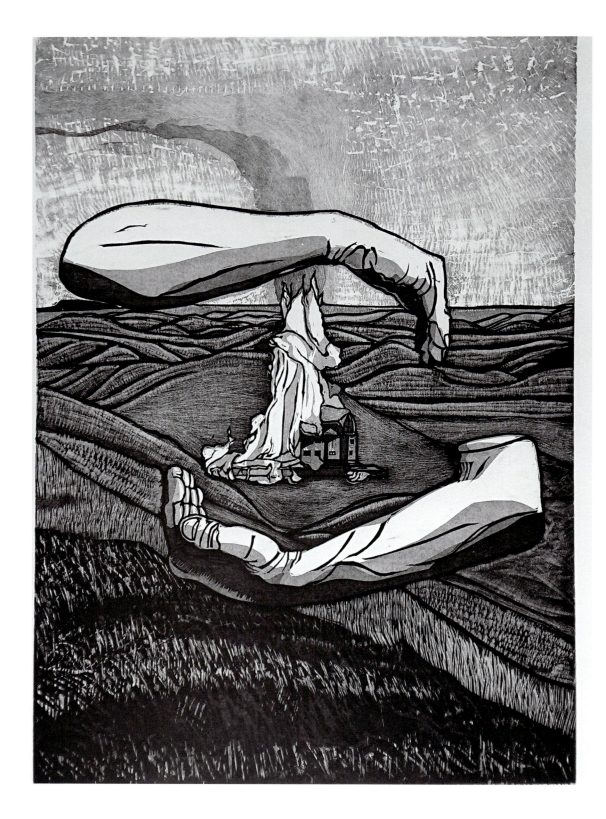

停火 (A/P) / Hold Fire (A/P)
1500mm x 1000mm x 3000mm

格拉汉姆·霍尔	Graham Hall
新西兰	New Zealand
雕塑	Sculpture

New Zealand
新西兰

International Art Exhibition
国际美术展

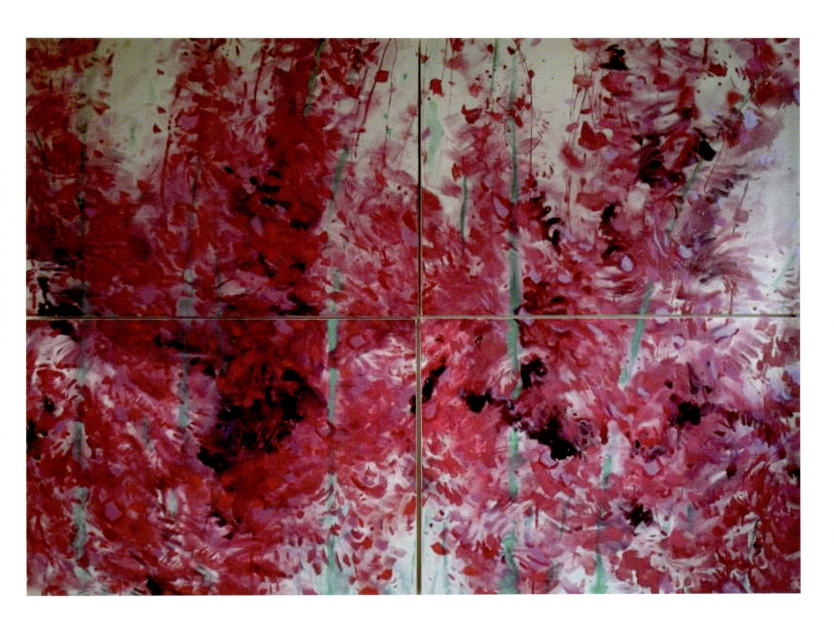

陈坚
新西兰
绘画

无题 / Unnamed

Jian Chen
New Zealand
Painting

| Work Collection of Arts / 美术作品集 | The Fifth Silk Road International Arts Festival / 第五届丝绸之路国际艺术节 | Nigeria / 尼日利亚 |

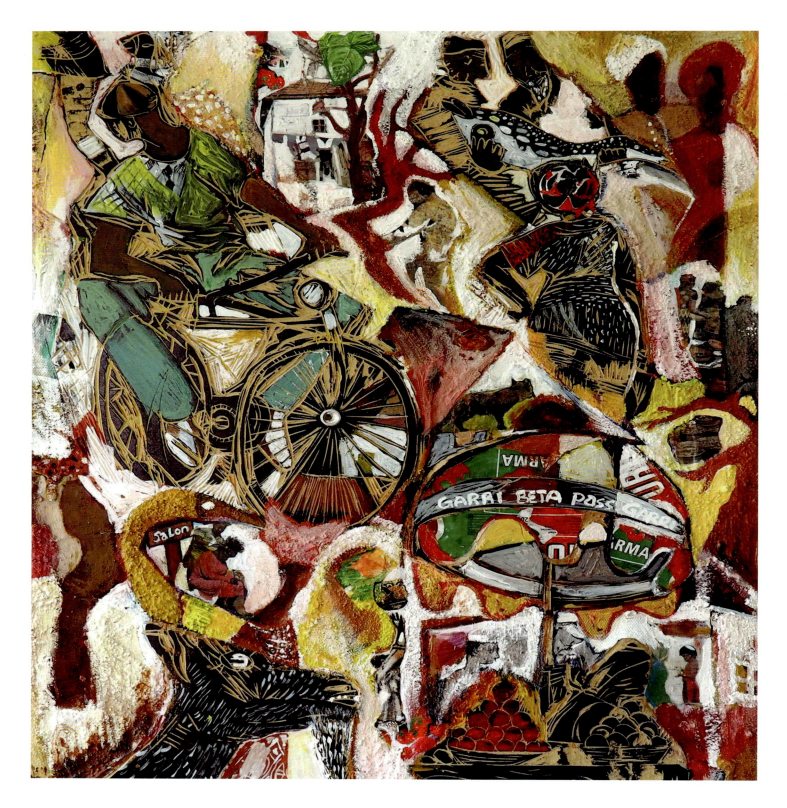

人，城市，街道，动物 / People, Cities, Streets, Animals
560mm x 700mm

奥拉扬朱·达达 | Olayanju Dada
尼日利亚 | Nigeria
绘画 | Painting

Norway
挪威

International Art Exhibition
国际美术展

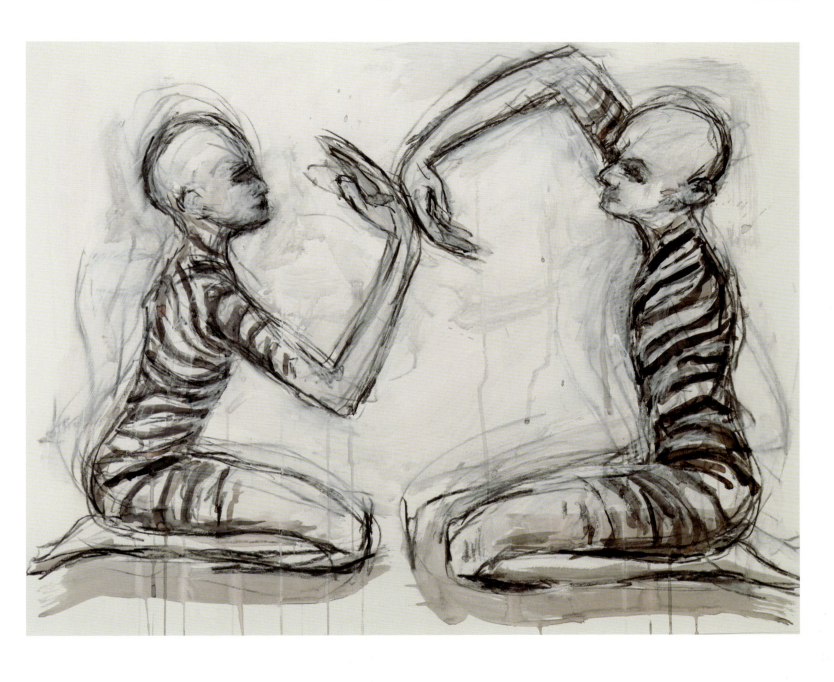

安琪·金
挪威
绘画

触 / Touch
585mm x 760mm

Anki King
Norway
Painting

Work Collection of Arts	The Fifth Silk Road International Arts Festival	Norway
美术作品集	第五届丝绸之路国际艺术节	挪威

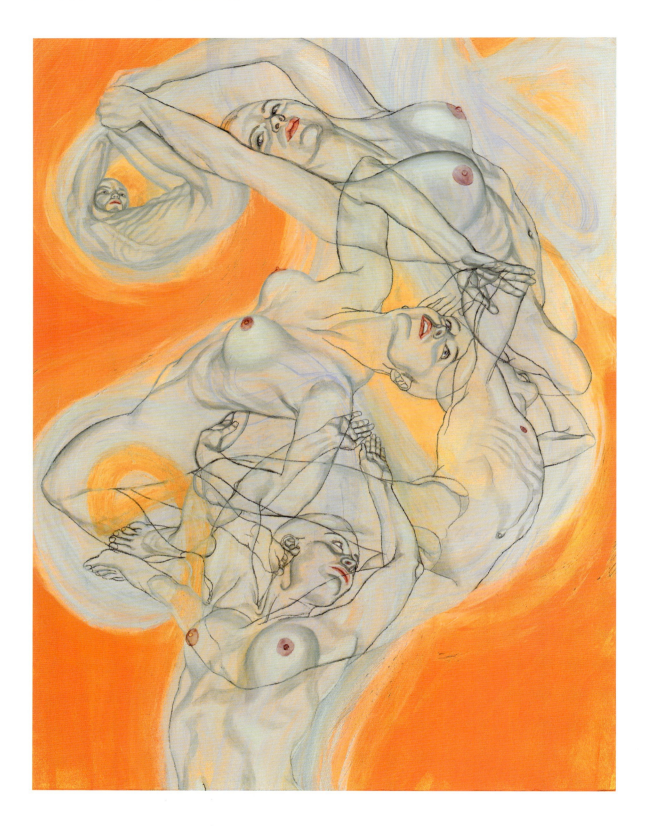

螺旋式上升的烟Ⅱ / Spiraling Smoke 2
1220mm x 920mm

索尔·乔珂	Sol Kjok
挪威	Norway
绘画	Painting

Oman 阿曼 | International Art Exhibition 国际美术展

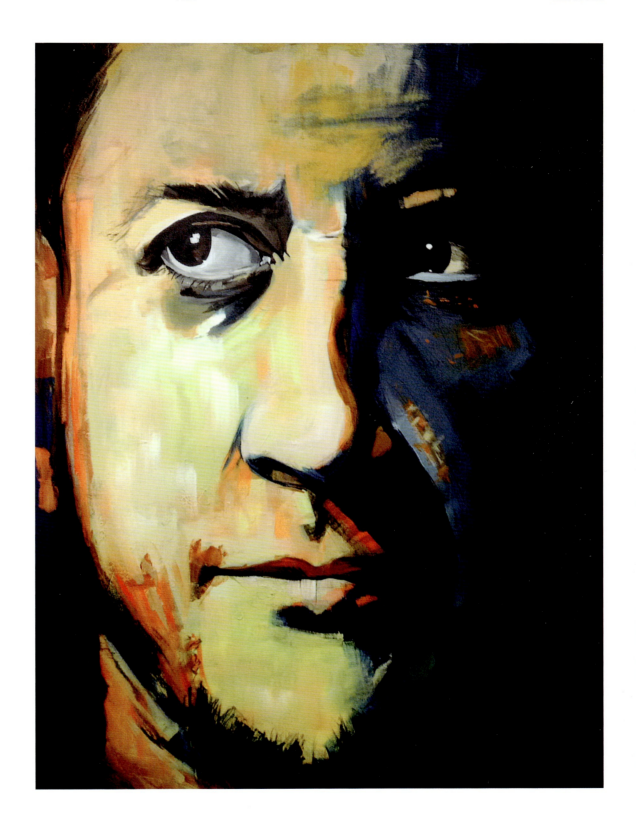

自画像 / Self Portrait

阿里·奈塞尔·萨夫·艾希耐
阿曼
绘画

Ali Nasser Saif AlHinai
Oman
Painting

Work Collection of Arts
美术作品集 | The Fifth Silk Road International Arts Festival
第五届丝绸之路国际艺术节 | Pakistan 巴基斯坦

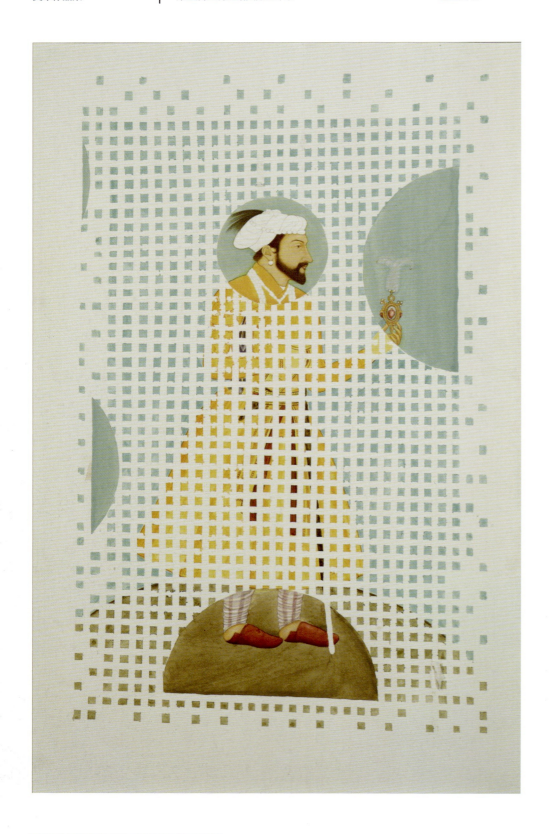

无题 / Unnamed
360mm x 540mm

S.M. 海亚姆　　S.M.Khayyam
巴基斯坦　　　Pakistan
绘画　　　　　Painting

Panama 巴拿马 — International Art Exhibition 国际美术展

非理性风险 / Irrational Risk
850mm x 630mm

安东尼·乔司·盖兹曼
巴拿马
绘画

Antonio José Guzman
Panama
Painting

| Work Collection of Arts | The Fifth Silk Road International Arts Festival | Paraguay |
| 美术作品集 | 第五届丝绸之路国际艺术节 | 巴拉圭 |

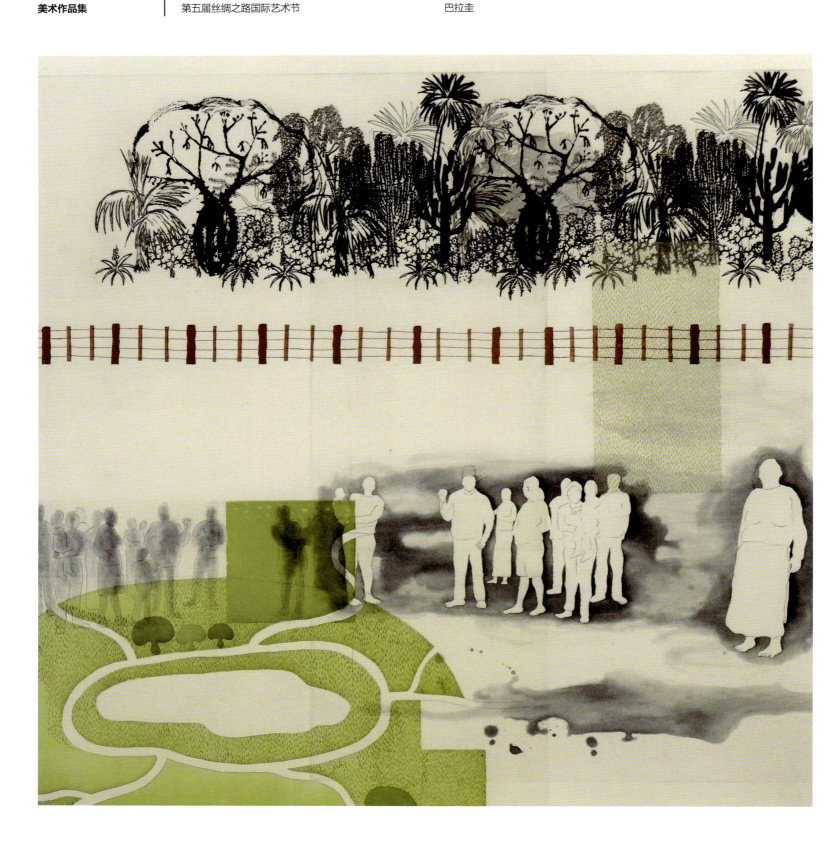

外壳Ⅱ / Enclosure 2
550mm x 600mm

米莉安·鲁道夫·米里亚姆
巴拉圭
绘画

Miriam Rudolph Hildebrand
Paraguay
Painting

Peru 秘鲁 — International Art Exhibition 国际美术展

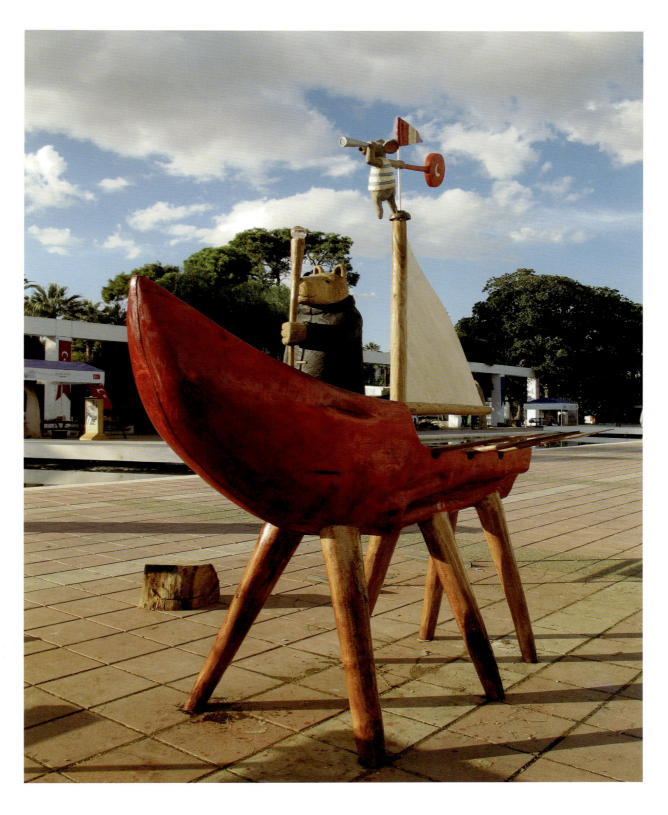

梦幻旅人 / Dream Traveler
3000mm x 1800mm x 2500mm

阿尔多·希罗玛
秘鲁
雕塑

Aldo Shiroma
Peru
Sculpture

Work Collection of Arts	The Fifth Silk Road International Arts Festival	Peru
美术作品集	第五届丝绸之路国际艺术节	秘鲁

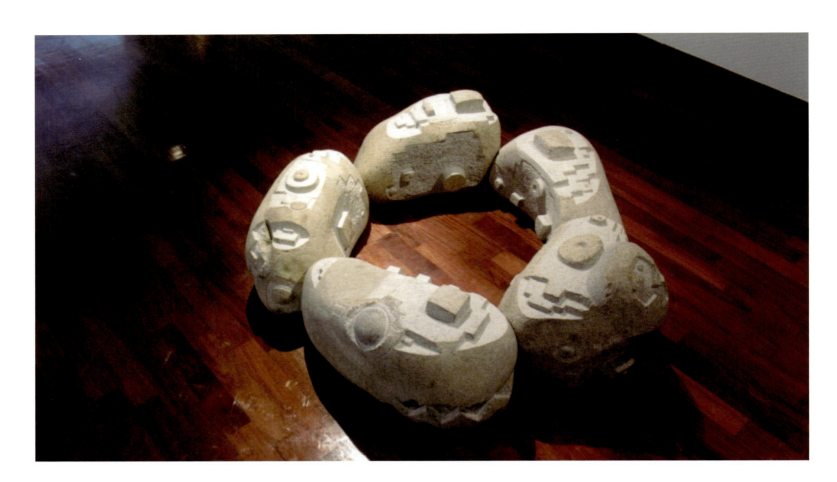

安第斯城堡 / Andean Citadel
1000mm x 1000mm x 400mm

巴勃罗·叶塔约	Pablo Yactayo
秘鲁	Peru
雕塑	Sculpture

Philippines
菲律宾

International Art Exhibition
国际美术展

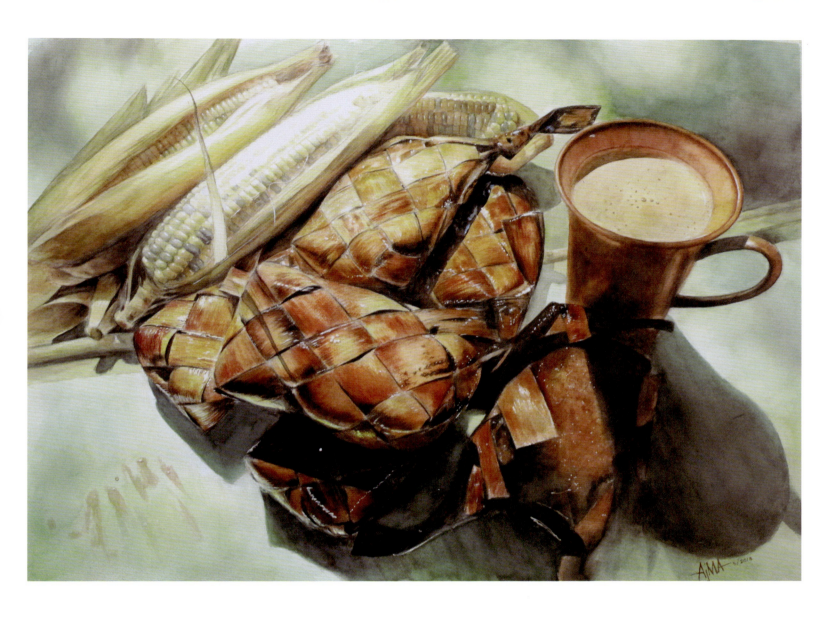

艾沙·乔伊·马帕瑙·艾利
菲律宾
绘画

马来粽 / Patupat
530mm x 730mm

Aizza Joy Mapanao Allid
Philippines
Painting

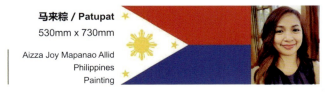

| Work Collection of Arts | The Fifth Silk Road International Arts Festival | Philippines |
| 美术作品集 | 第五届丝绸之路国际艺术节 | 菲律宾 |

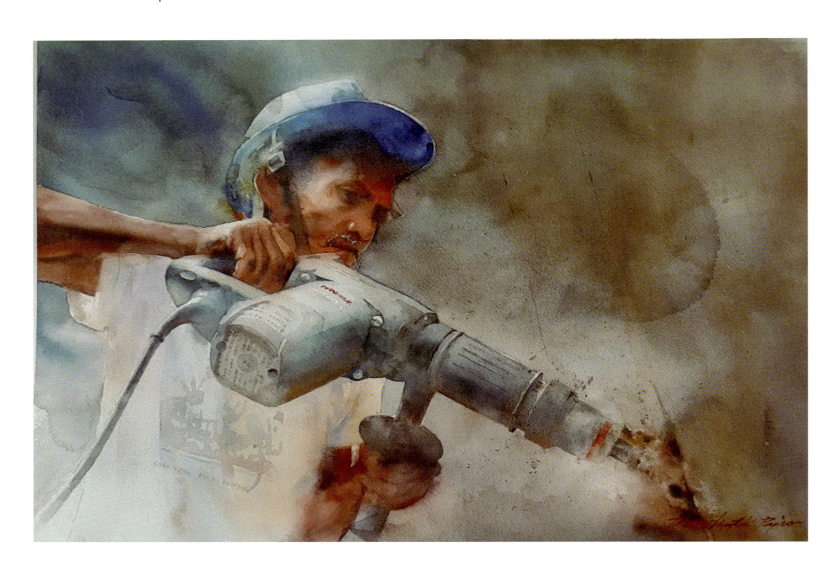

来之不易 / Hard Earned
3800mm × 560mm

迪诺·但丁·巴约	Dino Dante Pajao
菲律宾	Philippines
绘画	Painting

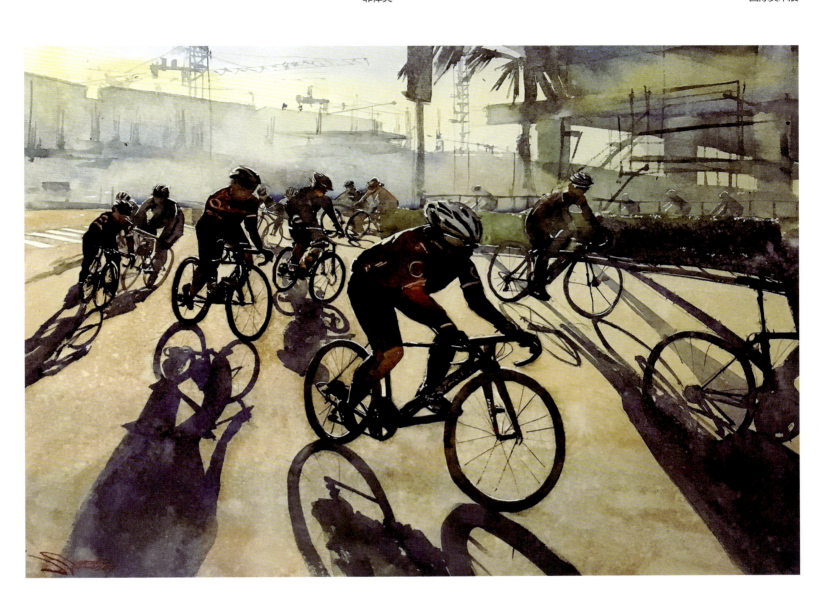

日出的海湾 / Sunrise by the Bay
530mm x 730mm

约翰·卡罗·巴尔加斯 | John Carlo Vargas
菲律宾 | Philippines
绘画 | Painting

| Work Collection of Arts | The Fifth Silk Road International Arts Festival | Philippines |
| 美术作品集 | 第五届丝绸之路国际艺术节 | 菲律宾 |

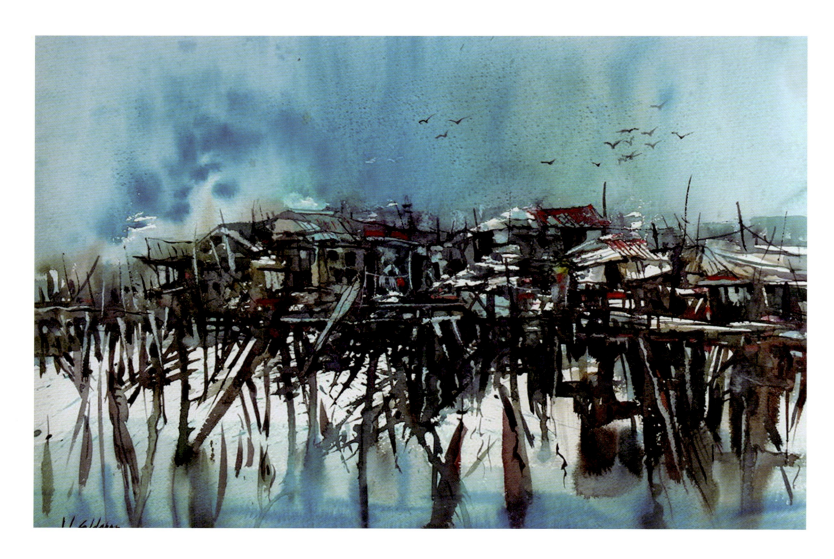

巴招 / Badjao
450mm x 600mm

威尔弗雷多·卡尔德龙	Wilfredo Calderon
菲律宾	Philippines
绘画	Painting

Poland
波兰

International Art Exhibition
国际美术展

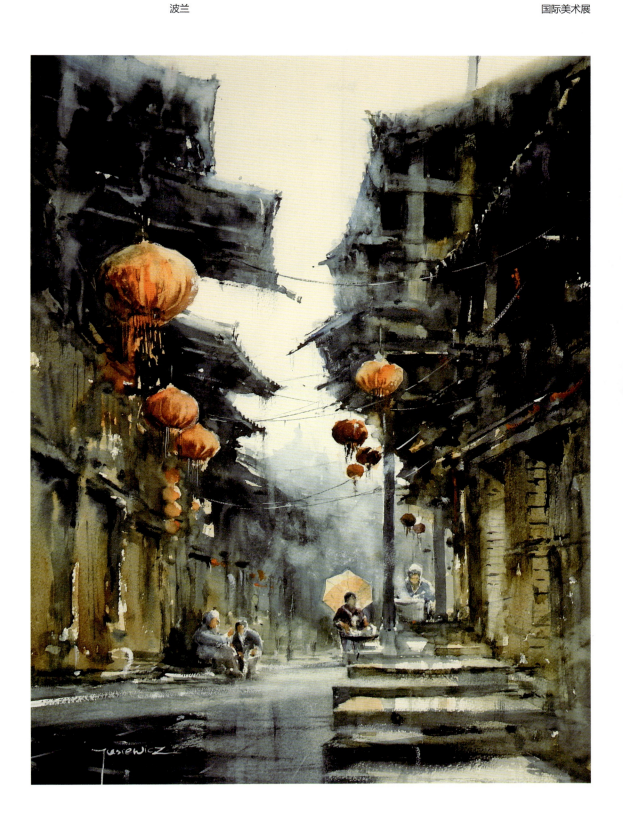

简单生活 / Simple Live
500mm x 350mm

麦克·加斯威克斯
波兰
绘画

Michal Jasiewicz
Poland
Painting

| Work Collection of Arts | The Fifth Silk Road International Arts Festival | Portugal |
| 美术作品集 | 第五届丝绸之路国际艺术节 第五届 | 葡萄牙 |

有机结构 / (In)Organic Structure
1000mm x 700mm

路易斯·菲利普·罗德里戈 | Luis Filipe Rodrigues
葡萄牙 | Portugal
雕塑 | Sculpture

刚果（布） R.Congo

International Art Exhibition
国际美术展

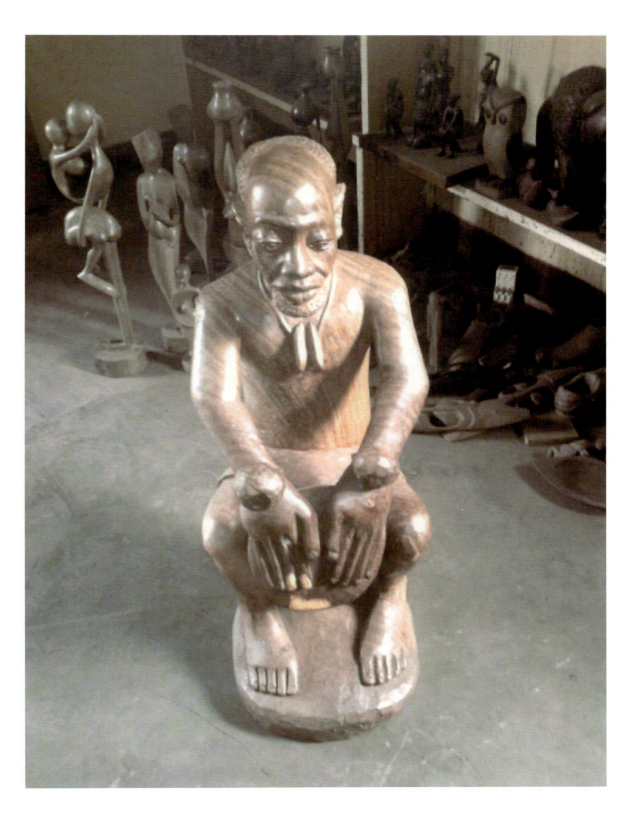

少爷 / Tambourinier

马森戈·艾玛
刚果（布）
雕塑

Massengo Emma
R.Congo
Sculpture

| Work Collection of Arts | The Fifth Silk Road International Arts Festival | Romania |
| 美术作品集 | 第五届丝绸之路国际艺术节 | 罗马尼亚 |

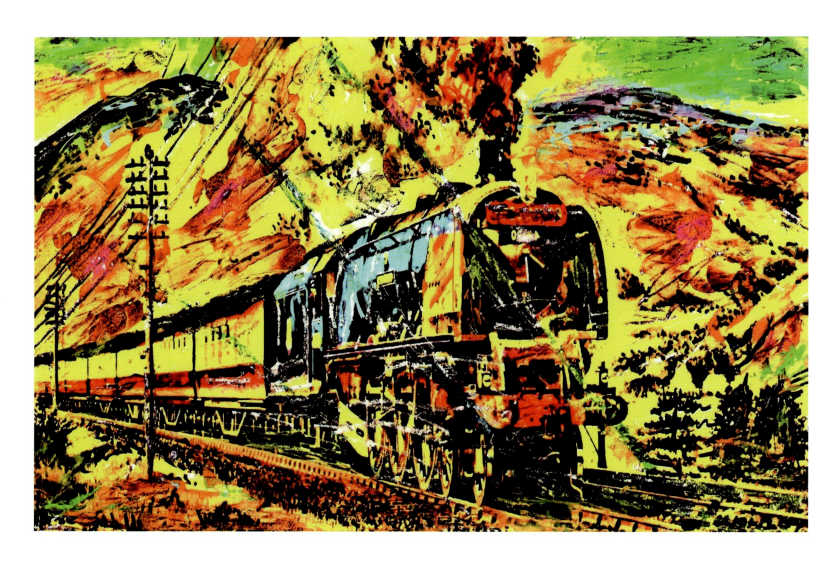

沙漠火车 / Desert Train
200mm x 280mm

马里安·芦浦	Marian Lupu
罗马尼亚	Romania
绘画	Painting

Russia
俄罗斯

International Art Exhibition
国际美术展

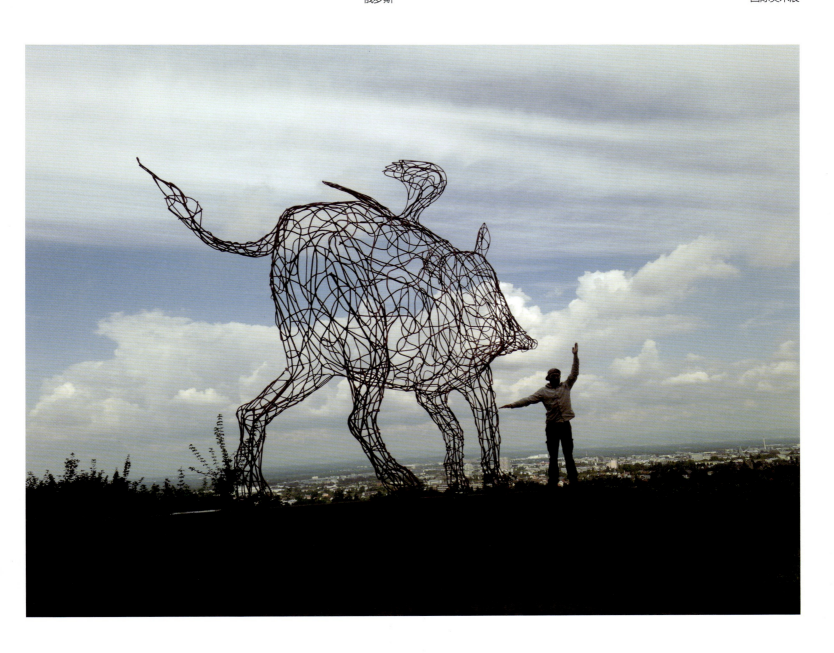

飞越达姆施塔特到法兰克福 / Flying Over Darm Stadt to Frankfurt
5100mm x 3900mm x 1600mm

格里博斯·特卡琴科 | Glebos Tkachenko
俄罗斯 | Russia
雕塑 | Sculpture

| Work Collection of Arts | The Fifth Silk Road International Arts Festival | Russia |
| 美术作品集 | 第五届丝绸之路国际艺术节 | 俄罗斯 |

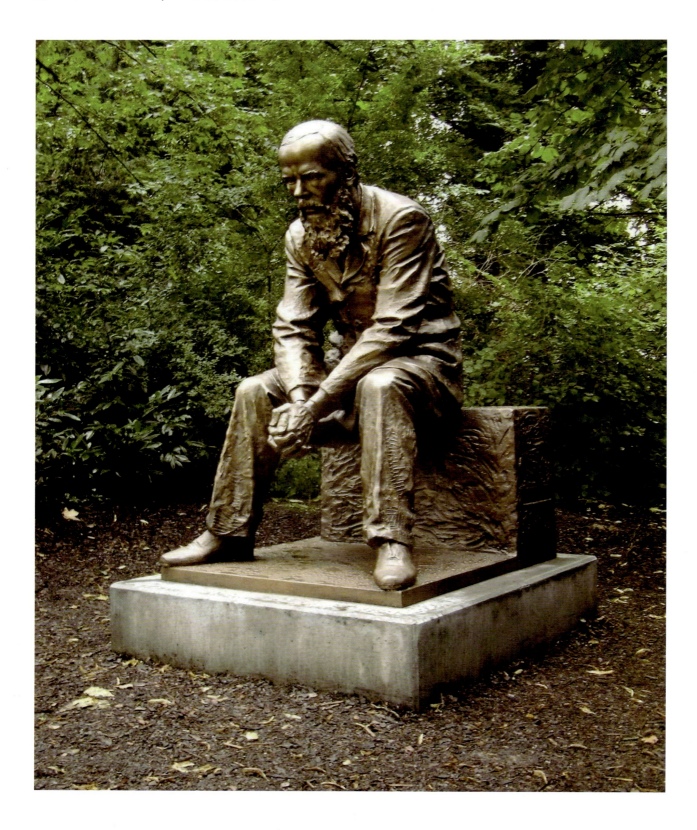

无题 / Unnamed

尼古拉·卡莱科诺夫 | Nikolay Karlykhanov
俄罗斯 | Russia
雕塑 | Sculpture

Russia
俄罗斯

International Art Exhibition
国际美术展

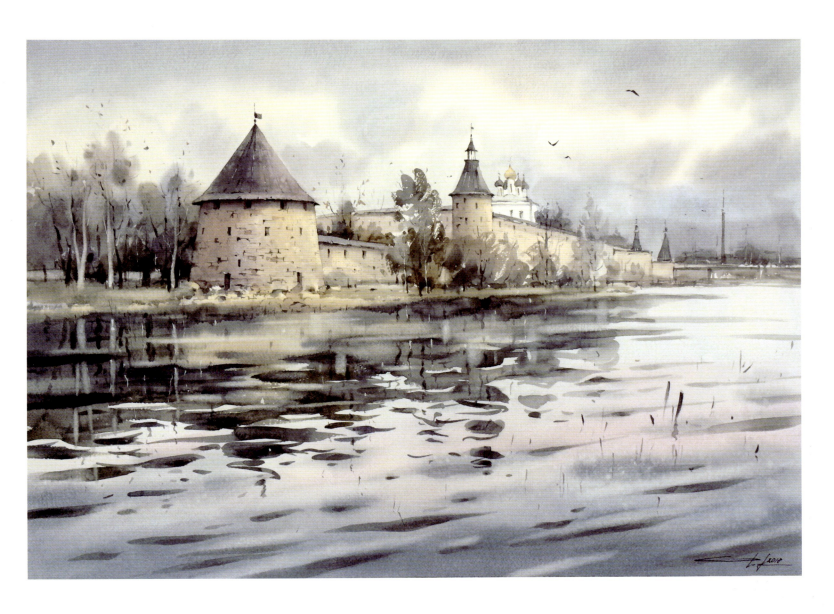

普什科夫 / Pskov
550mm x 750mm

奥尔加·卡成克 / Olga Kharchenko
俄罗斯 / Russia
绘画 / Painting

| **Work Collection of Arts** 美术作品集 | The Fifth Silk Road International Arts Festival 第五届丝绸之路国际艺术节 | Russia 俄罗斯 |

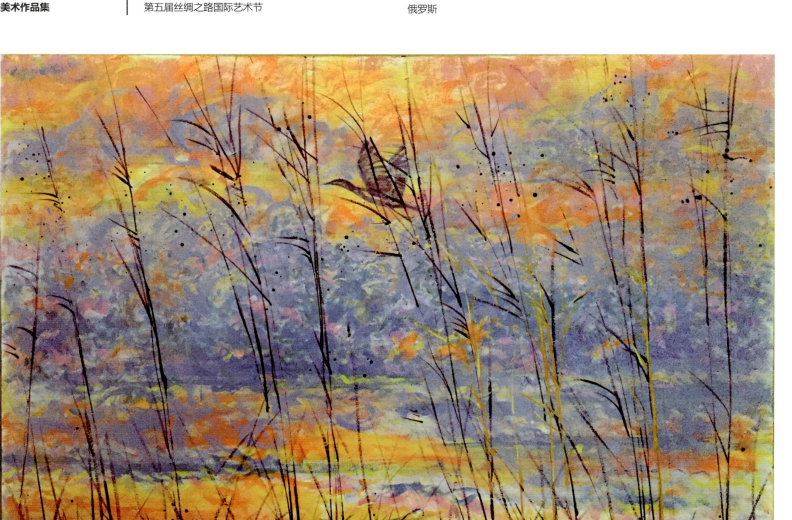

日出 / Sunrise
800mm x 1000mm

瓦伦蒂娜·杜萨维茨卡亚　　Valentina Dusavitskaya
俄罗斯　　　　　　　　　　Russia
绘画　　　　　　　　　　　Painting

Russia
俄罗斯

International Art Exhibition
国际美术展

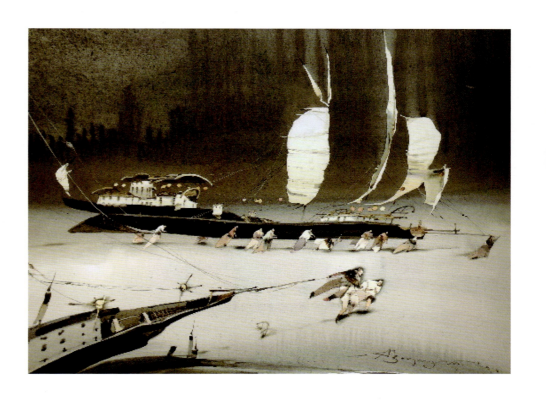

沃茨姆什·亚历克桑德尔
俄罗斯
绘画

盐 / Salt
520mm x 730mm

Votsmush Aleksandr
Russia
Painting

Work Collection of Arts	The Fifth Silk Road International Arts Festival	Russia
美术作品集	第五届丝绸之路国际艺术节	俄罗斯

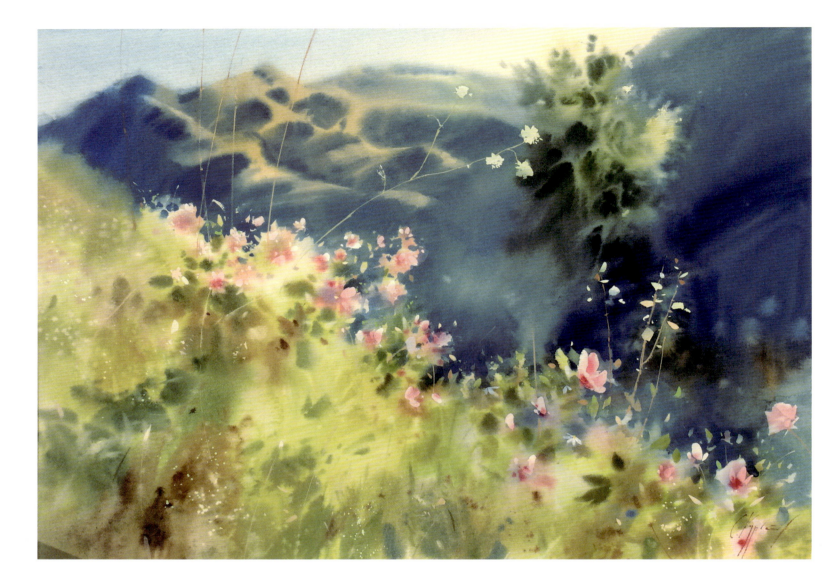

山之晨 / Mountains in the Morning
730mm x 540mm

谢尔盖·库尔巴托夫	Sergei Kurbatov
俄罗斯	Russia
绘画	Painting

Russia
俄罗斯

International Art Exhibition
国际美术展

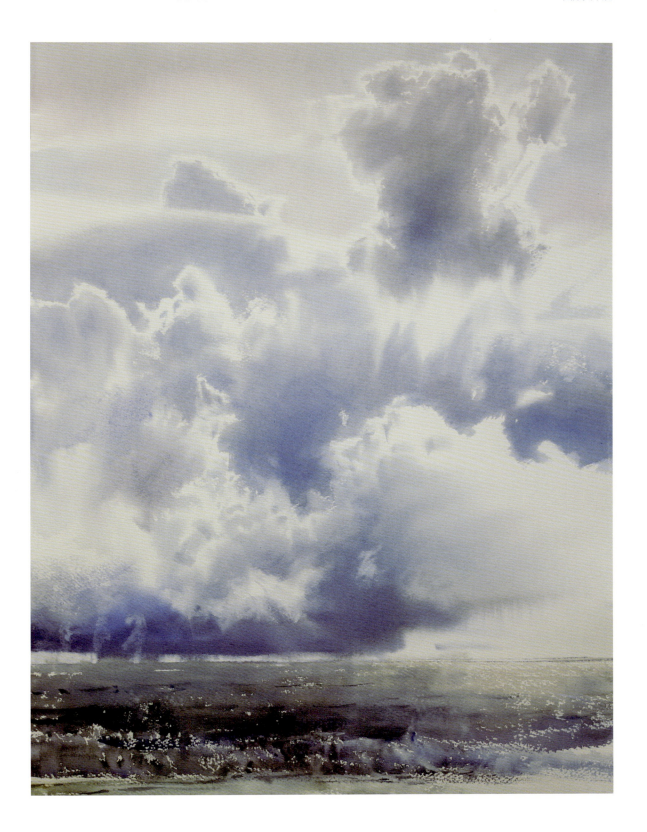

海天一体 / The Motion of Sea, the Motion in the Skies
760mm x 560mm

谢尔盖·特米雷夫 | Sergei Temerev
俄罗斯 | Russia
绘画 | Painting

| Work Collection of Arts | The Fifth Silk Road International Arts Festival | Rwanda |
| 美术作品集 | 第五届丝绸之路国际艺术节 | 卢旺达 |

无题 / Unnamed
500mm x 670mm

尤马希尔·艾萨卡里 | Umuhire Isakari
卢旺达 | Rwanda
绘画 | Painting

Saudi Arabia / 沙特阿拉伯 — International Art Exhibition / 国际美术展

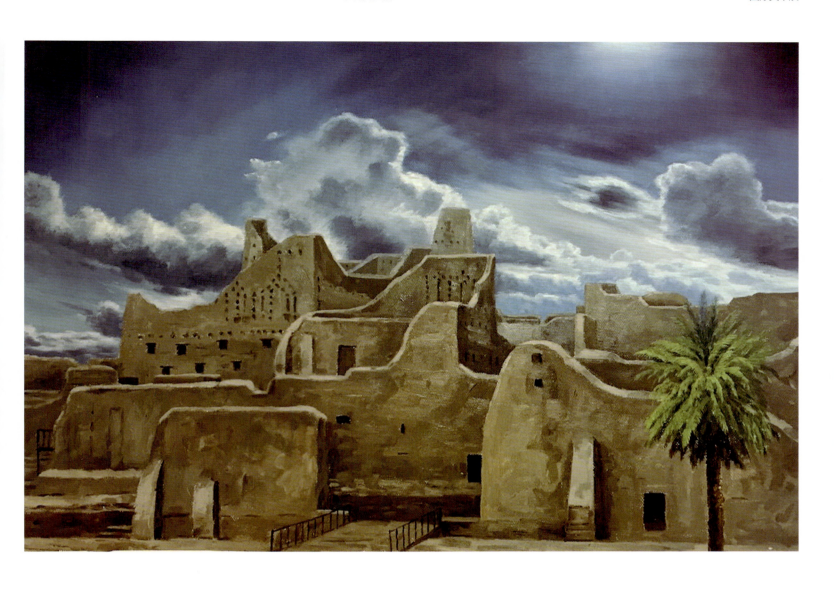

无题 / Unnamed

云芸
沙特阿拉伯
绘画

Aisha Yun
Saudi Arabia
Painting

| Work Collection of Arts | The Fifth Silk Road International Arts Festival | Serbia |
| 美术作品集 | 第五届丝绸之路国际艺术节 | 塞尔维亚 |

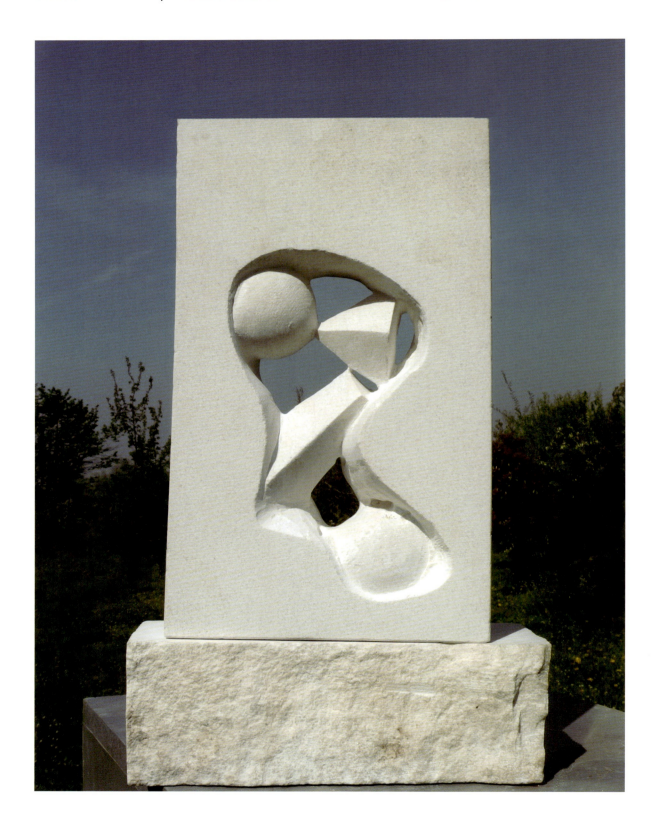

创造之美 / Beauty of Creation
250mm x 80mm x 350mm

德左克·科帕杰克	Djordje Cpajak
塞尔维亚	Serbia
雕塑	Sculpture

Serbia
塞尔维亚

International Art Exhibition
国际美术展

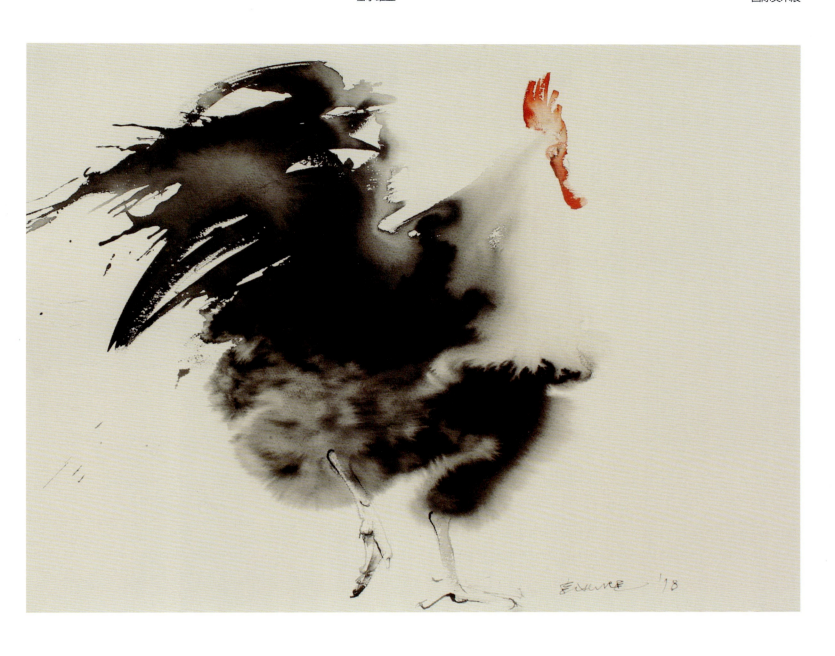

因迪尔·庞万诺科
塞尔维亚
绘画

勇敢 / Gallant
560mm x 760mm

Endre Penovac
Serbia
Painting

Work Collection of Arts	The Fifth Silk Road International Arts Festival	Seychelles
美术作品集	第五届丝绸之路国际艺术节	塞舌尔

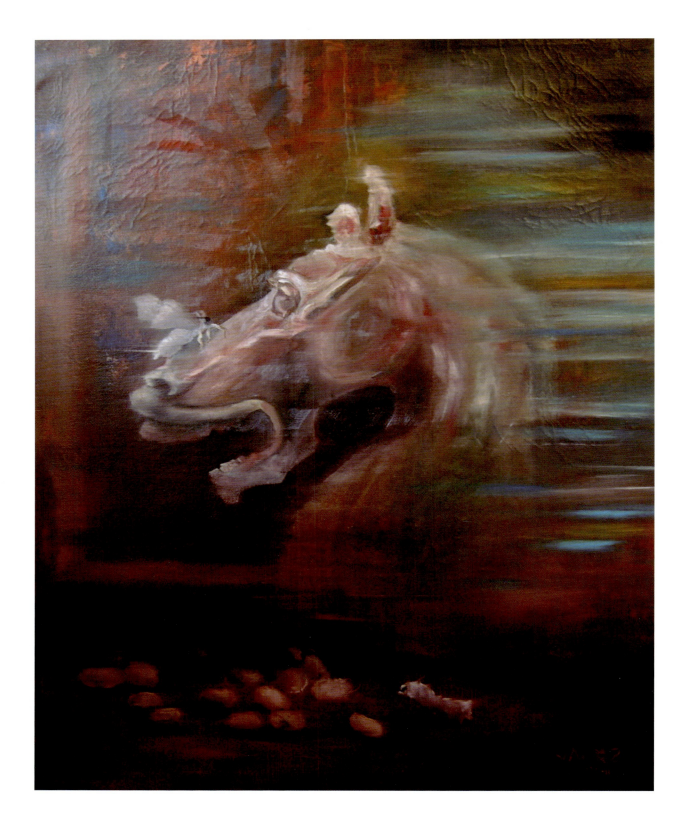

无题 / Unnamed
1000mm x 800mm

朱莉叶·齐利姆	Juliette Zelime
塞舌尔	Seychelles
绘画	Painting

谁最美？/ Who's the Fairest of Them All?
380mm x 558mm

谭关元　　　Tam Kwan Yuen
新加坡　　　Singapore
绘画　　　　Painting

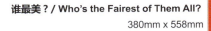

| Work Collection of Arts | The Fifth Silk Road International Arts Festival | Slovakia |
| 美术作品集 | 第五届丝绸之路国际艺术节 | 斯洛伐克 |

橡胶紫茉莉花 / Brasilien
250mm x 350mm

朱迪特·罗萨斯	Judit Rozsas
斯洛伐克	Slovakia
绘画	Painting

Slovakia
斯洛伐克

International Art Exhibition
国际美术展

探头 / Sonde
1000mm x 700mm

马丁·赛维科伟奇 | Martin Ševčovič
斯洛伐克 | Slovakia
绘画 | Painting

| Work Collection of Arts | The Fifth Silk Road International Arts Festival | Slovenia |
| 美术作品集 | 第五届丝绸之路国际艺术节 | 斯洛文尼亚 |

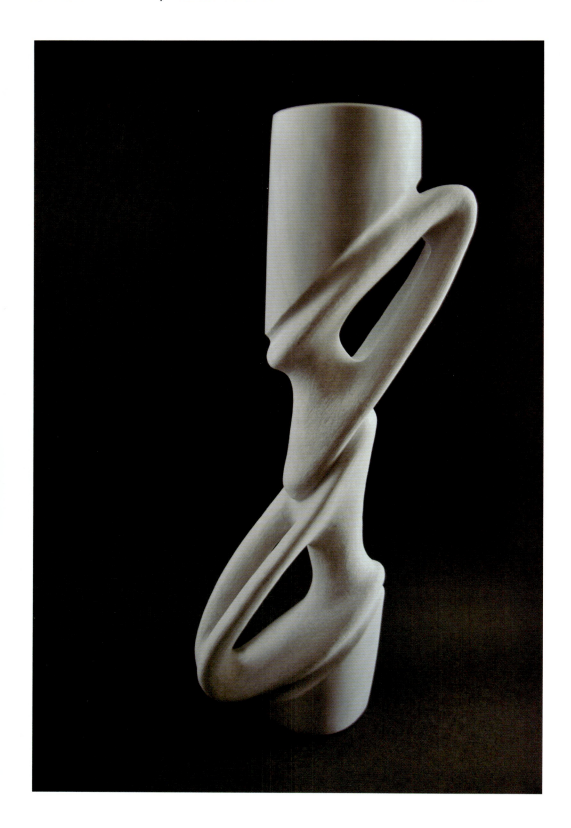

灵魂的影响 / Soul Impacts
500mm x 200mm x 100mm

阿里日尔·施特鲁凯莱	Arijrl Štrukelj
斯洛文尼亚	Slovenia
雕塑	Sculpture

South Africa
南非

International Art Exhibition
国际美术展

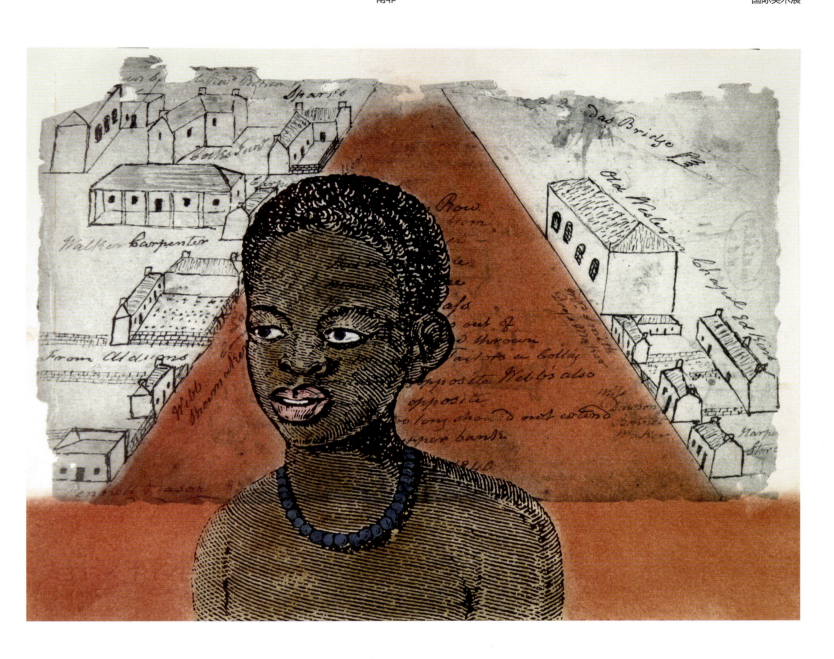

役于土地的忧虑 / *Slave Land Spectres*
400mm x 500mm

多米尼克·托本　|　Dominic Thorburn
南非　　　　　|　South Africa
绘画　　　　　|　Painting

Work Collection of Arts	The Fifth Silk Road International Arts Festival	Spain
美术作品集	第五届丝绸之路国际艺术节	西班牙

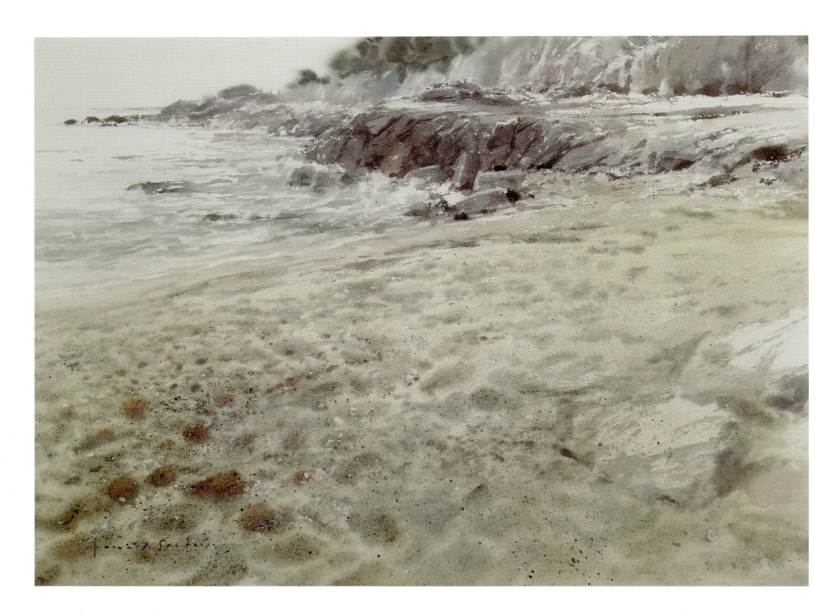

地中海景色 / Mediterranean View
520mm x 720mm

塞斯克·法雷　　　　　　　　Cesc Farre
西班牙　　　　　　　　　　　Spain
绘画　　　　　　　　　　　　Painting

Spain 西班牙 | International Art Exhibition 国际美术展

中心 / Center

丹尼尔·保罗 | Daniel Pablo
西班牙 | Spain
绘画 | Painting

| Work Collection of Arts | The Fifth Silk Road International Arts Festival | Spain |
| 美术作品集 | 第五届丝绸之路国际艺术节 | 西班牙 |

桥之颜色 I / Bridge of Colors1
520mm x 700mm

费尔南多·巴里昂诺夫	Fernando Barrionuevo
西班牙	Spain
绘画	Painting

Spain
西班牙

International Art Exhibition
国际美术展

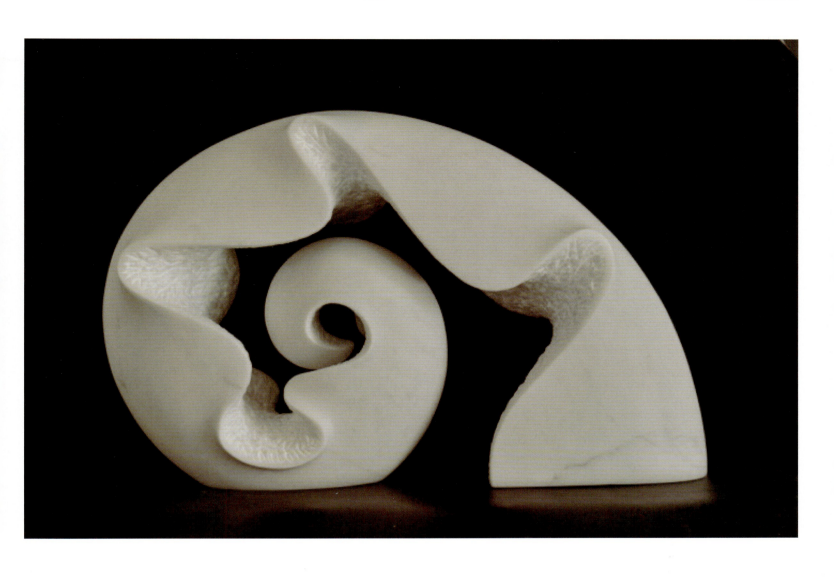

海贝 / Sea Shell
500mm x 320mm x 130mm

南多·阿尔瓦雷斯
西班牙
雕塑

Nando Alvarez
Spain
Sculpture

Work Collection of Arts	The Fifth Silk Road International Arts Festival	Spain
美术作品集	第五届丝绸之路国际艺术节	西班牙

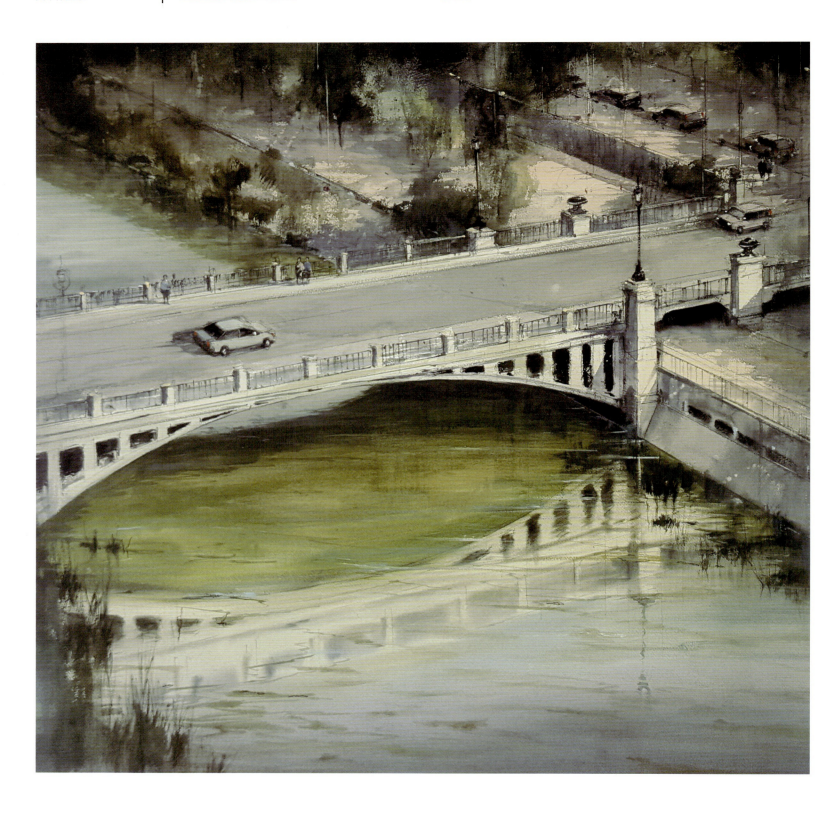

维多利亚女王大桥 / Queen Victoria Bridge
750mm x 750mm

巴勃罗·鲁本·洛佩斯·桑兹	Pablo Ruben Lopez Sanz
西班牙	Spain
绘画	Painting

Sudan
苏丹

International Art Exhibition
国际美术展

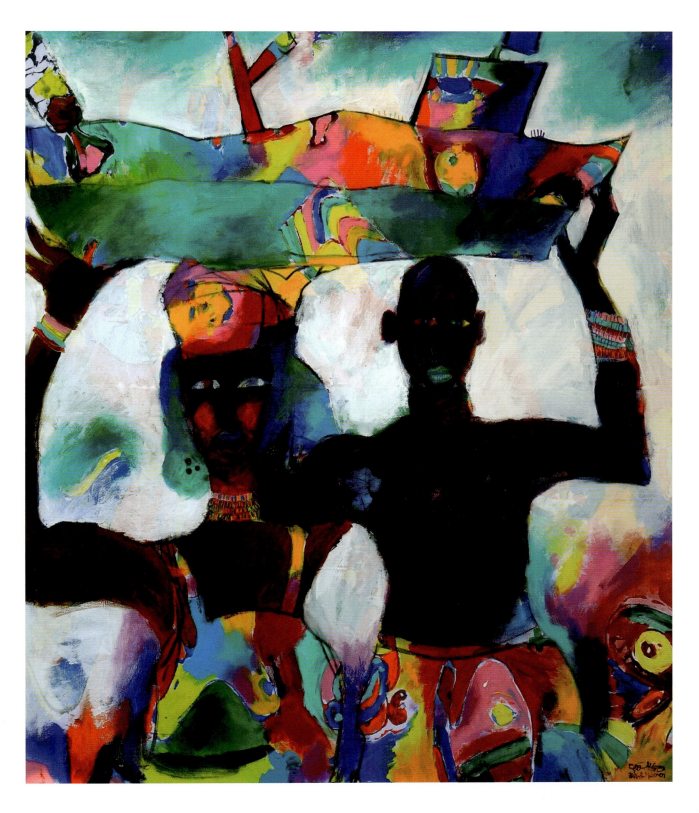

一起 / Together
1000mm x 1000mm

扎克·艾尔·玛波伦 | Zaki Al Maboren
苏丹 | Sudan
绘画 | Painting

| Work Collection of Arts / 美术作品集 | The Fifth Silk Road International Arts Festival / 第五届丝绸之路国际艺术节 | Sweden / 瑞典 |

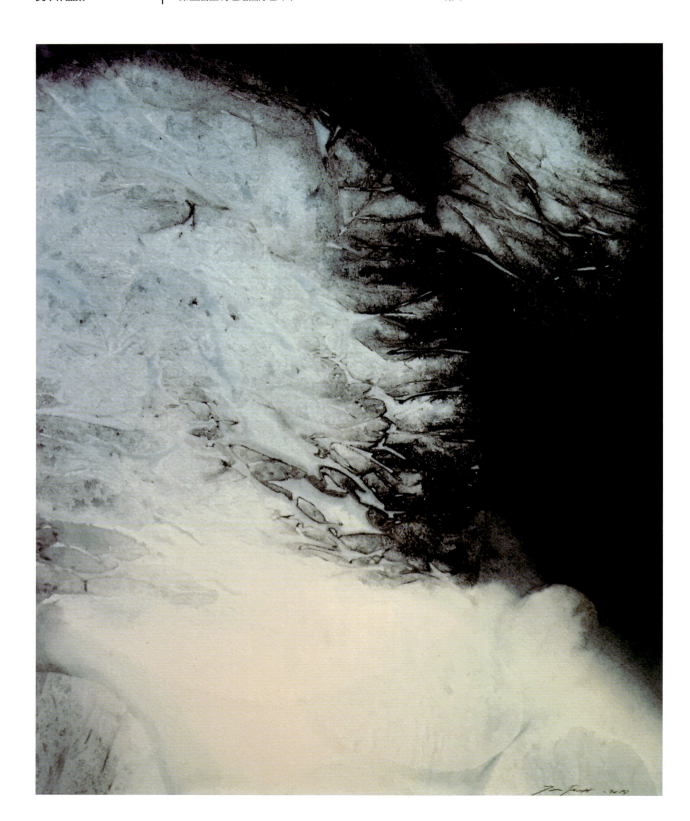

缠裹 / Wrapped Motions
400mm x 500mm

乔纳斯·佩特森 | Jonas Pettersson
瑞典 | Sweden
绘画 | Painting

Switzerland 瑞士 | International Art Exhibition 国际美术展

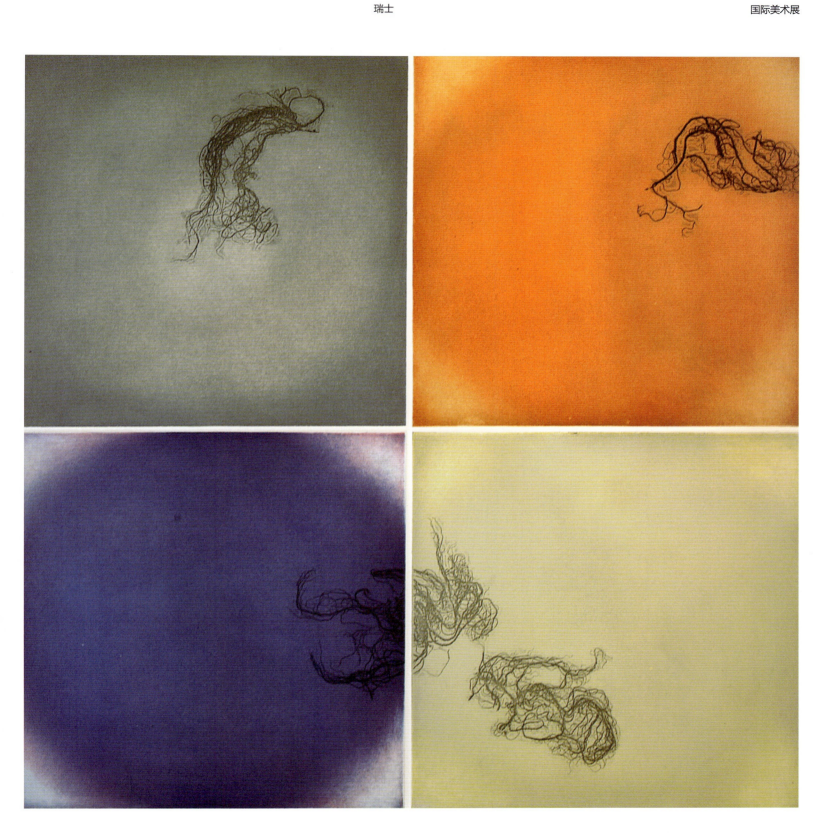

巴塞罗那IV / Barcelona 4
725mm x 590mm

卡尔·艾伯特·扬森
瑞士
绘画

Karl Albert Jansen
Switzerland
Painting

Work Collection of Arts	The Fifth Silk Road International Arts Festival	Syrian
美术作品集	第五届丝绸之路国际艺术节	叙利亚

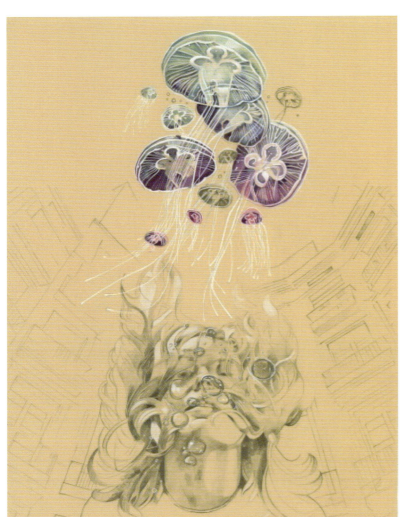
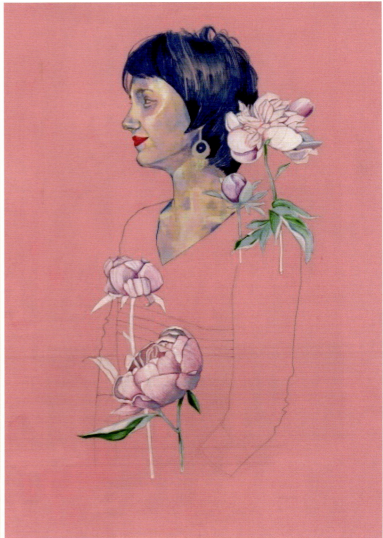

诺拉 / Nora
600mm x 800mm

阿利亚·阿布·哈多尔 | Aliaa Abou Khaddour
叙利亚 | Syrian
绘画 | Painting

Syrian
叙利亚

International Art Exhibition
国际美术展

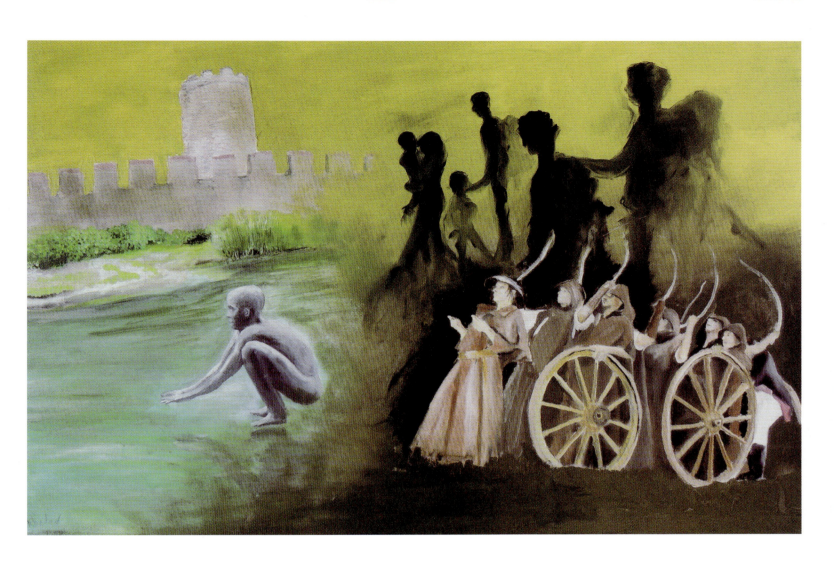

哈立德·阿尔多
叙利亚
绘画

新生 / Neues Leben
800mm x 1200mm

Khaled Al Deab
Syrian
Painting

Work Collection of Arts	The Fifth Silk Road International Arts Festival	Syrian
美术作品集	第五届丝绸之路国际艺术节	叙利亚

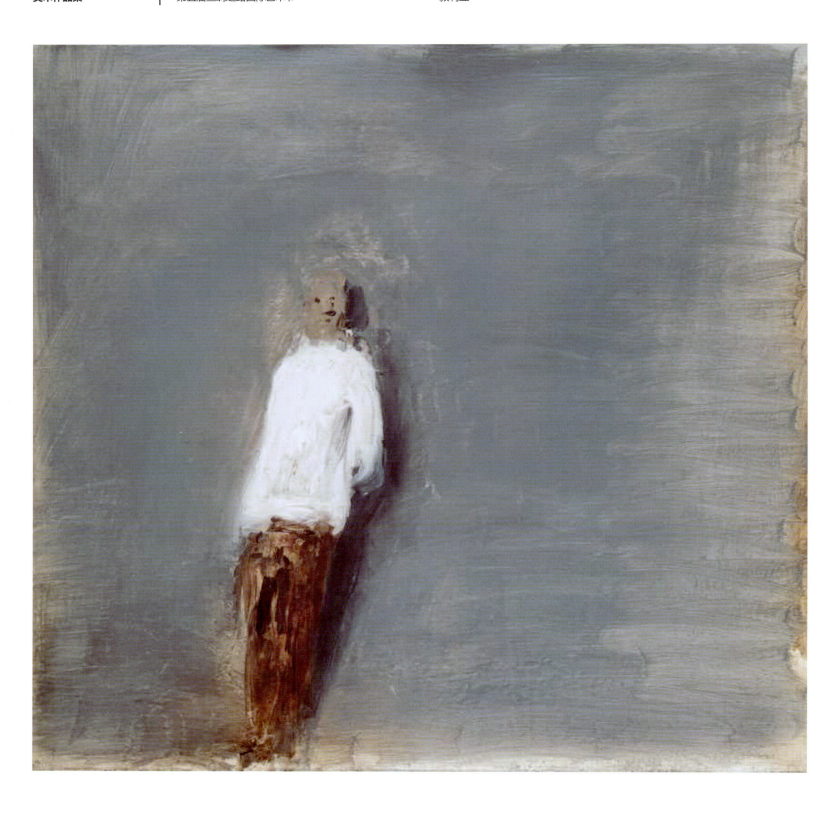

无题 / Unnamed
700mm x 700mm

纳赛尔·侯赛因 | Nasser Hussein
叙利亚 | Syrian
绘画 | Painting

Thailand
泰国

International Art Exhibition
国际美术展

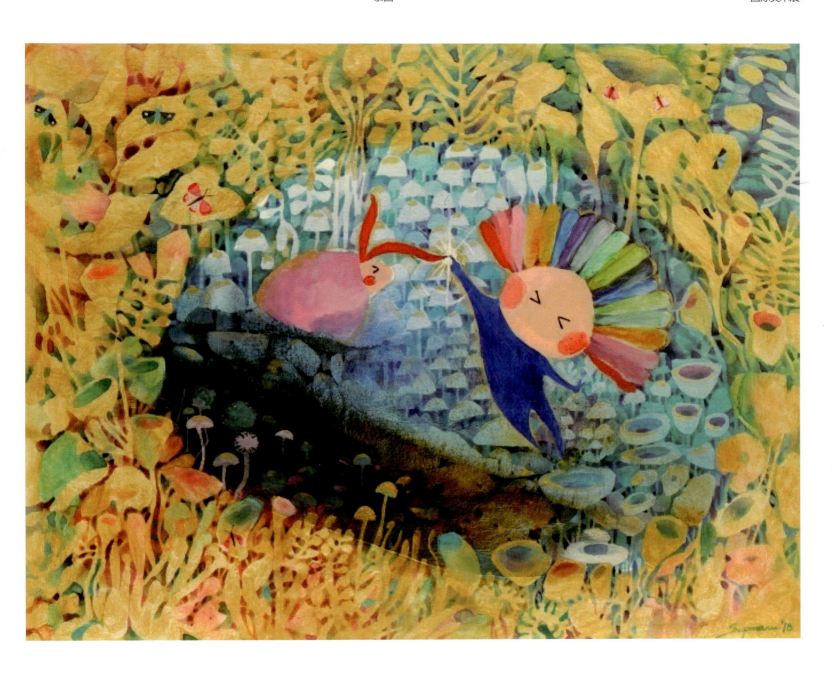

苏曼斯·克里斯蒂娜
泰国
绘画

一起 / **Together**
800mm x 1000mm
Supmanee Chaisansuk
Thailand
Painting

| Work Collection of Arts | The Fifth Silk Road International Arts Festival | Thailand |
| 美术作品集 | 第五届丝绸之路国际艺术节 | 泰国 |

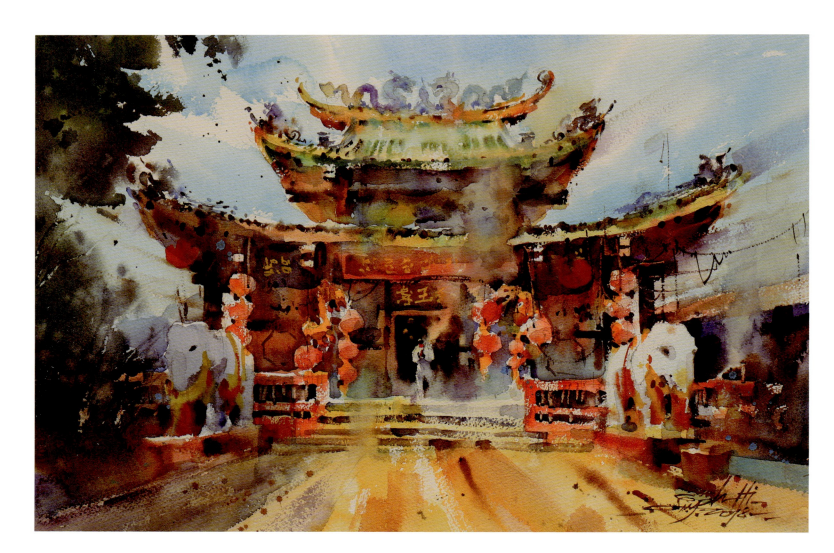

中国圣殿 / Chinese Shrine
380mm x 560mm

苏比霍沃特·锡兰塔那威沃特 | Suphawat Hiranthanawiwat
泰国 | Thailand
绘画 | Painting

Togo
多哥

International Art Exhibition
国际美术展

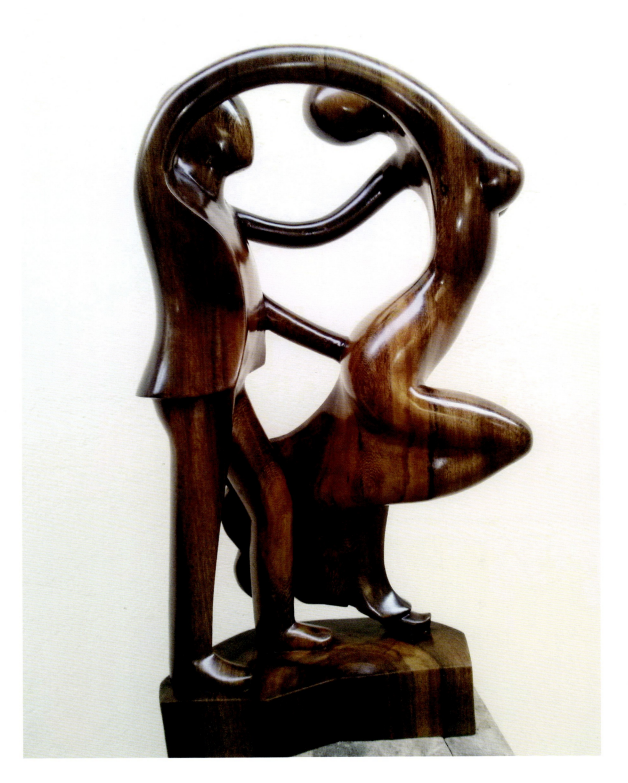

鲍佛·阿贝尔
多哥
雕塑

交响乐 / Symphonie
600mm
Aboflan Abel
Togo
Sculpture

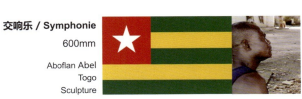

| **Work Collection of Arts** 美术作品集 | The Fifth Silk Road International Arts Festival 第五届丝绸之路国际艺术节 | Tunisia 突尼斯 |

我的突尼斯 / My Tunisia
600mm x 500mm

瑞姆·阿雅	Rim Ayari
突尼斯	Tunisia
绘画	Painting

Turkey　　　　　　　　　　　　　　　　　　　　　　　　　　International Art Exhibition
土耳其　　　　　　　　　　　　　　　　　　　　　　　　　　国际美术展

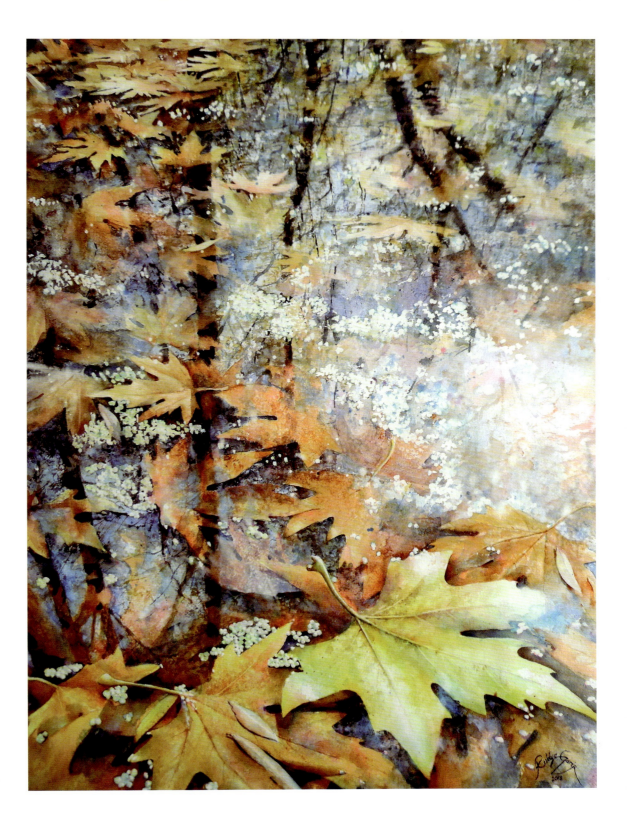

秋色 / Autum Reflections
760mm x 560mm

路基·贾丽普　　　Rukiye Garip
土耳其　　　　　Turkey
绘画　　　　　　Painting

| Work Collection of Arts | The Fifth Silk Road International Arts Festival | Turkey |
| 美术作品集 | 第五届丝绸之路国际艺术节 | 土耳其 |

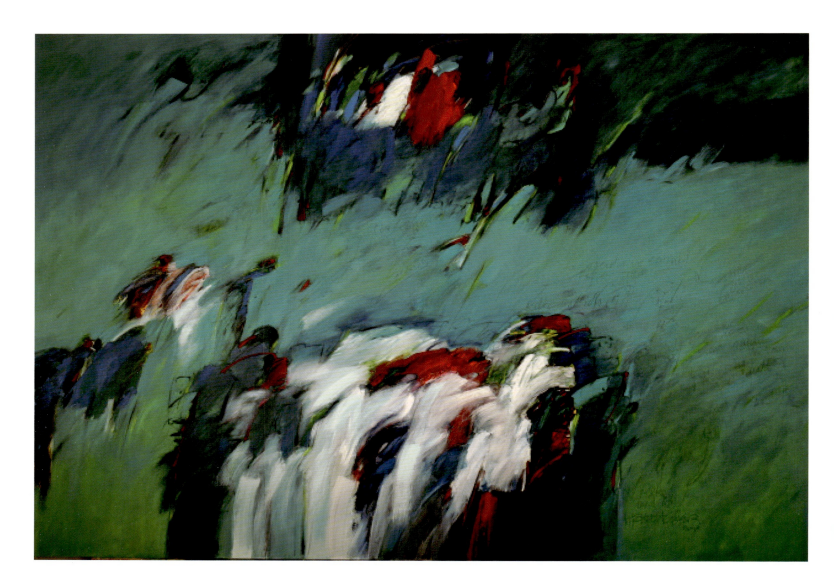

里尔克和我 / Rilke and I
700mm x 600mm x 500mm

穆罕默德·居尔	Mehmet Güler
土耳其	Turkey
绘画	Painting

Turkey
土耳其

International Art Exhibition
国际美术展

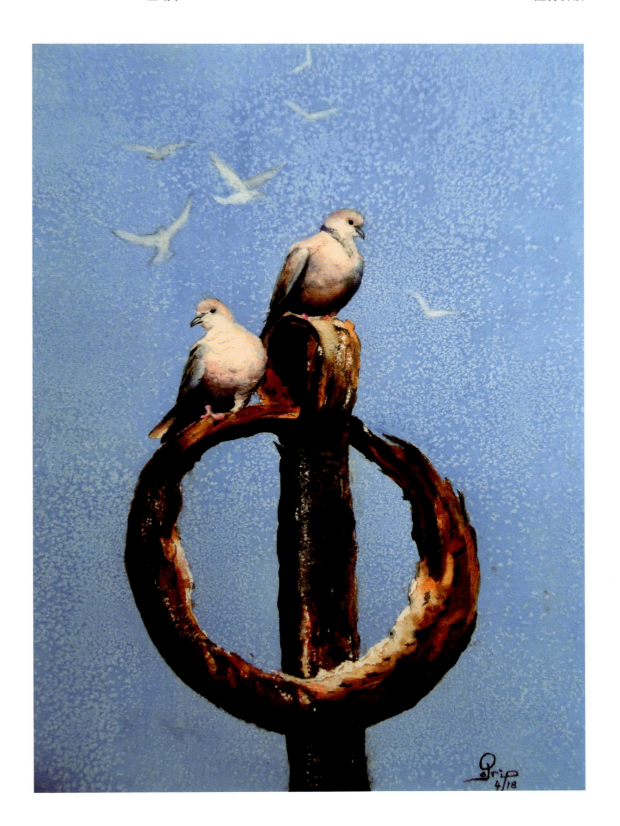

鸽 / Pigeons
2000mm x 2500mm

奥尔罕·贾丽普
土耳其
绘画

Orhan Garip
Turkey
Painting

| Work Collection of Arts | The Fifth Silk Road International Arts Festival | Turkey |
| 美术作品集 | 第五届丝绸之路国际艺术节 | 土耳其 |

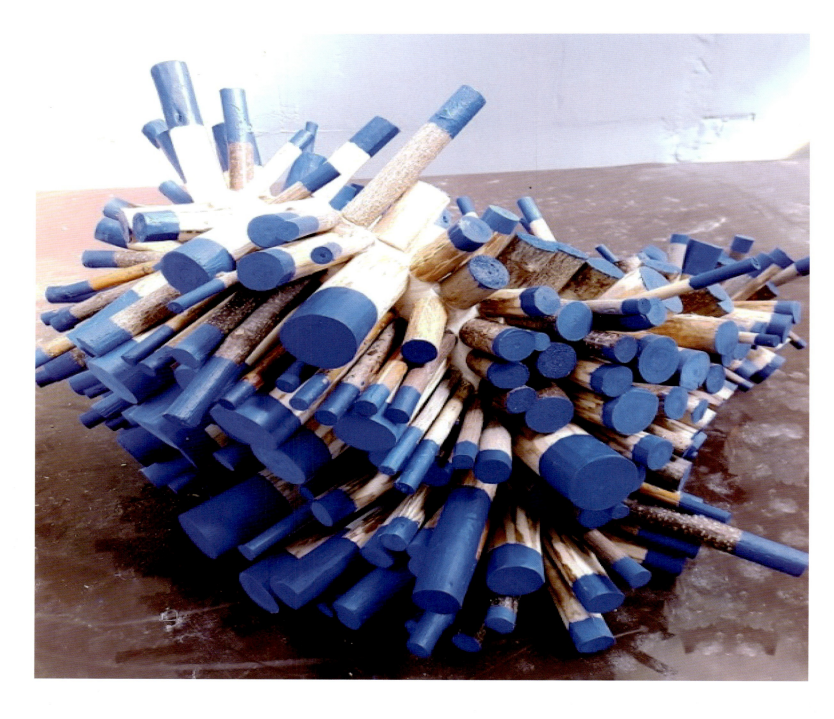

艺术工作 / Cultured Work
700mm x 600mm x 500mm

瓦罗·拖帕奇	Varol Topaç
土耳其	Turkey
雕塑	Sculpture

Uganda
乌干达
International Art Exhibition
国际美术展

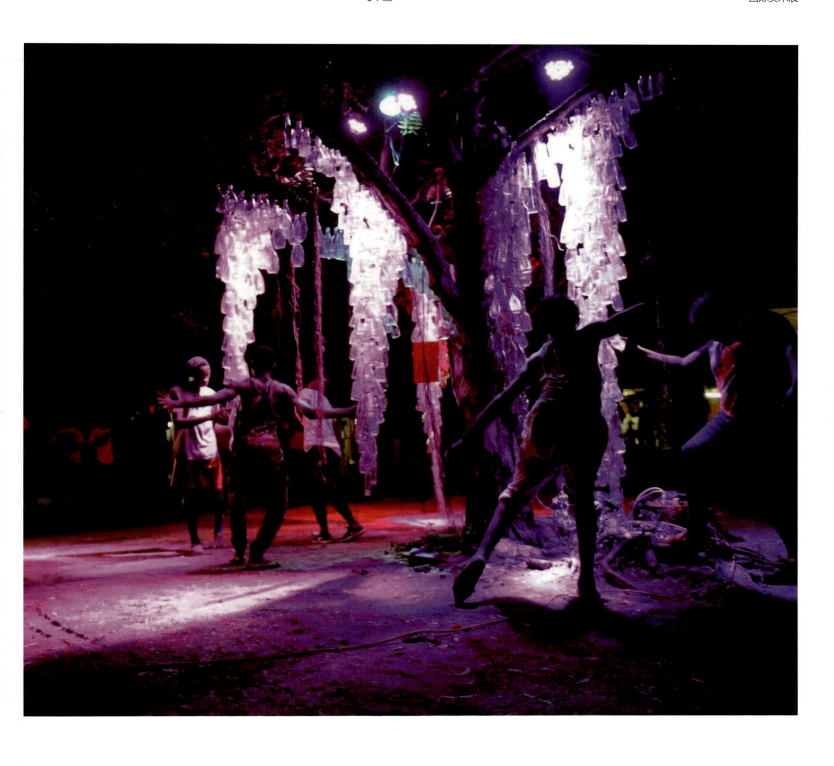

无题 / Unnamed

安培·吉利安·斯迪希 | Abe Gillian Stacey
乌干达 | Uganda
雕塑 | Sculpture

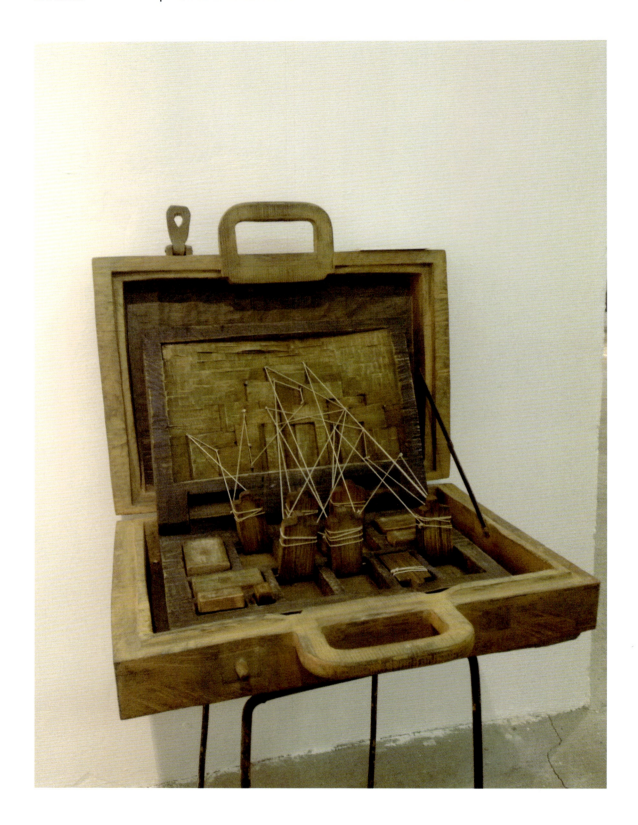

我的个人电脑 / My Personal Computer
600mm x 500mm x 500mm

安娜·伊万诺娃	Anna Ivanova
乌克兰	Ukraine
雕塑	Sculpture

Ukraine
乌克兰

International Art Exhibition
国际美术展

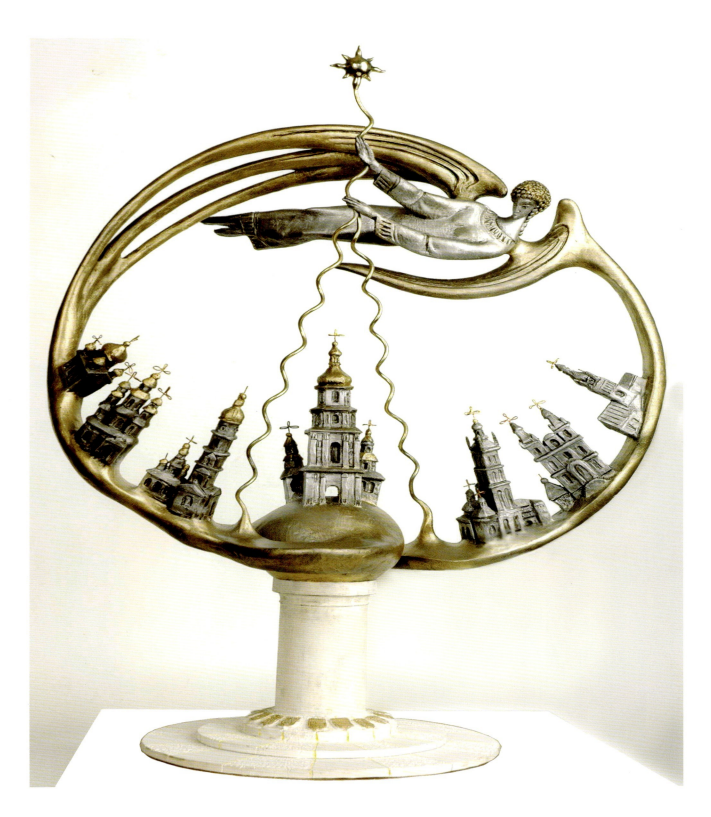

守护天使 / Guardian Angel
600mm x 400mm x 250mm

斯比尼耶夫·瑟希 | Sbitniev Serhii
乌克兰 | Ukraine
雕塑 | Sculpture

Work Collection of Arts	The Fifth Silk Road International Arts Festival	Ukraine
美术作品集	第五届丝绸之路国际艺术节	乌克兰

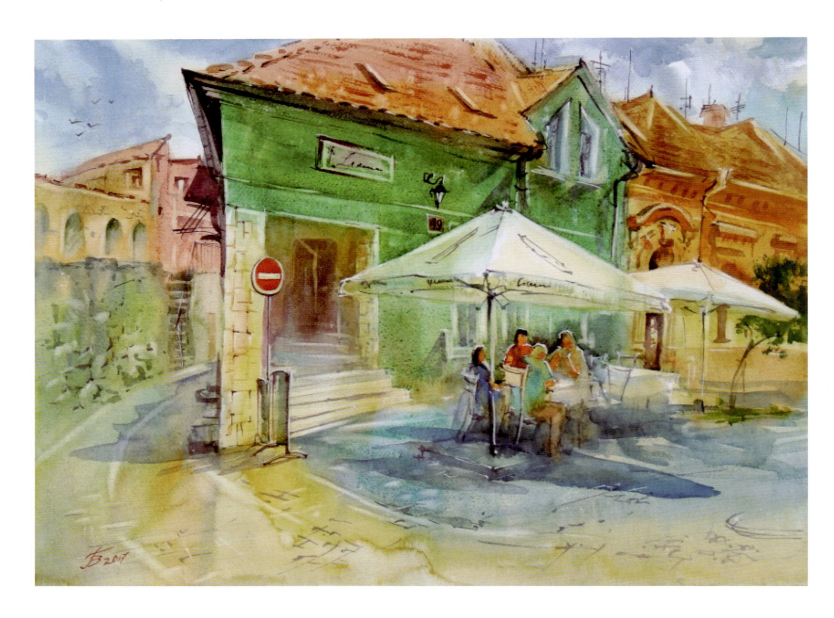

薰衣草咖啡馆 / Café Lavender
500mm x 700mm

格里戈里耶娃·维多利亚	Grigorieva Victoria
乌克兰	Ukraine
绘画	Painting

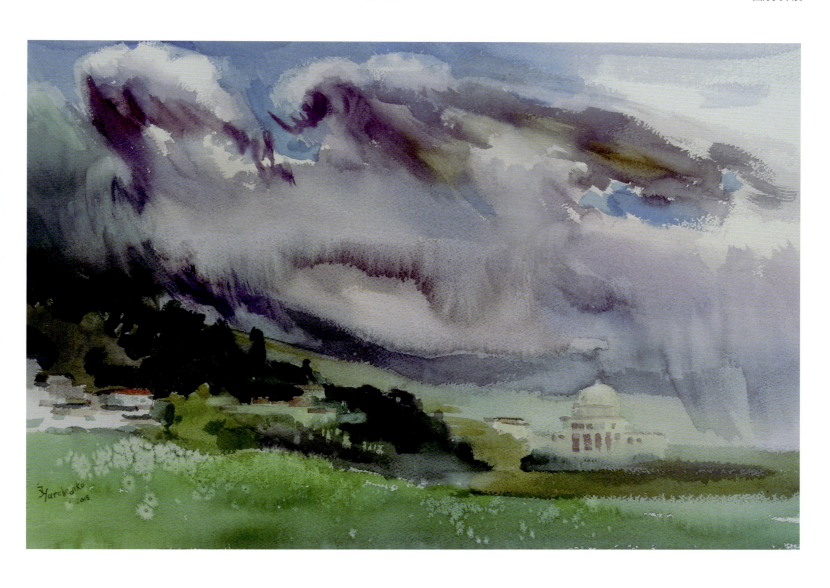

贝拉特·阿尔巴尼亚 / Berat Albania
560mm x 380mm

尤尔琴科·伊霍尔 | Yurchenko Ihor
乌克兰 | Ukraine
绘画 | Painting

Work Collection of Arts
美术作品集

The Fifth Silk Road International Arts Festival
第五届丝绸之路国际艺术节

United Kingdom
英国

铁丝网 / Chicken Wire
360mm x 680mm

安古斯·麦克尤恩	Angus Mcewan
英国	United Kingdom
绘画	Painting

United Kingdom / 英国 — International Art Exhibition / 国际美术展

沉重的负荷 / Heavy Load
500mm x 700mm

戴维·伯克森 / David Poxon
英国 / United Kingdom
绘画 / Painting

| Work Collection of Arts | The Fifth Silk Road International Arts Festival | United Kingdom |
| 美术作品集 | 第五届丝绸之路国际艺术节 | 英国 |

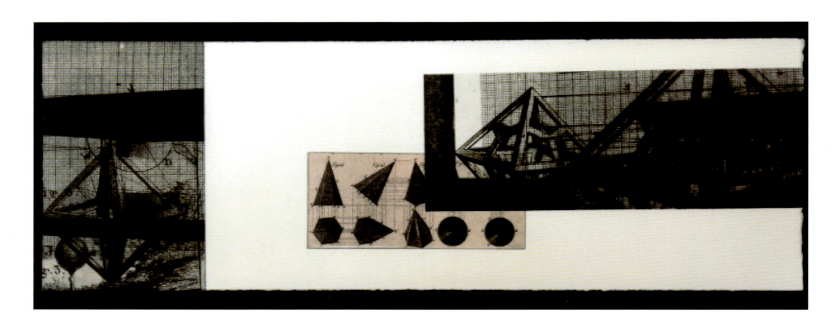

时间和运动 I / Time and Motion Studies 1
180mm x 520mm

尼古拉斯·迪维森 | Nicholas Devison
英国 | United Kingdom
绘画 | Painting

United States / 美国 — International Art Exhibition / 国际美术展

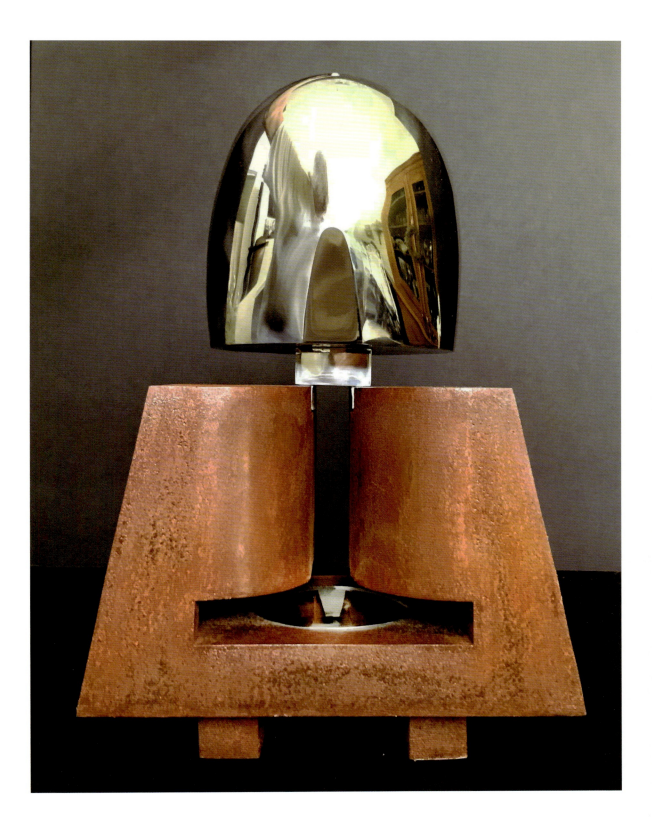

请听 4 号的沉默 / Listen to the Silence No.4

比利·李
美国
雕塑

Billy Lee
United States
Sculpture

Work Collection of Arts	The Fifth Silk Road International Arts Festival	United States
美术作品集	第五届丝绸之路国际艺术节	美国

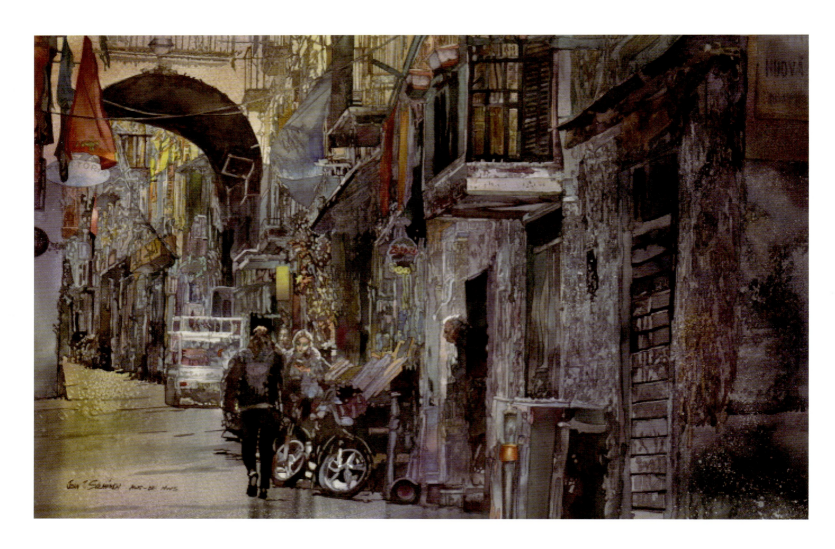

老邻居，那不勒斯 / Old Neighborhood, Napoli
635mm x 965mm

约翰·萨尔米宁	John Salminen
美国	United States
绘画	Painting

United States / 美国 — International Art Exhibition / 国际美术展

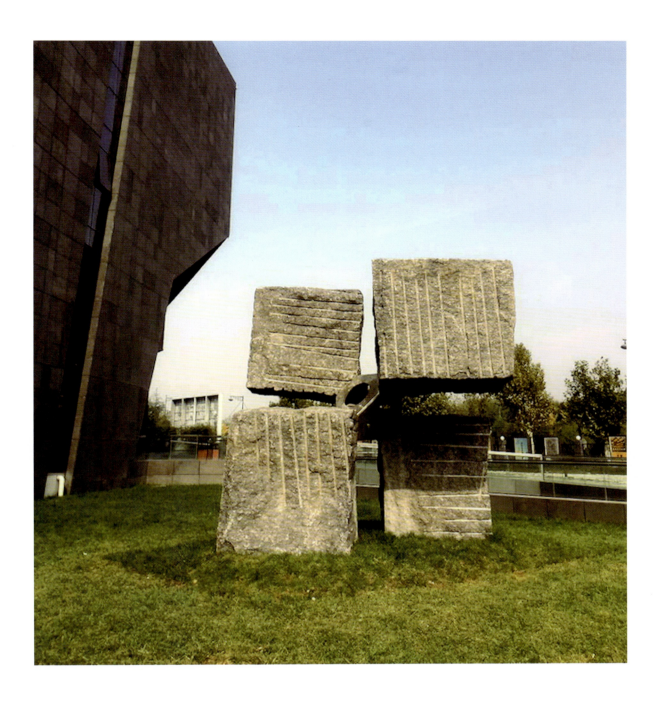

乔恩·巴洛·哈德森
美国
雕塑

无题 / Unnamed

Jon Barlow Hudson
United States
Sculpture

| Work Collection of Arts | The Fifth Silk Road International Arts Festival | United States |
| 美术作品集 | 第五届丝绸之路国际艺术节 | 美国 |

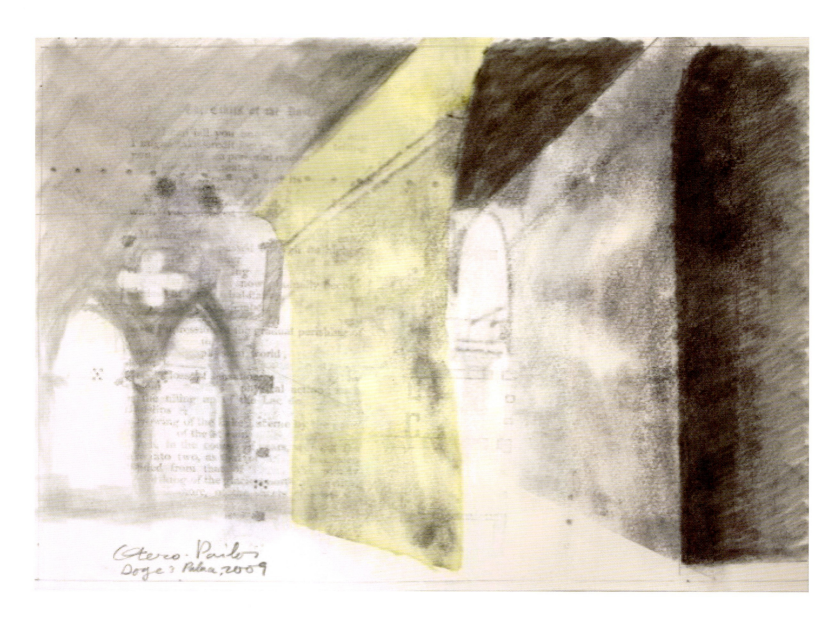

总督宫 I / Study for Doge's Palace 1

350mm x 250mm

奥泰罗·帕伊洛斯·乔治 | Otero Pailos Jorge
美国 | United States
绘画 | Painting

United States / 美国 — International Art Exhibition / 国际美术展

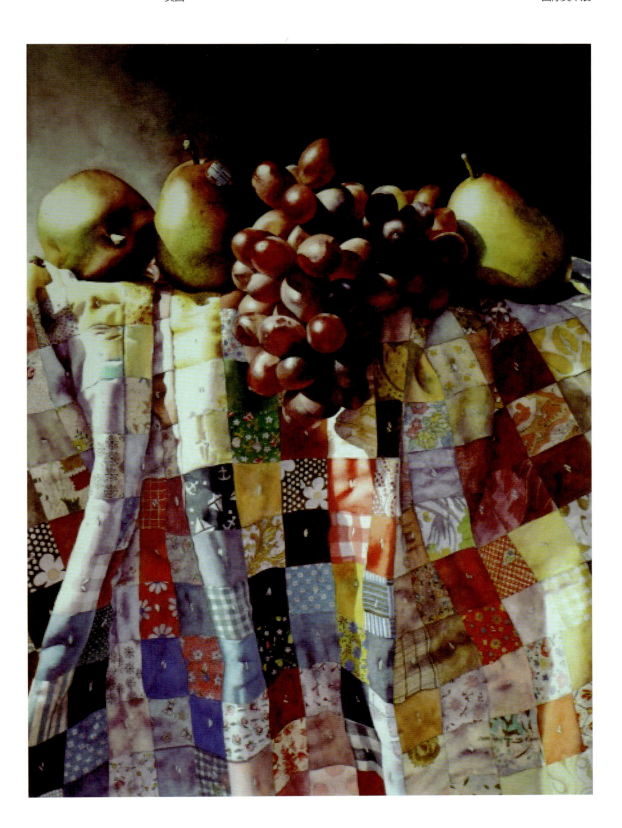

克里斯·克鲁平斯基
美国
绘画

闪光 / Illumination
760mm x 560mm
Chris Krupinski
United States
Painting

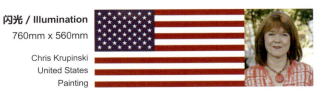

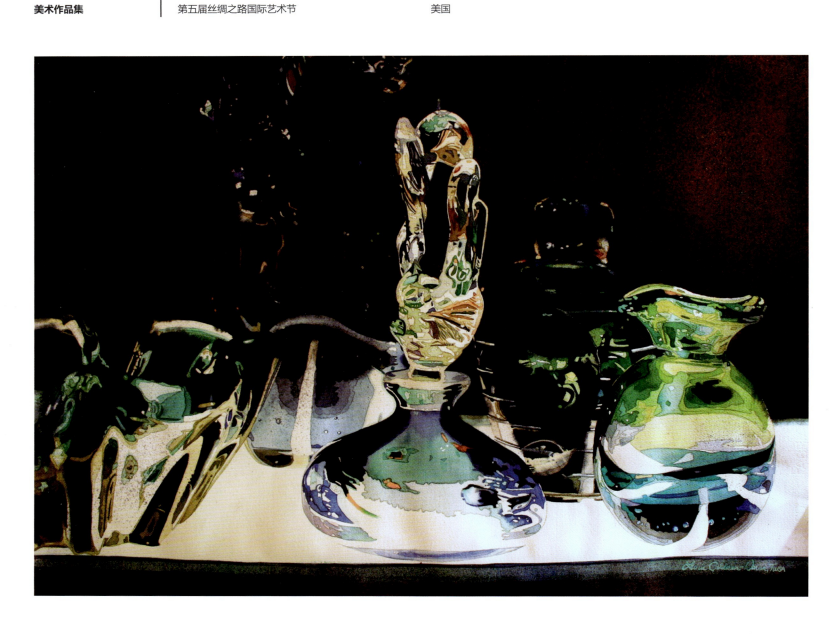

蓝色玻璃 / Glass in Blue
560mm x 760mm

劳里·金斯坦·华伦 | Laurie Goldstein Warren
美国 | United States
绘画 | Painting

United States / 美国 — International Art Exhibition / 国际美术展

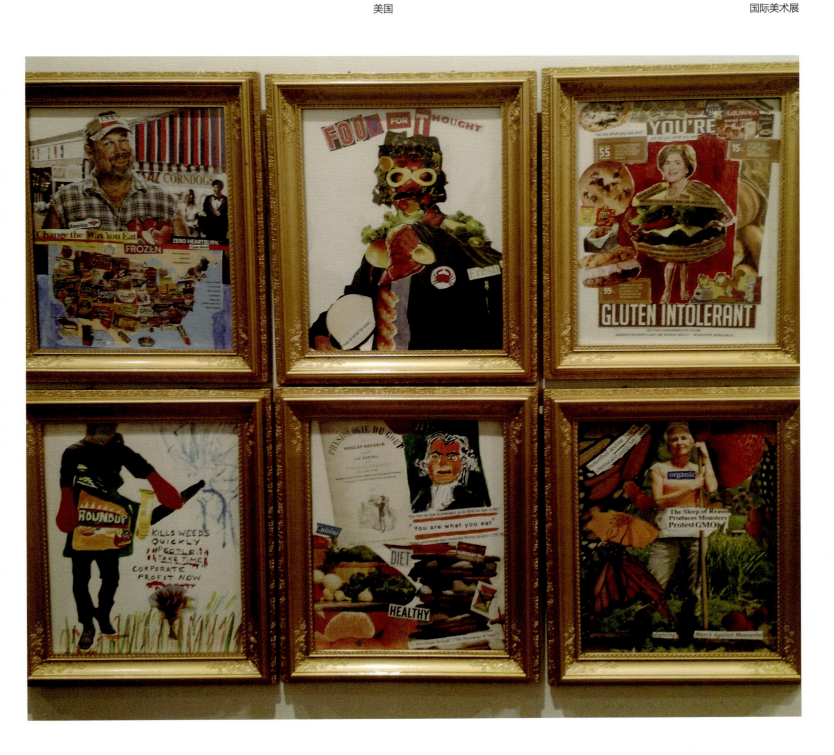

精神食粮 / Food for Thought Ties

610mm x 770mm

盖尔·列文 / Gail Levin
美国 / United States
绘画 / Painting

Work Collection of Arts	The Fifth Silk Road International Arts Festival	United States
美术作品集	第五届丝绸之路国际艺术节	美国

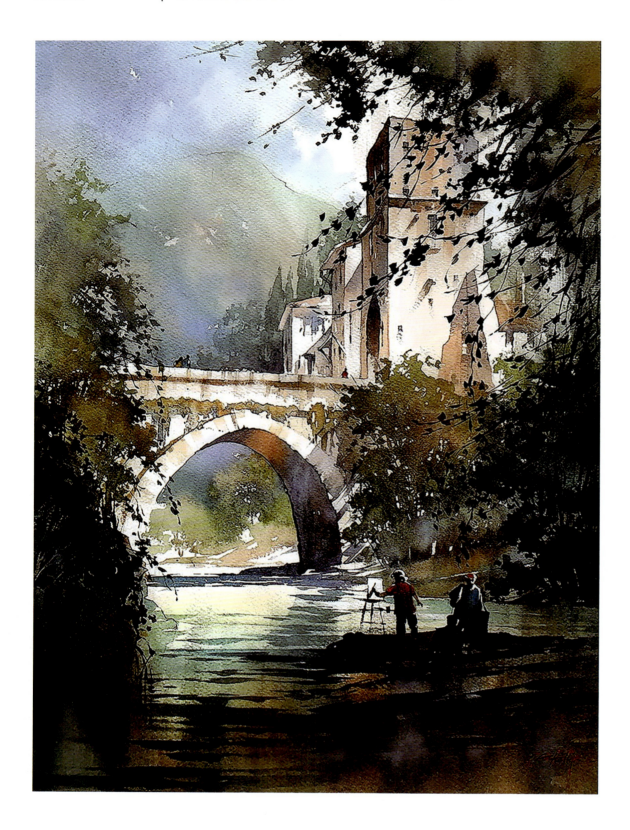

乡村绘画——意大利 / Painting in the Countryside—Italy
560mm x 760mm

托马斯·W·夏尔	Thomas W Schaller
美国	United States
绘画	Painting

Uzbekistan
乌兹别克斯坦

International Art Exhibition
国际美术展

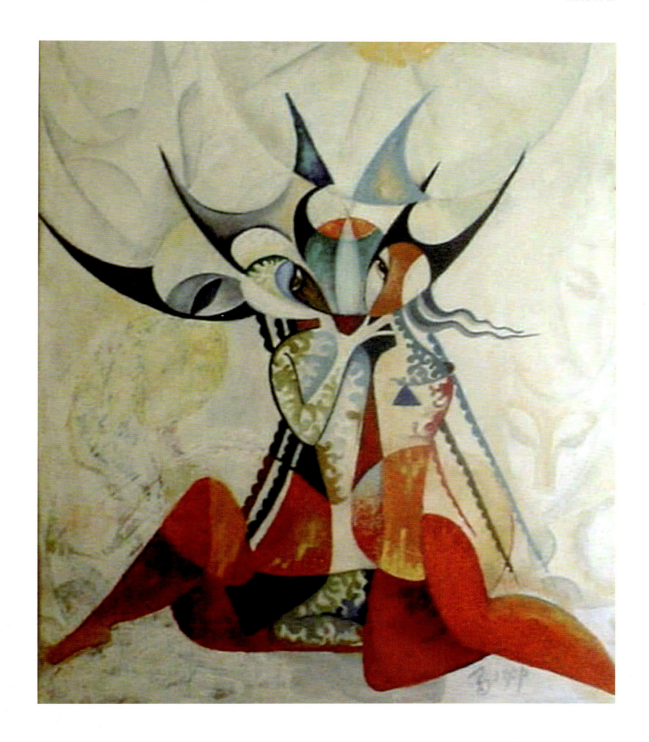

多面的东方 / The Many—Sided Eas
1100mm x 1000mm

古尔佐尔·苏塔诺娃　　Gulzor Sultanova
乌兹别克斯坦　　　　　Uzbekistan
绘画　　　　　　　　　Painting

| Work Collection of Arts | The Fifth Silk Road International Arts Festival | Uzbekistan |
| 美术作品集 | 第五届丝绸之路国际艺术节 | 乌兹别克斯坦 |

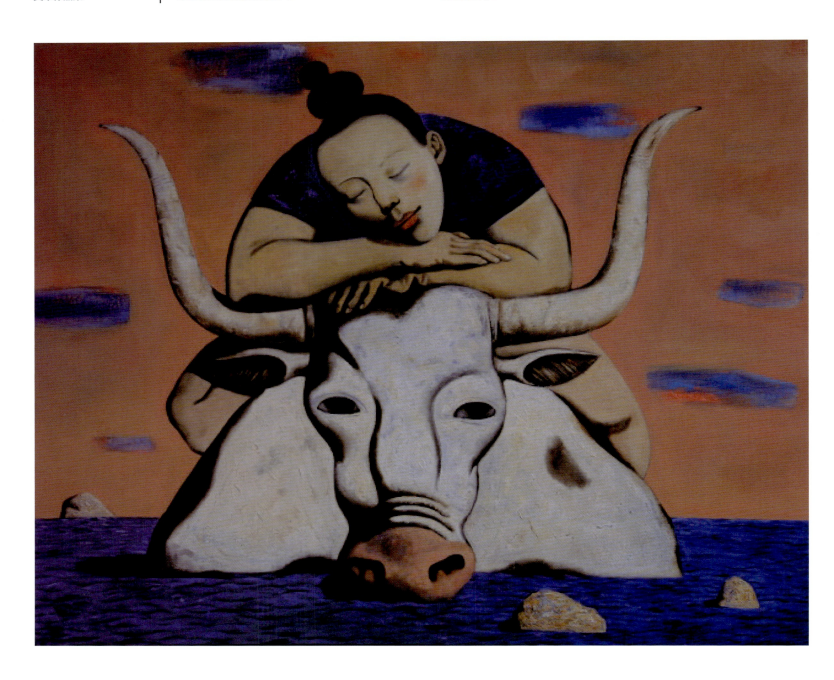

无题 / Unnamed
800mm x 1000mm

扎卡耶夫 | Zakarya Zakaryaev
乌兹别克斯坦 | Uzbekistan
绘画 | Painting

Venezuela / 委内瑞拉 — International Art Exhibition / 国际美术展

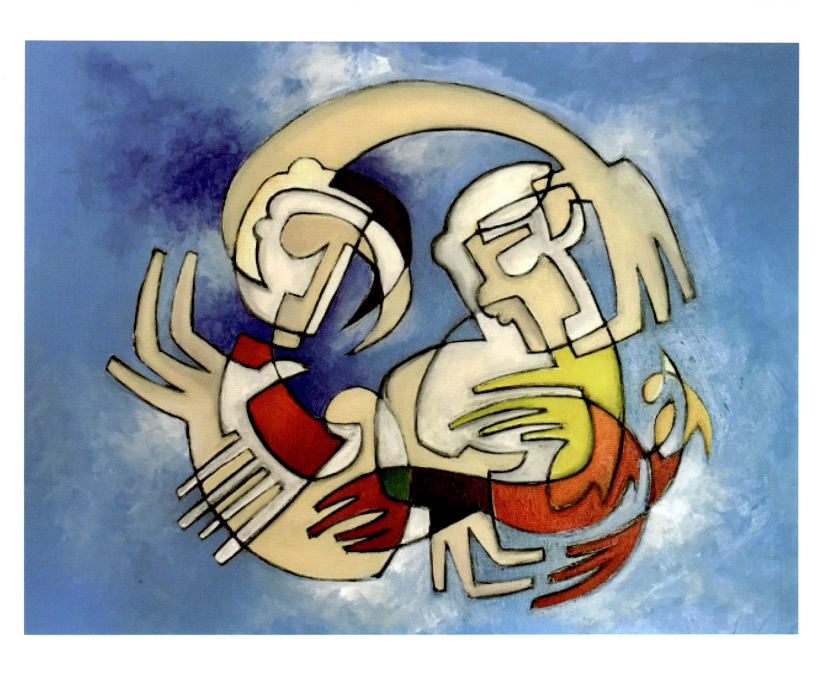

东部的拥抱 / Eastern Embrace
700mm x 600mm

罗纳德·帕雷德斯·瓦佳斯
委内瑞拉
绘画

Ronald Paredes Vargas
Venezuela
Painting

| Work Collection of Arts | The Fifth Silk Road International Arts Festival | Viet Nam |
| 美术作品集 | 第五届丝绸之路国际艺术节 | 越南 |

利奇菲尔德乡村 / Lichfield Countryside
380mm x 560mm

阮麦	Mai Nguyen
越南	Viet Nam
绘画	Painting

Viet Nam
越南

International Art Exhibition
国际美术展

花儿 / Flowers

阮图红
越南
绘画

Thu Huong Nguyen
Viet Nam
Painting

| Work Collection of Arts | The Fifth Silk Road International Arts Festival | Yemen |
| 美术作品集 | 第五届丝绸之路国际艺术节 | 也门 |

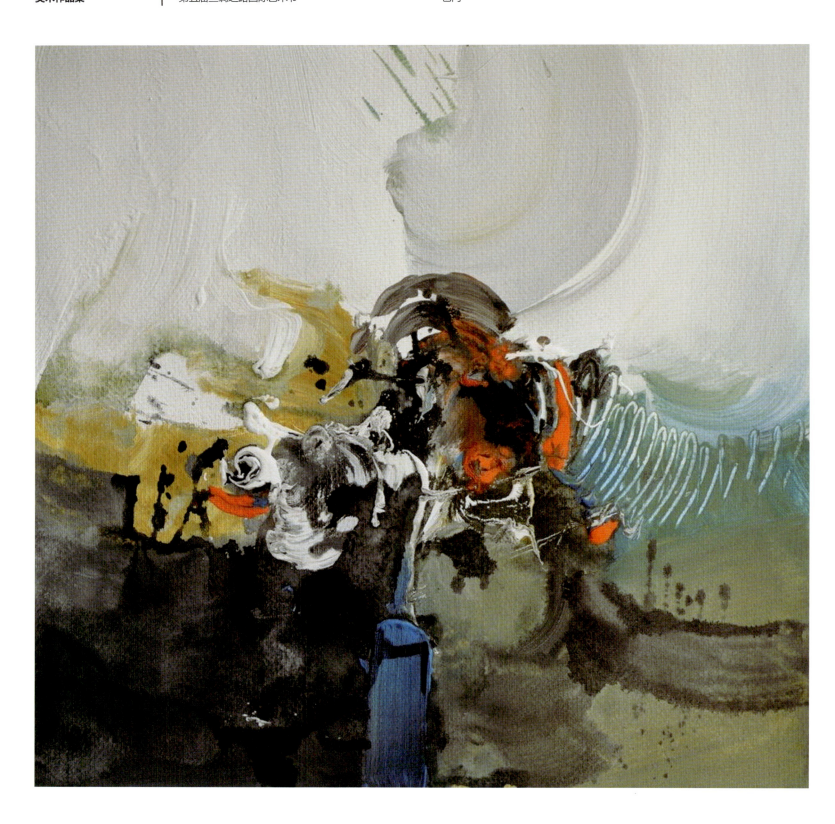

无题 / Unnamed

亚希尔·穆罕穆德·阿普度·阿斯安 Yasser Mohammed Abdo Alansi
也门 Yemen
绘画 Painting

Zambia
赞比亚

International Art Exhibition
国际美术展

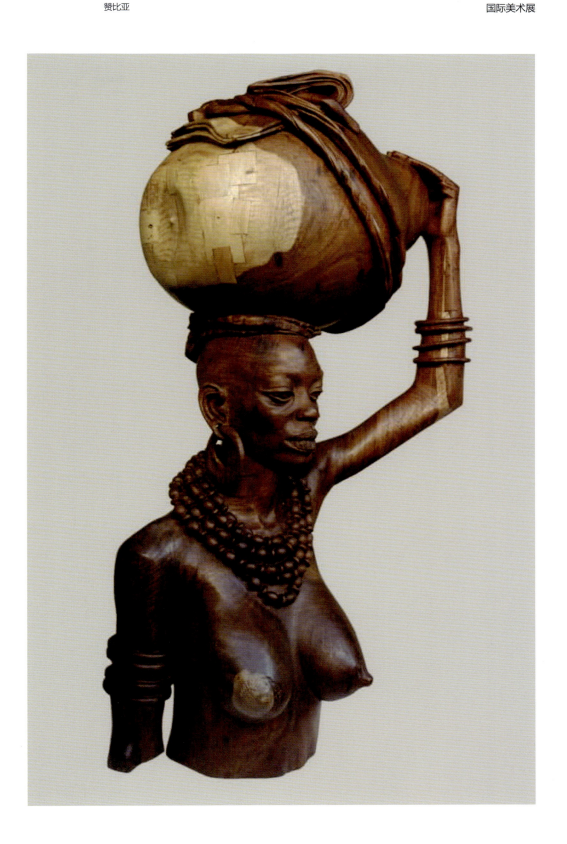

查尔·昌巴塔
赞比亚
雕塑

遣返 / Repatriation
1100mm x 550mm x 450mm

Charles Chambata
Zambia
Sculpture

| Work Collection of Arts 美术作品集 | The Fifth Silk Road International Arts Festival 第五届丝绸之路国际艺术节 | Zimbabwe 津巴布韦 |

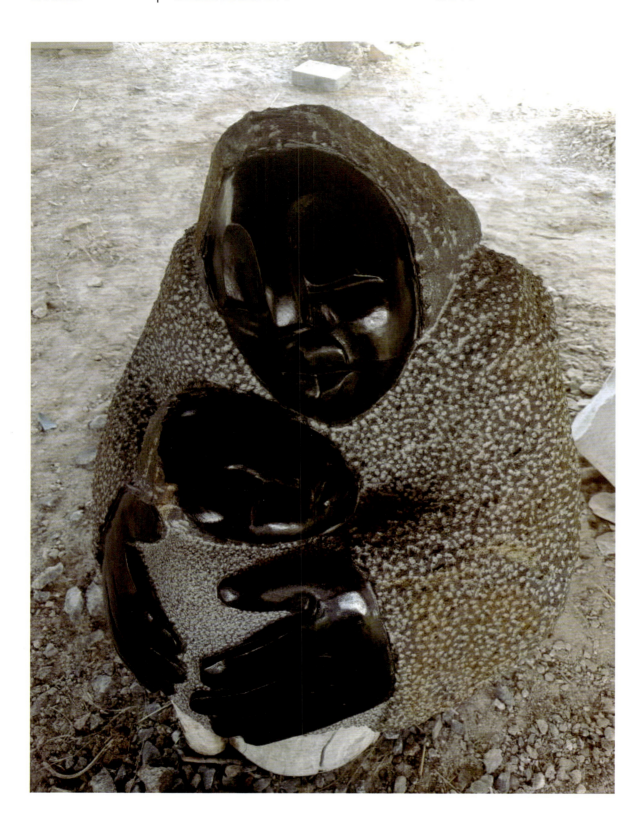

合为一体 / Together as One
1400mm x 700mm x 600mm

玛利亚·南亚行谷　　　Marian S. Nyanhongo
津巴布韦　　　　　　Zimbabwe
雕塑　　　　　　　　Sculpture

丝绸之路国际艺术节
The Silk Road International Arts Festival

第五届丝绸之路国际艺术展 《今日丝绸之路》 国际美术展
The Fifth Silk Road International Arts Festival Today Silk Road Special Exhibition of International Art Works

朝鲜 / 韩国联合特展作品
A Special Exhibition of D.P.R.Korea and Korea Joint Works

Work Collection of Arts	The Fifth Silk Road International Arts Festival	D.P.R.Korea
美术作品集	第五届丝绸之路国际艺术节	朝鲜

饲养员 / Breeder
1180mm x 920mm

成哲	Zhe Cheng
朝鲜	D.P.R.Korea
绘画	Painting

D.P.R.Korea 朝鲜 — International Art Exhibition 国际美术展

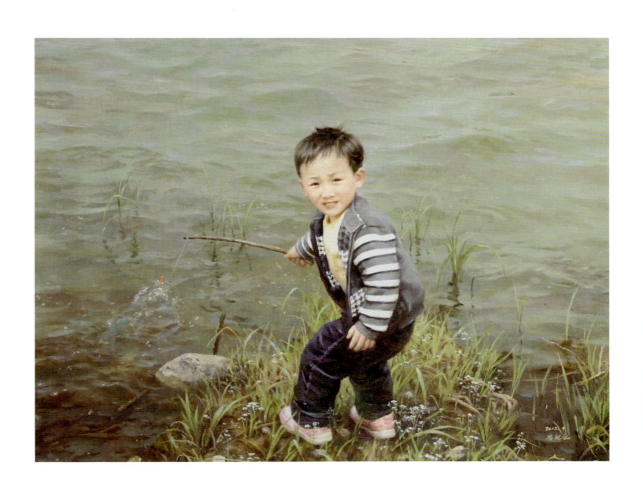

江边 / Riverside
1080mm x 860mm

金哲顺　　Zheshun Jin
朝　鲜　　D.P.R.Korea
绘　画　　Painting

| Work Collection of Arts | The Fifth Silk Road International Arts Festival | D.P.R.Korea |
| 美术作品集 | 第五届丝绸之路国际艺术节 | 朝鲜 |

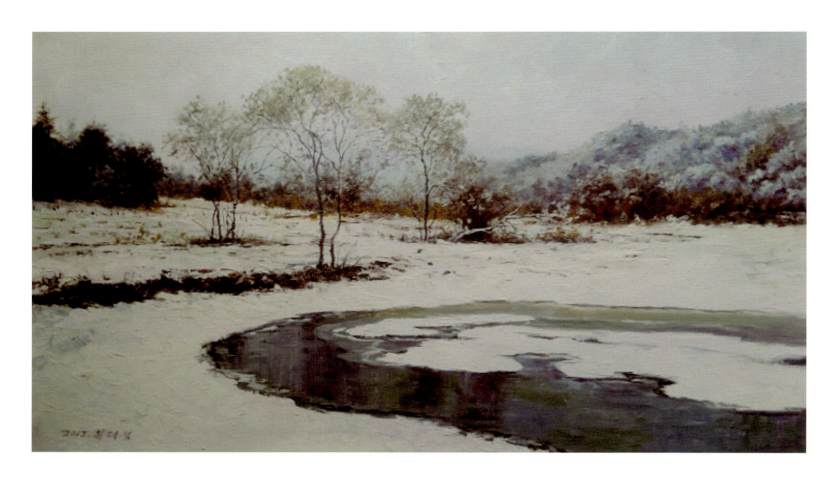

冬季 / Winter
1010mm x 600mm

崔大成	DachengCui
朝鲜	D.P.R.Korea
绘画	Painting

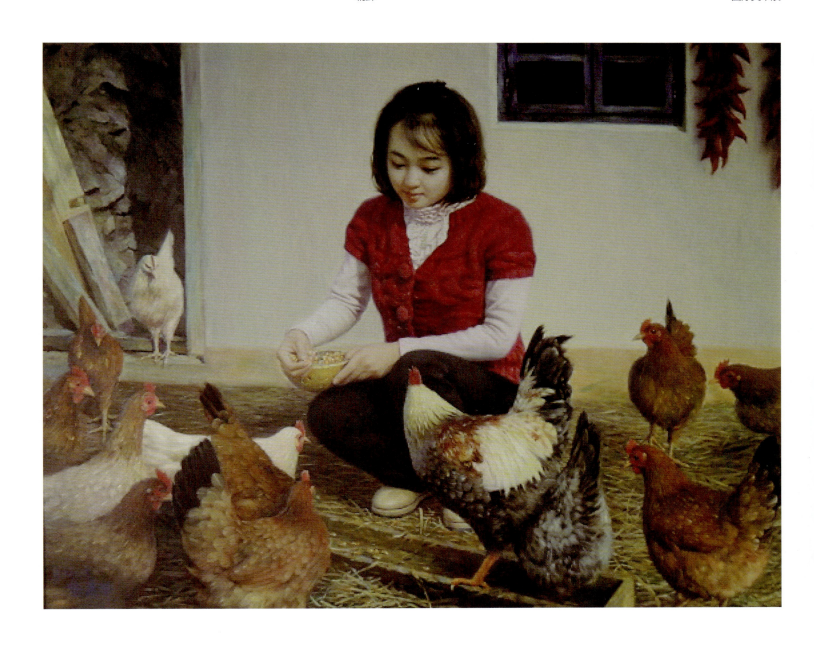

孙女 / Granddaughter
990mm x 790mm

姜勋英 / Xunying Jiang
朝鲜 / D.P.R.Korea
绘画 / Painting

Work Collection of Arts	The Fifth Silk Road International Arts Festival	D.P.R.Korea
美术作品集	第五届丝绸之路国际艺术节	朝鲜

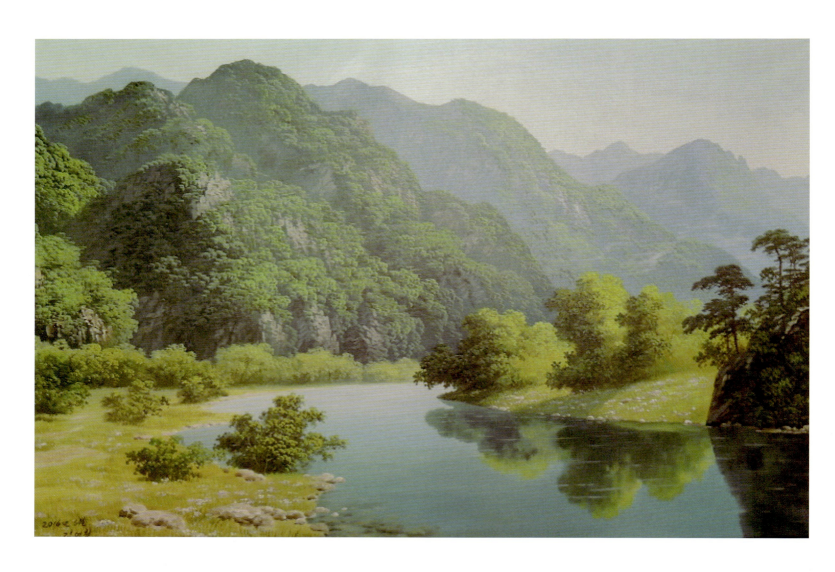

山村 / Mountain Village
900mm x 600mm

金永哲	Yongzhe Jin
朝鲜	D.P.R.Korea
绘画	Painting

D.P.R.Korea / 朝鲜 — International Art Exhibition / 国际美术展

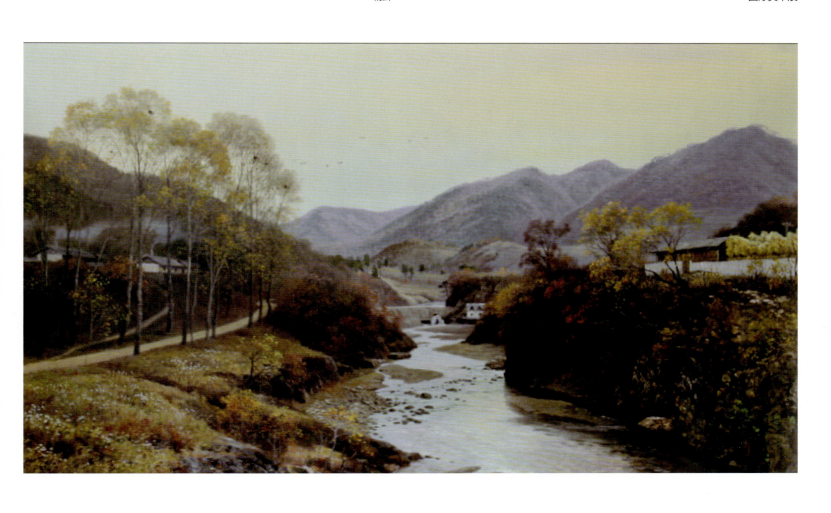

故乡山村 / Home Village
1670mm x 950mm

金元植 / Yuanzhi Jin
朝鲜 / D.P.R.Korea
绘画 / Painting

Work Collection of Arts | The Fifth Silk Road International Arts Festival | D.P.R.Korea
美术作品集 | 第五届丝绸之路国际艺术节 | 朝鲜

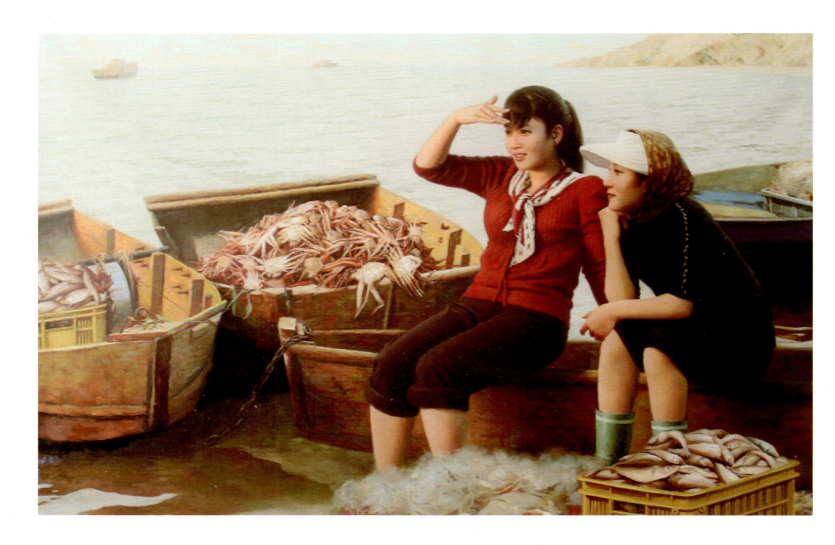

满船喜悦 / Loaded with Joy
1940mm x 1320mm

景玉	Yu Jing
朝鲜	D.P.R.Korea
绘画	Painting

D.P.R.Korea
朝鲜

International Art Exhibition
国际美术展

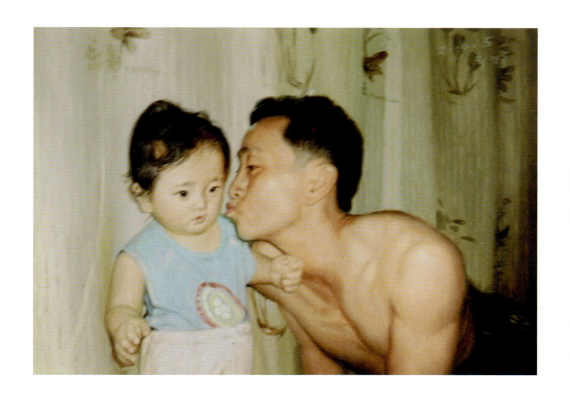

崔明国
朝鲜
绘画

女儿 / **Daughter**
610mm x 450mm

Mingguo Cui
D.P.R.Korea
Painting

| Work Collection of Arts | The Fifth Silk Road International Arts Festival | D.P.R.Korea |
| 美术作品集 | 第五届丝绸之路国际艺术节 | 朝鲜 |

希望 / Hope
1300mm x 970mm

李尚文	Shangwen Li
朝鲜	D.P.R.Korea
绘画	Painting

D.P.R.Korea / 朝鲜 — International Art Exhibition / 国际美术展

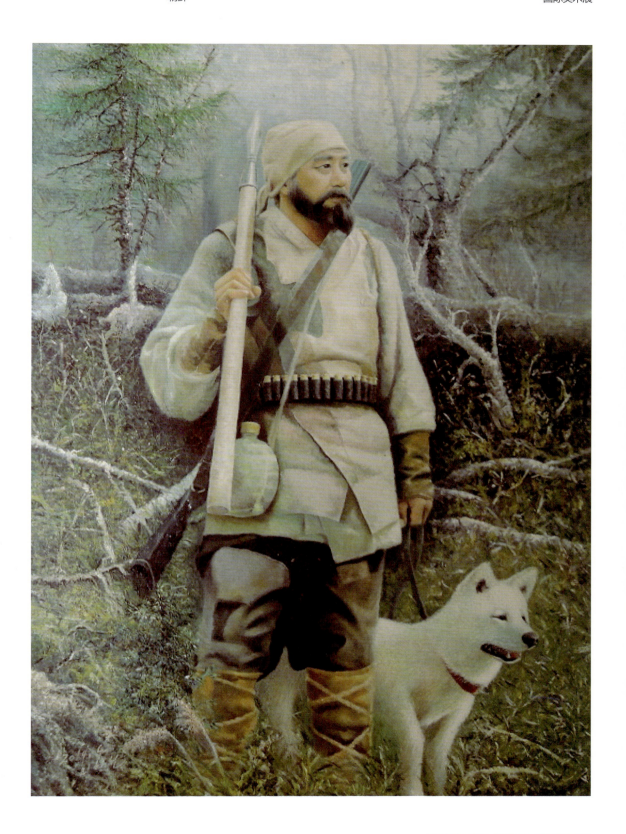

猎手 / Hunter
1310mm x 970mm

李玄哲 | Xuanzhe Li
朝鲜 | D.P.R.Korea
绘画 | Painting

| Work Collection of Arts | The Fifth Silk Road International Arts Festival | D.P.R.Korea |
| 美术作品集 | 第五届丝绸之路国际艺术节 | 朝鲜 |

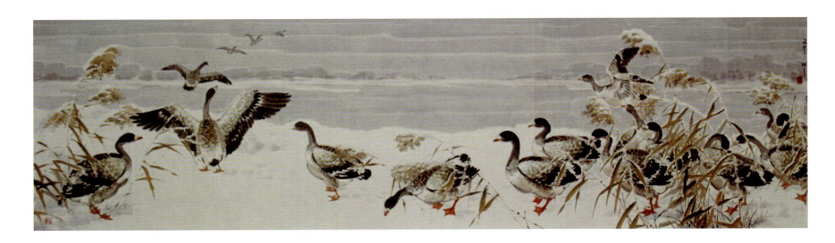

二月的大同江 / Datong River in February
2450mm x 680mm

李哲	Zhe Li
朝鲜	D.P.R.Korea
绘画	Painting

D.P.R.Korea / 朝鲜 — International Art Exhibition / 国际美术展

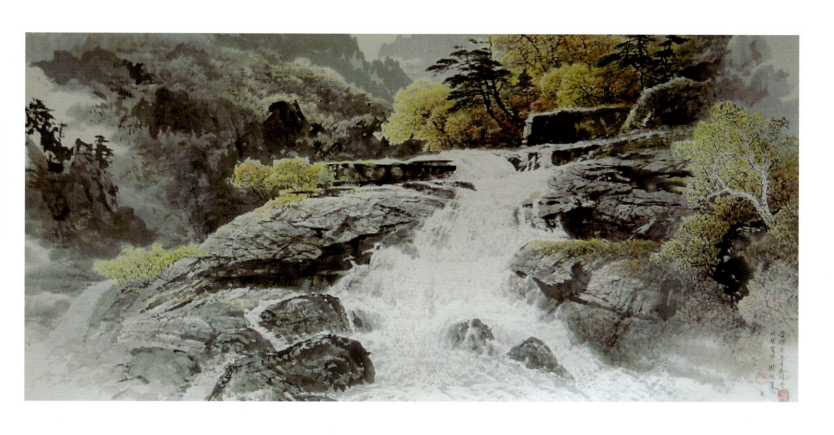

金刚山东石洞溪谷 / Jin'gang Mountain and Dongshi Stone Cave Valley

1280mm x 720mm

朴贤哲	Xianzhe Piao
朝鲜	D.P.R.Korea
绘画	Painting

| Work Collection of Arts | The Fifth Silk Road International Arts Festival | D.P.R.Korea |
| 美术作品集 | 第五届丝绸之路国际艺术节 | 朝鲜 |

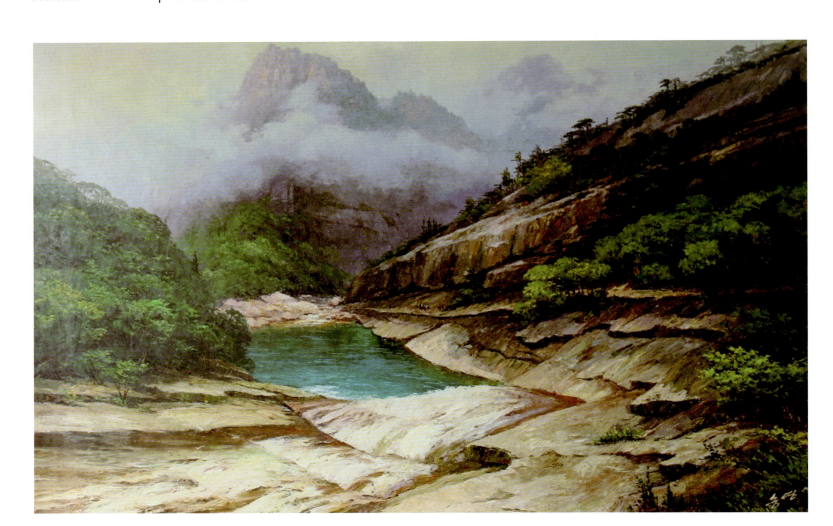

金刚山 / Jin'gang Mountain
1280mm x 81mm

宋永日	Yongri Song
朝鲜	D.P.R.Korea
绘画	Painting

D.P.R.Korea / 朝鲜 — International Art Exhibition / 国际美术展

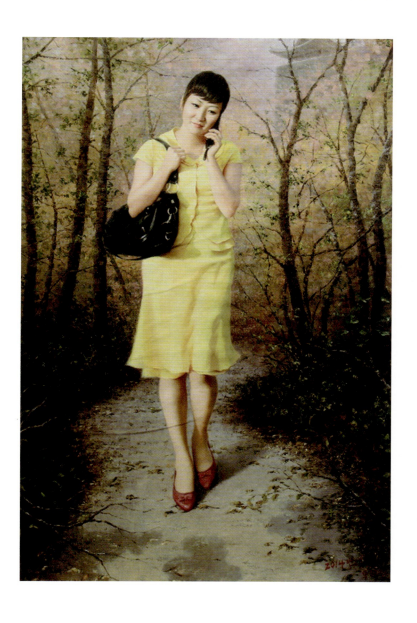

乙密台 / **Dense Units**
1640mm x 1130mm

俞赫哲 — Hezhe Yu
朝鲜 — D.P.R.Korea
绘画 — Painting

| Work Collection of Arts | The Fifth Silk Road International Arts Festival | Korea |
| 美术作品集 | 第五届丝绸之路国际艺术节 | 韩国 |

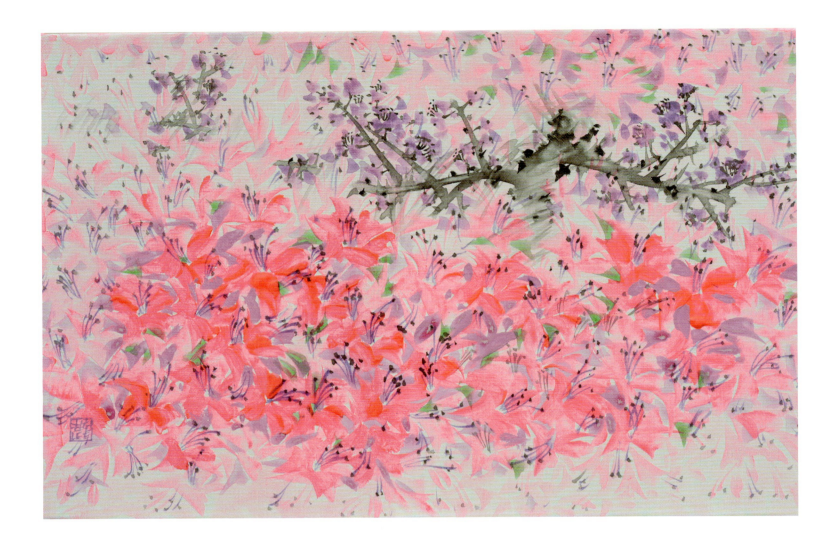

花舞 / Flower Dance

李範憲	Lee Bum Hun
韩国	Korea
绘画	Painting

Korea
韩国

International Art Exhibition
国际美术展

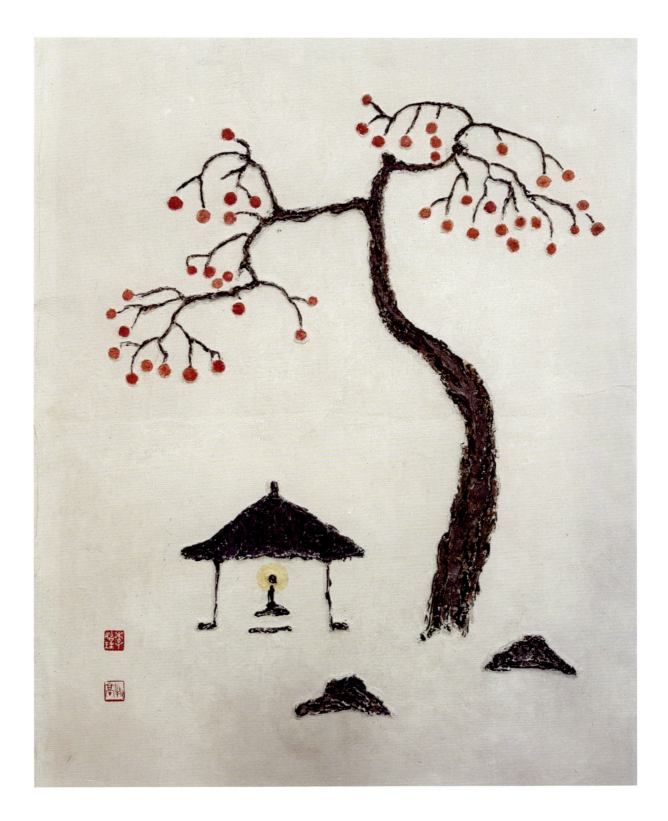

李始珪
韩国
绘画

禅 / Zen

Lee Si Kyu
Korea
Painting

| Work Collection of Arts | The Fifth Silk Road International Arts Festival | Korea |
| 美术作品集 | 第五届丝绸之路国际艺术节 | 韩国 |

恨——农家 / Hate—Peasant Family
910mm x 652mm

梁性模 Yang Seong Mo
韩国 Korea
绘画 Painting

Korea / 韩国 — International Art Exhibition / 国际美术展

都市木 / Urban Wood

金钟寿 / Kim Jong Shu
韩国 / Korea
绘画 / Painting

Work Collection of Arts | The Fifth Silk Road International Arts Festival | Korea
美术作品集 | 第五届丝绸之路国际艺术节 | 韩国

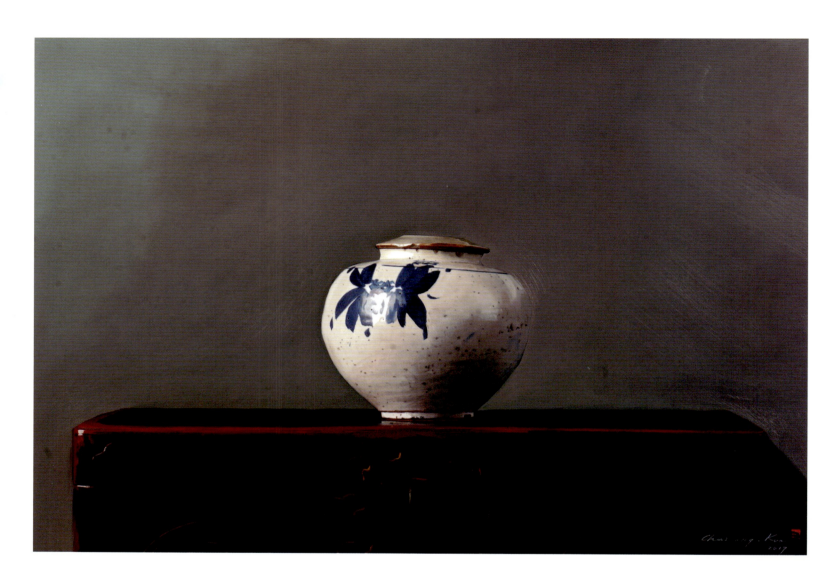

白陶瓷 / White Ceramics
727mm x500mm

具滋胜 | Koo Cha Soong
韩国 | Korea
绘画 | Painting

Korea
韩国

International Art Exhibition
国际美术展

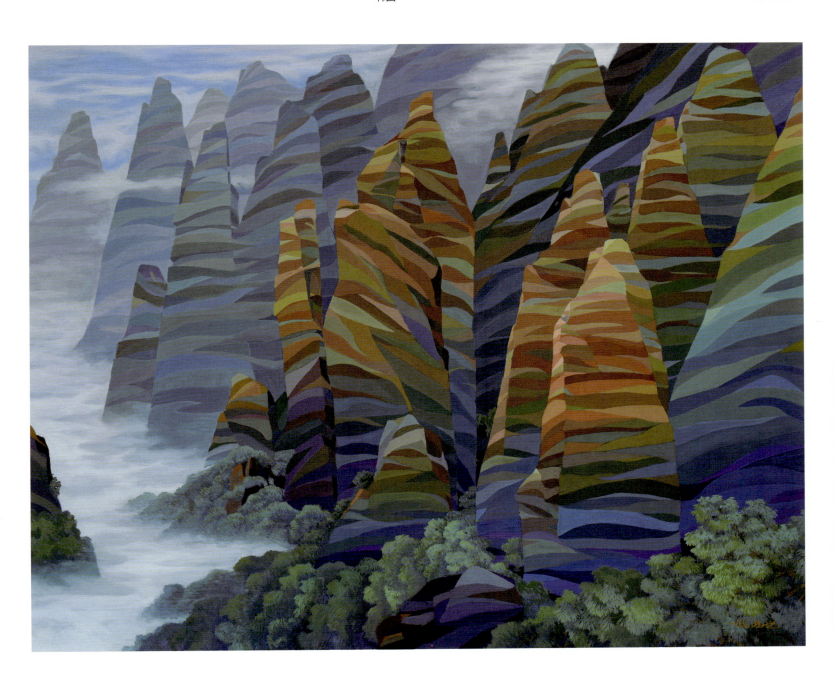

山光山舞——张家界 / Mountain Light Mountain Dance—Zhangjiajie
1620mm×1303mm

韩相润
韩国
绘画

Han Sang Yoon
Korea
Painting

Work Collection of Arts	The Fifth Silk Road International Arts Festival	Korea
美术作品集	第五届丝绸之路国际艺术节	韩国

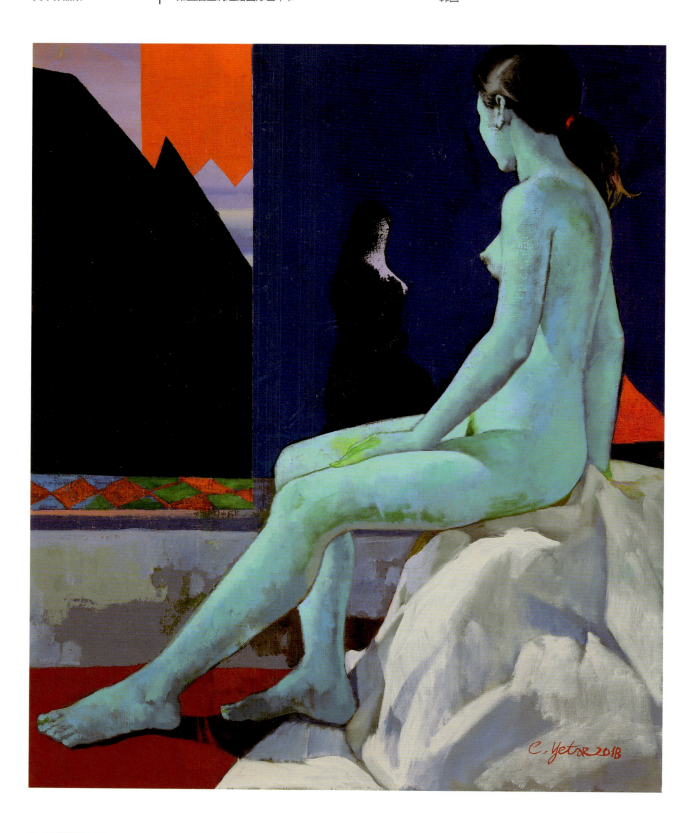

青色裸妇 / Cyan Naked Woman

崔礼泰 　　　　　　　　　 Choi Ye Tae
韩国 　　　　　　　　　　 Korea
绘画 　　　　　　　　　　 Painting

Korea
韩国

International Art Exhibition
国际美术展

我心目中的一座城市 / A City of My Mind

金永珉　　　　　Kim Yeong Min
韩国　　　　　　Korea
绘画　　　　　　Painting

| Work Collection of Arts | The Fifth Silk Road International Arts Festival | Korea |
| 美术作品集 | 第五届丝绸之路国际艺术节 | 韩国 |

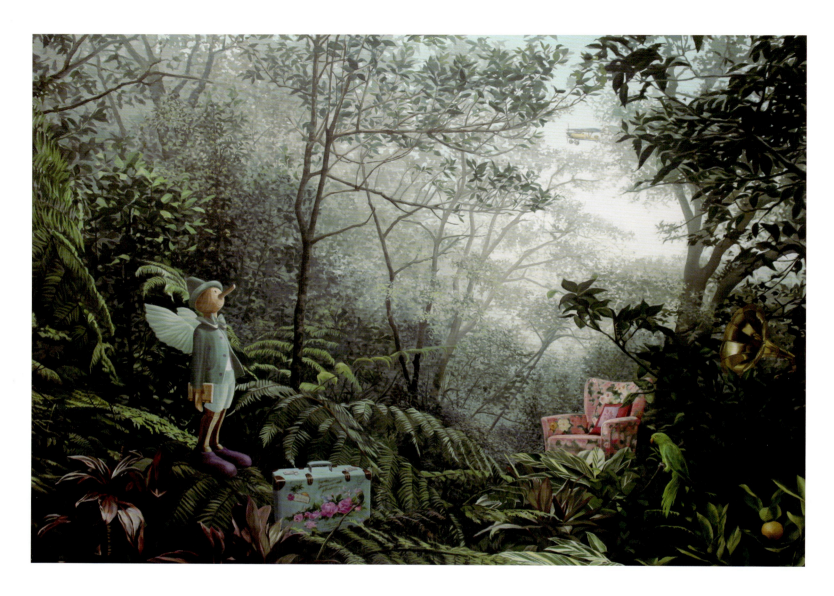

游牧民 / Nomads
1622mm×1120mm

黄济性　　　　　　　　Hwang Jea Sung
韩国　　　　　　　　　Korea
绘画　　　　　　　　　Painting

Korea
韩国

International Art Exhibition
国际美术展

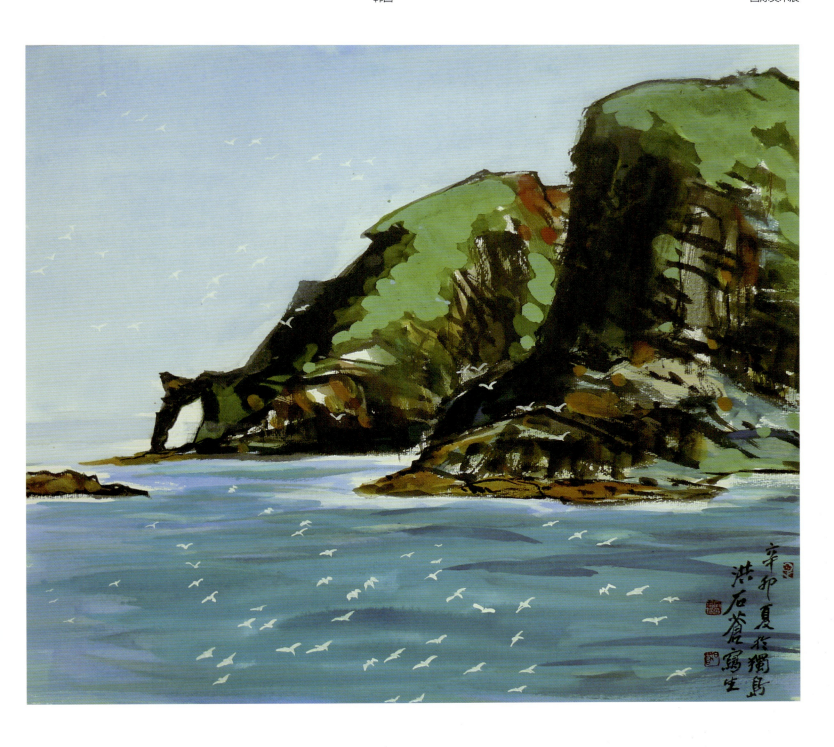

洪石苍
韩国
绘画

独岛 / Island Alone

Hong Suk Chang
Korea
Painting

| Work Collection of Arts / 美术作品集 | The Fifth Silk Road International Arts Festival / 第五届丝绸之路国际艺术节 | Korea / 韩国 |

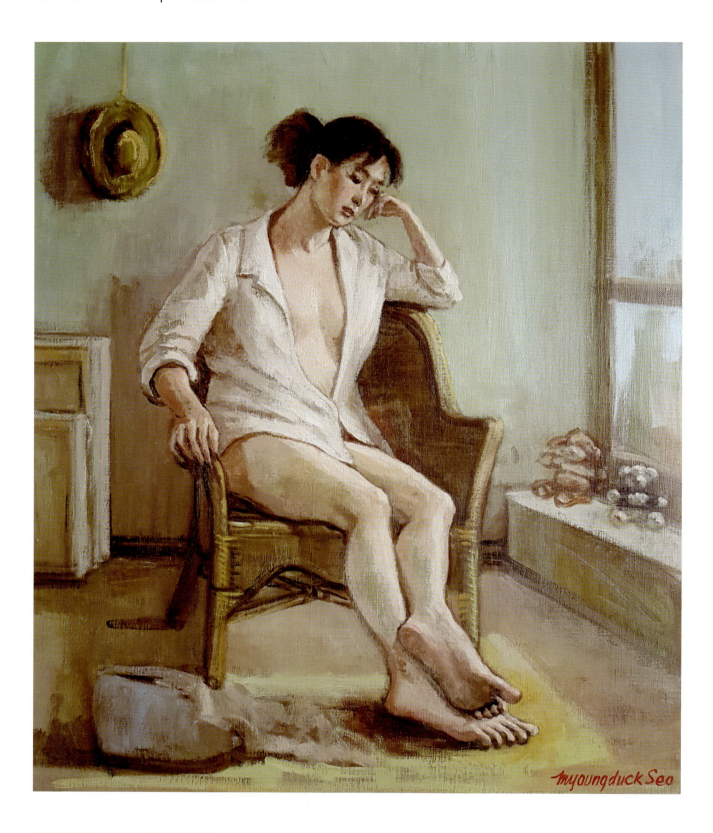

女人 / Woman

徐明德
韩国
绘画

Seo Myong Duk
Korea
Painting

Korea
韩国

International Art Exhibition
国际美术展

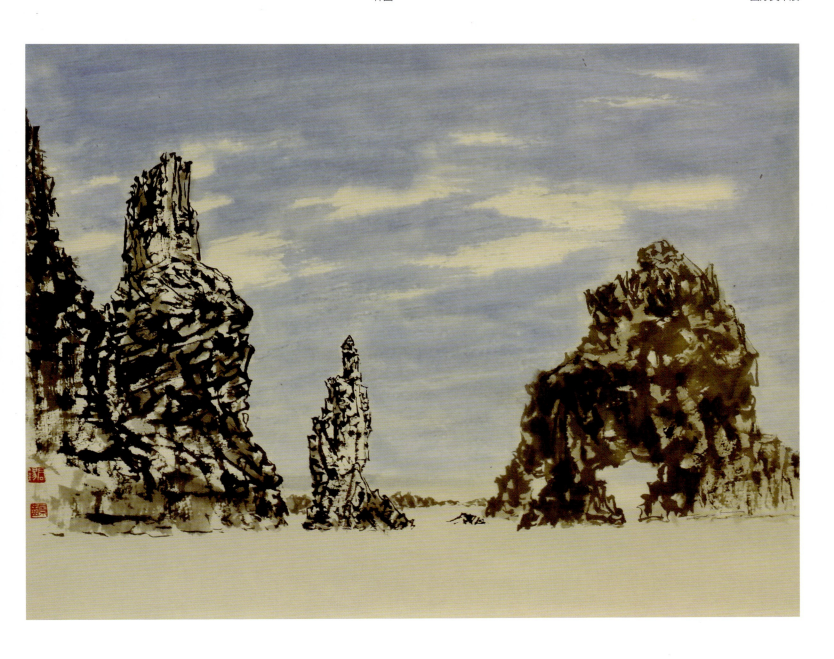

独岛气韵 / Rhyme of a Single Island
334mm x 242mm

南君锡　　　　　　　Nam Gun Seok
韩国　　　　　　　　Korea
绘画　　　　　　　　Painting

| Work Collection of Arts | The Fifth Silk Road International Arts Festival | Korea |
| 美术作品集 | 第五届丝绸之路国际艺术节 | 韩国 |

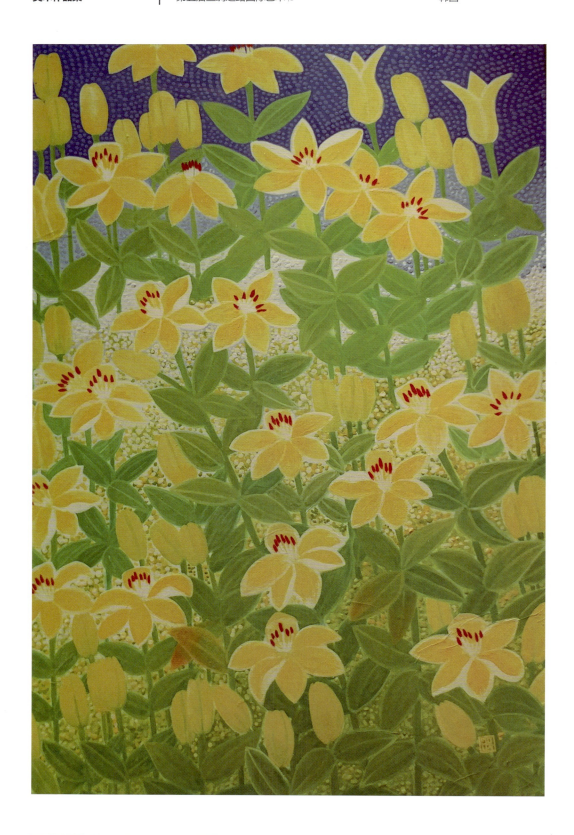

祝祭 / Festival

林美子
韩国
绘画

Lim Mi Ja
Korea
Painting

Korea
韩国
International Art Exhibition
国际美术展

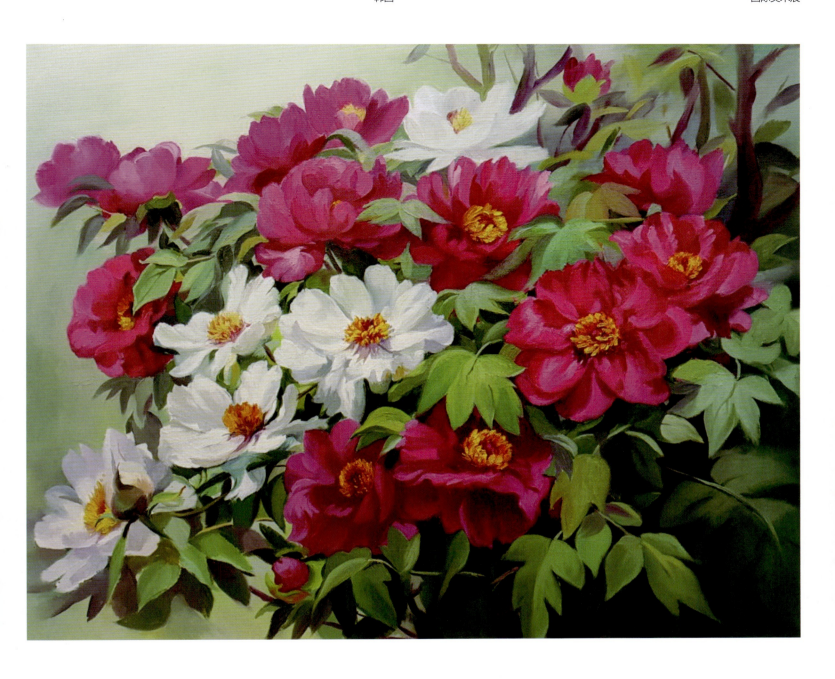

李是昀
韩国
绘画

牡丹 / Peony

Lee Ha Yoon
Korea
Painting

| Work Collection of Arts | The Fifth Silk Road International Arts Festival | Korea |
| 美术作品集 | 第五届丝绸之路国际艺术节 | 韩国 |

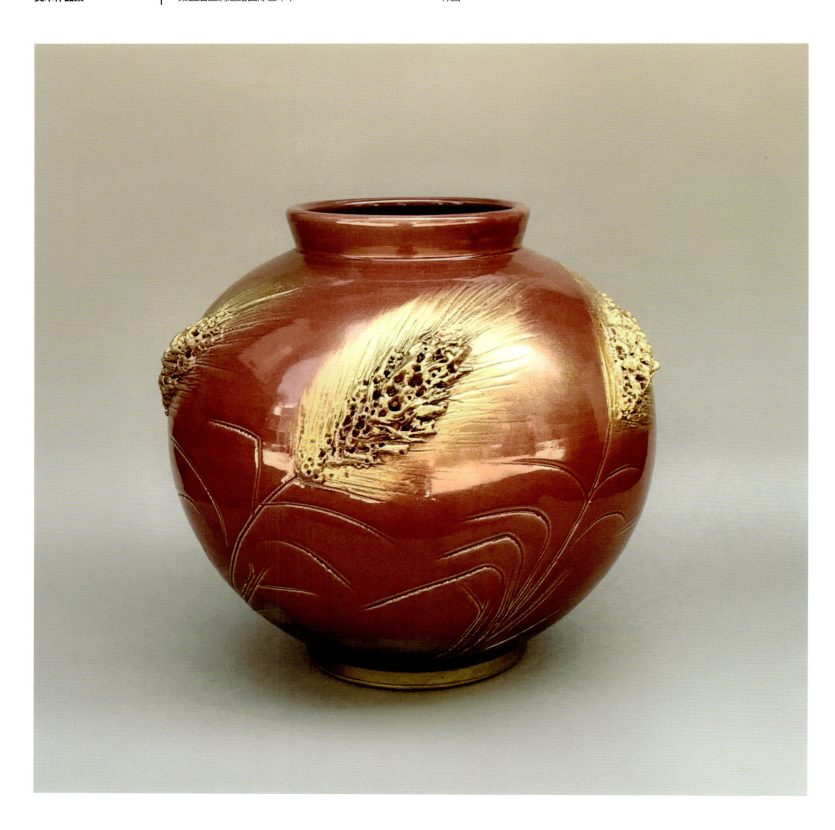

金麦白陶瓷 / Wheat White Ceramics
305mm x 155mm

金银珍	Kim Eun Jin
韩国	Korea
雕塑	Sculpture

Korea
韩国

International Art Exhibition
国际美术展

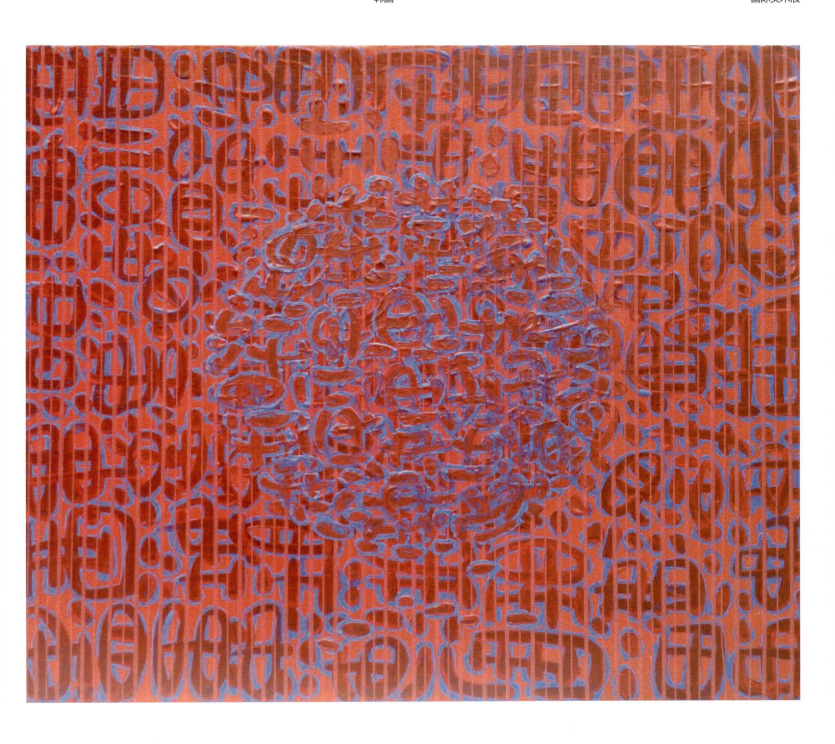

秦美晶
韩国
绘画

组成 / Look at Line

Jin Mi Jeong
Korea
Painting

| Work Collection of Arts | The Fifth Silk Road International Arts Festival | Korea |
| 美术作品集 | 第五届丝绸之路国际艺术节 | 韩国 |

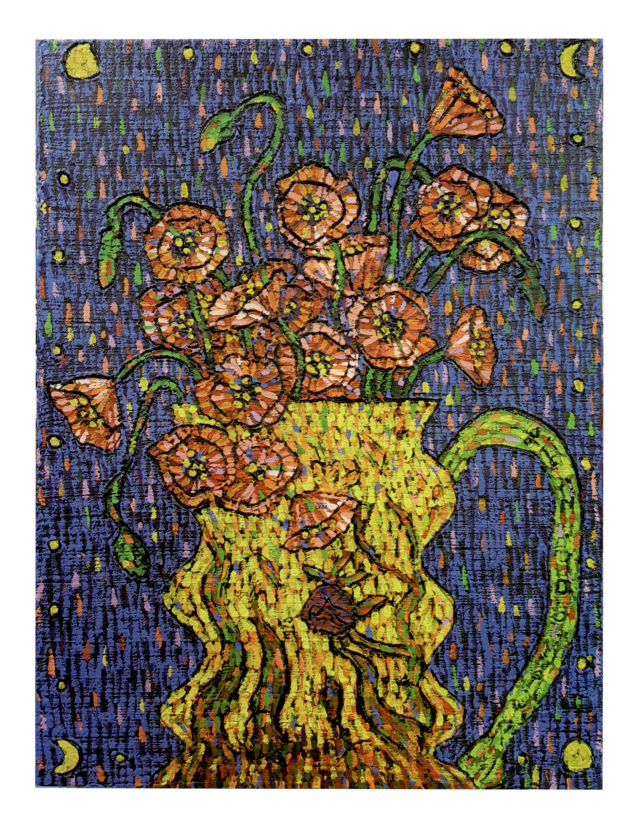

生活故事——欧洲陶瓷的永恒爱情 / Life Story—the Eternal Love of European Ceramics
530mm x 720mm

金容模	Kim Yong Mo
韩国	Korea
绘画	Painting

Korea / 韩国 — International Art Exhibition / 国际美术展

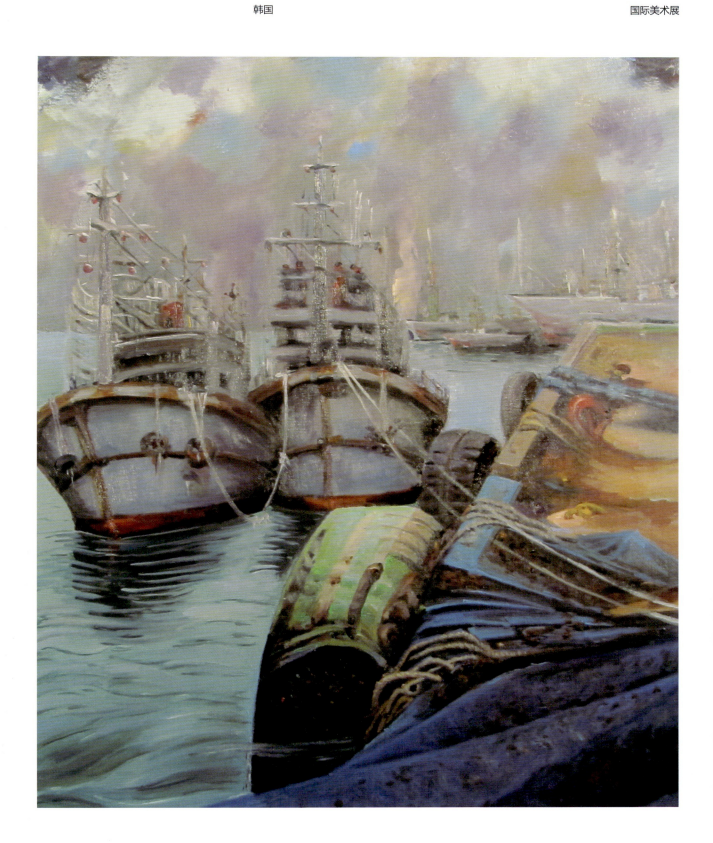

具象绘画 / Figurative Painting

黄顺奎
韩国
绘画

Hwang Soon Gou
Korea
Painting

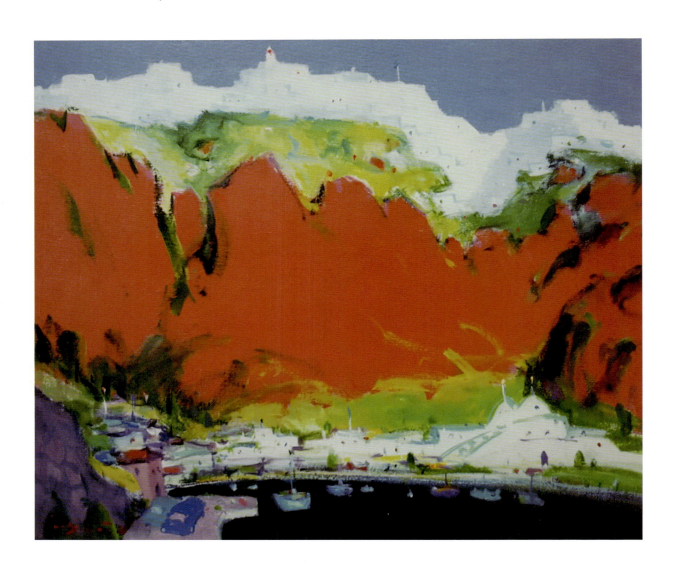

圣托里尼 / Santorini

赵成户	Jo Sung Ho
韩国	Korea
绘画	Painting

Korea / 韩国 / International Art Exhibition / 国际美术展

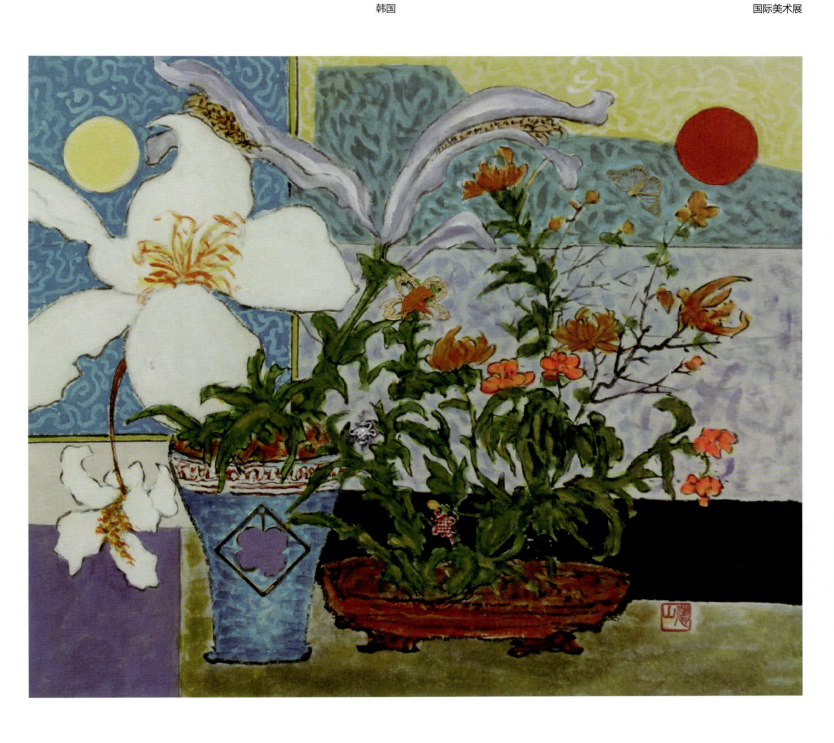

花盆 / Flowerpot
720mm x 600mm

尹命镐 / Yoon Myoung Ho
韩国 / Korea
绘画 / Painting

| Work Collection of Arts | The Fifth Silk Road International Arts Festival | Korea |
| 美术作品集 | 第五届丝绸之路国际艺术节 | 韩国 |

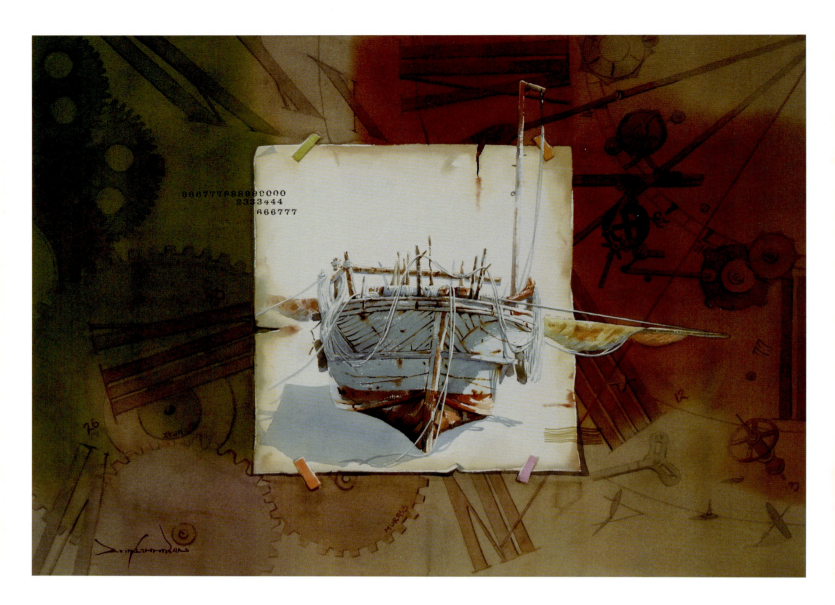

时间旅行 / Time Travel
700mm x1000mm

金美兰	Kim Mi Ran
韩国	Korea
绘画	Painting

丝绸之路国际艺术节
The Silk Road International Arts Festival

结语 / Conclusion

115 countries

305 works

绘画 / 雕塑 / 装置 / 影像

Painting / Sculpture / Installation / Image

2018 年 9 月 7 日，丝绸之路国际艺术节又将在中国西安迎来第五届的盛大开幕。作为中国两大国际艺术节之一，丝绸之路国际艺术节是中国国家层面对外进行文化与艺术交流的最为重要的国际性窗口；其中一个重要的板块，就是丝绸之路国际美术展。

历经五年的发展，丝绸之路国际美术展已成为国内具有影响的国际性美术展览之一。通过国际性的作品征集平台，本次展览共征集了来自 120 个国家和地区的艺术作品两千余幅，并精选出 115 个国家的 306 名艺术家参与丝绸之路国际艺术节国际美术展。本届美术展的亮点不仅包括参与国家与地区增多，参与的艺术家人数增加，而且包括参与的艺术家艺术水准较前四届有了重大突破。许多在国际舞台上著名的艺术家积极参与，来自国内的西安美术学院、鲁迅美术学院、四川美术学院、景德镇陶瓷大学等美术院也积极支持，这些都推动了本次展览学术水平的提升，充分彰显了丝绸之路国际艺术节在立足陕西的同时，打开了走向国际的良好局面，彰显了独有的艺术魅力和学术价值，体现了中国文化情结与中国文化温度。

本届今日丝绸之路国际美术展，一如既往地传承了艺术的多样性、多元性、国际性，致力于打造具有国际视野、世界各国艺术家积极参与的国际性美术展览平台，体现世界文化发展与和平交流。就让艺术作品让我们相识、相知、相融，更好地为世界文化发展作出贡献吧！让我们一同走来，感受丝路节美好的过去与未来吧！

西安建筑科技大学艺术学院院长 / 学术主持

International Art Exhibition

国际美术展

On September 7, 2018, the Fifth Silk Road International Arts Festival commences in Xi'an China. The Silk Road International Arts Festival, organized by the Ministry of Culture of the People's Republic of China and the Shaanxi Provincial People's Government, is one of the two major international Arts festivals in China. It is also the most important way of international communication for the cultural and artistic exchanges between China and other countries.

After five year's development with significant progress in this year, the Silk Road International Arts Festival International Arts Exhibition has become one of the most influential international Arts exhibitions. This year, we have received more than 2000 pieces of artworks through the international solicitation platform, in which 306 artists' artwork are selected from 115 countries for the exhibition in this year. The critical highlight of the festival's arts exhibition is not only the number of participating countries, but also the number of artists involved and the academic level of the exhibition with a significant breakthrough. Many excellent artists with worldwide reputations have attended this year's exhibition, directors from Xi'an Academy of Fine Arts, Lu Xun Academy of Fine Arts, Sichuan Academy of Fine Arts, Ceramic Institutes of Jingdezhen, and other domestic and international famous artists. This exhibition has become the art exhibition with the largest number of participation countries and regions in China, which fully demonstrates that the Silk Road International Arts Festival, based in Shaanxi, is expanding to the world with a unique artistic charm and advanced academic level.

The academic team of Today Silk Road International Arts Exhibition, will, as always, adhere to the idea that art is diverse, multidimensional and cosmopolitan. Inheriting the Chinese outstanding culture traditional, strive to build an international platform with international perspective and make the worldwide artists to participate actively in the international arts exhibition. This reflects the harmony, peace and communication of the world cultures. Through the artworks on the cultural exchange platform, we could meet, know and connect with each other, hold hands and contribute to the global culture development together..

Academic Chair: Baogang Lin

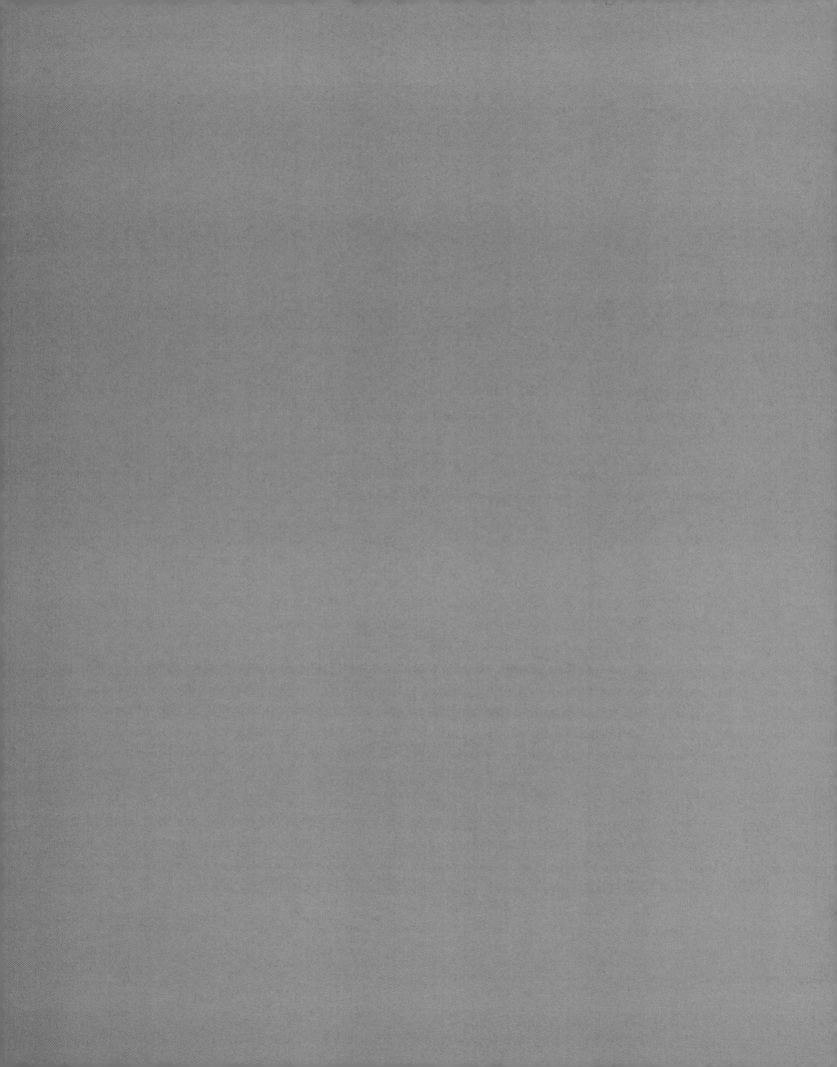

2014 2015 2016 2017 2018

4th

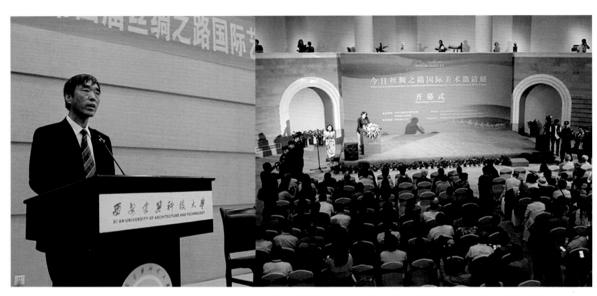

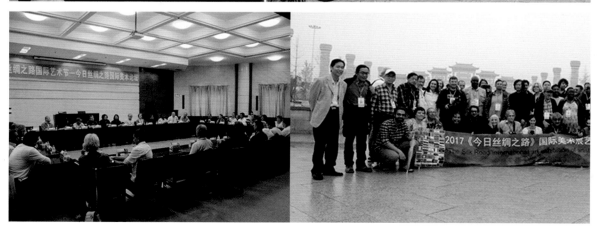

The 4th Today Silk Road International Atrs Exhibition Tidbit of the Academic Forum
第四届今日丝绸之路国际美术邀请展学术论坛花絮

图书在版编目(CIP)数据

2018第五届丝绸之路国际艺术节；今日丝绸之路国际美术展作品集 / 任宗哲，蔺宝钢主编. —北京：中国建筑工业出版社，2018.8
 ISBN 978-7-112-22483-8

Ⅰ.①2… Ⅱ.①任…②蔺… Ⅲ.①美术-作品综合集-世界-现代　Ⅳ.①J111

中国版本图书馆CIP数据核字（2018）第171103号

责任编辑：费海玲　张幼平
责任校对：张　颖

2018第五届丝绸之路国际艺术节
今日丝绸之路国际美术展作品集
任宗哲　蔺宝钢　主编
＊
中国建筑工业出版社出版、发行（北京海淀三里河路9号）
各地新华书店、建筑书店经销
天津图文方嘉印刷有限公司印刷
＊
开本：965×1270毫米　1/16　印张：21¼　字数：512千字
2018年8月第一版　2018年8月第一次印刷
定价：230.00元
ISBN 978-7-112-22483-8
　　　　（32564）

版权所有　翻印必究
如有印装质量问题，可寄本社退换
（邮政编码 100037）